NAKED TRUTHS

NAKED TRUTHS

Women, sexuality, and gender in
classical art and archaeology

Edited by
Ann Olga Koloski-Ostrow
Claire L. Lyons

London and New York

First published 1997
by Routledge
11 New Fetter Lane, London EC4P 4EE

Simultaneously published in the USA and Canada
by Routledge
29 West 35th Street, New York, NY 10001

First published in paperback 2000

Routledge is an imprint of the Taylor & Francis Group

Typeset in Garamond by
J&L Composition Ltd, Filey, North Yorkshire

Printed and bound in Great Britain by
Biddles Ltd, Guildford and King's Lynn

British Library Cataloguing in Publication Data
A catalogue record for this book is available from the British Library

Library of Congress Cataloguing in Publication Data
Naked Truths: Women, Sexuality and Gender in
Classical Art and Archaeology.
Edited by Ann Koloski-Ostrow and Claire L. Lyons.
p. cm.
Includes bibliographical references and index.
1. Women in art. 2. Sexuality in art. 3. Gender
identity in art. 4. Art, Classical.
I. Koloski-Ostrow, Ann Olga
II. Lyons, Claire L.
N7630.N36 1997
704.9'424'0938–dc20 96–41228

ISBN 0–415–15995–4 (hbk)
ISBN 0–415–21752–0 (pbk)

CONTENTS

CONTENTS

FIGURES AND TABLES

FIGURES

TABLES

NOTES ON CONTRIBUTORS

Aileen Ajootian Assistant Professor of Classics, University of Mississippi, USA. Publications: "Hermaphroditos," *Lexicon Iconographicum Mythologiae Classicae*, vol. 5, Zurich, Artemis Verlag, 1990; "Praxiteles," in J. J. Pollitt and O. Palagia (eds), *Personal Styles in Greek Sculpture*, New York, Cambridge University Press, 1996.

Larissa Bonfante Professor of Classics, New York University, USA. Publications: *The World of Roman Costume*, co-edited with Judith Sebesta, Madison, University of Wisconsin Press, 1994; *Reading The Past: Etruscan*, London, British Museum Publications, 1990; *Etruscan Life and Afterlife: A Handbook of Etruscan Studies*, Detroit, Wayne State University Press, 1986; *Etruscan Dress*, Baltimore, Johns Hopkins University Press, 1975.

Shelby Brown Research Associate, Institute of Archaeology, UCLA, USA. Publications: "Feminist Research in Archaeology: What Does It Mean? Why Is It Taking So Long?," in Amy Richlin and Nancy Rabinowitz (eds), *Feminist Theory and the Classics*, London, Routledge, 1993, pp. 238–71; "Death As Decoration: Scenes of the Arena on Roman Domestic Mosaics," in Amy Richlin (ed.), *Pornography and Representation in Greece and Rome*, Oxford, Oxford University Press, 1992, pp. 180–211; *Late Carthaginian Child Sacrifice and Sacrificial Monuments in the Mediterranean Context*, Sheffield, JSOT Press, 1991.

Beth Cohen She has taught at the University of Rochester in Italy, Bard College, Columbia University, and the University of Wisconsin, USA. Publications: editor, *The Distaff Side: Representing the Female in Homer's Odyssey*, New York and Oxford, Oxford University Press, 1995; "From Bowman to Clubman: Herakles and Olympia," *The Art Bulletin*, 1994, vol. 75, pp. 695–715; co-author with Diana Buitron *et al.*, *The Odyssey and Ancient Art: An Epic in Word and Image*, Bard College, Annandale-on-Hudson, NY, 1992; *Attic Bilingual Vases and Their Painters*, Garland Publishing, NY, 1978.

Natalie Boymel Kampen Ann Whitney Olin Professor of Women's Studies and of Art History, Barnard College, Columbia University, USA. Publications: *Image and Status: Working Women in Ostia*, Berlin, Mann, 1981; contributor, *Women in the Classical World: Image and Text*, New York and Oxford, Oxford University Press, 1994; editor, *Sexuality in Ancient Art: Near East, Egypt, Greece, and Italy*, Cambridge and New York, Cambridge University Press, 1996; "Theorizing Gender in Roman Art," in D. Kleiner and S. Matheson, *I, Claudia: Women in Roman Art*, New Haven, Yale University Press, 1996, pp. 14–25.

Ann Olga Koloski-Ostrow Assistant Professor of Classical Studies, Brandeis University, USA. Publications: *The Sarno Bath Complex*, Rome, "L'Erma" di Bretschneider, 1990; "Finding Social Meaning in the Public Latrines of Pompeii," in N. de Haan and G. jansen (eds), *Cura Aquarum in Campania: Proceedings of the Ninth International Congress on the History of Water Management and Hydraulic Engineering in the Mediterranean Region, BABesh*, Suppl. 4, Leiden, 1996, 79–86; "Water in the Roman World: New research from Cura Aquarum and the Frontinus Society," with N. de Haan, G. de Kleijn, and S. Piras, *JRA*, 1997, vol. 10, pp. 181–91; ed. and contributor "Water Use and Hydraulics in the Roman City," *Archaeological Institute of America Colloquia and Conference Papers*, forthcoming; "The City Baths of Pompeii and Herculaneum," in P. W. Foss and J. J. Dobbins (eds), *Pompeii and the Ancient Settlements Undr Vesuvius*, New York and London, Routledge, in press; and a book on health and sanitation in Roman Italy, in preparation.

Claire L. Lyons Collections Curator, Getty Research Institute for the History of Art and the Humanities, USA. Publications: *Morgantina Studies V: The Archaic Cemeteries*, Princeton, Princeton University Press, 1996; "Modalità di acculturazione a Morgantina," *Bollettino di Archeologia*, 1991, vols 11–12, pp. 1–10; "Sikel Burials at Morgantina: Defining Social and Ethnic Identities," in R. Leighton (ed.), *Early Societies in Sicily: New Developments in Archaeological Research*, London, Accordia Publications, 1996, pp. 177–88; and various articles on the history of archaeology and collecting.

Joan Reilly Director of Visual Resources, City University of New York, USA, 1993–5. Publications: "Many Brides: 'Mistress and Maid' on Athenian Lekythoi," *Hesperia*, 1989, vol. 58, pp. 411–44; "Standards, Maypoles, and Sacred Trees?," *Archäologischer Anzeiger*, 1994, pp. 499–505.

John Robb Lecturer in the Department of Archaeology, University of Southampton, England. Publications: "Burial and Social Reproduction in the Peninsular Italian Neolithic," *Journal of Mediterranean Archaeology*, 1994, vol. 7, pp. 27–71; "Gender Contradictions: Moral Coalitions and Inequality in Prehistoric Italy," *Journal of European Archaeology*, 1994, vol. 2, pp. 20–49;

"Violence and Gender in Early Italy," in D. Frayer and D. Martin (eds), *Troubled Times: Osteological and Archaeological Evidence of Violence*, New York, Gordon and Breach, in press.

Nanette Salomon Associate Professor of Art History at the College of Staten Island, City University of New York, and lecturer in Education at The Metropolitan Museum of Art, New York, USA. Publications: "The Art Historical Canon: Sins of Omission," in J. E. Hartman and E. Messer-Davidow (eds), *(En)gendering Knowledge: Feminists in Academe*, Knoxville, University of Tennessee Press, 1991, pp. 222–36; "The Venus Pudica: Uncovering Art History's 'Hidden Agendas' and Pernicious Pedigrees," in G. Pollock (ed.), *Generations and Geographies in the Visual Arts Feminist Readings*, London, Routledge, 1996, pp. 69–87.

Jane McIntosh Snyder Professor Emeritus of Classics and Women's Studies, Ohio State University, USA. Publications: *Stringed Instruments of Ancient Greece*, with M. Maas, New Haven, Yale University Press, 1989; *The Woman and the Lyre: Women Writers in Classical Greece and Rome*, Carbondale, Southern Illinois University Press, 1989; *Puns and Poetry in Lucretius' De Rerum Natura*, Amsterdam, Gruener, 1980.

Francine Viret Bernal Assistant and Ph.D. candidate at the Institute of Archaeology and Ancient History, Lausanne University, Switzerland. Publications: C. Bron, F. Viret Bernal, C. Bérard *et al.*, "Héraclès chez T.I.R.E.-S.I.A.S: traitement informatique de reconnaissance des éléments sémiologiques pour l'identification analytique des scènes," *Hephaistos*, 1991, vol. 10, pp. 21–33; "Argos, du palais à l'agora," *Dialogues d'Histoire Ancienne*, 1992, vol. 18.1, pp. 61–88; *Sur les ailes du sphinx: la mort dans l'art ibérique antique* (co-edited with D. Bally Chambaz), Lausanne, Musée Romain Lausanne-Vidy, 1996.

John G. Younger Professor of Classical Archaeology, Duke University, USA. Publications: *The Iconography of Late Minoan and Mycenaean Sealstones and Finger Rings*, Bristol, Bristol Classical Press, 1988; "Masters and Stylistic Groups of Seals of the Late Bronze Age," series of articles in *Kadmos*, 1982, vol. 21 to 1989, vol. 28; *A Bibliography for Aegean Glyptic in the Bronze Age*, Berlin, Mann, 1991; "Bronze Age Representations of Aegean Bull-Games, III" in R. Laffineur and W.-D. Niemeier (eds), *Politeia: Society and State in the Aegean Bronze Age*. Proceedings of the 5th International Aegean Conference, University of Heidelberg, 10–13 April, 1994 (*Aegeum* 12, 1995) vol. II, pp. 507–45

ACKNOWLEDGEMENTS

In an undertaking based on the efforts and contributions of many col-
leagues and friends, it is a pleasant task to recognize the help and support of
all those who have lent their time, experience, and wisdom to the project.
First and foremost, the co-editors would like to express their profound
gratitude to Shelby Brown, who developed the 1994 Archaeological Insti-
tute of America panel which became the source for several of the essays
published here. Her ideas have shaped our thinking in many ways, and we
have benefited from a dialogue that has been rich in challenging questions,
setting the stage for the kind of critical inquiry that has for long been
neglected in this field. Our warmest appreciation is extended to the vol-
ume's other contributors, Aileen Ajootian, Larissa Bonfante, Beth Cohen,
Joan Reilly, John Robb, Nanette Salomon, Jane Snyder, Francine Viret
Bernal, and John Younger, for their willingness to go beyond the usual
parameters in which their material has been considered and to pose fresh,
even controversial readings. We have been fortunate, also, in the expert
overview offered by Natalie Kampen in an epilogue that skillfully assesses
the various thematic strands and from them proposes yet further produc-
tive paths for thinking about gender and sexuality in classical antiquity. We
have likewise profited from the informative perspectives of the other
participants in the original AIA and American Philological Association
panels. Claire Lyons thanks the staff of the Resource Collections of the
Getty Research Institute for the History of Art and the Humanities, in
particular Linn Kier and Louise Hitchcock. Ann O. Koloski-Ostrow is
deeply appreciative for encouragement and support of various kinds
from the Bunting Institute of Radcliffe College and from the Department
of Classical Studies, the library staff, and the administration of Brandeis
University. The suggestions and constructive criticisms of colleagues
actively concerned with gender issues, and especially those of reviewer
Lin Foxhall, have been much appreciated. We are also grateful for the
proficient attention of the Routledge editorial staff. Finally, each of
the co-editors of this anthology would like to acknowledge and applaud
the good fortune of having found in her counterpart a patient and

stimulating colleague. Like two of E. B. White's Charlottes, we have worked to weave the threads of mutual interests and observations into the tapestry that is this volume. The concluding lines of E. B. White's *Charlotte's Web*, therefore, perhaps best express our collaboration: "She was in a class by herself. It is not often that someone comes along who is a true friend and a good writer. Charlotte was both."

Ann Olga Koloski-Ostrow
Waltham, Massachusetts

Claire Louise Lyons
Los Angeles, California

1

NAKED TRUTHS ABOUT CLASSICAL ART

An introduction

Claire L. Lyons
Ann Olga Koloski-Ostrow

Naked truths are truths that are sometimes uncomfortably presented, stripped of artifice or ornament, to be accepted at face value. Truths concerning such fundamental aspects of human interrelations as gender identity, desire, and power are far from transparent and natural, even in their denuded and dismantled incarnations. This is especially so in the instance of artistic creations and representations that serve the larger educational goals of social and political ideology. Contemporary feminist approaches that accentuate the centrality of gender and sexuality as core constructs in the interpretation of past and present cultures have been voiced in academic disciplines over the last several decades. Only recently, however, have these critical methodologies been applied to the visual arts and material culture of the classical Mediterranean world. While social and cultural anthropologists have utilized feminist perspectives quite aggressively in the economic and socio-political realms of their work, the potential usefulness of looking inclusively and relationally at women and men as they are represented in classical iconography, art, literary texts, and inscriptions has just begun to be explored.

The articles in this book are unified by an investigation of how gendered bodies and sexual difference are communicated visually and symbolically in the art and artifacts of what is broadly referred to as Graeco-Roman civilization. Representations of women and men in ancient wall-painting, sculpture, figured ceramics, and coroplastic production – whether clothed, partially disrobed, or completely naked – are reconsidered from fresh perspectives. What constitutes the sexuality of these images? What symbolic meanings and social inferences are embedded in the iconographical attributes of dress, body ornament, and personal possessions? What is the role of the viewer in constructions of gender in art, and what are the components of a "gendered" archaeology or ancient art history?

The inspiration for this anthology originated in two panels presented at

1

consecutive annual meetings of the Archaeological Institute of America and the American Philological Association. The first panel, sponsored by the Women's Classical Caucus, was held at the APA meeting in Washington, DC, in 1993.[1] It offered a broad survey of current approaches to questioning the material remains of antiquity for evidence of the expectations and roles under which women operated. The second session took place at the 1994 meeting of the AIA in Atlanta, Georgia.[2] These papers looked more closely at depictions of female and male bodies in order to decode the social meanings attached to nudity and dress as indicators of sexual status. Within the context of the primary professional organizations concerned with the archaeology, literature, and history of the classical world, these two sessions were among the first to explore methodologies and applications of representing sexuality and gender in the visual arts of prehistoric and classical societies in Greece and Italy. Based on a selection of the original panel papers and the addition of several complementary studies, this volume represents a cross-section of recent work by archaeologists and art historians engaged in re-assessing representations of the human figure in diverse cultures of the past. These studies apply various theoretical frameworks, ranging from anthropological perspectives on gender differentiation and structuralist iconographic analysis to overtly feminist criticism.

Because classical works of art have traditionally served as paradigms of Western European values, tastes, and styles in the visual arts, the task of revealing the iconographic messages that naturalize gender and sexual roles is an important one. Such artworks and artifacts were not only primary vehicles of communication in their own time, but continued to have a profound impact for centuries after and still have the power to shape how we see the past and relate it to the present. It is therefore ironic that students of classical art have not been inclined to engage in a more pointed interrogation of the "monuments" that constitute the substance of traditional research and teaching in the field. Despite a long-term interest in the mythological and psychological origins of the abundant imagery of fertility, eros, and the rituals that mark the passage through life-stages, relatively little attention has been paid to uncovering the visual mechanisms that regulate and reinforce gendered roles. The reasons for the lack of theoretical acuity in classical archaeology have been alluded to elsewhere: the focus on specific, localized data-sets with the aim of placing finds into narrowly defined chronological and stylistic categories; and the privileging of major monuments, fine art, and prestige trade-goods in an exclusive discourse of connoisseurship. Consideration of how gender can be used to interpret material remains has often been remedial and descriptive, rather than interpretive, and the criticism that women are often merely used as added ingredients in otherwise standard recipes is not without grounds.

This problem is explored by Shelby Brown in the introductory article,

"'Ways of Seeing' Women in Antiquity: An Introduction to Feminism in Classical Archaeology and Ancient Art History." Why have classical archaeologists, by contrast with many New World and prehistoric archaeologists, been slow to adopt theoretical frameworks that explicitly acknowledge gender as a fundamental construct in interpreting the material remains of the past? She suggests that classical archaeologists have tended to assume that female and male are fixed concepts, and as a result they present a simplistic and dichotomized view of the female lot in life. Brown offers a valuable survey of the application of feminist and post-structuralist research strategies to art and artifacts over the past twenty years, and critiques the disciplinary stance of classical archaeology, long preoccupied with "high" art and inclined to apply positivist, unproblematized readings to texts, images, and material culture. In the work of John Berger and Laura Mulvey, for example, the canonical and pleasing forms of the female nude became the subject of the male gaze, "posed, objectified, dehumanized, and idealized as an erotic sight for male pleasure."[3] Since then, a greater interest in the complexities of social context spurred by processual versus post-processual debates has encouraged classical archaeologists to consider the dynamics of gender more prominently in their research, resulting in a wealth of new thought and the dismantling of false disciplinary barriers.

The recent acknowledgement of the mediating role of gender has largely been expressed in a rapidly expanding body of theoretical writing and in the interpretation of specific sites. Most frequently, it has been applied to funerary contexts, where indications of biological sex, age, and pathology provide vital demographic documentation that can be extended to the analysis of associated grave goods and questions of social hierarchy. Domestic contexts, likewise, can be approached from the perspectives of division of labor and the gendering of space. These approaches are critical for the understanding of specific local assemblages of material, but tend to reconfirm dichotomies that bring us only to a preliminary level of understanding. Theoretical work over the last decade has demonstrated the validity of critiquing androcentric research strategies and has proposed various ways of looking at gender formation, but runs the risk of not always being applicable to the practical requirements of confronting the material at hand.

If anything, progress in this field to date has shown that no one formula or theoretical position can account for the infinite complexities of staging social identity. Because the construction of gender shifts depending on status, class, ethnicity, culture, and other factors, it is revealing to look at the evidence from the viewpoint of audience reception. Here the visual arts may be particularly useful, not only because of their narrative/didactic intent, but also because how they are seen and interpreted by different audiences reveals much about the underlying message. In this way, gender can be viewed as a performance that is

re-enacted or manipulated according to the needs of individuals and communities. The symbolism of clothing and jewelry, whether employed to conceal, accent, or expose the body beneath, carried clear and immediately legible messages for the viewer concerning not only the reproductive and erotic availability of the wearer, but also her or his position within community, social, and family hierarchies. Through the displacement of attributes, styles of dress, gesture, and "body language," artists are able to signal disapproval and the consequences of transgressing social boundaries.

The studies collected here treat monuments of fine art and architecture displaying gendered messages in civic and religious contexts, the so-called "minor arts" whose imagery was reflective of commonly shared understandings and values, and the mundane artifacts of daily life that express private acts and attitudes. Chronologically, our investigation takes its point of departure from the rich evidence for how femaleness/maleness were defined in prehistoric and protohistoric Italian mainland cultures. In the particular case studies of Greek, Etruscan, and Roman artworks that follow, specific examples from the Archaic to the Imperial periods illuminate the more subtle nuances of representing gender and sexuality in situations and contexts as varied as the private residence, the cult sanctuary, the public monument, and the grave. How messages and meta-narratives are differently received by viewers and how they function to implicate diverse audiences in collective notions of appropriate behavior and established value systems is a question that bears closer scrutiny.

Although the primary focus of the book is on the configurations of female identity and sexuality in antiquity, the iconography of male identity and sexuality plays no minor role and, indeed, is a fundamental source of visual cues as to what women are, become, should be, and cannot be. Implicit in a number of the papers is an acknowledgement that much work remains to be done on the processes of defining and maintaining norms of masculinity, which we cannot assume to have been any more of a cross-cultural given in the past than femininity was. The themes of heterosexual desire and beauty, procreative potency, homosexual relationships, alternative sexual identities, transgendering, and violence are communicated in the many modes of depicting the human body. Framed by opening and closing papers that diagnose the lack of attention paid to these central issues by historians of ancient art and prescribe future tools for sophisticated readings of the material and figural evidence, the essays lay the groundwork for establishing the historical and epistemological value of a critical consideration of gender in classical art.

CASE STUDIES

The articles that follow adopt a number of the methodologies outlined by Brown to analyze gender and sexuality in the representations of naked and

clothed bodies, the thematic thread that weaves through each of the papers in this anthology. All offer a direct response to the past reluctance of scholars to engage in such work. John Robb ("Female Beauty and Male Violence in Early Italian Society") reveals asymmetries in the symbolic expressions of male and female identity in Italic prehistory, where clothing, jewelry, weaponry, and weaving implements are the idioms utilized to define and legitimize gender and class distinctions. Based on a survey of skeletal biology, mortuary rites, and artistic representations of anatomically marked figures from the Neolithic to the beginning of the historical period, he proposes a social and symbolic interpretation of gender roles among "honor-shame" societies of Iron Age Italy. The association of weaponry and masculinity merges the concepts of legitimate violence, self-assertion, domination, prestige, and male potency. Female attributes, including personal ornaments and the utensils of cloth-work, emphasize feminine sexual desirability and have strong class overtones. Although at root such gender ideologies assist in enlisting individuals into a common hegemonic system of political and economic action, Robb acknowledges that ambiguity and disruption are inherent vulnerabilities in a system in which female sexuality and male potency are central. Such societies can never be simply unilateral, "top-down" systems. Female resistance in the form of "counter-hegemonies" may easily have been expressed in such archaeologically invisible practices and activities as folklore, humor, cuckoldry, and individual autonomy within the domestic or community spheres.

The structural oppositions contained in the formulation of male-violence-power and female-beauty-dependency have strong echoes in the art of the classical period. On various levels this formulation, visible in numerous instances of classical iconography, may locate Iron Age Italy as a precursor of Mediterranean patriarchy. Several papers take up representations of naked female bodies in Greek sculpture, vase painting, and coroplastic art. The fundamental concern for fertility and a healthy female body is discussed by Joan Reilly in a reconsideration of the figures of female torsos held by young girls on Athenian grave monuments. Reilly's contribution, "Naked and Limbless: Learning About the Feminine Body in Ancient Athens," suggests that such images, and their actual terracotta and marble counterparts, are not "dolls" or toys, but rather anatomical votives intended to assure that the dedicant attain a mature female body capable of producing and nourishing children. Reilly examines ancient Greek medical texts that recommended early intercourse as an antidote to the supposed reluctance of young girls to marry, a reluctance that was believed to risk maladies of the uterus and the girls' vulnerability to madness. The prophylactic properties of the truncated figurines helped to address cultural anxieties and expectations regarding the premenarchal girl's transition to womanhood, and to teach her the appropriate attitudes to her life as bride, wife, and mother.

Larissa Bonfante, in "Nursing Mothers in Classical Art," surveys the divergent iconography of the suckling mother in Greek and Etruscan cultures. The infrequency with which this "natural first act of the mother" was illustrated in Greek iconography is surprising to contemporary eyes accustomed to the ubiquitous image of the Christian Virgin Mary. The lack of nursing scenes furthermore appears to contradict the evidence of female cult sanctuaries cited by Reilly (and physical necessity) that women desired healthy bodies capable of childbirth and nursing. In Greek art, nursing infants are more regularly handed over to *kourotrophoi*, nurses and tutors, both human and animal, suggesting that social status plays a part in what were considered appropriate representations of motherhood. The images of mythological women such as Eriphyle and Andromache who give the breast to their offspring carry a disturbing subtext: the vicious death that the viewer realizes will soon befall Andromache's (good mother) son Astyanax, and the matricide of Eriphyle (bad mother) by her son Alcmaeon. The reasons for the Greek aversion to the naked breast are class-oriented and aesthetic, and may involve social taboos against the display of an icon that has the magical potency to protect or destroy.

If the bared breast connotes all the anxieties of a world of danger in Greek mythology, the Italic conception of nursing accentuates its nutritive aspects. The act is represented with much greater frequency in cult, votive, and funerary contexts throughout Etruria, Latium, and Magna Graecia. The iconography of the life-sized statue from Megara Hyblaea of a female suckling two babies at the slits of a garment purposefully designed to facilitate nursing, the votive statues of women holding numerous swaddled babies common in Latium and Campania, the engraved Etruscan mirrors showing Hera-Uni offering her breast to the young but mature Herakles-Hercle, even the Capitoline She-wolf, are but a few well-known examples of this imagery. The quantity and iconographic range of such representations suggest strong connections to local Italic and Etruscan cults of birth and motherhood. In Roman art deriving from Greek figural traditions, nursing scenes are infrequent and tend to allude once again to violence and the primitive nature of the barbarian "other."

In "Divesting the Female Breast of Clothes in Classical Sculpture," Beth Cohen further analyzes the disruptive and violent contexts in which one or both naked breasts are exposed in Greek art and proposes a new reading of the motif on a statue of a reclining female known as the "Barberini Suppliant." Beside the practical, intentional, or accidental exposure of the breast, as in the case of female athletes and Amazons, divine lovemaking or rape, prostitution, and frenzied Bacchic dancing (all extra-ordinary events, outside of the norm), the primary locus of the divested breast is in scenes presenting female victims of violence, such as the Lapith women attacked by Centaurs at the wedding of Pirithous and Hippodameia, the slaughter of Niobe's daughters and sons, and many other episodes. The dazed figure of

the "Barberini Suppliant," missing one sandal and unsuccessful in her pathetic attempt to hitch up her *chiton* and cover her naked bosom, is here interpreted as an image of the defenseless and wounded Cassandra in the moments following her rape by Ajax near the Temple of Athena in the citadel of Troy. Cassandra is a tragic figure who is disbelieved, violated, taken as a spoil of war, and eventually murdered. Her character is a *topos* for female victimization, yet the sentimental pathos of the Barberini sculpture masks her true situation and invites the spectator to participate vicariously in her humiliation, which appears to be an unfortunate but not unusual fate for a woman who is both foreign and of lower status.

Assuming a more critical position in the political issues surrounding female and male nudity as sites where power relationships and social difference are played out, Nanette Salomon offers a feminist reading of Praxiteles' Knidian Aphrodite in "Making a World of Difference: Gender, Asymmetry, and the Greek Nude." As the first monumental statue of a nude female, the Knidia heads a long Western artistic tradition of representing women who make the *pudica* gesture of fear or shame in one form or another. Unlike the nude male statue, already an exemplar of idealized humanity for several centuries before the female nude was introduced, sculptural representations of women (*korai*) stress the decorative, exterior treatment of drapery and hair rather than the organic, rational interior unity of their nude male companions (*kouroi*). This representational schema is linked to the homoerotic pleasure inherent in the physique of the youthful male, whose sexual attractiveness is determined by the overall grace, symmetry, and coherence of his form and is not confined only to his genitals. The focus on the buttocks of the Knidian Aphrodite and the teasing hand held before her pubis, however, constitute a paradigm of the female nude that is relished in terms of her sexual availability. The fetishistic quality of the sculpture is captured by Pliny and the pseudo-Lucian in the anecdote about a man, overcome with desire, whose semen stained the marble flesh after he spent a night in the temple. In this story, Aphrodite's status as the goddess of love is confounded and diminished in a discourse of mortal lust. Her statue becomes a political and social construction of the male gaze which functioned both to encourage heterosexual desire and to regulate female eroticism in the service of the male-dominated city-state.

Other instances of classical painting and sculpture reveal conflicting images of women that reflect society's preoccupations with the proper female role and the consequences that await transgressive, "unfemale" women. Francine Viret Bernal ("When Painters Execute a Murderess: The Representation of Clytemnestra on Attic Vases") studies images of the murderous Clytemnestra and her lover Aegisthus on Attic vases from the Archaic to the Classical period in order to disclose the *double-entendres* and metaphors that ancient vase painters employed as freely as writers. The figure of Clytemnestra embodied every form of danger to the social order.

7

She appropriates masculine prerogatives by choosing her lover and by participating in the brutal assassination of her husband, Agamemnon, whose throne is usurped by Aegisthus. Her weapon, the double-edged axe (*pelekus*), belongs properly in the realm of male priests who preside over sacrificial rites. On the famous Oresteia krater in Boston, Agamemnon struggles in a deadly woven net, a subversion of female craftwork that reduces him to the level of a snared beast in a perverted and cowardly sacrifice. Aegisthus is effeminized pictorially by the elegance of his hair and beard, his long garment, and the *barbitos* he holds – an instrument of seduction and poetry alluding also perhaps to eastern luxury and tyranny. Dressed in the outfit of a young warrior and democratic hero, Clytemnestra's son Orestes is presented in stark relief, a paragon of manly virtue and civic responsibility. In the visual representations of this myth, clothing and scenic props are used as semiophores for transgendering as an act of transgression and for the disruption of civic and religious order.

Four Attic figured vases illustrating the Greek lyric poet Sappho are the only extant depictions of her, except for profile heads on a small number of coins minted on Lesbos and a single Roman mosaic. Verified by the inscription of her name that is present on each of the vases, these Sappho portrayals (rather than portraits) are examined by Jane Snyder in "Sappho in Attic Vase Painting." Snyder contrasts the surviving representations with the stronger character of the Sappho persona as represented in the fragments of Sappho's own poetry, and finds that the iconography reproduces the "appropriate" model of female behavior, one that is reticent, passive, and uncharacteristically muted. On the earliest vase, a black-figured hydria of *c.* 500 BCE now in Warsaw, Sappho plays the *barbitos* but does not sing; in later scenes she either listens to Alcaeus' recitation, sits reading a book roll, or dances, but does not engage in the actual musical or oral performance of her poetry. The hypothesis that "men act and women appear" is confirmed in a comparison of her persona with that of male singers shown on Greek vases, such as Orpheus or Thamyris, whose mouths are open in song. The scene of Sappho in the company of other women situates the poet in the ordinary and secluded space of the *gynaikeion*, the women's quarters, and gives little indication of the historical figure so well known for her emotive intensity as a poet and intellectual dynamism as a teacher. Despite the paucity of representations, we might also ask whether there is a shift in artistic conventions such that the earlier, more active Sappho portrayal is replaced by a restrictive iconography of the mid fifth century that tones down female character and female action to conform with the predominant expectations of Athenian society.

On an architectural monument such as the Parthenon, constructed to epitomize ideal values central to the Athenian polis through its splendid decorative program, ideas about proper human relationships and behavior, piety, and civic and religious responsibilities are made concrete using the

visual cues of body image. John Younger's "Gender and Sexuality in the Parthenon Frieze" proposes a new reading of several figures shown in the relief frieze above the east entrance to the temple, an enigmatic episode that has been subject to divergent interpretations and lively debate. Here, a bearded man, a matron, a maiden, a girl, and a child appear to form a family unit concerned with components of the Panathenaic procession, stool and *peplos*. In addition to the multi-layering of religious and mythological meanings inherent in the scene, the particular activities, physical gestures, and grouping of the characters illustrate how male and female culture were transmitted to the next generation. Younger interprets the child figure holding the *peplos* as that of a young boy, paired with the older man in what would have been understood as a legitimate homoerotic relationship with strong undertones of socio-political inequality. The matron–maiden pair may likewise be seen as a corollary association through which older women share their experience to assist adolescent girls' passage through the social and physical transitions from girlhood to womanhood. The youngest girl stands apart from the "family," a pre-gendered child whose sexuality has not yet been constructed and who, unlike the boy-child, has no clear role. Younger assesses the complex sexual personae of the Olympian deities seated nearby, seeing in them role models (in the judgement of adult male Athenian citizens) for the sexual comportment of human individuals who occupy unequal positions in terms of their age group, gender identity, and political enfranchisement.

The sexual ambiguities insinuated by the subtle renderings of body and dress in the figures of Clytemnestra, Sappho, and the Parthenon's Olympian goddesses are manifested in very unambiguous terms in the case of the Hermaphrodite, an intriguing personage endowed with female breasts and male genitals. In "The Only Happy Couple: Hermaphrodites and Gender," Aileen Ajootian considers the voyeuristic interactions of the alluring sculpture of a reposing hermaphrodite, whose feminine backside attracts and exploits the gaze of viewers unsuspecting of its bisexuality, only obvious once a frontal view is gained. What may have been reduced to a titillating and prurient jest in the context of Hellenistic genre sculpture actually has an earlier role in religious imagery, where figurines of hermaphrodites deliberately expose their penises by lifting their dresses. Descriptions of bisexual or androgynous beings in early Greek cosmological and philosophical texts indicate that it was considered not an aberration but a powerful synthesis of male and female that emerged as a transcendent "third" gender. Later, the sexual duality came to share a dangerous quality of portent with apotropaic powers such as Bonfante suggests were attributed to the naked female breast.

The architectural design and painted decor of Roman houses created a symbolic stage where the performance of social rituals intersected with private activities. Ann Olga Koloski-Ostrow argues in "Violent Stages in

9

Two Pompeian Houses: Imperial Taste, Aristocratic Response, and Messages of Male Control" that the paintings and architecture of these houses give clear illustrations of a passion for theatrical themes, which may actually reflect imperial taste for the theater in the time of Nero and its influence on the popular culture of his day. The mythological repertoire of the wall decorations of the Casa del Menandro and Casa degli Amorini dorati in Pompeii, when read along with architectural spaces which "stage" specific social functions, communicate messages of control, domination, and the violence of power. Koloski-Ostrow applies modern feminist theory on visual pleasure in order to reinforce her assertion that many mythological scenes – the rape of Cassandra (whom we observe in the moments after the crime in Cohen's study), the abduction and return of Helen, Agamemnon receiving Briseis from Achilles – function to reinforce the authority of the *patronus* as much as the architectural layout of the house.

CONCLUSIONS

The concluding essay entitled "Epilogue: Gender and Desire," contributed by Natalie Boymel Kampen, takes up the thematic commonalities of the essays assembled in this volume. The complexities of the procedure of marking gender and constructing identity are underscored and heightened by the real challenge of assimilating ancient visual narratives with actual social practice. One becomes cognizant of otherwise elusive attitudes and behaviors in the ways that artistic representations reconfigure and naturalize social institutions. Kampen proposes that the concepts of "desire" and "desirability" can be used to develop more nuanced paths of inquiry into the issues surrounding sexuality and gender. Because it allows for relational and fluid interactions between individuals (singular and collective) acting in different contexts, desire offers an advantageous theoretical framework. One can imagine both women and men as the objects of erotic and aesthetic pleasure, and both submitting to domination or control albeit under varying circumstances and with different goals and outcomes. By examining how desire is manifested in different cultures and times, we can begin to arrive at a clearer notion of the interplay of beauty and eros, sex and gender, and power and violence in human relationships.

NOTES

1 "Feminist Approaches to Classical Art and Archaeology" (A. O. Koloski-Ostrow and C. L. Lyons, co-organizers). The abstracts of the seven panel papers were published in American Philological Association, *Abstracts of the One Hundred Twenty-fifth Annual Meeting*, 27–30 December 1993, Washington, DC, pp. 167–73.

2 "Body Image and Gender Symbolism: Women, Dress, and Undress" (organized by Shelby Brown on behalf of the AIA's Subcommittee on Women in Archaeology). For the abstracts of the six papers presented in this session, see *American Journal of Archaeology*, 1995, vol. 99, pp. 303–4.

3 S. Brown, *infra*, pp. 15–17.

2

"WAYS OF SEEING" WOMEN IN ANTIQUITY

An introduction to feminism in classical archaeology and ancient art history

Shelby Brown

The question of who defines the "norms" in society, and how the defini-
tions affect those not in power, has become a focus of concern within
modern American academe.[1] In the fields of ancient studies, this concern
has largely been addressed through feminist and related research,[2] influ-
enced by the developments in post-structuralist and postmodern theory in
a number of disciplines of the humanities. Classical archaeology and ancient
art history have lagged behind other branches of archaeology and art
history in acknowledging and accepting the legitimacy of feminist scholar-
ship. Art historians concentrating on later periods and archaeologists study-
ing non-Mediterranean or prehistoric subjects not labelled "art" have more
readily incorporated new theoretical approaches into their work. This is
largely a result of established traditions of research on ancient art, which
have emphasized "good" art and reinforced long-standing aesthetic ideals.
Furthermore, ancient art has often been subdivided according to medium
or type, and broken into isolated groupings that have served to discourage
an examination of broad social context. The idea that certain types of art
and images are naturally superior to others has also created an environment
that does not encourage scholarly self-criticism.

In this essay I discuss feminism and gender studies primarily in the
context of classical archaeology as practiced in North America.[3]
Approaches in North American archaeology are, however, related to and
influenced by work carried out elsewhere, and I refer as well to non-
American (especially British) archaeology. In addition, while classical
archaeology is often isolated theoretically from other disciplines and other
branches of archaeology, the field has nevertheless been affected by their
research. I focus here largely on classical archaeology's relationship with art
history and Mediterranean prehistory. Although these have inspired fem-
inist research on classical art and material culture, historical differences in

12

the subjects and goals of research have made communication between fields unnecessarily difficult.

FEMINISM VERSUS GENDER STUDIES

While the academic term "feminism" within archaeology can indicate simply the study of women's roles in society and women's relationships with others, obviously including men, it usually connotes as well a strong desire to view the world from a new perspective. This new perspective is predominantly female, but also emphasizes the point of view of groups regarded as marginal or outside the cultural mainstream.[4] Its goal is generally to challenge a particular male-centred, usually white European or Anglo-American, point of view. This can be an uncomfortable experience for those whose ideas are being questioned. Linda Nochlin, in her introduction to *Women, Art, and Power*, described feminist art history as "there to make trouble" and, at its strongest, "a transgressive and anti-establishment practice, meant to call many of the major precepts of the discipline into question."[5] As feminists attempt to see antiquity with new eyes, however, simple inversion of the *status quo* (women finally on top) has rarely been their goal. Rather, one of the aims of feminism has been to look at the "big picture" from the perspective of the many different people in it, and not just that of the (white, heterosexual) men.[6]

Archaeologists, especially within the Archaeological Institute of America (AIA) – and classical archaeologists in particular – have only recently become aware of feminist issues.[7] Preferring "gender studies," many have shied away from the term "feminist" as an indicator of an unseemly and unnecessary critical stance; after all, women are highly visible within the organization, and research on Women in Antiquity has been carried out for a long time.[8] "Gender studies" sounds safer, more inclusive of and friendly towards men. Although in practice it is sometimes the same enterprise as "feminist studies," it is less likely to represent a perspective grounded in women's experiences of "otherness," or to be directed towards undermining the *status quo*. Unlike archaeologists, many art historians, classicists, and anthropologists have confronted feminist issues for decades, and have long faced the problems associated with perceived or actual feminist aggressiveness. Scholars in these fields lament the ways in which feminism has been prematurely subsumed into the more inclusive, supposedly (but usually not) neutral field of gender studies, which is often less judgmental and political.[9]

Both feminist studies and gender research have been cited by archaeologists in polarizing ways, as positive signs of an appropriate open-mindedness[10] or as symbols of negative trends in the field.[11] An increasingly widespread acknowledgement of gender research seems to be related to archaeologists' broader acceptance of multicultural and anti-colonialist

13

perspectives, reflected in other fields of social science and the humanities, and in society at large. As evidenced in several contexts, through the agendas of committees, the subjects of publications and public lectures at annual conventions, and the many recent communications on the Internet, increasing numbers of archaeologists agree that research on women and gender is not a sideline to the study of society. Ironically, through ignoring almost two decades of feminist debate, many archaeologists have skipped from a masculinist world-view directly into the new, supposedly gender-neutral one, without having to experience the discomfort of confronting impolite feminist perspectives. Meanwhile, classical archaeologists in particular continue to avoid feminist theory, and indeed theoretical debates of all kinds. The reasons are illuminated by the history of interpreting ancient images of women and of attitudes towards engendering ancient material culture.[12]

ART HISTORY, THE "GAZE," AND THE NUDE

Consideration of the female nude as a male aesthetic ideal has been a useful starting point for the awakening of feminist consciousness, both within feminist art history of a quarter-century ago, and within archaeology of the past few years. What is a feminist agenda about the representation of women? How did it develop and affect the interpretation of ancient images? "Whose art?" is a question frequently asked (or implied) by feminist art historians about images of the female nude, for example, since naked female bodies are often seen as somehow naturally more aesthetically pleasing than other forms. It parallels the question, "Whose flesh?" which was eventually asked about beige products once called "flesh"-toned. Both questions force consideration of the intended viewer or consumer of art and the roles of those viewed within it. The focus is generally on the white, male viewer who decides what to look at, sets the standards of appropriateness, and judges what he sees. The question, "Whose art?" helps illuminate how power is distributed and relative hierarchy determined.

In order to evaluate how spectators interpret art, art historians have long investigated the history of art history. The influence of French structuralists and post-structuralists,[13] and especially semiotic and psychoanalytic theorists, of the 1970s to 1980s was crucial for feminist critiques of the canons of "Great Art" by male "geniuses" and of supposed objectivity in art-historical scholarship.[14] The first feminist challenges were leveled at the perspectives of a traditional art history in the United States in the early 1970s. Under the influence of the Women's Movement, authors from a variety of backgrounds began to rethink the contexts and meanings of representations of and by women.[15] Identifying the intended viewer of both popular and high art in modern Western society became the first step in a process of seeing art and art history through new eyes. The spectator of high art was

traditionally white, male, well educated and well off, and his dominance in choosing the subjects of art and establishing artistic canons effectively excluded others from doing so. Seeing, assumed by many to be the simple act of taking in with the eyes visual facts about the world and the beautiful, became a loaded term. By the early 1980s, the word "gaze" had often come to signify an author's awareness that both the subjects an artist chooses, and how one views them, depend on who has power in society. Women became aware of themselves as excluded "others" within art history.[16]

American, French, British, and eventually Australian, Norwegian, and other European feminists all strongly influenced one another's work in fields of literary analysis, film theory, psychoanalytic theory, art history, philosophy, and, finally, archaeology. Two British authors were especially influential in fostering debate about a defining male artistic gaze. John Berger based *Ways of Seeing* (1972) on his BBC television series of the same title. The series and book represented in part a reaction to Kenneth Clark's *The Nude: A Study in Ideal Form* (1956) and television series, "Civilization." Clark identified the nude, almost always meaning the female nude, as a central form of art in countries touching on the Mediterranean. For Clark, the nude was not just the subject, but rather a "form" of art, because nudes are idealized artistic creations based on naked female bodies. He described nakedness in real life as embarrassing[17] and real women (viewed by those whose eyes "have grown accustomed to the harmonious simplifications of antiquity")[18] as causing dismay with their shapelessness, wrinkles, pouches, and imperfections. According to Clark, the tendency of the female body, like the drift of all popular art, is towards the "lowest common denominator": in women this often manifests itself in unappealing potato-like shapes emphasizing female biological functions.[19] Such comments were not considered particularly outrageous in 1956.

In Clark's view, looking at naked women was a natural and aesthetically pleasing endeavor for men of a certain class, provided that the women were suitably fashioned into sexually attractive nudes for their audience – in whom they should arouse at least a vestige of erotic feeling.[20] In contrast, Berger opposed the whole "way of seeing" art and people that *The Nude* and "Civilization" represented. A polemical Marxist, he raised issues concerning the social and economic functions of Western art, issues completely ignored by Clark and highly unusual for their time. His observations on gender relations and the nude had a tremendous impact on feminist thinking; this, despite the fact that he made statements every bit as simplistic and dogmatic as Clark's.[21] The difference was that Berger expressed dramatically, in unequivocal and simple language, the male entitlement to look freely at women and the female experience of being observed and judged primarily on the basis of attractiveness to men. The impact of his eye-opening text and images, even almost a quarter-century after they were written, still outweighs for many Berger's often simple reversals of

Clark's position and his essentially shallow coverage of a vast and difficult subject.

Berger addressed the unequal gender relations implied by a dominant, male "way of seeing" and expressed the obligation of women to watch themselves being watched, without the power to look back in the same way.[22] He described how a woman

> has to survey everything she is and everything she does because how she appears to others, and ultimately how she appears to men, is of crucial importance for what is normally thought of as the success of her life. Her own sense of being in herself is supplanted by a sense of being appreciated as herself by another. . . . One might simplify this by saying: *men act* and *women appear.* Men look at women. Women watch themselves being looked at. This determines not only most relations between men and women but also the relation of women to themselves.
>
> <div align="right">(Berger, Ways of Seeing, pp. 46–7)</div>

Berger evaluated European oil paintings of nudes to illuminate the criteria by which women are passively positioned to feed a male sexual appetite, are judged as "sights," and are even blamed for the responses they elicit. He attacked the painting tradition in which a naked woman, posed to be seen by a dressed male spectator, is shown looking at herself in a mirror to signify her vanity. Berger addressed the male artists directly, in the second person: "You painted a naked woman because you enjoyed looking at her, you put a mirror in her hand and you called the painting *Vanity*, thus morally condemning the woman whose nakedness you had depicted for your own pleasure."[23] These were heady words for feminists to read in 1972 about "high" art.

Another influential British author, Laura Mulvey, articulated ideas similar to Berger's, in a different, far more theoretically informed context, in "Visual Pleasure and Narrative Cinema," written in 1973 and published in *Screen* in 1975.[24] In the introduction to a collection of her articles published in 1989, she describes how she wrote the piece "polemically and without regard for context or nuances of argument," and then saw it take on "a life of its own" and become her most influential work.[25] As a film-maker and film critic, Mulvey found her attitude towards the cinema profoundly influenced by the Women's Movement. "Watched through eyes that were affected by the changing climate of consciousness, the movies lost their magic."[26]

Behind much of Mulvey's work lies the idea that sexualized images of women did not represent women's own reality, but rather projections of male fantasies and fears. She believed that psychoanalytic theory could help reveal "the mechanics of popular mythology and its raw materials," including images of sexual difference. Structuralism and semiotics also served to

provide her with a descriptive language for images of women as signs and symptoms.[27] Like Berger, Mulvey describes a world "ordered by sexual imbalance," in which pleasurable looking is split between active/male and passive/female. She identifies a "determining male gaze," which projects its fantasy on to a female figure who connotes "to-be-looked-at-ness."[28]

The works of Berger, Mulvey, and other authors similarly identifying a dominant male gaze, generated enormous discussion of both the male view of art and of women, and the problematic position of the female spectator, who must see – and may enjoy – images of women generated under a system of male dominance and sexism. Are women passive receptors of or active aggressors against the male viewpoint? Are they intellectually and emotionally torn as they identify with, but cannot fully live, male voyeurism? Can they negotiate a positive emotional path between their own reality and the male-centred depiction of them? Is the effect and significance of the oppressive male gaze really so straightforward? What kinds of images of women would actually address the female experience? In the early 1970s, American feminists began to ask such questions, and debate the possible answers, in colloquia concerned with gender and sexuality presented at College Art Association (CAA) conventions and elsewhere.

In 1972, Linda Nochlin enlivened an annual convention of the CAA with a now-famous paper asserting that the term "erotic" as applied to traditional imagery of women really means "erotic-for-men." In her introduction to a session on "Eroticism and Female Imagery in Nineteenth-Century Art," Nochlin illustrated (partly by means of the audience's response) the ludicrous results of substituting male for female nudes. Using an overly simplistic and not fully parallel (but still highly effective) slide comparison, she contrasted a nude female apple-seller holding a tray of apples up to her naked breasts, with a nude man holding a tray of bananas in the vicinity of his penis. Her claim that women had no erotic terrain in art comparable to that of men could be, and was, debated. Nevertheless, her contention – that the male idea of what is erotic establishes the social norm – was favorably received at the time.[29]

De-mystification of the female nude and of sexualized images of women in Western art was one logical consequence of the feminist debate. Over the course of the next twenty years, feminists "deconstructed" an impressive array of images of naked and sexually vulnerable women in both elite and popular art, documenting over and over again how women were posed, objectified, dehumanized, and idealized as an erotic sight for male pleasure.[30] The social construction of gender, sexuality, and eroticism in representation was thereby convincingly revealed in a variety of ways. The concept of a dominant male gaze still continues to be explored today within a predominantly white academic art history, with a primary focus on the polarity male/female.[31] Within classical archaeology, however, the

17

idea of a dominant or intended spectator is relatively new, and art history has often been ignored as a source of useful new approaches.

ART HISTORY AND CLASSICAL ARCHAEOLOGY

Classical archaeologists have only recently begun to question the traditional frameworks of art-historical analysis and to take note of new theories of interpreting artistic images and engendering material culture. Why has the focus of much research in classical archaeology so long remained, in the blunt words of Brunilde Ridgway in an article about the study of ancient sculpture, "the self-fulfilling task of classification and dating that in its subjectivity and inaccuracy has given the discipline its dubious reputation"?[32] Mediterranean archaeologists generally fall into "camps" of prehistorians and classical archaeologists. The distance between the two is partly due to the latters' allegiance to attitudes founded in their field's origins in art collecting and antiquarianism. Within classical archaeology itself, those who primarily study art are also often methodologically out of tune with those who excavate and survey, who may therefore incorporate anthropological or theoretical perspectives.[33] North American classical archaeologists are generally isolated from scholars in other branches of archaeology, who have more frequently attempted to articulate and debate both their research goals and the rationale for them.[34] Even the identification and definition of "image" or "art" have frequently been left by classical archaeologists to the more theoretically astute prehistorians.[35] In a backlash against unself-critical, art-historical approaches to interpretation, some non-classical archaeologists have de-emphasized the value of studying art at all.[36]

Classical archaeologists and ancient art historians have too often examined stylistic and typological changes for their own sake, often on the basis of emotional and badly defined criteria. Many have assumed, at least as far as gender is concerned, that art simply reflects reality, and so does not require much in the way of analysis or criticism. They have frequently accepted as natural and universal their own definitions of Great Works by Great Men and their own belief in the timeless aesthetic appeal of certain types of images. Authors writing on nude classical sculptures, for example, have tended to ignore completely the gender relations implied by the body language, or to point out their titillating aspects without considering in any depth the social construction of modesty for women and voyeurism for men.

The impetus for classical archaeologists to change their "way of seeing," twenty years after Berger, has come from three primary sources: classics, prehistoric archaeology, and art history. Art history, of all the related fields which are reasonable sources for information about feminist theory, has only recently influenced classical archaeology. Since classical archaeologists

often teach in departments of art history, how could they fail for so long to absorb feminist art-historical research? In part, their ignorance is due to a gap perceived by many archaeologists between the ways they and art historians interpret ancient art and material culture. The divide was faced head-on by Ridgway in a controversial article on the state of research on ancient art published in early 1986. She identified the concern of archaeology as "*any* object from the ancient past, regardless of its aesthetic value and artistic importance, as a clue to cultural reconstruction." In contrast, Ridgway defined art history rather narrowly as "the study of aesthetically pleasing objects, in a scale ranging from the beautiful artifact to the masterpiece."[37] While this definition of an elitist art history did not incorporate the approaches of feminist art historians and other theorists concerned with later art, theoretical scholars were not generally the ones in communication with archaeologists or ancient art historians.[38]

Although classical archaeologists sometimes see themselves as ideologically distinct from art historians, other archaeologists often lump classical archaeology and art history together as atheoretical, art-focused, elitist fields.[39] Sometimes prehistorians and non-traditional classical archaeologists appropriate the study of art from the art historian (or classical-archaeologist-as-art-historian), who is maintained as the enemy. In his comments on a volume presenting new research in classical archaeology (*Classical Greece: Ancient Histories and Modern Archaeologies*, Ian Morris ed., 1994), Anthony Snodgrass describes the author of one chapter on pottery as having rescued his material from the art historians. According to Snodgrass, a modern approach to material culture asks, "Yes, but what was it *for*? Who was it *for*?" To answer these questions, archaeologists can bring pottery and sculpture into "real archaeology." Opponents of the new approaches are, Snodgrass says, neither the pure classicists nor the prehistorians, but rather the art historians who "regard the concept of 'total material culture' as a tedious impediment to their own mystic communication with the viewers and users of the pottery."[40] The end result of mutual scorn, miscommunication, and opposing methodological strategies has been the continued divide not only between classical archaeologists and other archaeologists, but also between scholars working in similar geographical areas and on related topics, depending on whether they see themselves as allied with art or archaeology, with theoretical or traditional approaches.[41]

On those rare occasions when theoretically aware art historians have borrowed from archaeology, whether of prehistoric or later periods, they have often been no more up-to-date on recent theoretical archaeological debates than archaeologists are about new approaches in art history. Over the last quarter-century, there has been one major collaboration of classical archaeologists with feminist art historians of later periods. In 1982, Norma Broude and Mary Garrard edited an important anthology of articles on art

and art history, written largely from a feminist perspective, and based in part on CAA sessions of the 1970s. *Feminism in Art History: Questioning the Litany* provided one of the first overviews of the progress made by feminist art historians of the 1970s in identifying and explaining their goals. Broude and Garrard defined the works included as "reconsiderations from a feminist perspective of some of the standing assumptions of the discipline,"[42] and hoped that the questions raised by feminism would lead to a redefinition of the field.[43] Remarkably, they devoted four chapters to ancient subjects. One indicator of the theoretical divide between art history and archaeology, however, was the editors' inclusion of a chapter reprinted from 1962 on the Great Goddess, based on ideas already long outdated within archaeological scholarship.[44] Another was their rather naive assumptions about the significance and universality of such a goddess.[45]

In a second volume published a decade later, *The Expanding Discourse: Feminism and Art History*, the editors noted a change of focus within feminist art history, from criticizing the *status quo* to breaking new ground.[46] In the earlier volume they had sought "to define a new genre of art-historical investigation, one that was distinguished more by an attitude than a methodology," while in the second volume they could draw on a "rich harvest" of feminist art-historical scholarship.[47] Unfortunately, this rich harvest still did not extend to ancient art, and only one author in this volume dealt with an ancient subject.[48] Furthermore, the approach to ancient goddess imagery remained naive from the archaeological perspective. Garrard herself contributed a chapter on Leonardo da Vinci that shows art history's continued unawareness of (or inability to evaluate critically) the archaeological arguments. She cites a generalized "prehistoric identification of the highest cosmic power as female," an ancient "way of thinking" to which Leonardo was "unusually attuned" and so able to reinvent spontaneously.[49] Even in contexts in which monolithic or essentialist models of thinking about nature and women are generally debunked,[50] the alluring vision of past female power-through-fertility is sometimes difficult to ignore outside archaeology, even when the evidence is unclear.[51] At the same time, archaeologists' "eerie silence" about feminism in general, and their problems with popular feminism in particular,[52] have isolated serious debate about archaeological evidence within narrow, internal fields of study.

Another source of the divide between classical archaeology and feminist art history is the latter's focus on the period from the Renaissance to the present. Feminist work has therefore often seemed irrelevant to ancient art. Even the foundation in Classical Greek sculpture of a western art-historical tradition emphasizing female nudes has rarely influenced feminists trained in later periods to venture into ancient studies. Such a directly classicizing image as Hiram Powers's "The Greek Slave" of 1843, a statue of a naked slave girl about to be sold to the Turks (which unites the male fantasy of viewing an aloof, "ladylike"[53] nude girl with the Western male fear of the

20

"Oriental"),[54] has inspired feminist criticism,[55] but little mention of its classical roots. The result in the 1970s and early 1980s was that classical archaeologists and ancient art historians did not learn about, much less borrow, feminist ideas presented at professional conferences unless they were also doing research in later periods.[56]

Recently, however, largely as a result of work by art historians trained in later periods and archaeologists influenced by literary and linguistic theory, publications on ancient art depicting women have begun to acknowledge the existence of an intended spectator with a particular point of view. A number of authors are even beginning to give Classical nudes the critical attention long accorded them elsewhere. Nanette Salomon's vigorous attacks on the traditional canons of high art and the history of the Western female nude, from Praxiteles on, are unparalleled (see *infra*, pp. 197–219); her primary area of study is non-classical and includes such subjects as Dutch genre painting.[57] Salomon analyzes possible layers of meaning behind the image of a naked and vulnerable woman who attempts to hide her genitals and breasts and to avoid eye contact with a male viewer. She identifies not just a defining male gaze directed at sculptures of nude Aphrodite, but also a negative underlying attitude towards women.

Robin Osborne has independently made a significant contribution as well, aimed primarily at "theoretical" classical archaeologists, to the subject of the gender relations implied by Classical female nude sculpture.[58] The chapters in this volume by Nanette Salomon, Joan Reilly, and Beth Cohen, and the work elsewhere of Natalie Kampen and Eve D'Ambra, among others, also represent a new look at the nude as the idealized model for women of feminine bodies and behavior.[59] Such new surveys, coupled with the more long-standing but still growing research on the symbolism of the body and of the erotic in ancient literature and art, augur an increased willingness in the 1990s to tackle the social construction of both gender and sexuality in classical antiquity.[60] Nevertheless, feminist research on ancient art will remain unnecessarily fragmented as long as scholarly divisiveness continues: in the theoretical approaches to different media,[61] in the isolation of work on sexuality from mainstream scholarship (and of feminist theory from "queer" studies);[62] and in the abiding segregation of classical archaeology from art history.[63]

THEORY IN ARCHAEOLOGY:
THE PROCESSUAL/POST-PROCESSUAL DEBATES

Old World prehistorians, who did not inherit classical archaeology's role as the transmitters of "good" ancient art, have often been more willing than classical archaeologists to consider the aims and methodologies of their field. One of the most influential debates about appropriate goals and approaches began in the 1960s, and drew a clear line between theoretical

and traditional approaches. Eventually, some repercussions were felt even within classical archaeology. The so-called "New" (or "processual") archaeology was strongly critical of atheoretical approaches to interpreting the past, which allowed archaeologists to act on the basis of their assumptions, without actually defining or testing them. "Old" archaeologists, among whom classical archaeologists were certainly included, continued to occupy themselves with issues of style and other cultural traits shaped and changed by historical accidents and individual achievements.[64] The New movement instead directed archaeologists to utilize the methodologies of science. The goal was largely to study cultural "process" (hence the term "processual") and to predict and explain regularities in human behavior in the aggregate.

New archaeology spread rapidly in the USA and Britain throughout the 1970s under the influence of such authors as the American anthropologist Lewis Binford and the British Aegeanist Colin Renfrew.[65] In hindsight, processual archaeology was a relatively short-lived phenomenon, characterized less by actual newness than by its polemical stance. Many of the processualists' concerns about the field echoed ones already voiced intermittently by various scholars since the turn of the century.[66] New archaeology existed contemporaneously with a variety of approaches, which were not always antithetical to processual aims. Nevertheless, New archaeology's adherents succeeded in focusing widespread attention, for the first time, on archaeology's goals and on the question of the field's potential for objective research.

In the 1970s, while feminist art historians and classicists debated issues of spectatorship and domination, and feminist anthropologists confronted male bias and "colonialist" attitudes towards their subjects of study, many archaeologists were focused on defending the "old" or trying to understand the New archaeology. New World and prehistoric Aegean archaeologists were most affected, since the majority of influential processual archaeologists came from their ranks. Some classical archaeologists, too, eventually began to acknowledge that the processualists' idea of framing hypotheses and testing them in some fashion was preferable to drawing conclusions based on preconceived ideas, and then simply assuming they were right.[67] Those not primarily concerned with objects defined as art even began to see beyond Great Works by Great Men and to consider "nameless human beings in groups."[68] The problem remained that the nameless beings somehow seemed to be male, and the information sought about them still reflected assumptions about male achievements and the superiority of certain cultures or attitudes. Other classical archaeologists, meanwhile, were only beginning to wake up to processual debates in the mid-1980s, when "post-processual" opposition to New archaeology was already gaining widespread acceptance.

What amounted to a post-processual attack was largely launched from

Cambridge in the late 1970s, with Ian Hodder representing perhaps the best-known figurehead.[69] The debunking of science as a vehicle for the discerning of "truth,"[70] along with the development of anti-colonialist and pro-multicultural outlooks, eventually contributed to widespread rejection of extreme processual ideas. The conviction grew that, in embracing science and positivism, archaeology, in the words of one semiotician, "tried to put on clothes not meant for it to wear."[71] Science could be interpreted in part as a reflection of Western male attitudes about the world and what is important. Again, prehistorians and New World archaeologists, to whom the post-processual authors were primarily addressing their work, took note far sooner than classical archaeologists. Rather than signifying unity of opposition to processualism, post-processual archaeologies include many different approaches and ideologies.[72] They generally share opposition to the idea that archaeological inquiry can be unaffected by present attitudes; therefore post-processualists undermine the idea of value-neutral realities discoverable in the archaeological record, and acknowledge bias in both the development of research strategies and the interpretation of collected data.

Hodder and his fellow Cambridge archaeologists were influenced in part by the same French thinkers as the feminist art historians and the classicists. In particular, the idea in literary criticism of reading texts as systems of symbolic meaning, rather than as factual representations of reality, affected approaches to interpreting material culture within theoretical archaeology.[73] As knowledge of related feminist research in anthropology and the philosophy of science spread, archaeologists became more aware of ideas about the validity of multiple perspectives on the same data. Some scholars began to acknowledge a problem with male-focused research bias, and even to undertake research on the social construction of gender. Nevertheless, while feminist theory can be included within the range of complicated, multi-faceted, relativist, contextual (post-processual) methods of interpreting the past, the journey to respectability of feminist work was late and has been slow.

It was not until 1984 that Margaret Conkey and Janet Spector first discussed archaeological research bias in favour of male ideas and supposed male achievements.[74] When there was little reaction, Joan Gero and Margaret Conkey organized a conference (held in 1988) on "Women and Production in Prehistory," and invited scholars working on a wide variety of topics to formulate new approaches to viewing and engendering their evidence.[75] The conference papers grew into the first collection of articles using feminist theory in archaeology. Since then, feminist or "gender" archaeology (while often seen as limited in scope or as a not clearly defined subfield) has become a small, but increasingly respectable component of prehistoric and New World archaeology.[76] "Feminist" in this context signifies primarily a theoretical stance which aims to imagine (at worst) or identify (at best) the nature and contexts of participation by women and "others" in

ancient society. Archaeologists have approached the task of seeing women and identifying gender in the archaeological record in very different ways, however, borrowing to greater and lesser degrees the excavation strategies of the processualists,[77] asking new questions of traditional evidence,[78] imaginatively reconstructing gender roles and relationships, and publishing in new formats.[79]

Ultimately, the backlash against processual archaeology's pretensions to scientific status which partly fuelled feminism within non-classical archaeology has also hindered the subsequent application of feminist approaches within the field. Among theoretical archaeologists, questions of gender have often been limited by broader philosophical debates about the possibility of drawing valid or objective conclusions about culture from a flawed material record. The interpretive jump from artifacts to the social actions and constructs behind them is problematic enough when one can rely on unstated assumptions about the fixity of gender roles through time or the importance of presumed male activities. Feminists who want to approach the excavation and interpretation of ancient material culture in a supposedly less sexist or otherwise revisionist way must justify providing yet one more version of the past.[80] Theory can be seen as a license for mere speculation.[81]

Philip Kohl, among others, worries that the problem of evidence which is "essentially silent on male/female tasks and roles" cannot be eliminated "simply by conjuring up one plausible, 'peopled' reading of this record. . . . If one cannot determine whether some socially important group labor was performed by women or men . . . one should simply admit it and ask other questions of the material."[82] The same rigor is not generally imposed, however, on those who identify "socially important" labors as male, or who ask "other questions" founded on modern assumptions about gender roles. Meanwhile, the debates about how to engender material culture, or about the very nature of the archaeological record,[83] have seemed largely irrelevant to classical archaeologists concerned with ancient art. Nevertheless, through their professional association with prehistorians, some classical archaeologists have become educated about feminist and other theoretical approaches to material culture. The gap in understanding due to the different interests of classical archaeologists and prehistorians has, however, limited their dialogue, as with archaeologists and art historians. Many classical archaeologists today still continue on their traditional way, with no clear idea of what the processual, post-processual, and other theoretical debates are about.[84] The relevance of theory to the field as a whole remains obscure.

LOOKING BACK AND LOOKING FORWARD

Classical archaeology's primary source of feminist theory, limited though its actual borrowings have been, is classics (and history through the medium

24

of classics). Classical archaeologists were first introduced to the criticisms of male bias taking place in other fields by Sarah Pomeroy's *Goddesses, Whores, Wives, and Slaves: Women in Classical Antiquity*, which she published in 1975. This book publicized the need for studies of ancient women, and many subsequent publications have focused on the evidence for women's lives and roles in ancient society, some including physical as well as written data.[85] Consideration of women and supposed women's issues was often directed into a subfield called Women in Antiquity, which left the normal field of study as male.[86] In other disciplines, research on women progressed from criticism of male bias and recovery of information about women to theoretical analyses of gender and evaluation of methodological strategies.[87] In classical archaeology, however, the goal remained largely to insert women into – or consider gender from the perspective of – traditional interpretive, iconographic, and stylistic frameworks, rather than to develop entirely new ways of looking at the evidence and explaining it.[88] Within other branches of archaeology, this has sometimes been called the "add women" – or "add women and stir" – method.[89] Classical archaeologists continued for well over a decade to maintain a polarized view of women in ancient art and society ("high" or "low") and to regard female roles – and female natures – as fixed.

More sophisticated approaches to seeing women have come largely from feminist classicists and historians interested in ancient art;[90] those archaeologists aware of literary criticism, especially structural linguistics and cultural studies;[91] and archaeologists familiar with classicists' work on issues of gender and sexuality.[92] Classicists/historians and archaeologists/ancient art historians have taken a more complex look at women as meaningful actors within society in joint publications (*Women in Ancient Societies: "An Illusion of the Night,"* Léonie Archer, Susan Fischler, and Maria Wyke, eds, 1994; *Women in the Classical World: Image and Text*, Elaine Fantham *et al.*, eds, 1994; *Art and Text in Ancient Greek Culture*, Simon Goldhill and Robin Osborne, 1994; *Pandora: Women in Classical Greece*, Ellen Reeder, ed., 1995; *Sexuality in Ancient Art: Near East, Egypt, Greece, and Italy*, Natalie Kampen, ed., 1996), sometimes taking strongly feminist positions (*Pornography and Representation in Greece and Rome*, Amy Richlin, ed., 1992). In the absence of major collections of work in their own field, feminist classical archaeologists and ancient art historians have also published in compilations of work by scholars in assorted social sciences and humanities, in books such as *(En)Gendering Knowledge: Feminists in Academe*, Joan Hartman and Ellen Messer-Davidow, eds, 1991, and *Feminisms in the Academy*, Domna C. Stanton and Abigail J. Stewart, eds, 1995.

Finally, in the 1990s, there has been an enormous surge of interest in the study of complex social, sexual, and gendered relationships as evidenced in art and material culture. Studies of and exchanges about ancient women, sex, and gender abound at conferences, on the Internet, and in print. The

list of published conference papers, collected works, and bibliographies grows longer every year. Concern about the term "feminist" is on the wane, and the idea that new perspectives are desirable is on the rise, among not only prehistorians and New World archaeologists, but also classical archaeologists. This volume illustrates that authors of more theoretically informed or explicitly feminist approaches to classical art are beginning to co-publish their own collections. Yet introducing feminist scholarship and other theoretical approaches into arenas of traditional research has not been easy. Ultimately, classical archaeology's success at "engendering" the field will very largely depend upon an increased willingness to communicate internally and to break down the arbitrary barriers between disciplines. Only then will we be able to make meaningful choices from among the many "ways of seeing" women in antiquity.

NOTES

1 This chapter (completed in January 1996) expands on introductions I gave to the 1993 and 1994 Archaeological Institute of America/American Philological Association (AIA/APA) panels on which this book is largely based. I organized the second panel, entitled "Body Image and Gender Symbolism: Women, Dress, and Undress," on behalf of what was then the new Subcommittee on Women in Archaeology of the AIA. I would like to thank all the contributors to the panel for their insights, and Claire Lyons and Ann O. Koloski-Ostrow for their vision and determination in bringing this volume to fruition. Grateful thanks go as well to Tracey Cullen, Louise Hitchcock, Natalie Kampen, Claire Lyons, Theresa Menard, Ann O. Koloski-Ostrow, and Paul Sandberg for helpful comments, bibliographic suggestions, and editing.

2 For example, archaeologists are making an effort to see and compensate for their role as "colonizers" of others' pasts: S. Brown, "Feminist Research in Archaeology: What Does It Mean? Why Is It Taking So Long?", in N. S. Rabinowitz and A. Richlin (eds), *Feminist Theory and the Classics*, New York, Routledge, 1993, p. 240; R. H. McGuire and R. Paynter (eds), *The Archaeology of Inequality*, Oxford, Basil Blackwell, 1991; D. Miller, M. Rowlands, and C. Tilley (eds), *Domination and Resistance*, London, Unwin Hyman, 1989; P. Stone and R. MacKenzie, *The Excluded Past: Archaeology in Education*, Boston, Unwin Hyman, 1990.

3 See J. P. Hallett, "Feminist Theory, Historical Periods, Literary Canons, and the Study of Graeco-Roman Antiquity," in Rabinowitz and Richlin, *Feminist Theory*, pp. 44–72 for relevant comments about feminist views of "the 'c' word" ("classical").

4 Craig Owens has pointed out how feminism is often regarded as one among many self-determination movements, and so is liable to be lumped together with them: C. Owens, "The Discourse of Others: Feminists and Postmodernism," in N. Broude and M. D. Garrard (eds), *The Expanding Discourse: Feminism and Art History*, New York, IconEditions, 1992, pp. 490–1. Yet one of the hallmarks of feminism is that it strives to acknowledge diversity and difference, and to participate in and incorporate others' efforts to move beyond "otherness." While feminist research focuses on women, it generally tries to take into consideration such differences as class, status, race, and more. For art history

see C. L. Langer, "Against the Grain: A Working Gynergenic Art Criticism," in A. Raven, C. L. Langer, and J. Frueh (eds), *Feminist Art Criticism: An Anthology*, Ann Arbor, UMI Research Press, 1988, p. 117; for classics, N. S. Rabinowitz, "Introduction," in Rabinowitz and Richlin, *Feminist Theory*, p. 11; for archaeology, I. Hodder, *Reading the Past: Current Approaches to Interpretation in Archaeology*, Cambridge, Cambridge University Press, 1991, pp. xiv, 168–72; M. di Leonardo, "Introduction: Gender, Culture, and Political Economy," in M. di Leonardo (ed.), *Gender at the Crossroads of Knowledge: Feminist Anthropology in the Postmodern Era*, Berkeley, University of California Press, 1991, p. 18, and also see pp. 140–3; M. W. Conkey and J. M. Gero (eds), "Tensions, Plurality, and Engendering Archaeology: An Introduction to Women and Prehistory," in J. Gero and M. Conkey (eds), *Engendering Archaeology: Women in Prehistory*, Cambridge, Mass., Basil Blackwell, 1991, p. 9. Feminist efforts fit into a broader reconsideration of the functions and traditions of displaying material culture and art in museums; see J. C. Berlo, R. B. Phillips, *et al.*, "A Range of Critical Perspectives: The Problematics of Collecting and Display, Part 1," *The Art Bulletin*, 1995, vol. 77, pp. 6–24; R. R. Bretell, V. N. Desai, *et al.*, "The Problematics of Collecting and Display, Part 2," *The Art Bulletin*, 1995, vol. 77, pp. 166–79; E. Hooper-Greenhill, *Museums and the Shaping of Knowledge*, New York, Routledge, 1992; I. Karp and S. D. Lavine (eds), *Exhibiting Cultures: The Poetics and Politics of Museum Display*, Washington, DC, Smithsonian Institution Press, 1991. Authors discussing archaeological subjects include: S. Pearce, *Archaeological Curatorship*, Leicester, Leicester University Press, 1990; S. Pearce, *Museums, Objects and Collections: A Cultural Study*, Washington, DC, Smithsonian Institution Press, 1992; G. W. Stocking, *Objects and Others: Essays on Museums and Material Culture*, Madison, University of Wisconsin Press, 1985.

5 See L. Nochlin, "Introduction," in L. Nochlin (ed.), *Women, Art, and Power and Other Essays*, New York, Harper and Row, 1988, p. xiii.

6 Recently, the tendency has also been to cease simply comparing "others" with the "norm," conceived as the dominant heterosexual male view, which scholars often assume they understand best. John Younger describes a different approach, in a statement on the Internet concerning his introduction to the American Philological Association session, "Current State of Gender and Sexual Studies": "I was attempting here to begin a definition of a new type of textual/artistic analysis: instead of looking at The Other, we assume The Other and look at the textual and artistic expressions of Central Society's values" (quoted with permission of author). Brief summaries of the introduction and papers are published in section 32, p. 131 of the 1995 127th APA convention abstracts.

7 Unfortunately, many of my conclusions about classical archaeology and the AIA are based on personal knowledge of programs at yearly conventions, on conversations with fellow classical archaeologists and other AIA members, and on other subjective evidence. Published data are rare. Steven Dyson documents the organization's lack of absorption of new approaches to archaeology in the early 1980s, as measured by a comparison of articles published in the *American Journal of Archaeology*" (the professional journal of the AIA) with those in the journal *American Antiquity*: S. L. Dyson, "Two Paths to the Past: A Comparative Study of the Last Fifty Years of *American Antiquity* and *American Journal of Archaeology*, *American Antiquity*, 1985, vol. 50, pp. 452–63. He also compares the relatively unchanging programs at annual AIA conventions in the fifty years from 1935 to 1985: S. L. Dyson, "The Role of Ideology and Institutions in Shaping Classical Archaeology in the Nineteenth and Twentieth Centuries," in A. L. Christenson (ed.), *Tracing Archaeology's Past. The Historiography*

of Archaeology, Carbondale and Edwardsville, Southern Illinois University Press, 1989, p. 133. AIA programs in the mid-1990s have begun to include gender research. The new AIA Subcommittee on Women in Archaeology (established in 1993) has also recently prepared a membership survey to answer questions about such topics as gender equity in the profession and about the research interests of AIA members. The subcommittee was formed late in contrast to comparable committees of related anthropological and art historical organizations, such as the Society for American Archaeology (SAA), the American Anthropological Association (AAA), the Society for Historical Archaeology (SHA), and the College Art Association (CAA). These groups have generally been more hospitable to and familiar with feminist and gender research, although scholars within their ranks also lament the slow acceptance of feminist ideas; see L. Vogel, "Fine Arts and Feminism: The Awakening Consciousness," in Raven, Langer, and Frueh, *Feminist Art Criticism*, p. 21.

8 This comment is founded on conversations with fellow archaeologists and AIA members.

9 N. Broude and M. D. Garrard, "Preface," in Broude and Garrard, *The Expanding Discourse*, p. x; C. Langer, "Turning Points and Sticking Places in Feminist Art Criticism," *College Art Journal*, 1991, vol. 50 (2), p. 28; Rabinowitz, "Introduction," pp. 10–11; J. W. Scott, *Gender and the Politics of History*, New York, Columbia University Press, 1988, p. 31. In addition to the use of the term "gender studies" to signify a more equal and less remedial (or political) study of women and men in society, the term is sometimes appropriate for emerging studies of sexuality and of genders that do not fall into neatly polarized categories of male or female. On the problems of conflating gender and sexuality with biological sex, see C. Claassen, "Questioning Gender: An Introduction," in C. Claassen (ed.), *Exploring Gender Through Archaeology: Selected Papers from the 1991 Boone Conference*, Madison, Prehistory Press, 1992, pp. 4–6; A. Cornwall and N. Lindisfarne, "Introduction," in A. Cornwall and N. Lindisfarne (eds), *Dislocating Masculinity: Comparative Ethnographies*, New York, Routledge, 1994, pp. 1–10; N. K. Denzin, "Sexuality and Gender: An Interactionist/Poststructural Reading," in P. England (ed.), *Theory on Gender/Feminism on Theory*, New York, Aldine de Gruyter, 1993, pp. 199–206; B. D. Miller, "Preface," in B. D. Miller (ed.), *Sex and Gender Hierarchies*, New York, Cambridge University Press, 1993, pp. 4–7; J. Nordbladh and T. Yates, "This Perfect Body, This Virgin Text: Between Sex and Gender in Archaeology," in I. Bapty and T. Yates (eds), *Archaeology After Structuralism: Post-Structuralism and the Practice of Archaeology*, New York, Routledge, 1990, pp. 222–37.

10 I. Bapty and T. Yates, "Introduction: Archaeology and Post-Structuralism," in Bapty and Yates, *Archaeology After Structuralism*, p. 1; Hodder, *Reading the Past*, pp. xiv, 168; I. Morris, "Introduction," in I. Morris (ed.), *Classical Greece: Ancient Histories and Modern Archaeologies*, Cambridge, Cambridge University Press, 1994, p. 44.

11 L. R. Binford, *Debating Archaeology*, London, Academic Press, 1989, p. 4.

12 The term "engendering" in archaeological writing can have multiple meanings. Usually it implies an interpretive approach that self-consciously examines its own biases about gendered behavior and that places women at the forefront of interpretation rather than men (woman-the-gatherer rather than man-the-hunter, for example); in this sense, engendered archaeology is often still remedial in looking for evidence of, and emphasizing, women's roles. At the same time its practitioners are generally theoretically aware and seek a variety of possible explanations for archaeological evidence, rather than

merely "adding women" to the picture of ancient society within a traditional framework of research.

13 Confusingly, structuralism and post-structuralism occasionally seem to embody the same, or almost the same, concepts in American art-historical and archaeological terminology; see Bapty and Yates, "Introduction," pp. 1–3; N. Broude and M. D. Garrard, "Introduction," in Broude and Garrard, *The Expanding Discourse*, p. 22, n. 5. One reason is the fact that theoretical "movements" are never truly successive, chronologically discrete, or ideologically distinct. Another is the historically slow American absorption of European theoretical debates. Americans too often must await translations of European publications, and sometimes embrace almost contemporaneously ideas that developed consecutively elsewhere.

14 Influential French scholars have included (among many others) Roland Barthes, Jacques Derrida, Michel Foucault, Jacques Lacan, Jean-François Lyotard, and Ferdinand de Saussure. See Broude and Garrard, "Introduction," pp. 1–7, 22–3, especially nn. 3–13, for a very brief but useful overview of the roles of post-structuralism, semiotics, and psychoanalytic theory within art history. See also M. Bal and N. Bryson, "Semiotics and Art History," *The Art Bulletin*, 1991, vol. 73, pp. 174–208; Owens, "The Discourse of Others"; J. W. Scott, "Deconstructing Equality-versus-Difference: Or, The Uses of Poststructuralist Theory for Feminism," in M. Hirsch and E. F. Keller (eds), *Conflicts in Feminism*, New York, Routledge, 1990, pp. 134–48. For an overview of French feminist authors see T. Moi, *French Feminist Thought: A Reader*, Oxford, Basil Blackwell, 1987; for a brief account of the context of their ideas within the non-feminist theoretical debates of male colleagues, see J. Duran, *Toward a Feminist Epistemology*, Savage, Rowman and Littlefield, 1991, pp. 161–81.

15 Recent overviews and collections of works on the history and growth of feminist art history make it easier for the novice to trace influential developments in the field. Good individual articles as well as broad overviews and collections include: K. Adler and M. Pointon, *The Body Imaged: The Human Form and Visual Culture Since the Renaissance*, Cambridge, Cambridge University Press, 1993; R. Betterton, "Introduction: Feminism, Femininity and Representation," in R. Betterton (ed.), *Looking On: Images of Femininity in the Visual Arts and Media*, New York, Pandora Press, 1987, pp. 1–17; N. Broude and M. D. Garrard, "Preface and Acknowledgments," in N. Broude and M. D. Garrard (eds), *Feminism and Art History: Questioning the Litany*, New York, Harper and Row, 1982, pp. vii–ix; N. Broude and M. D. Garrard, "Introduction: Feminism and Art History," in Broude and Garrard, *Feminism and Art History: Questioning the Litany*, pp. 1–17; Broude and Garrard, *The Expanding Discourse*; N. Broude and M. D. Garrard, "Introduction: Feminism and Art in the Twentieth Century," in N. Broude and M. D. Garrard (eds), *The Power of Feminist Art: The American Movement of the 1970s, History and Impact*, New York, Harry Abrams, 1994, pp. 10–29; W. Chadwick, *Women, Art, and Society*, London, Thames and Hudson, 1990; J. Frueh, "Towards a Feminist Theory of Art Criticism," in Raven, Langer, and Frueh, *Feminist Art Criticism*, pp. 153–65; J. Frueh, "The Body Through Women's Eyes," in Broude and Garrard, *The Power of Feminist Art*, pp. 190–207; T. Gouma-Peterson and P. Matthews, "The Feminist Critique of Art History," *The Art Bulletin*, 1987, vol. 69 (3), pp. 326–57; S. Langer, "Emerging Feminism and Art History," *Art Criticism*, 1979, vol. 1 (2), pp. 66–83; Nochlin, "Introduction"; L. Nochlin, "Women, Art, and Power," in Nochlin, *Women, Art, and Power*, pp. xi–xvi; Nochlin, *Women, Art, and Power*; L. Nochlin, "Starting From Scratch: The Beginnings of Feminist Art History," in Broude and

Garrard, *The Power of Feminist Art*, pp. 130–7; G. Pollock, "The Politics of Theory: Generations and Geographies. Feminist Theory and the Histories of Art Histories," *Genders*, 1993, vol. 17, pp. 97–120; Raven, Langer, and Frueh, *Feminist Art Criticism*; L. Tickner, "Feminism, Art History, and Sexual Difference," *Genders*, 1988, vol. 3, pp. 92–128; Vogel, "Fine Arts and Feminism." For a bibliographical survey of works on feminist art and art history, see C. Langer, *Feminist Art Criticism: An Annotated Bibliography*, New York, Macmillan, 1993. See L. Nead, "Seductive Canvases: Visual Mythologies of the Artist and Artistic Creativity," *Oxford Art Journal*, 1995, vol. 18 (2), pp. 59–69, and other essays in *Oxford Art Journal*, 1995, vol. 18 (2), for recent discussion of art-historical constructions of the male artist/genius.

16 See N. Bryson, *Vision and Painting: The Logic of the Gaze*, New Haven, Yale University Press, 1983, for the use of Gaze, capitalized; Broude and Garrard, "Introduction: The Expanding Discourse," p. 24, n. 29, comment on his unattributed use of the term. In 1988, Patricia Simons could cite "theories of the gaze" (quotation marks mine) with no description or explanation, and presume that her readers would know what she meant: P. Simons, "Women in Frames: The Gaze, the Eye, the Profile in Renaissance Portraiture," in Broude and Garrard, *The Expanding Discourse*, p. 39. For similar but not specifically feminist views, see also D. Preziosi, *Rethinking Art History: Meditations on a Coy Science*, New Haven, Yale University Press, 1989, pp. 31–6, 54–79, on the "panoptic gaze" of the art historian. Note also comments by Morris, "Introduction," p. 27.

17 K. Clark, *The Nude: A Study in Ideal Form*, New York, Pantheon Books, 1956, p. 1.

18 Clark, *The Nude*, pp. 5–6.

19 Clark, *The Nude*, p. 93.

20 Clark, *The Nude*, p. 8.

21 For an excellent (and positive) overview of Berger's goals as well as his problematic oversimplification of a number of issues, see P. Fuller, *Seeing Berger: A Reevaluation of Ways of Seeing*, London, Writers and Readers Publishing Cooperative, 1981 (pp. 3–4 on Clark); for a negative view of Berger's overgeneralizations about the concepts "naked" and "nude," and the construction of women's social presence, see M. Pointon, *Naked Authority: The Body in Western Painting, 1830–1908*, Cambridge, Cambridge University Press, 1990, pp. 4, 11–17. A number of feminists, including Pointon, have taken issue with Berger's apparent willingness to see women as colluding passively in their role as objects of the male gaze (Broude and Garrard, "Introduction: The Expanding Discourse," p. 24, n. 29; Pointon, *Naked Authority*, p. 16).

22 Sandra Bartky provides a fascinating analysis, presented in a less emotional, rhetorical form than Berger's, of the ways in which Western women restrict their gestures, postures, and movements and strictly govern their physical appearance to meet the judgmental male gaze: S. L. Bartky, "Foucault, Femininity, and the Modernization of Patriarchal Power," in S. L. Bartky, *Femininity and Domination: Studies in the Phenomenology of Oppression*, New York, Routledge, 1990, pp. 63–82.

23 J. Berger, *Ways of Seeing*, Harmondsworth and London, British Broadcasting Corporation and Penguin, 1972, p. 51.

24 L. Mulvey, "Visual Pleasure and Narrative Cinema," in L. Mulvey (ed.), *Visual and Other Pleasures*, Bloomington, Indiana University Press, 1989, pp. 14–38.

25 L. Mulvey, "Introduction," in Mulvey, *Visual and Other Pleasures*, p. vii.

26 Mulvey, "Introduction," p. xiii.
27 Mulvey, "Introduction," p. xiii.
28 Mulvey, "Visual Pleasure," p. 19. The terms "gaze theory" and "film theory" are related and sometimes interchanged. Neither refers to a consistent body of theory but rather to a general approach to recognizing the intended spectator of a work. Authors generally use the term "gaze theory" to signify a wide range of approaches to identifying and understanding the (overt and hidden) objectives of artists and spectators of both high and low art. "Film theory" often refers more specifically to psychoanalytical interpretations of film-spectatorship. See D. Robin, "Film Theory and the Gendered Voice in Seneca," in Rabinowitz and Richlin, *Feminist Theory*, pp. 102–7, for a brief overview of developments in modern film theory, and its application to ancient Roman theater. Feminist and related ancient art-historical analyses are not often explicit about (and their authors are perhaps sometimes unaware of) their indebtedness to gaze or film theory. For applications of gaze and film theory within classical archaeology, see S. Brown, "Death as Decoration: Scenes from the Arena in Roman Domestic Mosaics," in A. Richlin (ed.), *Pornography and Representation in Greece and Rome*, New York, Oxford University Press, 1992, pp. 182–3; D. Fredrick, "Beyond the *Atrium* to Ariadne: Erotic Painting and Visual Pleasure in the Roman House," *Classical Antiquity*, 1995, vol. 14 (2), pp. 266–89; A. Koloski-Ostrow, pp. 243–66 in this volume.
29 L. Nochlin, "Eroticism and Female Imagery in Nineteenth-Century Art," in Nochlin, *Women, Art, and Power*, pp. 136–44; for comments about the session by Nochlin herself see Nochlin, "Introduction," p. xiii; Nochlin, "Starting from Scratch" (with photographs of the nudes). For a critical review, although appreciative of the author's feminist goals, see Vogel, "Fine Arts and Feminism," pp. 38–41. Nochlin's article entitled "Why Have There Been No Great Women Artists?", which she began in 1970, was also a groundbreaking source of discussion and controversy; in it she identified the "hidden 'he' as the subject of all scholarly predicates," and the scholarly "one" as the "white-male-position-accepted-as-natural" (published in Nochlin, *Women, Art, and Power*, pp. 144–78).
30 Illuminating feminist analyses of the nude in high art (mostly painting) include the following: S. Alpers, "Art History and its Exclusions," in Broude and Garrard, *Feminism and Art History: Questioning the Litany*, pp. 183–200; D. Bauer, "Alice Neel's Female Nudes," *Woman's Art Journal*, 1994/5, vol. 15 (2), pp. 21–6; R. Betterton, "How Do Women Look? The Female Nude in the Work of Suzanne Veladon," in H. Robinson (ed.), *Visibly Female, Feminism and Art: An Anthology*, New York, Universe Books, 1988, pp. 250–71; M. L. Board, "Constructing Myths and Ideologies in Matisse's Odalisques," in Broude and Garrard, *The Expanding Discourse*, pp. 359–79; M. D. Carrol, "The Erotics of Absolutism: Rubens and the Mystification of Sexual Violence," in Broude and Garrard, *The Expanding Discourse*, pp. 139–59; M. A. Caws, "Ladies Shot and Painted: Female Embodiment in Surrealist Art," in Broude and Garrard, *The Expanding Discourse*, pp. 381–95; C. Duncan, "The Aesthetics of Power in Modern Erotic Art," in Raven, Langer, and Frueh, *Feminist Art Criticism*, pp. 59–69; C. Duncan, "The MoMA's Hot Mamas," in Broude and Garrard, *The Expanding Discourse*, pp. 347–57; Frueh, "The Body Through Women's Eyes;" T. Garb, "Renoir and the Natural Woman," in Broude and Garrard, *The Expanding Discourse*, pp. 295–311; T. Garb, "The Forbidden Gaze: Women Artists and the Male Nude in Late Nineteenth-Century France," in Adler and Pointon, *The Body Imaged*, pp. 33–42; M. D. Garrard, "Artemisia and

Susanna," in Broude and Garrard, *Feminism and Art History*, pp. 147–71; J. S.
Kasson, *Marble Queens and Captives: Women in Nineteenth-Century American
Sculpture*, New Haven, Yale University Press, 1990; R. Kendall and G. Pollock
(eds), *Dealing with Degas: Representations of Women and the Politics of Vision*,
London, Pandora Press, 1992; S. Kent, "Looking Back," in S. Kent and J.
Morreau (eds), *Women's Images of Men*, London, Writers and Readers Publishing,
1985, pp. 55–74; J. Marter, "Joan Semmel's Nudes: The Erotic Self and the
Masquerade," *Women's Art Journal*, 1996, vol. 16 (2), pp. 24–8; L. Nead, *The
Female Nude: Art, Obscenity, and Sexuality*, New York, Routledge, 1992; Nochlin,
"Women, Art, and Power;" Nochlin, "Eroticism and Female Imagery;" Owens,
"The Discourse of Others;" Pointon, *Naked Authority*; G. Pollock, "What's
Wrong with Images of Women?", in Betterton, *Looking On*, pp. 40–8; L.
Tickner, "The Body Politic: Female Sexuality and Women Artists Since
1970," in Betterton, *Looking On*, pp. 235–53. For early comparisons with nudes
in low art and advertisements, see P. Holland, "The Page Three Girl Speaks to
Women, Too," in Betterton, *Looking On*, pp. 105–19; K. Myers, "Fashion 'n'
Passion," in Betterton, *Looking On*, pp. 58–65; J. Williamson, "Decoding
Advertisements," in Betterton, *Looking On*, pp. 49–52, and other works in
Betterton, *Looking On*.

31 Despite feminism's frequently expressed desire to examine more general
questions of "otherness," the issue of a dominant white gaze (male and female)
or a dominant (hetero)sexual gaze has been approached more slowly, and
sometimes divisively. As Cassandra Langer has noted, "the question of the
gaze has yet to be fully explored within the context of lesbian and gay studies
or ethnic and multicultural diversity": Langer, "Turning Points," pp. 27–8. In
the study of ancient art and literature, the Lesbian, Gay, and Bisexual Classical
Caucus of the APA has promoted much relevant discussion on the Internet,
and sponsored a panel at the 1995 APA convention in San Diego.

32 B. S. Ridgway, "The Study of Classical Sculpture at the End of the 20th
Century," *American Journal of Archaeology*, 1994, vol. 98, p. 769.

33 Ridgway, "The State of Research on Ancient Art," *Art Bulletin*, 1986, vol. 68
(1), p. 21, notes this split as well. See L. Embree, "The Structure of American
Theoretical Archaeology: A Preliminary Report," in V. Pinsky and A. Wylie
(eds), *Critical Traditions in Contemporary Archaeology: Essays in the Philosophy,
History, and Socio-politics of Archaeology*, New York, Cambridge University Press,
1989, for definitions of so-called "theoretical" archaeology provided by (non-
classical) archaeologists responding to a questionnaire. Theoretical or anthro-
pological archaeology is generally characterized by hypothesis-testing and
explication of its theoretical concerns, and deals at least partly with broad
problems relevant to other social sciences. Non-theoretical ("traditional," or
"empirical") archaeology tends – say its opponents – to be more particularistic
and descriptive, to be less self-critical, and to operate on the basis of implicit,
unarticulated theories.

34 Recent histories of archaeology illuminate the divide in research strategies and
academic orientation between classical archaeology, other branches of archae-
ology, and related fields (primarily in the United States and Great Britain). See,
among others, Brown, "Feminist Research in Archaeology;" S. L. Dyson, "The
Role of Ideology and Institutions in Shaping Classical Archaeology in the
Nineteenth and Twentieth Centuries," in A. L. Christensen (ed.), *Tracing
Archaeology's Past: The Historiography of Archaeology*, Carbondale and Edwardsville,
Southern Illinois University Press, 1989; S. L. Dyson, "From New to New Age
Archaeology: Archaeological Theory and Classical Archaeology – A 1990s

Perspective," *American Journal of Archaeology*, 1993, vol. 97 (2), pp. 195–206; see also S. L. Dyson, "A Classical Archaeologist's Response to the 'New Archaeology'," *Bulletin of the American Schools of Oriental Research*, 1981, vol. 242, pp. 7–13"; Dyson, "Two Paths to the Past;" Morris, *Classical Greece*; A. Snodgrass, "Structural History and Classical Archaeology," in J. Bintliff (ed.), *The Annales School and Archaeology*, Leicester, Leicester University Press, 1991, pp. 57–72. Classical archaeologists in North America are generally subsumed within departments of classics or art history, where they are the odd ducks; prehistoric and New World archaeologists instead are included, and more firmly allied theoretically, with anthropology.

35 See, for example, K. A. Hays, "When Is a Symbol Archaeologically Meaningful? Meaning, Function, and Prehistoric Visual Arts," in N. Yoffee and A. Sherratt (eds), *Archaeological Theory: Who Sets the Agenda?* Cambridge, Cambridge University Press, 1993, pp. 81–92.

36 Ridgway, "The Study of Classical Sculpture," p. 759, nn. 4, 5; p. 760.

37 Ridgway, "The State of Research on Ancient Art," p. 7, n. 1.

38 "Theorists" were also not yet incorporated into art history in the 1980s quite as fully as they are in the 1990s. Many were criticizing their own field for reasons similar to Ridgway's (although in far more detail); see Preziosi, *Rethinking Art History*.

39 See Snodgrass, "Structural History and Classical Archaeology," pp. 59–63, on classical archaeology's association (in the eyes both of non-classical archaeologists, and internally) with art history and classics rather than with other branches of archaeology.

40 A. Snodgrass, "Response: The Archaeological Aspect," in Morris, *Classical Greece*, p. 198.

41 See J. Boardman, "Classical Archaeology: Whence and Whither?," *Antiquity*, 1988, vol. 62, pp. 795–7, for a (British) view of classical archaeology and Snodgrass's approach to it at that time. Boardman acknowledged the value of new approaches while defending the old.

42 Broude and Garrard, "Preface and Acknowledgments," p. vii.

43 Broude and Garrard, "Introduction: Feminism and Art History," p. 1.

44 V. Scully, "The Great Goddess and the Palace Architecture of Crete," in Broude and Garrard, *Feminism and Art History: Questioning the Litany*, pp. 33–43.

45 Broude and Garrard, "Introduction: Feminism and Art History," pp. 3–4. For an overview of the archaeological debates about prehistoric (primarily pre-Bronze-Age) goddess imagery, see Brown, "Feminist Research in Archaeology," pp. 254–6; M. W. Conkey and R. E. Tringham, "Archaeology and the Goddess: Exploring the Contours of Feminist Archaeology," in D. C. Stanton and A. J. Stewart (eds), *Feminisms in the Academy*, Ann Arbor, University of Michigan Press, 1995, pp. 199–247; M.-A. Dobres, "Re-considering Venus Figurines: A Feminist Inspired Re-analysis," in A. S. Goldsmith *et al.* (eds), *Ancient Images, Ancient Thought: The Archaeology of Ideology. Proceedings of the 1990 Chacmool Conference*, Alberta, Archaeological Association of the University of Calgary, 1992, pp. 245–62; L. Meskell, "Goddesses, Gimbutas, and 'New Age' Archaeology," *Antiquity*, 1995, vol. 69, pp. 74–86; L. Talalay, "Body Imagery of the Ancient Aegean," *Archaeology*, 1991, vol. 44 (4), pp. 46–9; L. Talalay, "A Feminist Boomerang: The Great Goddess of Greek Prehistory," *Gender and History*, 1994, vol. 6 (2), pp. 165–83. For information on the impact and various meanings of Great Goddesses within a feminist art history, see the special issue on the subject in *Heresies*, 1987, vol. 5; S. R. Binford, "Are Goddesses and Matriarchies Merely Figments of Feminist Imagination?," in C. Spretnak (ed.),

The Politics of Women's Spirituality: Essays on the Rise of Spiritual Power Within the Feminist Movement, New York, Anchor Books, 1982, pp. 541–9; Broude and Garrard, "Introduction: Feminism and Art in the Twentieth Century," pp. 22, 289, n. 44; G. F. Orenstein, *The Reflowering of the Goddess*, Elmsford, NY, Pergamon Press, 1990; G. F. Orenstein, "Recovering Her Story: Feminist Artists Reclaim the Great Goddess," in Broude and Garrard, *The Power of Feminist Art*, pp. 174–89. Also note the relevant review (by Estella Lauter) of feminist Goddess books in *Women's Art Journal*, 1995, vol. 15 (2), pp. 45–9. See H. Foley, "Interpretive Essay on the Homeric Hymn to Demeter," in H. P. Foley (ed.), *The Homeric Hymn to Demeter: Translation, Commentary, and Interpretive Essays*, Princeton, Princeton University Press, 1994, p. 168 (including nn.) on "spiritual feminism" and theories concerning the preservation of pre-patriarchal religious traces in later evidence for the worship of Demeter and Persephone.

46 Broude and Garrard, "Introduction: The Expanding Discourse," p. 1.

47 Broude and Garrard, "Preface," p. ix.

48 Natalie Kampen, who also contributed to the volume published in 1982 (N. Kampen, "Social Status and Gender in Roman Art: The Case of the Saleswoman," in Broude and Garrard, *Feminism and Art History: Questioning the Litany*, pp. 63–77; see also N. Kampen, *Image and Status: Roman Working Women in Ostia*, Berlin, Gebr. Mann Verlag, 1981), discusses the role of classicizing public art, in both Augustan Rome and eighteenth-century Europe, in demonstrating an ideal male view of gender relations (N. Kampen, "The Muted Other: Gender and Morality in Augustan Rome and Eighteenth-Century Europe," in Broude and Garrard, *The Expanding Discourse*, pp. 161–9). While the feminist scholarship on ancient art grows daily, it is still largely in the form of papers presented at professional conferences. The publication of some of these conferences in the next few years will increase the extant literature many times over.

49 M. D. Garrard, "Leonardo da Vinci: Female Portraits, Female Nature," in Broude and Garrard, *The Expanding Discourse*, p. 77. Garrard is reminded by some of Leonardo's paintings of the "ancient mother–daughter pairing of Demeter–Persephone, who in turn reflect the twin aspects of the even more ancient mother goddess" of many pre-Greek images. She does not provide references to ancient or modern literature on Demeter and Persephone or to twin aspects of any mother goddess, or to the problems of interpreting prehistoric female figurines from different places and chronological periods as symbols of pan-Hellenic or pan-European religious unity. She illustrates Leonardo's artistic tie to the mother goddess by juxtaposing the Mycenaean ivory of two women and a child (the identification/interpretation of which remains ambiguous) in the Athens National Museum with Leonardo's painting of the *Virgin, Christ Child, and Saint Anne* in the Louvre.

50 Broude and Garrard, "Introduction: The Expanding Discourse," pp. 5, 15–22.

51 More often outside than within archaeology, anthropology, and social history, prehistoric/Bronze-Age females are sometimes imagined as having been powerful in religion, or at least myth, if not more broadly within a matriarchal or gynocentric society (but preferably both). These ideas are largely based on three publications by Marija Gimbutas (*Goddesses and Gods of Old Europe: Myths and Cult Images*, Berkeley, University of California Press, 1982; *The Language of the Goddess*, San Francisco, HarperCollins, 1989; *The Civilization of the Goddess: The World of Old Europe*, New York, HarperCollins, 1991). Outside archaeology, the focus is often on modern, female-centred theoretical approaches and on the ways in which theories of ancient gynocentry empower women today. For

classics, see T. Passman, "Out of the Closet and Into the Field: Matriculture, the Lesbian Perspective, and Feminist Classics," in Rabinowitz and Richlin, *Feminist Theory*, pp. 181–208 (especially, 198–9); she discusses in a positive light the power of such feminist theories to effect social change, and notes the rejection of new approaches by classicists and archaeologists/art historians. Within archaeology and anthropology (n. 45), the focus is instead often on the problems with overly general and broad theories, on the nature of the material evidence itself, or on ethnographic data. See Sarah Pomeroy's conclusion about matriarchy in the preface to the new edition (1995) of her influential book, *Goddesses, Whores, Wives, and Slaves*: "Finally, often using data from non-Greek societies, in recent years anthropologists and social historians have shown that matriarchy is an intellectual construct rather than a historical reality" (New York, Schocken Books, 1995, p. xi). See also B. Hayden, "Observing Prehistoric Women," in Claassen, *Exploring Gender Through Archaeology*, p. 42, n. 1: "As it turns out, there may be no society in which women dominate the top 10 per cent of political positions To the extent that rituals are used for political ends . . . this may pertain to ritual life as well." For a historical survey of scholarship to 1981 (including anthropological, feminist, Classical, psychological) on possible prehistoric (primarily Bronze-Age) Aegean matriarchy/ matriliny, see S. B. Pomeroy, "Selected Bibliography on Women in Classical Antiquity," in J. Peradotto and J. P. Sullivan (eds), *Women in the Ancient World: The Arethusa Papers*, Albany, State University of New York Press, 1984, pp. 320–5, 347–54.

52 M. W. Conkey, "Making the Connection: Feminist Theory and the Archaeologies of Gender," in H. du Cros and L. Smith (eds), *Women in Archaeology: A Feminist Critique*, Canberra, Australian National University, 1993, pp. 11–12.

53 One of the long-standing messages of the Classical nude seems to be that a naked woman who distances herself from her viewer/victimizer, often by refusing to make eye contact, is a particularly appealing sight: Brown, "Feminist Research in Archaeology," pp. 258–9. The polarization between lady and whore, high and low sexuality, is thereby maintained.

54 For critical theory on Orientalism, see E. W. Said, *Orientalism*, New York, Pantheon, 1978; for a brief feminist commentary see Tickner, "Feminism, Art History, and Sexual Difference," p. 105; for a recent art-historical application, see K. D. Kriz, "Dido versus the Pirates: Turner's Carthaginian Paintings and the Sublimation of Colonial Desire," *Oxford Art Journal*, 1995, vol. 18, pp. 116–32.

55 For comments on "The Greek Slave," see, for example, Duncan, "The Aesthetics of Power," p. 60; T. W. Herbert, "The Erotics of Purity: The Marble Faun and the Victorian Construction of Sexuality," *Representations*, 1991, vol. 36, pp. 123–5; Kasson, *Marble Queens*, pp. 46–72. For an example of a traditional art-historical discussion of a nude in an Oriental setting, see G. M. Ackerman, *The Life and Work of Jean-Léon Gérôme*, New York, Harper and Row, 1986, p. 88. Writing about Jean-Léon Gérôme's graphic nineteenth-century paintings of a despairing, naked, white female slave on view on the auction block (nos 328, 329), Ackerman focuses entirely on the girl's body and clear skin, and on the contrasting colors within the painting, only briefly citing the slave's "embarrassment." In one painting we see her, as do her male viewers, from the front; in the other, we see both the Oriental men and the nude girl from the rear. Ackerman calls this reversal a "humorous example" of how perspective studies can be used either way (p. 255).

56 Natalie Kampen and Nanette Salomon are two scholars with "feet in both

camps" who have undertaken feminist analyses of ancient nudes and critical evaluations of the field of (ancient) art history; see below. See also C. Chard, "Nakedness and Tourism: Classical Sculpture and the Imaginative Geography of the Grand Tour," *Oxford Art Journal*, 1995, vol. 18, pp. 18–28.

57 Salomon's work first came to my attention through her chapter, "The Art Historical Canon: Sins of Omission," in J. E. Hartman and E. Messer-Davidow (eds), *(En)gendering Knowledge: Feminists in Academe*, Knoxville, University of Tennessee Press, 1991, pp. 222–36. See also her essay "The Venus Pudica: Uncovering Art History's 'Hidden Agendas' and Pernicious Pedigrees," in a collection focusing primarily on later art history, Griselda Pollock (ed.), *Generations and Geographies*, London, Routledge, 1996, pp. 69–87.

58 R. Osborne, "Looking On – Greek Style. Does the Sculpted Girl Speak to Women, Too?," in Morris, *Classical Greece*, pp. 81–96. See also his chapter in N. Kampen (ed.), *Sexuality in Ancient Art: Near East, Egypt, Greece, and Italy*, New York, Cambridge University Press, 1996.

59 New looks at the nude and the female body by ancient art historians are provided in Kampen, *Sexuality in Ancient Art*, by Kampen herself, Andrew Stewart, and many others. Eve D'Ambra spoke on "The Calculus of Venus: Nude Portraits of Roman Women" (also published in Kampen, *Sexuality*) and Gloria Pinney discussed "Fugitive Nudes: The Woman Athlete," at the 1994 AIA panel on "Body Image and Gender Symbolism." The 1995 AIA convention in San Diego featured a colloquium on "Embodying Gender," organized by Michelle Marcus. (See the *AIA Abstracts* of the 96th and 97th Annual Meetings (1994, vol. 18, and 1995, vol. 19).) Note also C. M. Havelock, *The Aphrodite of Knidos and Her Successors*, Ann Arbor, University of Michigan Press, 1995, and E. Reeder (ed.), *Pandora: Women in Classical Greece*, Princeton, Princeton University Press, 1995.

60 Studies in English in the 1990s on sexuality and the female body, as represented in ancient art and literature, include: J. Boswell, "Revolutions, Universals, and Sexual Categories," in M. Duberman, M. Vicinus, and G. Chauncey, Jr (eds), *Hidden From History: Reclaiming the Gay and Lesbian Past*, New York, Penguin Group, 1990, pp. 17–36; E. Cantarella, *Bisexuality in the Ancient World*, New Haven, Yale University Press, 1992; J. R. Clarke, "The Decor of the House of Jupiter and Ganymede at Ostia Antica: Private Residence Turned Gay Hotel?", in E. K. Gazda and A. E. Haeckl (eds), *Roman Art in the Private Sphere: New Perspectives on the Architecture and Decor of the Domus, Villa, and Insula*, Ann Arbor, University of Michigan Press, 1991, pp. 89–104; J. R. Clarke, "The Warren Cup and the Contexts for Representations of Male-to-Male Lovemaking in Augustan and Early Julio-Claudian Art," *The Art Bulletin*, 1993, vol. 75 (2), pp. 275–94; L. Foxhall, "Pandora Unbound: A Feminist Critique of Foucault's *History of Sexuality*," in Cornwall and Lindisfarne, *Dislocating Masculinity*, pp. 133–46; D. M. Halperin, *One Hundred Years of Homosexuality*, New York, Routledge, 1990; D. M. Halperin, "Sex Before Sexuality: Pederasty, Politics, and Power in Classical Athens," in Duberman, Vicinus, and Chauncey, *Hidden From History*, pp. 37–53; D. M. Halperin, J. J. Winkler, and F. I. Zeitlin (eds), *Before Sexuality: The Construction of Erotic Experience in the Ancient Greek World*, Princeton, Princeton University Press, 1990; Kampen, *Sexuality in Ancient Art*; M. A. Katz, "Sexuality and the Body in Ancient Greece," *Métis, Revue d'anthropologie du monde grec ancien*, 1989, vol. 4, pp. 155–79; M. Myerowitz, "The Domestication of Desire: Ovid's *Parva Tabella* and the Theater of Love," in Richlin, *Pornography and Representation*, pp. 131–57; A. Richlin, "Introduction," in Richlin, *Pornography and Representation*, pp. xi–xxiii; Richlin, *Pornography and Rep-*

resentation; A. Richlin, *The Garden of Priapus: Sexuality and Aggression in Roman Humor*, New Haven, Yale University Press, 1992; A. Richlin, "Not Before Homosexuality: The Materiality of the Cinaedus and the Roman Law Against Love Between Men," *Journal of the History of Sexuality*, 1993, vol. 3 (4), pp. 523–73; Salomon, "The Art Historical Canon," and Salomon's essay, pp. 197–219 in this book; H. A. Shapiro, "Eros in Love: Pederasty and Pornography in Greece," in Richlin, *Pornography and Representation*, pp. 53–72; G. Sissa, *Greek Virginity*, Cambridge, Mass., Harvard University Press, 1991; R. F. Sutton, Jr, "Pornography and Persuasion on Attic Pottery," in Richlin, *Pornography and Representation*, pp. 3–52; J. Winkler, *The Constraints of Desire: The Anthropology of Sex and Gender in Ancient Greece*, New York, Routledge, 1990; and the special edition on "Sexuality in Greek and Roman Society" of the journal *differences* (spring 1990), edited by David Konstan and Martha Nussbaum. See also L. A. Dean-Jones, *Women's Bodies in Classical Greek Science*, Oxford, Clarendon Press, 1994. See chapters by Barbara Kellum and Thomas Habinek in Thomas Habinek (ed.), *The Roman Cultural Revolution*, New York, Cambridge University Press, 1997. See A. Richlin, "Zeus and Metis: Foucault, Feminism, Classics," *Helios*, 1991, vol. 18 (2), pp. 160–80, for a scathing overview of the way much of the male scholarship on sexuality overlooks or reinvents points already made by feminist authors.

61 For example, within classical archaeology, structuralism and semiotic theory have had a greater influence on scholarly approaches to Greek pottery and vase-painting than to Greek sculpture (see Stewart, *Greek Sculpture*, p. 32; Ridgway, "The Study of Classical Sculpture," pp. 764–5; Snodgrass, "Structural History and Classical Archaeology," pp. 59–61 discusses the existence of varied scholarly approaches to pottery and sculpture, although he does not specifically mention semiotic theory). Until recently, the result has been that scholars of vase-painting have in general been more open to the idea that art does not simply represent reality, but rather systems of symbolic meaning; see, for example, G. Ferrari, "Figures of Speech: The Picture of Aidos," *Métis, Revue d'anthropologie du monde grec ancien*, 1990, vol. 5, pp. 185–200. Roman sculpture has received slightly more attention than Greek sculpture from feminists and researchers on gender symbolism; new publications on social and political meanings of gender include E. D'Ambra, *Private Lives, Imperial Virtues: The Frieze of the Forum Transitorium in Rome*, Princeton, Princeton University Press, 1993; Kampen, "The Muted Other;" N. B. Kampen, "Looking at Gender: The Column of Trajan and Roman Historical Relief," in Stanton and Stewart, *Feminisms in the Academy*, pp. 43–73; and Kampen in *Sexuality in Ancient Art*. The current interest in considering (especially Roman) ancient sculpture and monuments as "social constructs to be analyzed within a larger socio-cultural matrix," while based in social history rather than linguistics, is also indebted to structuralism and semiotics (quotation from A. P. Gregory, "'Powerful Images': Responses to Portraits and the Political Uses of Images at Rome," *Journal of Roman Archaeology*, 1994, vol. 7, p. 80, n. 1).

62 The social-historical and philosophical literature on sexuality has largely been authored in the context of feminist and lesbian/gay or queer studies, and is far from unified in outlook; see n. 31. See also K. King, "Producing Sex, Theory, and Culture: Gay/Straight Remappings in Contemporary Feminism," in Hirsch and Keller, *Conflicts in Feminism*, pp. 82–101. Note the summer–fall volume of *differences*, 1994, vol. 6, entitled "More Gender Trouble: Feminism Meets Queer Theory."

63 On the importance within feminist scholarship of crossing academic boundaries, see Stanton and Stewart, "Introduction", p. 3.

64 B. G. Trigger, "History and Contemporary American Archaeology: A Critical Analysis," in C. C. Lamberg-Karlovsky (ed.), *Archaeological Thought in America*, Cambridge, Cambridge University Press, 1989, p. 23.

65 See, for example, L. R. Binford and S. R. Binford (eds), *New Perspectives in Archaeology*, Chicago, Aldine Press, 1968; L. R. Binford, *An Archaeological Perspective*, New York, Seminar Press, 1972 (and, for later views, Binford, *Debating Archaeology*), and C. Renfrew (ed.), *The Explanation of Culture Change*, London, Duckworth, 1973; C. Renfrew, "The Great Tradition versus the Great Divide: Archaeology as Anthropology?", *American Journal of Archaeology*, 1980, vol. 84, pp. 287–98 (and, for later views, C. Renfrew, *Approaches to Social Archaeology*, Edinburgh, Edinburgh University Press, 1984; and C. Renfrew and P. Bahn, *Archaeology: Theories, Methods and Practice*, London, Thames and Hudson, 1991).

66 A. Wylie, "The Interplay of Evidential Constraints and Political Interests: Recent Archaeological Research on Gender," *American Antiquity*, 1992, vol. 57, p. 23.

67 Brown, "Feminist Research in Archaeology," p. 248.

68 N. C. Wilkie and W. D. E. Coulson, "Preface", in N. C. Wilkie and W. D. E Coulson (eds), *Contributions to Aegean Archaeology: Studies in Honor of William A. McDonald*, Minneapolis, University of Minnesota Press, 1985, p. xvi, quoting William McDonald.

69 See, for example, I. Hodder, *Symbols in Action*, Cambridge, Cambridge University Press, 1982; I. Hodder, "Postprocessual Archaeology," *Advances in Archaeological Method and Theory*, 1985, vol. 8, pp. 1–26; I. Hodder, *Reading the Past: Current Approaches to Interpretation in Archaeology*, Cambridge, Cambridge University Press, 1986; I. Hodder, *Theory and Practice in Archaeology*, New York, Routledge, 1992 (especially pp. 86–9); E. Engelstad, "Images of Power and Contradiction: Feminist Theory and Post-processual Archaeology," *Antiquity*, 1991, vol. 65, pp. 502–14; other well-known figures include Michael Shanks and Christopher Tilley: see their *Re-constructing Archaeology: Theory and Practice*, Cambridge, Cambridge University Press, 1987, and *Social Theory and Archaeology*, Albuquerque, University of New Mexico Press, 1987. Hays, "When Is a Symbol Archaeologically Meaningful?", p. 88, n. 1, provides a brief definition of processual and post-processual archaeology. For a broad overview see Renfrew and Bahn, *Archaeology*, pp. 34–5, 426–34; Trigger, "History and Contemporary American Archaeology;" B. G. Trigger, *A History of Archaeological Thought*, Cambridge, Cambridge University Press, 1989, pp. 294–319, 348–57; M. Shanks and I. Hodder, "Processual, Postprocessual and Interpretive Archaeologies," in I. Hodder, M. Shanks, and A. Alexandri *et al.* (eds), *Interpreting Archaeology: Finding Meaning in the Past*, New York, Routledge, 1995, pp. 4–5.

70 Duran, *Toward a Feminist Epistemology*, pp. 73–102; see also S. Harding, *The Science Question in Feminism*, Ithaca, Cornell University Press, 1986; E. F. Keller, *Reflections on Gender and Science*, New Haven, Yale University Press, 1985; J. H. Kelley and M. P. Hanen, *Archaeology and the Methodology of Science*, Albuquerque, University of New Mexico Press, 1988; A. Wylie, "The Constitution of Archaeological Evidence: Gender Politics and Science," in P. Galison and D. J. Stump (eds) *The Disunity of Science*, Stanford, Stanford University Press, 1996.

71 J. Molino, "Archaeology and Symbol Systems," in J.-C. Gardin and C. S.

Peebles (eds), *Representations in Archaeology*, Bloomington, Indiana University Press, 1992, p. 23.

72 A confusingly wide variety of archaeological approaches and theoretical positions are lumped together under the term post-processual; see J.-C. Gardin, "Semiotic Trends in Archaeology," in Gardin and Peebles, *Representations in Archaeology*, p. 87; Hodder, *Reading the Past*, pp. xiv, 168; Hodder, *Theory and Practice in Archaeology*, p. 88; J. Thomas, "After Essentialism: Archaeology, Geography, and Post-modernity," *Archaeological Review from Cambridge*, 1993, vol. 12 (1), p. 4.

73 Approaches to understanding material culture through structuralist and semiotic theory have been modified with time and with developments in post-structuralist/post-processual approaches. For comments on problems with textual readings of material culture, see V. A. Buchli, "Interpreting Material Culture: The Trouble With Text," in Hodder, Shanks, and Alexandri, *Interpreting Archaeology*, pp. 181–93, and C. Chippindale, "Grammars of Archaeological Design: A Generative and Geometrical Approach to the Form of Artifacts," in Gardin and Peebles, *Representations in Archaeology*, pp. 251–2.

74 They presented their ideas in an article published in *Advances in Archaeological Method and Theory*, 1984, vol. 7, pp. 1–38.

75 The collection was published by Gero and Conkey as *Engendering Archaeology*: J. M. Gero and M. W. Conkey, "Preface," in Gero and Conkey, *Engendering Archaeology*, p. xiii; Wylie, "The Interplay of Evidential Constraints," pp. 15–16.

76 Bapty and Yates, "Introduction," pp. 2–3, illustrate the view of feminist or gender archaeology as unclearly defined. For brief overviews of publications, conferences, and classes on feminist approaches to archaeology, see Claassen, "Questioning Gender: An Introduction," pp. 1–2; A. Wylie, "Foreword: Gender Archaeology/Feminist Archaeology," in E. Bacus, A. W. Barker *et al.*, *A Gendered Past: A Critical Bibliography of Gender in Archaeology*, Ann Arbor, Museum of Anthropology Publications, 1993, pp. vii–xiii. See R. Gilchrist, *Gender and Material Culture: The Archaeology of Religious Women*, New York, Routledge, 1994, pp. 2–8 and Brown, "Feminist Research in Archaeology," pp. 244–57, for a review of non-classical feminist approaches to archaeology. For comments on the state of prehistoric, New World and historic archaeology, and for collections of articles, see Claassen, *Exploring Gender Through Archaeology*; M. W. Conkey with S. W. Williams, "Original Narratives: The Political Economy of Gender in Archaeology", in di Leonardo, *Gender at the Crossroads of Knowledge*, pp. 102–39; T. Cullen, "Contributions to Feminism in Archaeology," *American Journal of Archaeology*, 1996, vol. 100, pp. 409–14; H. du Cros and L. Smith, *Women in Archaeology: A Feminist Critique*, Canberra, Australian National University, 1993; Gero and Conkey, *Engendering Archaeology*; R. Gilchrist, "Women's Archaeology? Political Feminism, Gender Theory and Historical Revision," *Antiquity*, 1991, vol. 65, pp. 495–501; Engelstad, "Images of Power and Contradiction;" L. Hurcombe, "Our Own Engendered Species," *Antiquity*, 1995, vol. 69, pp. 87–100; E. M. Scott, *Those of Little Note: Gender, Race, and Class in Historical Archaeology*, Tucson, University of Arizona Press, 1994; and D. Walde and N. Willows (eds), *The Archaeology of Gender: Proceedings of the 22nd Annual Chacmool Conference*, Alberta, Calgary University Press, 1991. Bacus, *A Gendered Past*, provides a critical bibliography.

77 See, for example, L. Gibbs, "Identifying Gender Representation in the Archaeological Record: A Contextual Study," in I. Hodder, *The Archaeology of Contextual Meanings*, Cambridge, Cambridge University Press, 1987, pp. 79–101; A. Strömberg, *Male or Female? A Methodological Study of Grave Gifts as Sex-indicators in Iron*

Age Burials from Athens, Jonsered, P. Åstroms Förlag, 1993; M. Whelan, "Gender and Archaeology: Mortuary Studies and the Search for Gender Differentiation," in Walde and Willows, *The Archaeology of Gender*, pp. 358–65.

78 Examples include M. N. Cohen and S. Bennett, "Skeletal Evidence for Sex Roles and Gender Hierarchies in Prehistory," in Miller, *Sex and Gender Hierarchies*, pp. 273–96, and M.-A. Dobres, "Gender and Prehistoric Technology: On the Social Agency of Technical Strategies," *World Archaeology*, 1995, vol. 27, pp. 25–49; see also Hayden's discussion of approaches, in "Observing Prehistoric Women."

79 Some authors have experimented with what have been called feminist "alternative narratives," presentations or interpretations of evidence which include emotion rather than enforce the scientific goal of objectivity. For examples, see J. D. Spector, "What This Awl Means: Toward a Feminist Archaeology," in Gero and Conkey, *Engendering Archaeology*, pp. 388–406, followed by J. Spector, with C. C. Cavender *et al.*, *What This Awl Means: Feminist Archaeology at a Wahpeton Dakota Village*, St Paul, Minnesota Historical Society Press, 1993; and R. Tringham, "Households with Faces: The Challenge of Gender in Prehistoric Architectural Remains," in Gero and Conkey, *Engendering Archaeology*, pp. 93–131; R. Tringham, "Engendered Places in Prehistory," *Gender, Place, and Culture*, 1994, vol. 1, pp. 169–203. For a fascinating example of a "masculinist" alternative narrative, see Christopher Tilley's tale of the development of processual and post-processual scholarship, in "On Modernity and Archaeological Discourse," in Bapty and Yates, *Archaeology After Structuralism*, pp. 130–6. Tilley fictionalizes a third-person account of the goals of various prominent leaders of the theoretical debates, using their first names. The story is inset into a more traditional assault on processual archaeology. Tilley employs sarcasm and personal attack to link author and reader in a feeling of superiority, reinforced by the fact that only those "in the know" will recognize the scholars named. Archaeology's history of new theoretical schools claiming "privileged status in determining what is valid explanation in archaeological research" (N. Yoffee and A. Sherratt, "Introduction: The Sources of Archaeological Theory," in N. Yoffee and A. Sherratt (eds), *Archaeological Theory: Who Sets the Agenda?* Cambridge, Cambridge University Press, 1993, p. 1) is well illustrated here, as it is in general by both processual and post-processual polemics. While feminist scholarship certainly has also had its share of polemical and internally divisive research during transitions in thinking, the general tendency is towards accommodation of varied approaches. See comments on the subject of divisiveness by Broude and Garrard, "Introduction: The Expanding Discourse," p. 5, concerning art history, and A. Richlin, "The Ethnographer's Dilemma and the Dream of a Lost Golden Age," in Rabinowitz and Richlin, *Feminist Theory*, p. 272, concerning classics.

80 See the overview of many of the relevant issues in A. Wylie, "Beyond Objectivism and Relativism: Feminist Critiques and Archaeological Challenges", in Walde and Willows, *The Archaeology of Gender*, pp. 17–23; see also Wylie, "The Interplay of Evidential Constraints," and the comments on that essay by B. J. Little, "Consider the Hermaphroditic Mind: Comment on 'The Interplay of Evidential Constraints and Political Interests: Recent Archaeological Research on Gender,'" *American Antiquity*, 1994, vol. 59, pp. 539–44, and M. Fotiadis, "What is Archaeology's 'Mitigated Objectivism' Mitigated By? Comments on Wylie," *American Antiquity*, 1994, vol. 59, pp. 545–55. Wylie responds in turn to their comments in: A. Wylie, "On 'Capturing Facts Alive in the Past' (Or

Present): Response to Fotiadis and to Little," *American Antiquity*, 1994, vol. 59, pp. 556–60.

81 A. Wylie, "A Proliferation of New Archaeologies: Beyond Objectivism and Relativism," in Yoffee and Sherratt, *Archaeological Theory*, p. 22.

82 P. L. Kohl, "Limits to a Post-processual Archaeology (Or, The Dangers of a New Scholasticism)," in Yoffee and Sherratt, *Archaeological Theory*, p. 15.

83 L. E. Patrik, "Is There an Archaeological Record?," *Advances in Archaeological Method and Theory*, 1985, vol. 8, pp. 27–62.

84 My evidence remains anecdotal: personal communication with classical archaeologists who see in the debates about theoretical issues no relevance to their research.

85 Pomeroy's importance to the study of ancient women in classics and archaeology was such that she inspired the title of an overview of research on women in antiquity: P. Culham, "Ten Years After Pomeroy: Studies of the Image and Reality of Women in Antiquity," *Helios*, 1987, vol. 13 (2), pp. 9–30. For an overview of approaches to understanding women before and after 1975 and Pomeroy, see A. Katz, "Ideology and 'the Status of Women' in Ancient Greece," in R. Hawley and B. Levick (eds), *Women in Antiquity: New Assessments*, New York, Routledge, 1995, pp. 21–43.

86 I cannot adequately summarize works focusing on women and fitting into the category of research generally called Women in Antiquity. They include S. Blundell, *Women in Ancient Greece*, New York, Cambridge University Press, 1995; A. Cameron and A. Kuhrt (eds), *Images of Women in Antiquity*, Detroit, Wayne State University Press, 1983; H. P. Foley (ed.), *Reflections of Women in Antiquity*, New York, Gordon and Breach Science Publishers, 1981; N. B. Kampen, "Between Public and Private: Women as Historical Subjects in Roman Art," in S. B. Pomeroy (ed.), *Women's History and Ancient History*, Chapel Hill, University of North Carolina Press, 1991; E. C. Keuls, *The Reign of the Phallus: Sexual Politics in Ancient Athens*, New York, Harper and Row, 1985; J. Peradotto and J. P. Sullivan (eds), *Women in the Ancient World: The Arethusa Papers*, Albany, State University of New York Press, 1984; Pomeroy, *Women's History and Ancient History*; Reeder, *Pandora*; B. S. Ridgway, "Ancient Greek Women and Art: The Material Evidence," *American Journal of Archaeology*, 1987, vol. 91, pp. 399–409; S. Silberberg-Pierce, "The Muse Restored: Images of Women in Roman Painting," *Woman's Art Journal*, 1993/4, vol. 14 (2), pp. 28–36.

87 Brown, "Feminist Research in Archaeology," pp. 257–8; Conkey and Spector, "Archaeology and the Study of Gender," pp. 17–18; Frueh, "Towards a Feminist Theory of Art Criticism," pp. 155–6; A. Wylie, "Gender Theory and the Archaeological Record: Why Is There No Archaeology of gender?," in Gero and Conkey, *Engendering Archaeology*, pp. 31–5.

88 On non-classical archaeologists' similar – although less severe – problems with moving towards new theoretical and interpretive strategies for viewing femininity, masculinity, and constructs of gender, see Claassen, "Questioning Gender;" Conkey and Spector, "Archaeology and the Study of Gender," pp. 17–18; Cornwall and Lindisfarne, "Introduction," pp. 2–4; Gilchrist, "Women's Archaeology?", p. 499; Wylie, "Gender Theory and the Archaeological Record," p. 31. For classical periods in particular see the book by Lin Foxhall, *Studying Gender in Classical Antiquity*, forthcoming with Cambridge University Press. See Miller, "The Anthropology of Sex and Gender Hierarchies," pp. 4–7, on issues of sex and gender research in anthropology. Given the state of comparable research in archaeology, it is ironic that Miller introduces her book

with the comment, "There is little need these days for another general collection of anthropological essays on sex and gender" (Miller, "Preface", p. xiii).

89 Conkey with Williams, "Original Narratives," p. 124; Wylie, "Gender Theory," p. 39.

90 P. duBois, *Sowing the Body: Psychoanalysis and Ancient Representations of Women*, Chicago, University of Chicago Press, 1988; P. duBois, *Centaurs and Amazons: Women and the Pre-history of the Great Chain of Being*, Ann Arbor, University of Michigan Press, 1991; Myerowitz, "The Domestication of Desire;" B. Rawson, "From 'Daily Life' to 'Demography'," in Hawley and Levick (eds), *Women in Antiquity*, pp. 1–20.

91 G. Ferrari, "Figures of Speech;" G. F. Pinney, *Figures of Speech*, Chicago, University of Chicago Press, forthcoming.

92 Foxhall, "Pandora Unbound;" Foxhall, *Studying Gender in Classical Antiquity*.

3

FEMALE BEAUTY AND MALE VIOLENCE IN EARLY ITALIAN SOCIETY[1]

John Robb

A lived hegemony is always a process. It is not, except analytically, a system or a structure. It is a realized complex of experiences, relationships, and activities, with specific and changing pressures and limits. In practice, that is, hegemony can never be singular.

R. Williams[2]

The legendary history of Rome is a history of crimes of honor. Mars and Rhea Silvia, Romulus and Remus, the Sabine women, Lucretia – all of these stories show how ideals of female beauty and male violence were central to gender and political ideologies. What of Rome's real history, and its prehistory? In sifting the reality behind such ideological statements, our task is difficult. Most archaeological sources are mute on the subtler aspects of the extended nervous system we call culture. Nevertheless, there is substantial archaeological material that can be used to construct a prehistory of gender, and it has never been seriously assembled for this purpose. In Italy, we might mention numerous excavated cemeteries, skeletal data on biological sex, violence, and lifestyle, and above all a rich record of prehistoric and protohistoric art.

This paper has both empirical and theoretical goals. Empirically, it will review the archaeological sources on gender in art, skeletal biology, and mortuary studies, from the Neolithic to the Iron Age. While gender ideologies are constructed within specific social contexts, at least in broad outlines there are wide zones of homogeneity; for instance, Iron-Age Central Italy shared a core of male and female symbols not only with the rest of Italy but with much of Europe as well. With prehistoric gender studies in their infancy, making broad generalizations is necessarily the first step; figuring out when and why they are wrong will be the second.

The second goal is theoretical. As students of ideology, our job is not only to identify gender systems but to understand how they actually worked in society as well. What it meant to be male or female is interdependent with the definition of other genders and with economic and social conditions in which meanings were enacted. Thus a social and

43

symbolic interpretation of female and male gender ideologies in Iron-Age Italy will be presented. Moreover, we cannot assume there was unanimity on what central gender symbols meant; to the contrary, ambiguity was an inherent and necessary aspect of Iron-Age gender ideologies.

At 6000 BCE, Italian Neolithic gender systems probably resembled those in many ethnographically known tribal societies.[3] Classical gender systems shared many features known ethnographically from Mediterranean "honor and shame" societies.[4] How New Guinea evolved into Rome is a fascinating and important problem.

GENDER ATTRIBUTION AND ARCHAEOLOGICAL SYMBOLS: A METHODOLOGICAL NOTE

There are four basic sources on the "archaeology of gender" (see Bacus *et al.*, and Conkey and Gero[5] for introductions to the fast-growing field). Each has its own possibilities and limitations. Grave goods provide one of the few ways to associate cultural meanings directly with biological sex, the *sine qua non* of gender research, and they often present gender as a basic social identity of the deceased. They show one particular social context, however, which may not always be typical. Moreover, particularly for the Iron Age and Classical periods, skeletons are often not preserved for study, and burials are often "sexed" according to grave goods rather than from independent biological criteria. This is a practice that cannot provide any information about gender that goes beyond the archaeologist's presuppositions. "Art," a heterogeneous category, includes iconography created for aesthetic, ritual, decorative, and other purposes. Art provides a rare glimpse of symbolic life, though its meanings reflect particular symbolic contexts and are notoriously open to misinterpretation. Literary and historical evidence share many of these characteristics, though it is absent for prehistoric periods and for many historic periods as well. Finally, skeletal evidence provides a non-symbolized foil for these cultural representations, giving evidence as to the lifestyle, economic standing, and violence suffered by males and females.

The first problem to tackle in understanding prehistoric ideology is gender attribution, as we cannot assume *a priori* that symbols such as weapons or ornaments were associated with one gender; even apparently gender-related patterns may actually reflect other factors such as activity specialization.[6] The most useful tool for gender attribution is direct reference to sexual characteristics, either iconographically or through association with sexed burials. While biological sex does not automatically equal gender, it makes a good starting point, as gender systems with two genders are by far the commonest, and additional genders are often based on inversion or recombination of two principal genders.[7] Distributional patterns offer a second lead. Distributional patterns are patterns of association or contrast

between symbols which we suspect refer to gender, and between such symbols and more explicitly gendered symbols. While indirect, such patterns are particularly important when the commonest gender icons are taken for granted rather than accompanied by explicitly biological identification – the trousers-and-skirt phenomenon.

Identifying females in Italian prehistoric art provides examples of both techniques. In Neolithic figurines and Copper and Bronze Age stelae, females are marked unambiguously through anatomical characteristics, primarily the breasts. In rock art, figures marked with a dot are sometimes identified as females,[8] mostly because this is a formal variant which never occurs with anatomically marked male figures. Distributional patterns also supply a third likely female symbol: the necklace is consistently found in combination with other "female" symbols, and is almost never associated with "male" symbols. Similar chains of inference supply male symbols. By this technique, we can reconstruct a system of core symbols whose meaning depends partly on external references, mostly biological, and partly on internal contrasts and associations.

As with any symbolic system, counter-examples are inevitable. How does one interpret a burial or image which combines "male" and "female" symbols? There are three possibilities. First, the reconstructed symbolic system may be wrong. Reconstruction is especially tricky in the case of symbols which are not central to gender identities but tend to be statistically commoner within one or another gender. Secondly, the data may be in error; for example, skeletal remains will be sexed correctly about seventy to ninety per cent of the time.[9] Finally, once a symbol has been endowed with meaning, it can be used to comment creatively or ironically on situations far removed from its core context. For instance, in Classical art and literature, females using weapons usually represent divine figures, exceptional cases of female valor in crises, or permutations of society such as the Amazons, all of which consciously invert "normal" symbolic expectations for special purposes.

THE CORE SYMBOLS OF GENDER

Neolithic

Even combining all sources of evidence, there is little concrete data on Neolithic gender ideologies (Table 1). In the Italian peninsula, males were often buried lying on their right side and females on the left side,[10] as in other European contexts,[11] but in northern Italy both sexes seem to have been buried on the left side. Burial goods are infrequent and show no clear gender-related patterns. No historical information is extant for this period, and the skeletal evidence is too scanty to reveal gender patterns, although cranial fractures suggestive of violence are known in both sexes.[12]

Table 1 Archaeological sources on gender in prehistoric Italy

	Neolithic (6000–3000 BC)	Copper/Bronze Ages (3000–800 BC)	Iron Age (800 BC–)
Art: figurines	female figurines in villages	–	small warrior bronzes (Etruscan, Venetic, nuraghic)
Art: rock art	Porto Badisco (hunting and abstract art); Valcamonica (ploughs, "idols", spirals)	Valcamonica, Monte Bego (daggers, axes, stags, hunting, ploughs, oxen)	Valcamonica (varied images, warfare)
Art: stelae	only two known (Arnesano, Alfaedo; gender not marked)	scattered Alpine Copper Age stelae ("cosmic" figures); Lunigiana stelae (males with daggers, females with breasts); scattered Bronze Age examples (same imagery)	Lunigiana stelae; Daunia stelae; Villanovan stelae; sporadic others (males with panoply, females with ornaments)
Art: miscellaneous imagery	–	–	tomb and pottery decorations – male warriors, females with ornaments, occasional weaving scenes
Burials	little gender differentiation	weapons appear as grave goods	males with weapons, females with ornaments and weaving gear
Skeletal evidence	little gender differentiation in lifestyle	little gender differentiation in lifestyle	trauma, physical stress more frequent in males
Literary evidence	–	–	males: warfare and hunting; females: weaving and ornamentation

In art, female representations occur in small clay figurines, of which about a dozen are known (Fig. 1).[13] When females are identified in plastic media, the primary diacritic is the breasts. Two Neolithic stelae are known,[14] both without overt signs of gender. In rock art at both Porto

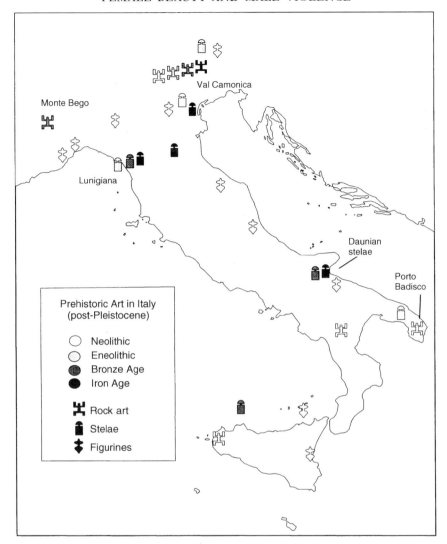

Figure 1 Prehistoric art in post-Pleistocene Italy

Badisco and Valcamonica,[15] occasional figures marked with a dot between the legs have been identified as females. The only clearly interpretable male symbolism is hunting, identified as such by anatomically marked male figures hunting deer with bows at Porto Badisco.[16] Both this art and several faunal samples suggest that hunting was a ritually important activity associated with male gender.[17] Whitehouse notes that representational art and figures identified as females are commoner near the entrance of Porto

Badisco than in the less accessible chambers, and argues that cult caves were the loci where males produced secret ritual knowledge which allowed them to control their societies' cosmology.

By playing connect-the-dots with the limited evidence, and acknowledging the hazards of doing so, we might reconstruct a balanced cognitive opposition between female symbols centred on the female body and male symbols centred on hunting.[18] This may have been associated spatially with a village:periphery distinction,[19] but appears not to have been systematically elaborated into a political ideology.

Eneolithic and Bronze Age

Copper and Bronze Age evidence is more plentiful, especially for artistic representations of the human body. Burials are less informative, as in much of Italy collective burial obscured connections between individuals and grave goods, and the same practice discourages correlation of biological characteristics with sex in mixed skeletal deposits. Again, there is no literary evidence for these periods.

The clearest female imagery in this period is the direct use of sexual characteristics, primarily the breasts, to identify females. In the Alpine Copper Age stelae, this occurs at Lagundo and in related examples from outside Italian territory.[20] In the Lunigiana corpus of stelae, breasts appear on thirteen of thirty-four stelae bearing any gender-related symbols.[21] Similar Bronze Age stelae with breasts are known from Castelluccio dei Sauri in Apulia,[22] as well as from Sardinia, Corsica, and France. The shared imagery among these stelae suggests that, though scattered geographically, they have a common semantic language; in the intervening empty regions, stelae may also have been made of wood, which would not survive archaeologically.[23] In all of these examples, the breasts are modelled in a highly conventionalized style and there is no other gender-specific anatomical detail, nor any attempt to portray clothing. The stelae may not have been intended to portray an actual unclothed body; rather, their anatomical imagery seems to have been used simply to denote a female personage, with nudity and clothedness as semantic dimensions alien to them.

Only one other feature appears specific to female stelae, the necklace. All Lunigiana stelae with necklaces for which the relevant parts have survived are also sculpted with breasts,[24] and the same is true for the later Bronze Age Castelluccio dei Sauri stele. This appears to have been more recently adopted as a female symbol, as one Copper Age Alpine stele bears both a necklace and weapons. Necklaces are shown in combination with anatomical features, but are almost never used as a substitute for them. They thus provide a secondary, additive symbolism.

Analogous direct anatomical references for males are absent. Instead,

from the Copper Age, weapon symbolism appears. In Alpine rock art at Valcamonica and Valtellina, daggers and halberds are repeated in clusters of dozens of carvings.[25] Weapon images also appear frequently in the Monte Bego Bronze Age petroglyphs,[26] and sporadic examples suffice to show that this was a general rather than local preoccupation. At Lunigiana, twenty-one of forty-two stelae for which the body is preserved bear carvings of weapons.[27] While the dagger is the basic weapon shown in the stelae, some also depict other weapons, usually axes or spears. In the few artistic representations known from the peninsula rather than northern Italy (e.g. Castelluccio dei Sauri), daggers also figure as a basic motif. Grave goods help to fill in the geographical and temporal gaps in art evidence. Copper and bronze daggers and finely flaked flint daggers and points are common grave goods throughout the Italian peninsula (it should be noted that it is usually impossible to tell which individuals they were deposited with in multiple burials). In northern Italy, the same is true for some Copper-Age cultures[28] and most Bronze-Age cultures. This stands in sharp contrast to the Neolithic, where lithic artefacts in graves tend to be tools rather than weapons. It begins a tradition of weaponry as grave goods which lasts through the Iron Age.

How can we be sure that weapons truly were male symbols? Although they have traditionally been interpreted as such, this is usually assumed rather than demonstrated, and at least one scholar has seriously proposed that all the Lunigiana stelae represent females, including ones with weapons.[29] There are two lines of evidence: direct sexual references and distributional patterns. The former is scanty; a few Alpine rock carvings show figures with phalluses using weapons, and anatomically female figures are never shown with weapons. Distributional patterns provide stronger support.[30] In the only body of art large enough for tabulation, the Lunigiana stelae, it is clear that weapons and the female symbols identified above are mutually exclusive. The mutual exclusion of breasts and weapons also holds for sporadic stelae. The weapons:breasts contrast thus defines two mutually exclusive categories of person, depicted in approximately equal numbers, one of which is unmistakably female and the other of which is characterized by artifacts which were male-associated both earlier, in Neolithic hunting cults, contemporaneously in a few rock art images, and later, in well-understood Iron-Age contexts. This suggests that weapons were indeed male symbols.

As with female symbols, male symbols include both basic markers and secondary ones which can be combined with the basic icons but not substituted for them. For instance, most "male" Lunigiana stelae with weapons include daggers, axes or swords, and spears in late examples, whose great popularity in rock art confirms their "primary icon" status. They sometimes also include belts, which, conversely, are rarely found on stelae with female symbols. Finally, one other Bronze Age male symbol is

plowing. At Monte Bego, a number of figures representing ithyphallic males plowing suggest that plows and teams of oxen were ideologically celebrated male-associated symbols, and this may help account for the numerous depictions of yoked teams and *bucrania* found there and elsewhere in the Alps.

Iron Age

Evidence for gender symbols is abundant in the Iron Age. Grave goods have provided far less information than they have potential to, as archaeologists often assume gender interpretations rather than demonstrate them by comparison with biologically sexed skeletons. Nevertheless, several cemetery studies (for example, at Pontecagnano[31] and Osteria dell'Osa[32]) have shown that weapons were deposited with males. Spears are more commonly found than swords. This probably reflects an economic distinction – swords were costlier.[33] Armor is found in graves much more rarely, probably owing to its greater expense. At Osteria dell'Osa and other sites, miniature replicas of weapons were deposited, implying that weapons were both important symbols and costly ones.

Art evidence confirms that weapons were the primary material symbol of masculinity. Iron Age stelae in all regional groups include iconographic references to weaponry or scenes of warfare (Table 2). The latest Lunigiana stelae depict persons with recognizable Iron-Age "antennae-handled"

Table 2 Gender-specific grave goods in sexed burials at Pontecagnano

	Female	Male
8th–7th centuries BCE	pendants beads intertwined rings coiled springs buttons pins	spear sword/sheath razor knife plate
7th–5th centuries BCE	spindle whorl earrings rings	spear point knife large belt (*cinturone*) bracelet
5th–3rd centuries BCE	pendants rings pins earrings mirror	spear point sword/sheath knife large belt (*cinturone*) bracelet strigil

swords. Weaponry also characterizes the Sardinian stelae at Monte Prama,[34] and both the Etruscan stelae at Bologna[35] and Venetic stelae at Padova[36] bear inset scenes of armed warfare. The Daunian stelae with arms[37] bear a standard kit of sword, breastplate, and shield. Rock art at Valcamonica now includes actual warrior figures as well as depictions of weapons themselves, and small bronze figurines of warriors are common in a number of Iron Age societies.[38] In most of this art, as in earlier periods, there is no explicit sexual identification of weapon-users as males. A scattering of bronze figurines and rock carvings, however, depicts weapon-users as anatomically male. Etruscan art as well provides abundant evidence in tomb paintings, mirror engravings, and small bronzes that weapon-users were almost always intended to be males, as denoted through anatomical characteristics, face and body form, and names. The literary and historical traditions referring to protohistoric times are also unanimous in regarding weapon-users as primarily male; when females are described as using weapons, it is almost always accompanied by some explanation of such an unusual circumstance. Interestingly, this association of males with the tools and practice of violence is confirmed by skeletal evidence; at Pontecagnano, traumatic injuries were far more common among adult males than among females.[39]

For women, the Iron Age brought two symbolic innovations: spinning and ornamentation. Art evidence for spinning and weaving is limited; for instance, weaving appears in only one inset scene on a Daunian stele,[40] and is relatively uncommon in Etruscan tomb-paintings, sculpture, and minor arts. The paucity of references may reflect the fact that spinning and weaving, while ideologically important in defining females, were less a focus of dramatic interest than warfare. From the Final Bronze Age on, however, spindle whorls are frequently found as grave goods throughout Italy.[41] Sexed burials show that they are found in female graves.[42] Literary and historical references, although dating to later periods, confirm that spinning and weaving were important female activities (for instance, in Livy's (I.57) conventionalized portrait of Lucretia as a model wife spinning industriously at home alone). The burial evidence, in particular, helps to establish spinning and weaving as a female symbolism on a par with male weaponry.

Bietti Sestieri's analysis of Osteria dell'Osa[43] highlights an especially significant aspect of spinning. While spindle whorls are found with females of all ages, sets of weaving gear are associated with female burials near the threshold of adulthood. This suggests that spinning may have been particularly relevant to aspects of female gender newly established or salient at this time. Spinning was a key part of household economic production, and may have had symbolic connotations of wifely virtue; spindle whorls in graves may have betokened the attainment of marriageable status, the death of an unmarried adult female, or some similar meaning.

Evidence for ornamentation as female symboling comes from grave goods, art, and literary sources. The pattern of grave goods, with males

buried with arms and females with ornaments, is evident already in the precociously rich Stratum 3 graves at Toppo Daguzzo.[44] Throughout the Iron Age, this basic pattern persists (Table 2). Both males and females wore *fibulae*, but *fibulae* styles were often gender-specific and female burials tend to contain *fibulae* more often.[45] Although the exact configuration of female and male ornaments varies regionally and temporally,[46] other ornaments, particularly earrings and pendants, are rarely found with males. In art, in several Iron Age stelae traditions, there are no or few definite female figures (e.g. Lunigiana, Period C; Bologna; Monte Prama). In the Daunian series, gender attribution is somewhat problematic,[47] but, given the male: arms equation, it is clear that the appropriate visual equivalent for females was an array of *fibulae*, necklaces, and belts worn with a long robe. This is confirmed by many examples from contemporary Etruscan art, which show women in all contexts dressed in earrings, arm bracelets, necklaces, and frequently elaborate coiffures. Literary comment makes it clear that jewelry was recognized as a specifically female means of expressing social status (e.g. Livy 34:7.8–9).[48] The Etruscans occasionally even used gold orthodontic devices to correct the appearance of marriageable young women.[49]

Thus the Iron Age saw the symbolic clothing of women. Ornamentation and clothing had probably always differentiated men and women in practice, but from the late Bronze Age they became ideologically salient symbols which superseded biological characteristics in archaeologically visible situations including art imagery and burial goods (Fig. 2). Ornamentation

	Female		Male		
	extended symbols	core symbols	core symbols	extended symbols	social changes
Neolithic		female body	hunting		
Copper/ Bronze Age	necklace/ ornament, spinning, weaving	female body	simple weapons (dagger, axe)	ploughing/ oxen?	rise of trade-oriented male prestige networks
Iron Age		ornaments; spinning, weaving	complex weapons (panoply)		social stratification

Figure 2 The evolution of gender symbols in prehistoric Italy

probably served to mark an abstract conception of beauty as a valued part of female identity. Though poorly defined, this is as good a way as any to express a quality established through self-presentation in social situations via the visual characteristics of the culturally modified body and, presumably, their effects upon the reactions of others.

GENDER WITHIN SOCIETY: THE IRON AGE

Although archaeological study often halts triumphantly at identifying basic symbols, symbolic analysis really begins rather than ends here. Gender symbols in particular should be problematized. They serve to make social reality unquestionable through the compelling, involuntary symbolism of the body.[50] They thus enforce meanings not only of gender but also of prestige and power, central aspects of society as a whole.[51] The case in hand points out the need to delve into gender symbols. Weapons were used for three thousand years of Neolithic life before they became an archaeologically ubiquitous icon of maleness. The matter-of-fact representation of female anatomy as a conventional diacritic in the Neolithic and Bronze Age surely had little to do with Classical nudity, loaded as it was with connotations of sex and power.[52] To the extent that we automatically treat weapons as a natural male symbol or the female nude as an object of aesthetic beauty, we are merely paying tribute to the effectiveness of these symbols in naturalizing the constructed social world.

In the second half of this paper, I will examine the relations between female and male gender symbols, and between these symbols and their broader social context.

STRUCTURAL RELATIONS BETWEEN GENDER SYMBOLS: THE CASE FOR MALE DOMINATION

Symbols work at several levels. In the structuralist tradition stemming from de Saussure, symbols derive their meaning from contrasts on an abstract level analytically separable from their usage in given instances. As recent theorists have pointed out, while the structuralist formulation is flawed in many ways, the distinction between an abstract, generative, often unconscious level where core meanings are constituted and the realm of actual practices in which they are enacted is central to modern social theory.[53] For instance, without such distinctions, it is difficult to understand how semantically central "key symbols"[54] such as weaponry and weaving can authorize widely divergent interpretations, or "sheafs of meaning" in Barth's phrase,[55] as well as how symbols can shift their basic meanings over time.

This point provides a useful methodological premise for the following interpretation of Iron Age gender systems. I discuss male and female as dichotomous, mutually exclusive and complementary categories, without

going into alternative genders or non-gendered identities. This is partly a practical decision: faced with scrappy Iron Age material, it seems useful to block out major, obvious social categories before proceeding to more layered interpretations. Beyond this, however, one of the most fruitful ethnographic methods for approaching gender is to construct a generative system of relatively simple abstract axioms, many of which are actually based upon cognitive binary oppositions such as male/female.[56] That such cognitive dichotomies often underwrite much more complex situations "on the ground" in no way diminishes the power of this approach. For example, at Osteria dell'Osa,[57] obvious male and female symbols were most common in young adult burials; in this case, it seems more logical to suppose that individuals remained classified as male or female their entire lives, but that the social salience of these categories varied through the lifespan, rather than to conjecture that the aged formed a third gender or a genderless category. Looking at symbols on several levels similarly helps clarify why people chose to use the symbols they did. Weapons are tools of violence. We need not suppose that every time a male wore a weapon he was contemplating violent acts. In a given context, a weapon may have been used to refer to ritualized or symbolic rather than actual violence, or may have even served as a purely iconic badge of male or elite status (an interpretation certainly supported by findings of non-functional or over-elaborate display weapons in all periods from the Copper Age on). Analyzing weaponry *only* within such particular contexts, however, leaves key questions unanswered and gives symbols an unwarranted appearance of arbitrariness. Why are swords rather than saws or salad forks the common Iron Age symbols of maleness? How are their contextual connotations – actual violence, ritual violence, identity badges – interdependent with each other and with an abstract underlying semantic?

In this section, I will discuss the semantics of female beauty and male violence, aiming to reconstruct something like the system of pervasive gender-defining attitudes, gestures, and behaviors which Bourdieu calls *hexis*.[58] In the following sections, I will discuss aspects of how this system may have been translated into "on the ground" social relations.

Weapons as symbols defined males in terms of their capacity for violence. From the Copper Age on, the use of the dagger as a lowest-common-denominator male icon implies that an attitude of readiness for violence was required to enter the world of adult male politics, regardless of the degree to which violence was actually practiced. This symbolism continues through the Iron Age, even as the weapons used change. Archaeologically and artistically attested exercises such as wrestling and hunting reinforce the identification of agonistic struggle with maleness. Another route to the psyche is provided by later linguistic evidence. In the Roman sexual vocabulary,[59] weapons are a frequent and readily understood metaphor for the phallus. A wide range of terms for sexual activity are based on

the semantic field of beating, striking, and other strongly transitive actions which overlap into violence. Much of the Latin sexual vocabulary, and, presumably, its underlying concepts, is oriented around terms which express both sexual interaction between an active and a passive participant, usually male and female, and aggression, domination, or humiliation between two potentially active participants, usually two males.[60] It is true that we know little of comparable vocabulary in either Etruscan or the Italic dialects of Iron-Age Italy, but if we treat the Latin evidence as representing a cultural tradition rather than a purely linguistic phenomenon, we may infer semantic continuity. Extrapolating back, we might read into the broad Iron-Age emphasis on weapons and maleness a semantic merging of concepts of violence, the capacity for transitive action, self-assertion, domination, and male sexuality.

As a political idiom, violence defined categories such as active and passive which would have been easily mapped on to social divisions and prestige hierarchies. The psychological impulse to violence was probably translated into political action via concepts of prestige or "honor," which would have made obligatory for socially recognized males the duty to exercise and defend one's rights, whether economic, political, or sexual.

There is a little evidence from the same sources that the female body may have occupied the converse position. In earlier times, the female body itself had served as a powerful symbol, and it is hard to believe it lost this fundamental meaning when overt physiological symbols were superseded by clothing and ornaments. At least this is the implication of the considerable number of Classical references identifying female fertility with the fertility of the earth, even on the level of pseudo-medical ideas[61] and sexual slang[62] based upon images of plowing, fields, and sowing; this symbolism may date to the Bronze Age, to judge from rock carvings of ithyphallic ploughmen at Monte Bego. Beauty, however, is an ambiguous ideal, a social value contingent upon others' reactions. Moreover, juxtaposing violence and beauty as innate, abstract male and female characteristics maps gender distinctions on to power distinctions of transitive agenthood. Via this structural usurpation, the semantics of desire thus casts women in the "unmarked" or structurally contained half of an asymmetrical opposition. As this reconstruction suggests, when the classical nude used male nakedness to symbolize power and female nakedness to symbolize vulnerability,[63] it was building upon meanings latent in earlier Iron Age gender systems.

As with male gender, abstract symbols were translated into behavior via systems of prestige and sanction. Linking sexuality, violence, and honour made women's sexuality a political as well as personal matter, so that control of access to women came to rest with the family rather than the individual.[64] The idea that female beauty provoked male desire which was stronger than women's power to resist it dictated an ideal of seclusion and

reserved comportment as a key to female chastity, a system which contained women literally as well as structurally.

As an overall interpretation, the male–female distinction was enacted through bodily *hexis* organized around the structurally complementary semantics of violence and beauty, and symbolized through weapons, weaving, and ornamentation. This system authorized males to be the primary political actors while defining complementary, encompassed spheres of valued activity for females.[65] To the extent that male activities linked family production with the larger political and economic scene, women would have also been economically and politically dependent on them for status, security, and the means of pursuing their goals. As a scenario, this conforms to the cross-cultural generalization that males derive their status from relations to other males, while females often derive it from their relations to males.[66] It sets Iron-Age Italy as a firm precursor to Mediterranean patriarchy.

NECESSARY AMBIGUITIES: THE CASE FOR MULTIVOCAL GENDER IDEOLOGIES

There are, however, several reasons to question this tidy interpretation. As Foucault[67] remarks, such top-down analyses of power are at once correct and glib. Power is not a commodity freely exercised by a superordinate segment of society on its subordinates. Rather, it is inherent in social relations, and works on and through both groups. This is especially pertinent to gender ideologies, which constitute an invisible power via the unconscious operations of the body. Moreover, the "male-domination" interpretation privileges formal institutions and coercive structures over informal practices and tacit or consensual orders, and assumes that public symbolic life somehow represents the real experiential "bottom line." Furthermore, major gender symbols may bear different interpretations by different groups within society. Empirically, the ethnographic world is rife with "male-dominated" societies which turn out to offer women much autonomy and power on second glance or when the ethnographer asks the right questions. Many occur within classic Mediterranean "honor and shame" societies.[68]

The core symbols of Iron-Age gender ideology would have been identified readily and uniformly by all members of society. This monolithic structure, however, was liable to dispute, misrecognition, and faulty translation into reality. From historical accounts, artistic representations and burials, we know that class was often as salient as gender in reckoning status and that women of all ranks sometimes exercised considerable influence within their sphere. Epitaphs show that even slave women and freedwomen were respected for their occupations.[69] Roman laws entitled fathers and husbands to kill adulterous spouses,[70] but these laws seem

usually to have been discussed as badly needed correctives rather than common practices. Too many of our sources on issues such as beauty and the moral nature of males and females are male-oriented for us to be certain we understand other points of view; this is so even for Roman times, much less for the virtually prehistoric Iron Age. The separation of gender spheres, for instance, may have given women as well as men realms of autonomous control.[71] Alternative views on power and gender may have been built into the symbolic system. For example, given its centrality in sexual politics, women's sexuality held a great promise for disrupting male power. Male honor depended partially on women's behavior, making cuckoldry and impotence vulnerable points in the system. Not surprisingly, these are sources of female ridicule of Mediterranean machismo in some recent societies,[72] and they probably were in ancient times as well.

Gender relations in ancient Italy, thus, are ambiguous to us not merely from defects of evidence, but because they were probably ambiguous to the natives as well. Was male violence practical protection or symbolic repression of women? Were men masters of the household or nominal spokesmen for collective decisions? Were ornaments tokens of value and affection or of social control? Was women's sexuality a threat to society? If so, whose society? As Gramsci pointed out,[73] dominant political and economic systems generate both hegemonic cultural systems and internal counter-hegemonies. Male symbolic hegemony, propagated through politics, may well have been opposed by female counter-hegemonies propagated through less formal and archaeologically visible channels such as family bonds, folklore, humor, and mythology. The resulting ambiguities of gender would have provided material for resistance and, at the same time, would have helped to incorporate opposed groups into systems of common action.

PRACTICAL VALOR AND EVERYDAY BEAUTY: THE CASE FOR GENDER AS CLASS IDEOLOGY

The concept of hegemony raises the point that gender ideologies do not exist in a social vacuum, and some developments of gender ideology in the Iron Age must be ascribed to the influence of class. Iron-Age societies inherited symbolisms of male weaponry and female biological attributes, in a social environment of incipient stratification among elite and non-elite clans. The rise of wealth-based social classes, particularly from the eighth century on, stimulated rapid change in how gender distinctions were symbolized. For both male and female symbols, the amount of detail and variation in stelae, rock art, and grave goods leapt dramatically with class stratification. Ornamentation, originally an "additive" symbol used in conjunction with anatomical features, replaced anatomical features as the common icon for females. Far from being mere shifts of fashion, both

of these trends expanded the symbolic register to allow new ranges of personal distinction.

For males, the simple weapon or hunting image evolved into a whole panoply specifically dedicated to warfare. As the Servian census (Livy I.43) makes clear, weapons and defensive armor were costly enough that only the wealthy could be expected to outfit themselves with the top-of-the-line gear. The upper three classes were assigned swords, the bottom two only spears, javelins, and slings. Interestingly, the arms portrayed on the Daunian stelae, the sword, breastplate, and round shield, correspond well to those prescribed for Livy's most elevated class, confirming that the stelae were intended to represent a wealthy elite. Cavalry were especially expensive, and chariots were the pinnacle of weaponry as aristocratic display. Equipment was only the beginning, however. Both for informal fighting, raiding and defence, and in formal warfare, success demanded organization and numbers. While individual valor was extolled, security in Iron Age Italy would have been based upon the ability to mobilize armed supporters, and this probably reflected wealth and control of property and clients more than anything else.

Female symbols show a similar evolution from a few standardized symbols to a much more diverse symbolic register which accurately reflected degrees of wealth; at least, this is the implication of the replacement of the breasts as a primarily female marker by a wide range of ornamentation. Unlike biological characteristics, ornaments were obvious symbols of wealth and a means of asserting prestige. In art such as the Daunian stelae, high levels of ornamentation are the norm. The gradation in grave goods from a simple *fibula* to the troves found in eighth- to sixth-century "princely" tombs in Etruria, Latium, and Campania points out the fact that fulfilment of this ideal was highly variable. Clothwork and seclusion may have had class overtones as well. The position of the weaver as a skilled worker contributing directly to the exchange value of household production implies a certain autonomy and status probably not enjoyed by all females in a large household. Moreover, the opportunity to weave in chaste seclusion like the ideal respectable matron may have been attainable only for women whose labor was not needed in the fields or in the market. For recent Italian villagers, at least, practicing fine craftwork distinguished elite women from common peasants.[74]

Gender-related symbols thus provided the main idiom for prestige distinctions. This created a contradiction: as experiential meanings of male violence and female beauty were channelled into actual goals with economic price-tags attached, only elites could completely fulfill the ideals which were prescribed for all men and women. For ordinary people, the abstract ethic was situationally redefined relative to their role or place in society.[75] Fulfilling the ideal of respectable male or female behavior relative to one's position required co-operation and participation in economic and

political structures. Hence ideals such as male honor, which could theoretically have motivated egalitarian rebellion against hierarchical structures, served instead to fit individuals into these structures. By demarcating legitimate, honorable violence, which upheld normal social relations, from non-legitimate violence, this arrangement made gender ideology a necessary support of political order. At the same time, ambiguous and multiple interpretations of gender ideology allowed various groups to remain committed to structurally different positions within the overall system. Gender ideology in Iron Age Italy was thus inextricable from class structures, and both its florid symbolic elaboration and its recalcitrance to simple exegesis derive ultimately from its role in supporting a strongly class-stratified society.

CONCLUSIONS

While preliminary and general in nature, this investigation yields several basic conclusions about gender symbols and their role in prehistoric and Iron-Age Italy.

First, the basic symbols of female and male identity show remarkable continuity from the end of the Neolithic to the Iron Age. It is equally striking how this core of symbols was adapted to successive social regimes. In Neolithic times, females are symbolized primarily by their biological attributes. Hunting is an important male symbol. In the tribal world of the Neolithic, hunting and the female body probably formed the focus of gender-specific cults. In the Copper Age, symbolisms for females remain more or less unchanged, with the addition of simple ornaments, such as the necklace, as secondary symbolisms. Weapons, particularly the dagger, are introduced as the central symbol of adult male status. As these societies developed intensified agricultural and pastoral economies, wide trade networks, and political systems oriented towards male competition for prestige, the identification of males with weapon use was harnessed to politics.[76] The result was the formation of a widespread *koiné* of gender attributes. In the Iron Age, both female and male symbolic registers expand greatly. For women, anatomical images and simple ornaments are superseded by a far greater variety of ornaments and clothing, and for males the simple dagger evolves into a whole panoply of weapons and armor. This burgeoning symbolic language was driven by competition for distinctions of prestige in new circumstances of social stratification.

Secondly, moving beyond identification of symbols to interpretation, weapons represented a status based on a male capacity for violence, which may in turn have provided symbolic grounding for a *hexis* of systematically assertive behaviors in many realms of life. Ornaments as female symbols were probably tied to an ideology that valued women for their beauty, and they served to display women's wealth as well. The two symbolisms formed

complementary parts of a dualistic system ascribing active roles and public life to males and neutral roles within a contained, domestic life to females, with sanctions of dishonor or shame for individuals not conforming to this.

Thirdly, this neat, almost stereotypical reading, however, overlooks much possible ambiguity and alternative sources of power latent in it. For instance, Classical authors often deride women's nature and capabilities; we know little, however, of what the women they devalue said in response through other, unwritten channels of communication. Both archaeological and historical evidence and ethnographic comparisons hint at various sources of power for women which offered the possibility of resistance or counter-hegemony.

Fourthly, gender symbols of warfare, ornamentation, and weaving refer to social ideals which were theoretically prescribed for all individuals. In actuality, achieving these ideals depended on one's wealth and class status. But the emotional commitment which gender symbols commanded helped to keep poorer individuals from reacting to class biases, and gender ideology thus formed a powerful support for class stratification.

The exercise of reconstructing prehistoric and protohistoric gender relations, with all the dangers of theorizing with scraps of evidence, is nevertheless worthwhile for two results. First, it shows clearly how the Italian Iron Age built on a prehistoric foundation of symbolism. Secondly, it allows us to speculate on the role of gender in society, a far more complex question than simply identifying key gender symbols. That bodily symbols of maleness and femaleness were turned to expressing class distinctions speaks strongly for the emotional centrality of gender. That they nonetheless do not afford a single interpretation of "women's status" or "men's status" highlights an inherent aspect of ideology. One function of symbols is to keep inconvenient realities from impinging too directly upon the consciousness. Ancient society was riven by deep social divisions between male and female and wealthy and poor. By allowing the necessary ambiguity for different interpretations from different points of view, gender ideologies helped to bridge these divisions and enlist individuals in very different positions – males and females, elites and commoners – into a hegemonic system of political and economic action.

NOTES

1 I am grateful to Jennifer Trimble for critical comments on the manuscript of this paper. Financial support for various aspects of the research was provided by the Wenner-Gren Foundation for Anthropological Research and the Department of Anthropology and Rackham School of Graduate Studies, University of Michigan. I am also grateful to the Museo Nazionale di Antropologia, Firenze, and the Museo Nazionale di Pontecagnano for permission to study materials in

their care. This paper was written in 1994–5, and I have not had the opportunity to incorporate works coming to my attention after this date.

2 R. Williams, "Selections from Marxism and Literature," in N. Dirks, G. Eley, and S. Ortner (eds), *Culture/Power/History*, Princeton, Princeton University Press, 1994, p. 598.

3 J. Robb, "Gender Contradictions: Moral Coalitions and Inequality in Prehistoric Italy," *Journal of European Archaeology*, 1994, vol. 2, pp. 20–49; R. Whitehouse, *Underground Religion: Cult and Culture in Prehistoric Italy*, London, Accordia Research Center, 1992.

4 P. Bourdieu, *The Logic of Practice*, Stanford, Stanford University Press, 1990; P. Bourdieu, *Outline of a Theory of Practice*, New York, Cambridge University Press, 1977; S. Brandes, *Metaphors of Masculinity: Sex and Status in Andalusian Folklore*, Philadelphia, University of Pennsylvania Press, 1980; J. Peristiany (ed.), *Honor and Shame: The Values of Mediterranean Society*, Chicago, University of Chicago Press, 1967.

5 E. Bacus *et al.* (eds), *A Gendered Past: A Critical Bibliography of Gender in Archaeology*, Ann Arbor, Museum of Anthropology, University of Michigan, 1993; M. Conkey and J. Gero, "Tensions, Pluralities and Engendering Archaeology: An Introduction to Women and Prehistory," in M. Conkey and J. Gero (eds), *Engendering Archaeology*, Oxford, Basil Blackwell, 1991, pp. 3–30.

6 W. Eisner, "The Consequences of Gender Bias in Mortuary Analysis: A Case Study," in D. Walde and N. Willows (eds), *The Archaeology of Gender: Proceedings of the 22nd Annual Conference of the Archaeological Association of the University of Calgary*, Calgary, University of Calgary, 1991, pp. 352–7.

7 S. Cucchiari, "The Gender Revolution and the Transition from Bisexual Horde to Patrilocal Band: The Origins of Gender Hierarchy," in S. Ortner and H. Whitehead (eds), *Sexual Meanings*, New York, Cambridge University Press, 1981, pp. 31–79.

8 E. Anati, *Evolution and Style in Camunian Rock Art*, Capo di Ponte, Edizioni del Centro, 1976; R. Whitehouse, "Tools the Man-maker: The Cultural Construction of Gender in Italian Prehistory," *Journal of the Accordia Research Center*, 1992, vol. 3, pp. 41–54.

9 W. Krogman and M. Iscan, *The Human Skeleton in Forensic Medicine*, 2nd ed., Springfield, C. C. Thomas, 1986; for a prehistoric Italian case, see L. Barfield, "Chalcolithic Burials in Northern Italy: Problems of Social Interpretation," *Dialoghi di Archeologia*, 1986, vol. 4, pp. 241–8.

10 J. Robb, "Burial and Social Reproduction in the Peninsular Italian Neolithic," *Journal of Mediterranean Archaeology*, 1994, vol. 7, pp. 27–71.

11 I. Hodder, *The Domestication of Europe*, London, Basil Blackwell, 1990.

12 J. Robb, "Violence and Gender in Early Italy," in D. Frayer and D. Martin (eds), *Troubled Times: Violence and Warfare in the Past*, New York, Gordon and Breach, 1997, pp. 108–41.

13 L. Barfield, *Northern Italy before Rome*, London, Thames and Hudson, 1971; L. Bernabò Brea, *Gli scavi nella caverna delle Arene Candide. Parte I: Gli strati con ceramiche*, Bordighera, Istituto di Studi Liguri, 1946; L. Bernabò Brea and M. Cavalier, *Meligunìs Lipára. Volume I: La stazione preistorica della contrada Diana e la necropoli preistorica di Lipari*, Palermo, S. F. Flaccovio, 1960; P. Graziosi, *L'arte preistorica in Italia*, Firenze, Sansoni, 1974; P. Graziosi, "Nuove manifestazioni d'arte mesolitica e neolitica nel Riparo Gaban presso Trento," *Rivista di Scienze Preistoriche*, 1975, vol. 30, pp. 237–78; U. Rellini, *La più antica ceramica dipinta d'Italia*, Roma, Collana Meridionale Editrice, 1934; S. Tinè, *Passo di Corvo e la civiltà neolitica del Tavoliere*, Genova, Sagep, 1983.

14 Graziosi, *L'arte preistorica in Italia*; F. G. Lo Porto, "La tomba neolitica con idola di pietra di Arnesano," *Rivista di Scienze Preistoriche*, 1972, vol. 27, pp. 357–72.

15 E. Anati, "Le figurazioni di pugnali della Valcamonica," *Preistoria Alpina*, 1974, vol. 10, pp. 113–36; E. Anati, "Post-paleolithic Stylistic Changes in Rock Art as Illustrated by the Valcamonica Cycle," in P. Ucko (ed.), *Form in Indigeneous Art*, Canberra, Australian Institute of Aboriginal Studies, 1977, pp. 337–56; E. Anati, *Valcamonica: 10.000 anni di storia*, Capo di Ponte, Edizioni del Centro, 1980; Graziosi, *L'arte preistorica in Italia*; P. Graziosi, *Le pitture preistoriche di Porto Badisco*, Firenze, Martelli, 1980; Whitehouse, *Underground Religion*.

16. Cf. Whitehouse, "Tools the Man-maker," Table 1.

17 J. Robb, "Gender Ideology and Social Evolution in Prehistoric Italy," paper presented at the 57th Annual Meeting, Society for American Archaeology, Pittsburgh, 1992; Whitehouse, *Underground Religion*; though cf. R. Skeates, "Ritual, Context and Gender in Neolithic South-eastern Italy," *Journal of European Archaeology*, 1994, vol. 2, pp. 199–214.

18 Robb, "Burial and Social Reproduction."

19 Cf. Hodder, *The Domestication of Europe*.

20 Graziosi, *L'arte preistorica in Italia*.

21 A. Ambrosi, *Corpus delle statue-stele lunigianesi*, Bordighera, Istituto Internazionale di Studi Liguri, 1972; A. Ambrosi, *Statue-stele lunigianesi*, Genova, Sagep, 1988; cf. Whitehouse, "Tools the Man-maker," Table 2.

22 M. A. Acanfora, "Le stele antropomorfe di Castelluccio dei Sauri," *Rivista di Scienze Preistoriche*, 1960, vol. 15, pp. 95–123.

23 E. Anati, *Le statue-stele di Lunigiana*, Milano, Jaca Book, 1981; L. Barfield, "Burials and Boundaries in Chalcolithic Italy," in C. Malone and S. Stoddart (eds), *Papers in Italian Archaeology IV: The Cambridge Conference, vol. II*, Oxford, British Archaeological Reports International Series 245, 1985, pp. 152–76.

24 Cf. J. Robb, *From Gender to Class: Inequality in Prehistoric Italy*, Ph.D. dissertation, Department of Anthropology, University of Michigan, 1995, Table 6.14; Whitehouse, "Tools the Man-maker," Table 2.

25 Anati, "Le figurazioni di pugnali della Valcamonica;" Anati, "Post-paleolithic Stylistic Changes in Rock Art as Illustrated by the Valcamonica Cycle;" Anati, *Valcamonica: 10.000 anni di storia*.

26 C. Conti, *Corpus delle incisioni rupestri di Monte Bego: fasc. 1, zona 1. regione dei Laghi Lunghi*, Bordighera, Istituto Internazionale di Studi Liguri, 1972; G. Isetti, "Corpus delle incisioni lineari di Val Meraviglie," *Revue des Études Ligures*, 1965, vol. 31, pp. 45–110.

27 Ambrosi, *Corpus delle statue-stele lunigiane*; Ambrosi, *Statue-stele lunigianesi*; Robb, *From Gender to Class*, Table 6.14; Whitehouse, "Tools the Man-maker," Table 2.

28 Barfield, "Chalcolithic Burials in Northern Italy;" Barfield, "Burials and Boundaries in Chalcolithic Italy."

29 R. Formentini, "L'immagine femminile nelle statue-menhirs," in W. Waldren, J. Ensenyat, and R. Kennard (eds), *Second Deya International Conference of Prehistory: Recent Developments in Western Mediterranean Prehistory: Archaeological Techniques, Technology and Theory*, vol. 2, Oxford, Tempus Reparatum BAR International Series 574, 1991, pp. 365–85.

30 Cf. Whitehouse, *Underground Religion*.

31 M. L. Vida Navarro, "Warriors and Weavers: Sex and Gender in Early Iron Age Graves from Pontecagnano," *Journal of the Accordia Research Center*, 1992, vol. 3, pp. 67–100; J. Robb, original data.

32 A. M. Bietti Sestieri, *The Iron Age Community of Osteria dell'Osa: A Study of Sociopolitical Development in Central Tyrhennian Italy*, Cambridge, Cambridge University Press, 1992.

33 M. Pacciarelli, "L'organizzazione sociale nella Calabria meridionale agli inizi dell'età del ferro: considerazioni preliminari sulla necropoli di Torre Galli," *Dialoghi di Archeologia*, 1986, vol. 4, pp. 283–94.

34 E. Atzeni, *Ichnussa: la Sardegna delle origini all'età classica*, 2nd ed., Milano, Garzanti, 1982.

35 P. Padovana, *Le stele villanoviani di Bologna*, Capo di Ponte, Edizioni del Centro, 1977.

36 G. Fogolari and A. Prosdocimi, *I veneti antichi: lingua e cultura*, Padova, Editoriale Programma, 1988.

37 M. L. Nava, *Stele daunie*, Firenze, Sansoni, 1980; M. L. Nava (ed.), *Le stele della Daunia: sculture antropomorfe della Puglia protostorica dalle scoperte di Silvio Ferro agli studi più recenti*, Milano, Electa, 1988.

38 O. Brendel, *Etruscan Art*, Harmondsworth and Baltimore, Penguin, 1978; Fogolari and Prosdocimi, *I veneti antichi*; G. Lilliu, *La civiltà nuragica*, Milano, Garzanti, 1982.

39 F. Sonego and C. Scarsini, "Indicatori scheletrici e dentari dello stato di salute e delle condizioni di vita a Pontecagnano (Salerno) nel VII–V sec. a.C.," *Bullettino di Paletnologia Italiana*, 1994, vol. 85, pp. 1–25; Robb, "Violence and Gender in Early Italy."

40 Nava, *Stele daunie*; Nava, *Le stele della Daunia*.

41 G. Bartoloni, "A Few Comments on the Social Position of Women in the Proto-historic Coastal Area of Western Italy Made on the Basis of a Study of Funerary Goods," *Rivista di Antropologia*, 1988, vol. 66, pp. 317–36; A. M. Bietti Sestieri, "Economy and Society in Italy Between the Late Bronze Age and Early Iron Age," in R. Hodges and G. Barker (eds), *Archaeology and Italian Society*, Oxford, British Archaeological Reports International Series 102, 1981, pp. 133–55.

42 Bietti Sestieri, *The Iron Age Community of Osteria dell'Osa*; Vida Navarro, "Warriors and Weavers;" J. Robb, original data.

43 Bietti Sestieri, *The Iron Age Community of Osteria dell'Osa*.

44 M. Cipolloni Sampò, "Dinamiche di sviluppo culturale e analisi archeologica: problemi interpretativi nello scavo di un sito," *Dialoghi di Archeologia*, 1976, vol. 4, pp. 225–35.

45 Bietti Sestieri, *The Iron Age Community of Osteria dell'Osa*; Vida Navarro, "Warriors and Weavers."

46 Vida Navarro, "Warriors and Weavers."

47 About one-seventh of the stelae fragments known show armed figures, dressed in short tunics; the rest depict figures decorated with long robes, belts, *fibulae*, and necklaces. Neither kind gives anatomical clues to gender. Ferri argued that stelae with ornaments and weapons represented females and males respectively. One major argument against this is that stelae with ornaments far outnumber stelae with weapons, although to some extent the numerical disparity between the two categories is artificial; stelae with ornaments are more easily recognized in fragments, and statistical tabulation of Nava's data shows that the ornamented:armed ratio is close to even if we count only large fragments from the upper part of the stelae. Nava (*Stele daunie*; *Le stele della Daunia*) argues that males were represented by both types, while females were represented only by stelae with ornaments, including particular styles of ornaments, shoulder and neck form, and hair arrangement. In support of this, we

might note that many male Iron-Age burials do not include weapons but do include *fibulae*, creating a burial population more or less mirroring the stelae population.

48 Quoted in L. Bonfante, "Daily Life and Afterlife," in L. Bonfante (ed.), *Etruscan Life and Afterlife*, Detroit, Wayne State University Press, 1986, pp. 232–78.

49 R. Corruccini and E. Pacciani, "'Orthodontistry' and Dental Occlusion in Etruscans," *Angle Orthodontist*, 1989, vol. 59, pp. 61–4.

50 Bourdieu, *The Logic of Practice*; M. Foucault, *Discipline and Punish: The Birth of the Prison*, London, Allen Lane, 1977.

51 S. Ortner and H. Whitehead, "Introduction: Accounting for Sexual Meanings," in S. Ortner and H. Whitehead (eds), *Sexual Meanings*, Cambridge, Cambridge University Press, 1981, pp. 1–28.

52 N. Salomon, "Making a World of Difference: Gender, Asymmetry, and the Greek Nude", *infra*, pp. 197–219.

53 Bourdieu, *The Logic of Practice*; A. Giddens, *The Constitution of Society*, Berkeley, University of California Press, 1984; S. Ortner, "Theory in Anthropology since the Sixties," *Comparative Studies in Society and History*, 1984, vol. 1, pp. 126–66; M. Sahlins, *Historical Metaphors and Mythical Realities*, Ann Arbor, University of Michigan Press, 1981.

54 S. Ortner, "On Key Symbols," *American Anthropologist*, 1972, vol. 75, pp. 1338–46.

55 F. Barth, *Cosmologies in the Making: A Generative Approach to Cultural Variation in Inner New Guinea*, Cambridge, Cambridge University Press, 1987; see also V. Turner, *The Forest of Symbols: Aspects of Ndembu Ritual*, Ithaca, Cornell University Press, 1967.

56 Cf. Bourdieu, *The Logic of Practice*.

57 Bietti Sestieri, *The Iron Age Community of Osteria dell'Osa*.

58 Bourdieu, *The Logic of Practice*.

59 J. Adams, *The Latin Sexual Vocabulary*, London, Duckworth and Baltimore, Johns Hopkins University Press, 1982.

60 Cf. J. Hallett, "Roman Attitudes towards Sex," in D. Kertzer and R. Saller (eds), *The Family in Italy from Antiquity to the Present*, New Haven, Yale University Press, 1991, pp. 1265–78.

61 J. Bestor, "Ideas about Procreation and their Influence on Ancient and Medieval Views of Kinship," in D. Kertzer and R. Saller (eds), *The Family in Italy*, pp. 150–68.

62 Adams, *The Latin Sexual Vocabulary*.

63 Salomon, "Making a World of Difference," *infra*, pp. 197–219.

64 D. Cohen, "The Augustan Law on Adultery: The Social and Cultural Context," in D. Kertzer and R. Saller (eds), *The Family in Italy*, pp. 109–26.

65 Cf. S. Dickison, "Women in Rome," in M. Grant and R. Kitzinger (eds), *Civilization of the Ancient Mediterranean*, New York, Scribner's, 1988, pp. 1319–32.

66 Ortner and Whitehead, "Introduction: Accounting for Sexual Meanings."

67 M. Foucault, "Two Lectures", in N. Dirks, G. Eley, and S. Ortner (eds), *Culture/Power/History*, Princeton, Princeton University Press, 1994, pp. 200–21.

68 R. Bell, *Fate and Honor, Family and Village: Demographic and Cultural Change in Rural Italy since 1800*, Chicago, University of Chicago Press, 1984; D. Cohen, "Seclusion, Separation and the Status of Women in Classical Athens," *Greece and Rome*, 1989, vol. 36, pp. 3–15; D. Gilmore, "Men and Women in Southern Spain: 'Domestic Power' Revisited," *American Anthropologist*, 1990, vol. 92, pp. 953–70.

69 S. Joshel, *Work, Identity and Legal Status at Rome*, Norman, University of Oklahoma Press, 1992.

70 M. Lefkowitz and M. Fant, *Women's Life in Greece and Rome*, Baltimore, Johns Hopkins University Press, 1982.

71 Cohen, "Seclusion, Separation, and the Status of Women in Classical Athens."

72 Bell, *Fate and Honor, Family and Village.*

73 Williams, "Selections from Marxism and Literature," p. 598.

74 Bell, *Fate and Honor, Family and Village*; A. Blok, *The Mafia of a Sicilian Village, 1860–1960: A Study of Violent Peasant Entrepreneurs*, New York, Harper, 1974; Cohen, "Seclusion, Separation, and the Status of Women in Classical Athens."

75 For an ethnographic parallel, see J. Davis, "Honor and Politics in Pisticci," *Proceedings of the Royal Anthropological Institute*, 1969, vol. 5, pp. 69–81.

76 Robb, "Gender Contradictions."

4

DIVESTING THE FEMALE BREAST OF CLOTHES IN CLASSICAL SCULPTURE

Beth Cohen

According to Pliny (*Natural History* 36.20), the fourth-century sculptor Praxiteles was praised most for his entirely nude statue of the goddess Aphrodite purchased by the island of Knidos.[1] Yet, although total nudity already defined a woman's fertile body in visual representations beginning in Paleolithic and Neolithic times,[2] during roughly the first half of the first millennium BC – early in historical Greece – "The female nude," as John Boardman has noted, "is not yet a proper subject for Greek art."[3]

In the Late Archaic period, *c.* 520–480 BC, mastering the naturalistic representation of the nude female body was, nevertheless, explored in the private context of Athenian vase painting, and here achieving a visually convincing rendering of female breasts was quite a challenge.[4] But Classical culture sought perfection through an ideally proportioned nude male,[5] and in monumental sculpture of the fifth century BC the several nude females that have been preserved are but footnotes.[6]

As is often pointed out in current scholarship, in Classical art as in Classical history and literature, the Greek male determined the image of the female that has come down to us.[7] During the fifth century, what Margarete Bieber called a "well-known Greek motif . . . the divesting of one breast" on otherwise draped female figures became a popular visual symbol,[8] while total nudity was generally suppressed. Reliance upon this divestment motive afforded a potent allusion to the naked female body at the same time that its literal representation was carefully contained and regulated by the male artist.[9] This subtle motive, furthermore, was in keeping with the controlled, understated style of most fifth-century art. Bieber argued that (partial) "divesting of clothes always has a definite meaning in accordance with the subject represented."[10] The present study surveys when and how the female breast is bared in Greek art, focusing on known representations of the motive primarily during the fifth century BC with some comparanda from the fourth century, drawn from vase painting, Roman copies, and literary sources as well as Greek sculpture. On the basis of this analysis it will be possible to reconsider the iconography of a marble statue in the Louvre depicting a woman with one breast divested of

clothes, known as the Barberini Suppliant (Fig. 3), to which I shall return later.

In daily life a respectable, well-to-do Greek woman, particularly in restrictive Athenian society, would have been properly, even richly, dressed on those occasions she left the seclusion of her home to appear in public.[11] The predominant formal female garments of Classical Greece – the *peplos* and the *chiton* – were designed to cover the female breast as well as the rest of the body. The Classical *peplos*, the simpler of the two garments, was basically a piece of woollen cloth, folded to proper (ankle) length, drawn around the body, pinned together at the shoulders and, normally, belted at the waist. For the *chiton*, folded linen cloth was sewn on the long open side

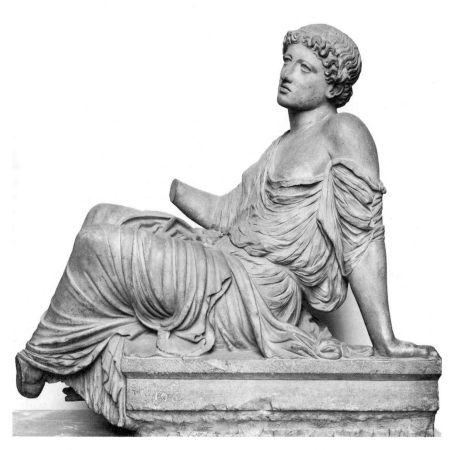

Figure 3 The Barberini Suppliant, Roman marble copy of fifth-century BC Greek statue, Paris, Musée du Louvre MA 3433

and often buttoned rather than sewn across the top edge, leaving an opening for the head; this tubular dress could also be belted at the waist.[12]

On the one hand, a *peplos* could be worn over a *chiton*, and either dress could be overlaid by a mantle or cloak, offering ever more formality and concealment. On the other hand, both the *peplos* and the *chiton* – loose garments, folded, wrapped and tied to fit – could more readily be loosened or set in disarray than closely tailored clothing. Both could also open or be opened at the shoulders while a woman was still wearing them, and, as undergarments were not customary, a loosened or opened dress would readily have laid bare the female breast. Indeed, as Bieber observed, in visual art female breasts were sometimes shown divested of clothes (e.g., Figs 3–7). Classical representations of clothed female figures with exposed breasts may be divided, conceptually and physically, into four main categories, which illustrate that, as Larissa Bonfante has cautioned, "The image of the female breast was too powerful to be represented lightly."[13]

Category (1): women wearing garments designed to expose the breast, appears to be as rare in Greek art as it must have been in Greek life during the early Iron Age. During the Bronze Age, by contrast, as is well attested in visual representations, garments of both mortal women and goddesses were indeed designed to expose their breasts.[14] The scant evidence from the historical period of roughly the first half of the first millennium BC for wearing garments that reveal the breast points to an association with particular activities. For example, an Archaic bronze statuette of a running maiden in the British Museum, of *c.* 560 BC, may preserve visual evidence for the breast-revealing dress of virgins who participated in foot races during the festival in honor of the goddess Hera (the *Heraia*) at Olympia. In this statuette, the female runner's short tunic is fastened at her left shoulder and folded neatly down beneath her exposed right breast.[15] Now-lost statues of Spartan female victors at Olympia and the fashion of breast-revealing female running clothes are both documented in ancient literary sources.[16] Some of the young maidens who participated in foot races celebrating the cult of Artemis at Brauron may have been similarly dressed.[17] Strictly speaking, the attire of female runners straddles *Category (1)*, fashion design, and *Category (2)* below, purposeful breast exposure, because the side of their garment let down could have been worn up – fastened at the shoulder.

An Archaic terracotta group from Megara Hyblaea in Sicily depicts perhaps the quintessential female activity: Here a goddess suckling a pair of twins wears a nursing costume with a strategic cut-out for each breast.[18] In art as in life, however, nursing women usually bare but a single breast by purposely loosening the standard concealing Greek garments. The latter form of exposure belongs to *Category (2): breasts purposely divested of clothes by females themselves*. For example, Aphrodite opens her *chiton* at the right shoulder to accommodate a small Eros on a red-figure Apulian squat

(aryballistic) lekythos in the Museo Nazionale, Taranto of *c.* 380 BC.[19] On a contemporaneous fourth-century Tarantine squat lekythos in London, attributed to the Suckling Painter, Hera nurses the infant Herakles.[20] Bonfante has recently pointed out that preserved images of nursing mothers predominate in the art of Magna Graecia, where they were probably inspired by local custom and belief in fertile mother goddesses, rather than in the art of Classical Greece itself, where wet nurses generally took over the task of suckling children.[21]

The literary evidence, however, suggests that breast-baring in the context of maternal nursing did have particular potency and special poignancy in Greek tradition. Like the legendary war chariots and duels of male military iconography, references to noble women who breast-fed their young may have served to evoke the heroic past. In the *Iliad* (22.90) Hecuba exposes her breast, supplicating her son Hektor not to enter the fateful battle with Achilles in which he will die:

> And his mother wailed now, standing beside Priam,
> weeping freely, loosing her robes with one hand
> and holding out her bare breast with the other,
> her words pouring forth in a flight of grief and tears:
> "Hector, my child! Look – have some respect for *this!*
> Pity your mother too, if I ever gave you the breast
> to soothe your troubles, remember it now, dear boy –
> beat back that savage man from safe inside the walls!"[22]

According to Pausanias (10.25.9), in Polygnotos' *Iliupersis,* a famous lost Classical painting in the *Lesche* of the Cnidians at Delphi, the son of Hektor and Andromache (Astyanax) was shown "grasping" or "clinging to" "his mother's breast."[23] This painting departed from earlier literary and visual traditions in which Astyanax would already have been killed.[24] Here Polygnotos appears to have shown the Trojan princess Andromache, as she faced a future of slavery, nursing her frightened child in public, amid the survivors of her defeated city.[25] In Classical tragedy Klytaimestra also bares her breast after the Trojan War, but in an ironic reversal of the loving mother's supplication of her son, to plead for her own life as Orestes, avenging the murder of Agamemnon, is about to kill her.[26] A later visual image of Klytaimestra exposing her left breast before Orestes has been preserved on a Paestan red-figure amphora of *c.* 340 BC in the J. Paul Getty Museum.[27]

The breast purposely divested of clothes in *Category (2)* also serves as a sign of what may be termed positive erotic encounter such as in representations of divine rape. An eager Danae, for example, bares both breasts, as she receives Zeus in the form of a shower of gold on a Boeotian calyx-krater from the late fifth century in the Louvre.[28] We learn from Euripides that the adulteress Helen escaped the murderous

wrath of her husband Menelaos after the Trojan War apparently by baring her breast to rekindle his desire.[29] While an erotic basis for Menelaos' having dropped his sword is suggested in fifth-century BC vase painting, no graphic depictions of Helen's breast baring have been preserved.[30]

Baring the breast is not the only option of female physical exposure for expressing or arousing desire. Indeed, Late Archaic red-figure vases depict both Satyrs and men aroused by a sudden glimpse of the female pubes afforded by a raised skirt.[31] But exhibiting the female genitals was, of course, considered indecent exposure, best restricted to obscene jests of women in myth or aspects of cult ritual. The old nurse Baubo raised her skirt to make the mourning goddess Demeter laugh, and Baubo's gesture may be symbolized in a distinctive series of terracotta figurines from fourth-century Priene.[32] In votive terracottas from seventh-century Crete and Hellenistic Egypt, Aphrodite, goddess of love and fertility, raises her skirt to reveal her genitals.[33] The famed Roman copy known as the *Aphrodite Kallipygos*, in which the goddess lifts her draperies to admire her beautiful buttocks, may go back to a Late Classical original of the fourth century BC.[34] However, in monumental Greek art from the Classical period of the fifth century, baring the breast is, without exception, the classic choice of partial physical exposure for female representations.[35]

Category (3) consists of *breast exposures by garments accidentally loosened or set in disarray through an action or pose of the wearer.* This motive first becomes fashionable in monumental art of the later fifth century, and many of the known examples are from Athens and mainland Greece. Now as a maenad or nymph dances, possessed by Dionysiac frenzy, one or both of her breasts may unwittingly be exposed.[36] On the famous statue of a lovely flying Nike by Paionios at Olympia, dated to *c.* 420 BC, the left breast is bared as her wind-blown draperies open at the shoulder in the course of her action.[37] This motive also occurs on female acroterial sculptures, from the roofs of Classical buildings, which depict not only Nikai but such beings as Aurae or Nereids,[38] who exist in liminal realms, traversing the boundaries between air and water and earth.

On the Parthenon garments slip off the shoulders of female goddesses, notably Artemis and Aphrodite,[39] and afterwards, also on the Athenian Akropolis, on the parapet relief of the little Ionic temple, *c.* 420–400 BC, the *chiton* of Athena Nike ("a goddess of martial victory and fertility") slips off her left shoulder, while that of the famous Nike, the so-called "sandal binder," slips off her right.[40] Finally, in the famous copy of a Classical Aphrodite of *c.* 420 BC in the Louvre (the Roman *Venus Genetrix* type), the goddess of love's diaphanous, ungirt *chiton* slips so far down that her left breast is exposed.[41] Accidental breast baring also becomes a positive erotic symbol for a mortal woman when she is raped (unexpectedly) by a god. For example, on a Classical Greek statue from the late fifth century BC in the Museum of Fine Arts, Boston (Fig. 4), Leda's *peplos* opens along her right

70

Figure 4 Leda and the Swan, Greek marble sculptural group, *c.* 420–400 BC, Boston, Museum of Fine Arts 04.14, H. L. Pierce Fund

side, exposing her right breast in the front view, as she innocently presses the Zeus-swan to her body.[42]

A strikingly ominous context for the breast accidentally divested of clothes in *Category (3)* is found in Roman copies of one of the so-called three-figure reliefs generally held to date between 430 and 400 BC. This composition represents the daughters of Pelias, misled by Medea, who cut up and boil their father in a vain attempt to rejuvenate him.[43] As the central

Peliad bends over, absorbed in busily readying the cauldron, her right breast spills over the top of her garment as it slides off her shoulder.

Significantly, well before the several alluring images of the last quarter of the fifth and early fourth century, the major context for divesting the female breast of clothes in Greek art was also a negative one – marking female victims of physical violence. Thus, the final grouping, *Category (4)*, consists of *female breasts exposed by garments violently ripped open or loosened on account of violent interaction with others.*

The earliest preserved exposed female breasts in monumental sculpture of the Classical period occur in the Battle of Lapith Greeks and Centaurs at the Wedding Feast of Peirithoos and Deidameia (or Hippodameia) from the west pediment of the Temple of Zeus at Olympia of the 460s BC. This sculptural composition may depend on a lost Early Classical painting in the Theseion at Athens.[44] As Christine M. Havelock has noted, "Women are present in centauromachies but they are victims rather than contestants."[45] At Olympia one drunken Centaur grapples with the newly wed bride, grabbing her left breast as she tries to protect it with her own hand while pushing his head away with her elbow, and as another Centaur attacks a young female wedding guest (Fig. 5) her *peplos* is unfastened (i.e. unpinned) at the left shoulder, exposing her breast.[46]

In ancient Greece a woman normally became a bride soon after the beginning of her menses – as early as fourteen or fifteen years of age.[47] The female Lapiths violated at Olympia are implicitly still virgins; their pre-maternal breasts are small, compact, and firm. Small, young breasts, in fact, appear to constitute an ideal type, eminently suitable for divestment of clothes in Classical sculpture.[48]

The motive of the violently exposed female breast recurs in depictions of the Centauromachy on Attic red-figure pottery, such as the name vase of the Florence Painter,[49] and, most notably, on the south metopes of the Parthenon. On south metope 29 a Centaur carries off a struggling Lapith woman whose left breast is exposed.[50] And in the Parthenon's Centauromachy, as on south metope 10, both breasts of a Lapith woman under attack may also be divested of clothes.[51] At the end of the century, on the brutal Centauromachy frieze from the Temple of Apollo Epikourios at Bassae, the exposed left breast of a young woman fleeing is juxtaposed with the fully exposed body of a second woman whose garment is pulled off by a Centaur as she seeks refuge at a cult statue.[52] This juxtaposition at Bassae dramatically underscores the degree to which the subtle motive of the breast divested of clothes was an intentional artistic choice of a society that had traditionally shunned full female nudity in monumental art.

Roman copies of the mythological decoration on Pheidias' lost cult images for the Parthenon and for the Temple of Zeus at Olympia document the great High Classical Athenian sculptor's preference for the divested breast beyond the design of the Parthenon's metopes. A relief in

72

Figure 5 Maiden attacked by Centaur from West Pediment of the Temple of Zeus, Greek marble pedimental sculpture, *c.* 470–457 BC, Olympia, Museum

St. Petersburg, probably reflecting the slaughter of the children of Niobe by Apollo and Artemis from the armrests of the lost throne of the Olympian Zeus (Pausanias 5.11.2–3), of *c.* 430–420 BC, includes the poignant motive of a young daughter of Niobe reaching around to grab the fatal arrow in her back as she falls.[53] In contrast to the almost totally nude marble statue of the Dying Niobid in the Museo Nazionale delle Terme (found in Rome and not necessarily made on the Greek mainland),[54] Pheidias' mortally wounded Niobid, still dressed in her rich, voluminous draperies, displays but a single divested breast – the left breast. The same motive of partial undress is employed for her dying sister at the center of the St. Petersburg copy, except that it is this Niobid's right breast that is exposed.[55] Niobids, whatever their degree of undress, bring to mind Sir Kenneth Clark's definition, some forty years ago, of the nude of pathos, which "is always

73

the expression of the same idea, that man in his pride has suffered the wrath of the gods."[56]

Already in the Archaic period, exotic long-sleeved and trousered garments were commonly worn by Amazons in Athenian art, and in the fifth century such attire came graphically to denote the local equation of this mythical barbaric race of female warriors with the Persian enemy.[57] Yet relief copies of the Amazonomachy that once embellished the golden exterior of the Shield of Pheidias' Athena Parthenos, the cult image of the Parthenon constructed between 447 and 438 BC, document that the Amazons in this great battle composition wore short *chiton*s, with skirts of either knee or thigh length to afford freedom of motion.[58] In Pheidias' depictions of lone Amazons and of duels in which the winner was not yet clear, the short *chiton*s of his female warriors covered both of their shoulders and thus both of their breasts. Significantly, by contrast, the garments worn by defeated Amazons or those about to be defeated by Greek warriors were (ripped) open at one shoulder and hung down loosely, exposing one of these Amazons' breasts.[59] That breast exposure was an intentional symbol of violent defeat appears to be underscored by the depiction of a dead Amazon falling upside down whose garment, on the Strangford and Lenormant copies of the shield, remained open, thus defying the rules of gravity, so that her left breast could be exposed.[60]

In readily laying bare the femininity of these foreign aggressors, short *chiton*s subtly surpass the implications of fancy, but physically concealing, oriental dress for the iconography of Amazons. This innovation, commonly associated with Classical sculpture, may be traced back to lost monumental painting as early as the 470s or 460s BC. The preserved link is a splendid Athenian vase of the 450s BC: the red-figure volute-krater in the Metropolitan Museum of Art, attributed to the Painter of the Woolly Satyrs, which juxtaposes an Amazonomachy with a Centauromachy at the Wedding Feast (Figs 6–7). In the relevant part of the "big battle" between Greeks and Amazons (on the right half of the obverse), as Bothmer describes it, "a young Greek, probably Theseus, thrusts his spear at an Amazon who turns in her flight to defend herself with the axe, while a companion, her axe raised in both hands, comes to her assistance."[61] These two fighting Amazons wear boldly patterned leggings topped by short *chiton*s, but not long-sleeved tunics. As the fleeing Amazon, burdened by her now-useless shield, twists round stretching to swing her axe, her short *chiton* bursts open at the right shoulder and, flying downward, exposes her right breast and part of her left. In but an instant the hero's spear will hit home. And the fleeing Amazon's fate is suggested by the frontal Amazon fallen in an anguished pose under the krater's handle: "in the background, . . . mostly hidden by the terrain, lies an Amazon who has brought her left arm over her head and clutches her breast with her right hand."[62]

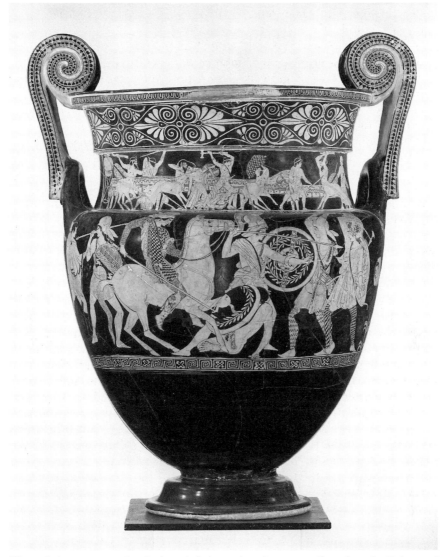

Figure 6 Amazonomachy, Attic red-figure volute-krater, attributed to the Painter of the Woolly Satyrs, Greek, *c.* 470–460 BC, New York, Metropolitan Museum of Art 07.286.84, Rogers Fund, 1907

In a contest described by Pliny (*Natural History* 34.53), Pheidias is named among four or five Classical sculptors believed to have created statues of Amazons for the Temple of Artemis at Ephesos. The best Roman copies of three different Amazon types, which surely go back to fifth-century originals, share physical features with potent iconographic connotations. All

75

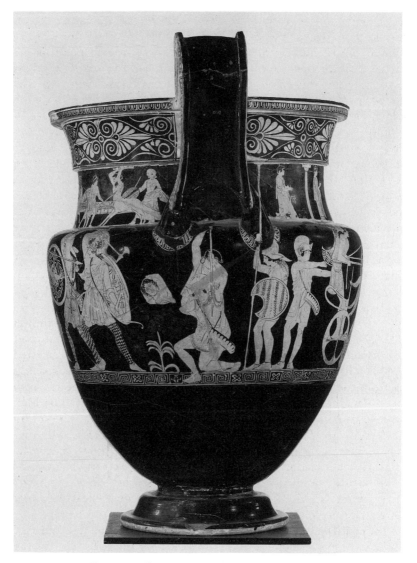

Figure 7 Side view of volute-krater in Fig. 6

three Amazons – the Lansdowne (Berlin/Sciarra) (Fig. 8), Capitoline (Sosi-
kles) and Mattei types – are similarly dressed in a short *chiton* pulled up and
belted at the waist. And the *chiton* of each is fastened at but a single
shoulder so that at least one of her breasts is bare. Moreover, each Amazon
is wounded – the Lansdowne and the Capitoline types beside the exposed
right breast and the Mattei type on her left thigh – and each deals
differently with her physical and psychological pain in both pose and

mood.[63] According to Bieber, in order to relieve the wound on the Mattei Amazon's thigh part of the skirt of her *chiton* "is lifted and tucked in at the belt," and the Capitoline Amazon, who holds up the front of her *chiton*, "may have torn it open in order to free the wound in her right breast."[64] Evelyn Harrison observes that, because the Lansdowne Amazon is wounded on her right side, "the chiton, though still fastened on the right shoulder, has been pushed aside so that the right breast is uncovered"[65] – in addition to the left. According to Andrew Stewart this Amazon, whose demeanor is the most pathetic, "has clearly been raped."[66] The noble Ephesian Amazons are violently defeated enemies of the Greeks represented immediately after battle. On the one hand, these monumental bare-breasted females, images distilled from a narrative context of legendary military conflict, are impressive trophies of Greek victory.[67] On the other hand, as Havelock has pointed out, "For a woman spectator there is only one message: behave like an Amazon and you will be overcome."[68]

As we have seen, when the breast of a Classical Amazon (Figs 6–8) or Niobid is divested of clothes, it is ostensibly occasioned by action and does not simply result from fashion, i.e. a garment designed to expose the breast. Their bared breasts, above all, represent a potent visual convention employed by Classical artists to denote female victims of physical violence. In subsequent Classical Athenian and early South Italian vase painting other female figures also come to be depicted with their breasts divested of clothes in different contexts involving physical violence: Prokris (right), dying from the mistaken throw of her husband Kephalos' spear;[69] Kanake (right), a daughter of Aeolos, after her suicide (*Category 2 or 3!*) on account of an incestuous relationship with her brother Makareus;[70] Dirke (both), dragged to her death by the bull,[71] and Lykurgos' wife (left), as he kills her in his madness.[72] Finally, Kallisto, shown with a bare (right) breast during her transformation into a bear that will be shot down by Artemis, might also find a place here.[73] These ominous contexts for women shown with exposed breasts in Greek art bring to mind the dire fates of women in Classical tragedy.[74]

To summarize: proper dress for respectable women in Archaic and Classical Greece was designed to cover their bodies fully. Yet the female breast divested of clothes was a popular motive in Classical art, and the known representations may be divided into four categories. Certain female activities that involved either *(1)* breast-revealing garments or *(2)* divesting the female breast of concealing draperies are occasionally represented in art: running, particularly in cult celebration, and breast-feeding of children, particularly in heroic legend and in the art of Magna Graecia. Purposeful breast baring *(2)* belongs to the iconography of supplication, e.g., for mothers of grown sons. In depictions of divine rape the female breast may be either purposely bared *(2)* or accidentally exposed *(3)*. Breasts accidentally divested of clothes in visual art *(3)* also result from a female

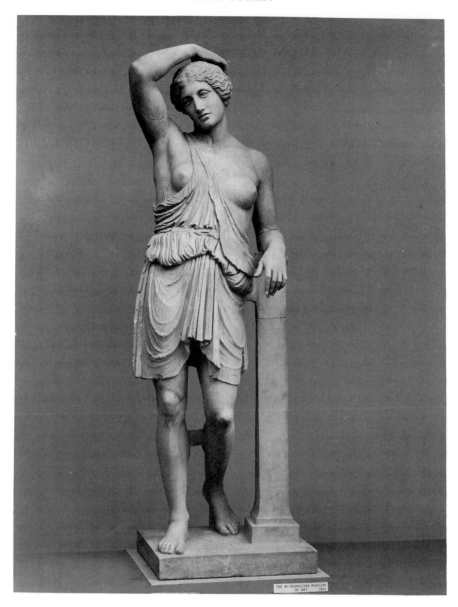

Figure 8 Lansdowne Amazon, Roman marble copy of fifth-century BC Greek statue, New York, Metropolitan Museum of Art 32.11.14, gift of John D. Rockefeller, 1932

figure's absorption in a particular activity, such as dancing or flying. And the goddess Aphrodite's breast can be accidentally exposed *(3)* even in a quiet pose, bringing to the fore her associations with fertility as well as with female beauty and erotic love. Yet the earliest and broadest context for divesting the breast of clothes in Classical Greek art consists of representations of female victims of physical violence *(4)*. This context is particularly important, beginning in the Early Classical period, for Lapith women in the Centauromachy (Fig. 5) and, in the High Classical period, for Amazons (Figs 6–8).

In Classical art usually only one breast is exposed (e.g., Figs 4, 5), but sometimes both are (Fig. 8). Harrison has proposed that "The bared right breast most often has erotic significance; the bared left suggests motherhood or care of the young."[75] But, as she readily admits, there are many exceptions.[76] In fact, there is no hard and fast rule. Alternating right and left exposures may be employed for balance in the same composition. (Roman copyists can switch sides or cover a divestment.)[77] Often there are layers of meaning. For example, Leda's left breast is exposed in a divine erotic encounter during which she is impregnated (Fig. 4). And the left or right breast as well as both breasts may also be divested of clothes in negative contexts of physical violence (Figs 5–8).

How does the Barberini Suppliant (Fig. 3) fit into this picture? This sculptural type is a classic image of a female with one exposed breast, whose iconographic context is no longer known: A very young woman sits on an architectonic platform leaning on her left arm, with her head tilted slightly back and to the side. Her lower right arm is raised, but the hand and whatever, if anything, it held is missing. She wears a sandal on her right foot; but her left foot is bare. Her mantle is wrapped around the lower part of her body, and her *chiton*, which is belted at the waist, has slipped off her left shoulder revealing her small and firm left breast.

On the basis of the logical and finely detailed rendering of her draperies, Bieber, influenced by nineteenth-century tradition, believed the Barberini Suppliant to be a Greek original;[78] in fact, however, she must be the best Roman copy of a work clearly Attic and just post-Parthenonian in style, dating *c.* 430–420 BC.[79] Despines has recently associated the copy with joining marble fragments from the Athenian Akropolis, which he believes belong to the fifth-century original of the Barberini Suppliant type.[80] Should Despines's proposal prove to be valid, an Akropolis provenience for the Greek original would be entirely in keeping with the classic Athenian style reflected in the famous Roman copy in the Louvre.

The Barberini statue's proposed identifications, which began in the nineteenth century, have included most mythological females who might plausibly, or implausibly, have been represented with a bare breast: Ariadne, Dido, Penelope, a wingless Nike, Laodameia (Protesilaos' wife who

committed suicide after his death), an Erinys, Kallisto, Demeter, a Muse, Elektra, Danae, Alkmene, Iphigeneia, Aphrodite and also – Despines's recent proposal – Io after Zeus' amorous visit.[81] Thus interpretations of her restrained Classical mood have run the gamut from abject despair to erotic ecstasy. She has not yet been called a Lapith woman, a Niobid, a maenad, or a mother whose child has been ripped from her breast. Indeed, the only name that has stuck is no name – the suggestion of F. Matz in 1871, "La nostra statua senza meno rappresenta una supplice."[82] The architectonic seat is usually considered an altar, but it has also been called a threshold, a tomb, a rock, a temple step, a sacrificial platform, and a chest.[83] Before reconsidering the Barberini statue's seat, however, let us look at her breast.

A noteworthy feature of the divestment motive here (Fig. 3) is that the cloth of this young woman's *chiton* cups her breast's underside. Usually when the female breast is bared in Greek art, the garment hangs down to fully reveal the breast's entire form (cf. Figs 4–8). The partial breast exposure of the Barberini Suppliant suggests a specific narrative moment. After her garment slipped or was pulled off her shoulder, she pressed the fabric under her arm, attempting to cover her nudity. Just now it has slipped down again – below the nipple of her breast – but she is still too dazed, whether by passion or by despair, to notice.[84] Her initial instinctive shame, however, does not belong to the iconography of ecstatic recipients of divine love. Perhaps, instead, the Barberini Suppliant has endured an unwanted *violent* attack, but remains vulnerable, and thus her bared breast should be viewed in the context of *Category (4)* – female victims of physical violence.

A quiet moment after the height of action was a subtle narrative choice favored by the renowned Classical painter Polygnotos. Pausanias records (9.4.1) that Polygnotos painted an "Odysseus *after* the Slaughter of the Suitors," and he describes (10.25.1–27.4) the artist's lost *Iliupersis* in the Clubhouse of the Cnidians at Delphi – a painting of Troy *after* the sack.[85] Here Polygnotos depicted Kassandra *after* her rape by Ajax (Paus. 10.26.3): "Ajax the son of Oileus stands by an altar holding a shield, swearing an oath about his shameless act against Kassandra. Kassandra is seated on the ground and holds the image of Athena, since she pulled the image down from its base when Ajax was dragging her away from her place as a suppliant."[86] Mark Stansbury-O'Donnell's drawing of the lost painting shows Polygnotos' Kassandra virtually fully draped, and in this particular detail he appears to have followed Carl Robert's reconstruction.[87] Yet in depictions of her *rape* preserved in both Archaic and Classical Athenian vase painting, this young and beautiful, as yet unmarried daughter of Priam is one of the first mythological female characters consistently represented as fully or partially nude (Fig. 9).[88] In a monumental classical representation

Figure 9 Rape of Kassandra, Attic red-figure Nolan amphora, attributed to the Ethiop Painter, Greek, *c.* 440 BC, New York, Metropolitan Museum of Art 56.171.41, Fletcher Fund, 1956

of Kassandra after the infamous attack by Ajax would nudity have been utterly avoided?

The Barberini Suppliant (Fig. 3) does not reproduce Polygnotos' Kassandra exactly – yet her partially bared breast would suit a modest young princess, still dazed by an attack, who, not quite successfully, has attempted to cover her nudity. Significantly, the Suppliant's seat (now only partly preserved), as also observed by Despines, was a stepped platform, and thus not an altar as it has often been identified.[89] In the fifth-century iconography of Kassandra's rape, vase painters begin to define the image of Athena as a statue by setting it on a statue base (Fig. 9).[90] Whereas in Late Archaic representations, such as the red-figure *Iliupersis* scenes attributed to Onesimos and the Kleophrades Painter, the base of the statue at which Kassandra vainly seeks refuge is a simple block form,[91] in Classical examples, such as the Nolan amphora by the Ethiop Painter in the Metropolitan Museum (Fig. 9), the statue of Athena regularly stands on a stepped base.[92] In the Classical period a small stepped statue base, like the now-frontal archaizing image itself, could well have been perceived as a venerable relic of Archaic Greece.[93] In Apulian vase painting of the early fourth century Kassandra sits on the stepped statue base with her arm around the still-standing Palladion of Athena.[94] Might the Barberini Suppliant's seat be a statue base from which the sacred ancient image has toppled?[95]

After her rape, ill-fated Kassandra was taken as a concubine by Agamemnon to Mycenae, where she was murdered along with the returning king. Klytaimestra's violent attack on the Trojan princess appears on the tondo of a Classical red-figure cup in Ferrara by the Marlay Painter, and in this image the horror of the action is underscored as one of Kassandra's breasts is divested of clothes.[96] And although I hesitate to add yet another name to the Barberini Suppliant's list, her exposed breast is compelling evidence for calling her Kassandra.

As we have seen, an important key to interpreting major contexts for the representation of female figures in Classical art of the fifth century BC lies in the bared female breast. Subsequently, this motive not only enjoyed popularity throughout Classical antiquity, but it was also employed with sophisticated insouciance by Western artists.

NOTES

This article is an expanded version of a paper delivered at the Annual Meeting of the Archaeological Institute of America in Atlanta, Georgia, 28 December 1994 (abstract: *American Journal of Archaeology*, 1995, vol. 99, 315–16). It is dedicated to the memory of Margarete Bieber. I thank the following people for providing practical help, bibliographic suggestions, or valuable comments: Larissa Bonfante, Dietrich von Bothmer, Evelyn B.

Harrison, Mario Iozzo, Ira S. Mark, Charles Mercier, Joan R. Mertens, Elizabeth J. Milleker, H. A. Shapiro, Natalia Vogeikoff, Constanze Witt, and press reviewer Lin Foxhall. Any remaining mistakes are my own.

The following short titles have been used:

ARV[2]: Beazley, J. D., *Attic Red-figure Vase-painters*, 2nd ed., Oxford, Clarendon Press, 1963.

Beazley Addenda[2]: Carpenter, T. H., *Beazley Addenda: Additional References to ABV, ARV*[2] *& Paralipomena*, 2nd ed., Oxford, Oxford University Press, 1989.

LIMC: *Lexicon Iconographicum Mythologiae Classicae*, Zurich, Artemis Verlag, 1981–.

OCD: N. G. L. Hammond and H. H. Scullard (eds), *The Oxford Classical Dictionary*, 2nd ed., Oxford, Clarendon Press, 1970.

Paralipomena: J. D. Beazley, *Paralipomena, Additions to Attic Black-figure Vase-painters and to Attic Red-figure Vase-painters*, 2nd ed., Oxford, Clarendon Press, 1971.

1 See C. M. Havelock, *The Aphrodite of Knidos and Her Successors: A Historical Review of the Female Nude in Greek Art*, Ann Arbor, University of Michigan Press, 1995, and also Nanette Salomon, "Making a World of Difference: Gender, Asymmetry, and the Greek Nude," pp. 197–217 in this volume.
2 The invention of woven cloth in the Neolithic period and the subsequent importance of clothing manufacture in civilized life have recently been examined by E. J. W. Barber, *Prehistoric Textiles: The Development of Cloth in the Neolithic and Bronze Ages with Special Reference to the Aegean*, Princeton, Princeton University Press, 1991, and *Women's Work: The First 20,000 Years: Women, Cloth and Society in Early Times*, New York, Norton, 1994.
3 J. Boardman, *Greek Sculpture: The Archaic Period*, New York, Oxford University Press, 1978, p. 13. See also L. Bonfante, "Nudity as a Costume in Classical Art," *American Journal of Archaeology*, 1989, vol. 93, pp. 558–62 and N. Himmelmann, *Ideale Nacktheit in der griechischen Kunst*, Berlin, W. de Gruyter, 1990, pp. 47–52. For the nature of the preserved evidence from early Greece see S. Böhm, *Die "nackte Göttin": Zur Ikonographie und Deutung unbekleideter weiblicher Figuren in der frühgriechischen Kunst*, Mainz, P. von Zabern, 1990.
4 I have discussed this issue in B. Cohen, "The Anatomy of Kassandra's Rape: Female Nudity Comes of Age in Greek Art," *Source*, 1993, vol. 12 (2), pp. 37–46.
5 See now W. G. Moon (ed.), *Polykleitos, the Doryphoros, and Tradition*, Madison, University of Wisconsin Press, 1995. Cf. R. Sennett, *Flesh and Stone: The Body and the City in Western Civilization*, New York and London, W. W. Norton, 1994, pp. 22, 33, 86.
6 *Infra*, pp. 72 and 74 and nn. 52 and 54.
7 For example, R. Just, *Women in Athenian Law and Life*, London and New York, Routledge, 1989, pp. 1–3, 11–12 and *passim*; H. King, "Medical Texts as a Source for Women's History," in Anton Powell (ed.), *The Greek World*, London, Routledge, 1995, p. 199; M. Skinner, "Introduction" and P. Culham, "Ten Years After Pomeroy: Studies of the Image and Reality of Women in Antiquity," in *Rescuing Creusa: New Methodological Approaches to Women in Antiquity*, *Helios*, N. S. vol. 13 (2), 1987, pp. 1 and 14–15.
8 M. Bieber, *Ancient Copies, Contributions to the History of Greek and Roman Art*, New York, New York University Press, 1977, pp. 59, 63.
9 L. Nead, *The Female Nude: Art, Obscenity and Sexuality*, London, Routledge, 1992, p. 6.

10 Bieber, *supra*, n. 8.

11 Just, *supra*, n. 7, pp. 4–7, 105–25, particularly 113; R. Garland, *The Greek Way of Life*, Ithaca, Cornell University Press, 1990, p. 233; E. Fantham *et al.*, *Women in the Classical World: Image and Text*, New York and Oxford, Oxford University Press, 1994, pp. 69–71, 79–80, 83, 96–103, 106–9. Sennett, *supra*, n. 5, p. 34, for the distinction between male versus female space and "street" versus "house" dress.

12 For clear diagrams see S. Woodford, *An Introduction to Greek Art*, New York, Duckworth, 1986, figs 70, 73. M. Bieber, *Griechische Kleidung*, Berlin, W. de Gruyter, 1928, is useful for the photographs of draped women; E. B. Harrison, "The Dress of the Archaic Greek Korai," in D. Buitron-Oliver (ed.), *New Perspectives in Early Greek Art*, Hanover and London, University Press of New England, 1991, pp. 217–39, notes differences between Archaic and Classical dress.

13 Bonfante, *supra*, n. 3, p. 568, and *infra*, pp. 174–96. See also Bieber, *supra*, n. 8. Ancient medical texts focus on female genital and uterine problems related to reproduction, e.g. A. Rousselle, *Porneia: On Desire and the Body in Antiquity*, trans. F. Pheasant, Oxford and New York, Basil Blackwell, 1988. Breasts, however, are defined in Hippocratic medical texts as glands that swell, on women (but not men) because they produce milk: see Fantham *et al.*, *supra*, n. 11, p. 185. The breasts' proximity to the vital organs, which the Classical Greeks believed to be the locus of the human mind, must also have affected the ancients' perception of them; see, e.g., R. Padel, "Women: Model for Possession by Greek Daemons," in A. Cameron and A. Kuhrt (eds), *Images of Women in Antiquity*, Detroit, Wayne State University Press, 1983, p. 10.

14 E.g., faience snake goddess from Knossos, Herakleion Museum, Late Minoan I, and gold ring from Isopata, Herakleion Museum, Late Minoan I–II: P. Demargne, *The Birth of Greek Art*, New York, Golden Press, 1964, figs 212, 214, 248. See also the female figures in a "costuming scene" in frescos from the House of the Ladies at Akrotiri, Thera: N. Marinatos, *Art and Religion in Thera: Reconstructing a Bronze Age Society*, Athens, Mathioulakis, 1984, pp. 100–2, figs 68–71.

15 See N. Serwint, "The Female Athletic Costume at the Heraia and Prenuptial Initiation Rites," *American Journal of Archaeology*, 1993, vol. 97, pp. 403–7, fig. 1. Serwint, pp. 408–10, postulates a date of *c.* 460 BC for the Greek original of a female runner in the Vatican, p. 408, fig. 2; however, I find it difficult to believe that this statue reflects a fifth-century BC work.

16 Fantham *et al.*, *supra*, n. 11, pp. 59–60, fig. 2.1; Serwint, *supra*, n. 15, pp. 404–6; Pausanias 5.16.2–4; see also Euripides, *Andr.* 596–9.

17 For associations of nudity and short *chiton*s with the cult of Artemis at Brauron see L. Kahil, "Mythological Repertoire of Brauron," in W. G. Moon (ed.), *Ancient Greek Art and Iconography*, Madison, University of Wisconsin Press, 1983, pp. 235–8, 236, figs 15.9–15.10. See also E. D. Reeder, *Pandora: Women in Classical Greece*, Baltimore and Princeton, Princeton University Press, 1995, pp. 321–8. References to this exhibition catalogue, which appeared after this article was completed, have been inserted in the notes.

18 Syracuse, Museo Archeologico Regionale 53234, mid to late sixth century BC: J. Boardman, *Greek Sculpture: The Late Classical Period*, London, Thames and Hudson, 1995, pp. 162–3 and fig. 174. See Garland, *supra*, n. 11, p. 79 on the negative attitude towards multiple births.

19 Inv. 4530; K. Schefold, *Die Göttersage in der klassischen und hellenistischen Kunst*,

Munich, Hirmer, 1981, p. 198, fig. 270 (incorrectly called an aryballos). Cf. F. Lissarrague, "Women, Boxes, Containers: Some Signs and Metaphors," in Reeder, *supra*, n. 17, p. 100 and p. 99, fig. 14.

20 London, British Museum, F 107; K. Schefold and F. Jung, *Die Urkönige, Perseus, Bellerophon, Herakles und Theseus in der klassischen und hellenistischen Kunst*, Munich, Hirmer, 1988, pp. 130, 132 and 131, fig. 157.

21 Bonfante, *supra*, n. 3, pp. 567–8, and, e.g., S. Blundell, *Women in Ancient Greece*, London, British Museum Press, 1995, p. 141. A votive relief in the Metropolitan Museum of Art, 24.97.92, showing a seated woman with an exposed breast and a maidservant holding a baby, frequently placed *c.* 425–400 BC, must be later in date and is thus not included in the present discussion; see G. M. A. Richter, *Metropolitan Museum of Art: Catalogue of Greek Sculpture*, Cambridge, Mass., Harvard University Press, 1954, pp. 44–5, no. 67, pl. 55b; N. Demand, *Birth, Death and Motherhood in Classical Greece*, Baltimore, Johns Hopkins University Press, 1994, pp. 87–8, 123 and pl. 1; Reeder, *supra*, n. 17, pp. 334–5, no. 103.

22 R. Fagles, trans., Homer, *The Iliad*, Harmondsworth, Penguin, 1991, p. 544; on mothers' supplications of their sons see C. Mercier, *Suppliant Ritual in Euripidean Tragedy*, Diss. Columbia Univ., 1990, p. 48.

23 See W. H. S. Jones, trans., Pausanias, *Description of Greece*, Cambridge, Mass., Harvard University Press, 1979, p. 517, n. 1.

24 S. Woodford, *The Trojan War in Ancient Art*, Ithaca, Cornell University Press, 1993, p. 109; see also *LIMC* II, s.v. Astyanax I (O. Touchefeu), pp. 929–30 on the literary tradition, pp. 931–3, 936–7 on representations in Greek art. D. Castriota, *Myth, Ethos, and Actuality: Official Art in Fifth-Century B.C. Athens*, Madison, University of Wisconsin Press, 1992, p. 112; cf. his discussion of Polygnotos' painting in the Stoa Poikile, Athens, pp. 128–30, fig. 12.

25 Cf. M. Robertson, *A History of Greek Art* I, Cambridge, Cambridge University Press, 1975, p. 248; Bonfante, *supra*, n. 3, p. 568, n. 144; Castriota, *supra*, n. 24, p. 112.

26 E.g. Aeschylus, *Cho.* 531, 545, 897; Euripides, *El.* 1206; *Or.* 527. See Mercier, *supra*, n. 22, p. 48, and Viret Bernal, *infra*, pp. 93–107.

27 80.AE.155.1; T. H. Carpenter, *Art and Myth in Ancient Greece*, London, Thames and Hudson, 1991, fig. 355.

28 *Ibid.*, fig. 144; Paris, Louvre CA 925. Cf. Leda, *infra*, n. 42. Depictions of Danae and Leda with the transformed Zeus cleverly allude to the sexual intercourse – "rape" in the modern sense of the word. Cf. the pursuit of mortal women by Zeus, E. Keuls, *The Reign of the Phallus*, New York, Harper and Row, 1985, pp. 50–1, and by male deities in general, S. Kaempf-Dimitriadou, *Die Liebe der Götter in der attischen Kunst des 5 Jahrhunderts v. Chr.* Beih. 11 *Antike Kunst*, 1979, pp. 22–44, and pls 12–16, 18–19, 25–31. See now on distinguishing divine rape from pursuit A. Stewart, "Rape?," in Reeder, *supra*, n. 17, particularly pp. 74–8.

29 *Andr.* 627; *OCD* 2, p. 419, performed *c.* 426 BC. On the erotic aspect of breast baring as a means of supplication see Mercier, *supra*, n. 22, p. 126.

30 Woodford, *supra*, n. 24, pp. 112–14, 113, fig. 108, Toledo, Museum of Art 67.154, Attic red-figure bell-krater. Cf. Vatican inv. 16535, red-figure oinochoe, connected with the Heimarmene Painter, *ARV*[2] 1173; J. Boardman, *Athenian Red Figure Vases: The Classical Period*, London, Thames and Hudson, 1989, fig. 309; the depiction includes Aphrodite, Eros, and Peitho (persuasion). See also K. Schefold and F. Jung, *Die Sagen von den Argonauten, von Theben und Troja in der klassischen und hellenistischen Kunst*, Munich, Hirmer Verlag, 1989, pp. 294–6

BETH COHEN

and J. H. Oakley, "Nuptial Nuances: Wedding Images in Non-Wedding Scenes of Myth," in Reeder, *supra*, n. 17, pp. 64–6. For verbal imagery see D. E. Gerber, "The Female Breast in Greek Erotic Literature," *Arethusa*, 1978, vol. 11, pp. 203–12.

31 Cohen, *supra*, n. 4, pp. 40–1, 44, and M. F. Kilmer, *Greek Erotica on Attic Red-Figure Vases*, London, Duckworth, 1993, pp. 143–4, 151 and pls R318, R361.

32 M. Olender, "Aspects of Baubo: Ancient Texts and Contexts," in D. M. Halperin, J. J. Winkler, and F. I. Zeitlin (eds), *Before Sexuality: The Construction of Erotic Experience in the Ancient Greek World*, Princeton, Princeton University Press, 1990, pp. 83–113. On cult ritual see H. P. Foley, "Background: The Eleusinian Mysteries and Women's Rites for Demeter," in H. P. Foley (ed.), *The Homeric Hymn to Demeter, Translation, Commentary, and Interpretive Essays*, Princeton, Princeton University Press, 1994, p. 73. See Ajootian, *infra*, pp. 220–42.

33 Böhm, *supra*, n. 3, p. 166 no. TK 45, pl. 34a; and *LIMC* II, 1, s.v. Aphrodite (A. Delivorrias), p. 85, nos 762–4, *LIMC* II, 2, pl. 75, Aphrodite nos 763–4.

34 Naples, Museo Nazionale 6020: Boardman, *supra*, n. 18, p. 76, fig. 82; cf. *LIMC* II, 1, s.v. Aphrodite (A. Delivorrias), p. 85, n. 765; *LIMC* II, 2, pl. 76; dated variously, from the late fourth to the first century BC.

35 C. Johns, *Sex or Symbol?: Erotic Images of Greece and Rome*, London, British Museum Publications and Austin, University of Texas Press, 1982, p. 72, for the opinion that "the female genitals do not lend themselves so well to artistic depiction as the male." On an association between the exhibition of women's body parts and pornography see H. N. Parker, "Love's Body Anatomized: The Ancient Erotic Handbooks and the Rhetoric of Sexuality," in A. Richlin (ed.), *Pornography and Representation in Greece and Rome*, New York and Oxford, Oxford University Press, 1992, p. 99.

36 E.g., Roman Neo-Attic relief, Rome, Palazzo dei Conservatori, probably by Kallimachos: A. Stewart, *Greek Sculpture: An Exploration*, New Haven and London, Yale University Press, 1990, II, fig. 436; see also B. S. Ridgway, *Fifth Century Styles in Greek Sculpture*, Princeton, Princeton University Press, 1981, pp. 210–13. Cf. Karlsruhe 259, Attic red-figure hydria, Painter of the Carlsruhe Paris (workshop of Meidias Painter), *c.* 420–410 BC, *ARV*² 1315, 1 and 1690; *Beazley Addenda*² 362; J. Charbonneaux *et al.*, *Classical Greek Art*, New York, G. Braziller, 1972, p. 287, fig. 330, and also fig. 348, Taranto, Museo Nazionale 8263, Apulian volute-krater, Karneia Painter, *c.* 410 BC. See J. R. Green, *Theatre in Ancient Greek Society*, London, Routledge, 1994, pp. 24–5, fig. 2.6, for an Attic red-figure pelike in Berlin, inv. 3226, on which a chorusman is shown as a maenad with a bare breast. On the identification of the female companions of Dionysos as nymphs rather than maenads see G. M. Hedreen, "Silens, Nymphs, and Maenads," *Journal of Hellenic Studies*, 1994, vol. 114, pp. 47–69 and T. H. Carpenter, "Nymphs, Not Maenads, on Attic Red-Figure Vases," *American Journal of Archaeology*, 1995, vol. 99, p. 314.

37 Stewart, *supra*, n. 36, II, pls 408–10.

38 E.g., J. Boardman, *Greek Sculpture: The Classical Period*, London, Thames and Hudson, 1985, post-Parthenonian examples in Athens: fig. 116, 'Nereid', Athens, Agora S182; fig. 119, Nereid, Athens 3397; see also the *akroteria* of the Temple of Asklepios at Epidauros, of *c.* 380–370 BC; Stewart, *supra*, n. 36, II, fig. 455 (Nike) and fig. 457 (Aura). See also Boardman, *supra*, n. 18, figs 9.3, 11.1, 12.

39 E.g., on the east frieze (Artemis), F. Brommer, *Der Parthenonfries*, Mainz, P. von

86

Zabern, 1977, pls 178–9, 182; goddesses "K" and "M" (Aphrodite) on the east pediment, F. Brommer, *Die Skulpturen der Parthenon-Giebel*, Mainz, P. von Zabern, 1963, pls 47, 49. See E. B. Harrison, "Two Pheidian Heads: Nike and Amazon," in D. Kurtz and B. Sparkes (eds), *The Eye of Greece: Studies in the Art of Athens*, Cambridge, Cambridge University Press, 1982, p. 87, n. 180, and I. S. Mark, "The Gods on the East Frieze of the Parthenon," *Hesperia*, 1984, vol. 53, pp. 293–4; Younger, *infra*, pp. 120–53. For the impression of a lost relief showing Aphrodite wearing a slipping *chiton*, accompanied by Eros, Berlin, Antikensammlung, Staatliche Museen zu Berlin Preussischer Kulturbesitz, see now Reeder, *supra*, n. 17, pp. 151–3, no. 17.

40 I. S. Mark, *The Sanctuary of Athena Nike in Athens: Architectural Stages and Chronology*, *Hesperia* suppl. 26, 1993, p. 96, and see n. 14, interpreted as an undertone of sexuality.

41 Paris, Louvre MA 525: *LIMC* II, 1, p. 34, 225; *LIMC* II, 2, pl. 25 Aphrodite 225, and P. Karanastassis, "Untersuchungen zur kaiserzeitlichen Plastik in Griechenland, I: Kopien, Varianten und Umbildungen nach Aphrodite-Typen des 5. Jhs. v. Chr.," *Mitteilungen des Deutschen Archäologischen Instituts, Athenische Abteilung*, 1986, vol. 101, pp. 211–17, pls 46, 1; 47, 1; 48, 1–2.

42 Boston, Museum of Fine Arts 04.14. Ridgway, *supra*, n. 36, pls 41–2, and see 67–8, no. 7; the statue may have come from a pediment. Cf. the Late Classical Leda type, in which more of the body is exposed, Boardman, *supra*, n. 18, p. 77 and fig. 91.

43 E.g., Roman copy, Vatican, ex Lateran; Ridgway, *supra*, n. 36, pls 130–1; 206–9, bibliography pp. 220–1. For the Berlin copy: Boardman, *supra*, n. 38, fig. 239.2. See H. Meyer, *Medeia und die Peliaden: Eine attische Novelle und ihre Entstehung*, Rome, G. Bretschneider, 1980, pp. 38–50, and pp. XIX, 27, 44 for the association with Euripides.

44 B. Cohen, "Paragone: Sculpture versus Painting, Kaineus and the Kleophrades Painter," in W. G. Moon (ed.), *supra*, n. 17, pp. 172, 175, 189, n. 53 for bibliography.

45 C. M. Havelock, "Mourners on Greek Vases," in N. Broude and M. D. Garrard (eds), *Feminism and Art History: Questioning the Litany*, New York, Harper and Row, 1982, p. 46. See R. Osborne, "Framing the Centaur: Reading Fifth-century Architectural Sculpture," in S. Goldhill and R. Osborne (eds), *Art and Text in Ancient Greek Culture*, Cambridge, Cambridge University Press, 1994, pp. 52–84.

46 B. Ashmole and N. Yalouris, *Olympia: The Sculptures of the Temple of Zeus*, London, Phaidon, 1967, pl. 111, Centaur and Bride; pls 127, 130–1, Lapith maiden and Centaur. On the poorly preserved Olympia metope showing Herakles and the Amazon, the fallen Amazon may well have been depicted with an exposed breast or breasts; see B. Cohen, "From Bowman to Clubman: Herakles and Olympia," *Art Bulletin*, 1994, vol. 75, p. 707, fig. 16.6; cf. p. 709, fig. 17.6 and p. 712, fig. 19.

47 Her marriage would have been to an older man of about thirty years of age, see J. H. Oakley and R. H. Sinos, *The Wedding in Ancient Athens*, Madison, University of Wisconsin Press, 1993, p. 10. On the age of menarche in ancient Greece see H. King, "Bound to Bleed: Artemis and Greek Women," in Cameron and Kuhrt (eds), *supra*, n. 13, p. 112 and cf. "Medical Texts as a Source for Women's History," in A. Powell (ed.), *The Greek World*, London, Routledge, 1995, p. 210.

48 On the Old Market Woman, New York, Metropolitan Museum 9.39, a Roman

copy of a Hellenistic original, her naturalistic, sagging breast is exposed by the hanging neckline of her draperies – a wry comment on the ideal Classical motive. See R. R. R. Smith, *Hellenistic Sculpture*, London, Thames and Hudson, 1991, frontispiece and fig. 175, and pp. 137–8, 280 with bibliography. Cf. also the ideal phallus of the Classical male nude, which was depicted as youthfully small in size: K. J. Dover, *Greek Homosexuality*, London, Duckworth, and Cambridge, Mass., Harvard University Press, 1978, pp. 125–6; Johns, *supra*, n. 35, p. 52, and T. McNiven, "The Unheroic Penis," *SOURCE: Notes in the History of Art* (fall 1995), vol. 15 (1), pp. 10–16.

49 Florence, Museo Archeologico Nazionale 3997, red-figure column-krater, *ARV*², 541, 1 and 1658; *Beazley Addenda*², 256; A. M. Esposito and G. de Tommaso, *Museo Archeologico Nazionale di Firenze, Antiquarium: Vasi Attici*, Florence, Edizioni Il Ponte, 1993, p. 63, fig. 96.

50 F. Brommer, *Die Metopen des Parthenon*, Mainz, P. von Zabern, 1967, pl. 225.

51 *Ibid.*, pl. 197. Cf. south metope 12, pl. 201.

52 C. Hofkes-Brukker, *Der Bassai-Fries in der ursprünglich geplanten Anordnung*, Munich, Prestel, 1975, p. 55, slab H4–524. On the order of the slabs, see I. Jenkins and D. Williams, "The Arrangement of the Sculptured Frieze from the Temple of Apollo Epikourios at Bassae," in O. Palagia and W. Coulson (eds), *Sculpture from Arcadia and Laconia: Proceedings of an international conference held at the American School of Classical Studies at Athens*, 10–14 April 1992, Oxford, Oxbow Books, 1993, pp. 57–77; fig. 2, slab 542, 5; cf. Boardman, *supra*, n. 18, pp. 23–4 and fig. 5.5. For the imagery see Osborne, *supra*, n. 45, p. 79 and N. Spivey, "Bionic Statues," in A. Powell (ed.), *supra*, n. 47, pp. 449–50.

53 St. Petersburg, Hermitage, inv. no. A 434, ex Campana collection; for a good detail see G. Becatti, *Problemi fidiaci*, Milan, Electa, 1951, pl. 75, fig. 233. On the reconstruction of Pheidias' Niobid reliefs see C. Vogelpohl, "Die Niobiden vom Thron des Zeus in Olympia," *Jahrbuch des Deutschen Archäologischen Instituts*, 1980, vol. 95, pp. 197–226; 216, figs 7–8, reconstruction drawings, and see particularly pp. 225–6 and 236, fig. 11 for the addition of a relief copy of the falling daughter, London, British Museum 1962.8-24.2. For a Classical reflection of the Niobids on the throne see B. Shefton, "The Krater from Baksy," in D. Kurtz and B. Sparkes (eds), *The Eye of Greece: Studies in the Art of Athens*, Cambridge, Cambridge University Press, 1982, pp. 163–4; reconstruction drawing, p. 150, fig. 3.

54 Ridgway, *supra*, n. 36, pl. 25; cf. discussion, pp. 55–9.

55 Becatti, *supra*, n. 53, pl. 76, fig. 234.

56 K. Clark, *The Nude: A Study in Ideal Form*, London, John Murray, and New York, Pantheon Books, 1956, p. 214.

57 For representations of Amazons in Persian dress see D. von Bothmer, *Amazons in Greek Art*, Oxford, Oxford University Press, 1957, particularly pls 75–86, and cf. Archaic examples, pls 59, 61, 64, 68–9; for the Amazons' Athenian iconography see W. B. Tyrrell, *Amazons: A Study in Athenian Mythmaking*, Baltimore, Johns Hopkins University Press, 1984; Just, *supra*, n. 7, pp. 241–51, and summary in Fantham *et al.*, *supra*, n. 7, pp. 128–35, with bibliography.

58 Harrison, *supra*, n. 39, p. 85. On the dress of Pheidias' Amazons see also Bothmer, *supra*, n. 57, p. 214. The Amazonomachy also occurs on the poorly preserved west metopes of the Parthenon, which are not discussed here.

59 For the reconstruction see E. B. Harrison, "Motifs of the City-siege on the Shield of Athena Parthenos," *American Journal of Archaeology*, 1981, vol. 85, pp. 281–317, particularly p. 297, ill. 4; pl. 47, fig. 7; pl. 48, fig. 11. She notes, p. 293, that in the case of the copy of the dead Amazon on the Aphrodisias sarco-

phagus the left side of the *chiton* is unfastened rather than the right as on the Strangford shield, pl. 47, figs 7–8.

60 See the reconstruction drawing in Boardman, *supra*, n. 38, fig. 110. Cf. E. B. Harrison, in "The Composition of the Amazonomachy on the Shield of Athena Parthenos," *Hesperia*, 1966, vol. 35, pp. 114–15, who champions the reliability of the Patras shield and the Piraeus reliefs over the Strangford and Lenormant shields, pls 36a, 37a. Harrison, *supra*, n. 39, p. 293, proposes that the Strangford shield uses "the chiton unfastened on the right shoulder indiscriminately as an Amazonian uniform;" and yet she also suggests, *supra*, n. 59, p. 294, that an open-shouldered dress was given "to an Amazon to show that she was an Amazon." Fantham *et al.*, *supra*, n. 11, p. 59, equates the breast-revealing dress of Classical Amazons with the attire of human female runners; this association is correctly negated by Serwint, *supra*, n. 15, pp. 411–14. Serwint, pp. 413–14, 413, nn. 49–50, however, wrongly associates the later literary tradition of Amazons mutilating or removing their right breasts with the bared (left) breast motive in Classical sculpture, which she believes "may refer symbolically to the mutilation of the (right) breast but does not actually record it."

61 Bothmer, *supra*, n. 57, p. 168, see 161, no. 7 and 163, pl. 75. ARV^2 613, 1 and 1662; *Paralipomena* 39, 7 and *Beazley Addenda²*, 268–9. For the association of this vase with lost monumental painting and the achievements of Mikon and Polygnotos see Cohen, *supra*, n. 44, pp. 184–5 and fig. 12.9a.

62 Bothmer, *supra*, n. 57, p. 168. I disagree with Bothmer's appraisal of the fleeing Amazon's *chiton* as purposely worn attached at only the left shoulder.

63 On the dress, wounds, and exposed breasts of the Ephesian Amazons see Bothmer, *supra*, n. 57, pp. 220–1. The names of the sculptors given by Pliny and even the existence of the Ephesos contest itself have been questioned, and the usual scholarly exercise of attributing the copy types to hands of individual masters is not of central concern here. See, e.g., B. Ridgway, "A Story of Five Amazons," *American Journal of Archaeology*, 1974, vol. 78, pp. 1–17; M. Weber, "Die Amazonen von Ephesos", *Jahrbuch des Deutschen Archäologischen Instituts*, 1976, vol. 91, pp. 28–96. See also the recent appraisals by Stewart, *supra*, n. 36, pp. 162–3 and 263, bibliography (J); for the types, pls 388–90, and by Harrison, *supra*, n. 39.

64 Bieber, *supra*, n. 8, p. 11. See also M. Bieber's interesting analysis and reconstruction photographs in "Der Chiton der ephesischen Amazonen," *Jahrbuch des Deutschen Archäologischen Instituts*, 1918, vol. 33, pp. 49–75, 50, fig. 2 and pls 1–3; photographs reprinted in Bieber, *supra*, n. 8, pls 1–2.

65 Harrison, *supra*, n. 39, p. 81.

66 Stewart, *supra*, n. 36, p. 162.

67 On the iconography see W. Gauer, "Die Gruppe der ephesischen Amazonen, ein Denkmal des Perserfriedens," in H. A. Cahn and E. Simon (eds), *Tainia: Festschrift für Roland Hampe*, Mainz, P. von Zabern, 1980, particularly pp. 219–24. Cf. Serwint, *supra*, n. 15.

68 Havelock, *supra*, n. 45, p. 47.

69 London E 477, Attic red-figure column-krater, the Hephaistos Painter, ARV^2 1114, 15; *Beazley Addenda²*, p. 331; Boardman, *supra*, n. 30, fig. 201.

70 Bari, Museo Provinciale 1535, Lucanian hydria, Amykos Painter, *c.* 420–410 BC; A. D. Trendall, *The Red-figured Vases of Lucania, Campania and Sicily*, Oxford, Oxford University Press, 1967, p. 45, no. 221, pl. 18; Schefold and Jung, *supra*, n. 30, pp. 44–5, fig. 34; a theme from Euripides' lost tragedy *Aiolos*, performed in 423 BC, see *LIMC* I, 1, s.v. Aiolos (F. Giudice), 398–9; *LIMC* I.2, pl. 310.

71 Policoro, Museo Nazionale 35297, Early Lucanian pelike, Policoro Painter, *c.* 400 BC, Schefold and Jung, *supra*, n. 30, p. 39, fig. 29; after Euripides' tragedy of *c.* 410 BC; bibliography p. 364, no. 29. Trendall, *supra*, n. 70, p. 58, no. 286, pl. 26, 3.

72 Naples, Museo Nazionale 3237, Lucanian volute-krater, Brooklyn Budapest Painter, J. Charbonneaux *et al.*, *Classical Greek Art*, New York, G. Braziller, 1972, p. 306, fig. 353; Trendall, *supra*, n. 70, p. 114, no. 593; see also Schefold, *supra*, n. 19, pp. 186–7.

73 Malibu, J. Paul Getty Museum 72.AE.248, Apulian oinochoe, the Black Fury Group, *c.* 400–375 BC; A. D. Trendall, *Red Figure Vases of South Italy and Sicily*, London, Thames & Hudson, 1989, fig. 135.

74 See N. Loraux, *Tragic Ways of Killing a Woman*, trans. A. Forster, Cambridge, Mass., Harvard University Press, 1987.

75 Harrison, *supra*, n. 39, pp. 86–7.

76 Ibid. Cf. images of goddesses nursing with the right breast, *supra*, nn. 19 and 20; Serwint, *supra*, n. 15, p. 413.

77 E.g., Bieber, *supra*, n. 8, pp. 46–7, pls 23–8, adaptations of Venus Genetrix type.

78 *Ibid.*, pp. 28–9.

79 For the other copies of the type see J. Dörig, "Kalamis-Studien," *Jahrbuch des Deutschen Archäologishen Instituts*, 1965, vol. 80, p. 146, fig. 2, Vatican; p. 147, fig. 3, St. Petersburg, Hermitage. For the head in New York, collection of I. Love, see Ridgway, *supra*, n. 36, pls 87–8, and see also her excellent discussion of the Barberini Suppliant type, pp. 112–14.

80 G. Despines, "H IKETIΔA Barberini," *Praktika tou 12. Diethnous Synedriou Klasikes Archaiologis, Athens, 4–10 September 1983*, Athens, 1988, vol. 3, pp. 65–9, pl. 13, 1, joins Akropolis Museum fragments 7310 and 928. I have not yet had the opportunity to examine these fragments but find it difficult to accept that the Barberini Suppliant is not a copy of a bronze original.

81 An excellent summary of interpretations in earlier bibliography is given by Dörig, *supra*, n. 79, pp. 144–50; for his own interpretation (Alkmene) pp. 153–66; see also P. Mingazzini, "Un tentativo di esegesi della Supplice Barberini," *Antike Kunst*, 1968, vol. 11, pp. 53–4 (Iphigeneia); S. Karouzou, "Die 'Schutzflehende' Barberini," *Antike Kunst*, 1970, vol. 13, pp. 34–47 (Danae): she believes the statue to be a contemporary copy of a bronze original; for Karouzou's initial identification of the statue as Danae see P. Amandry, "Communications," *Bulletin de Correspondance Hellénique*, 1940–1, vols 64–5, pp. 251–2; Ridgway, *supra*, n. 36, p. 113, points out the associations with Aphrodite; Despines, *supra*, n. 80, pp. 67–8 (Io). The scholarly interpretations began with E. Q. Visconti, *Musée Pie-Clémentin II*, Milan, J. P. Giegler, 1819, pp. 286–90, who believed the statue type to be Roman (Dido).

82 F. Matz, "Statua di donna sedente del Palazzo Barberini," *Annali dell'Instituto di Corrispondenza Archeologica*, 1871, vol. 43, p. 204. Matz believed that the restored right hand of the statue actually belonged to the original; thus his identification depended on interpreting the tubular object held in the (restored) hand as a branch. Many interpretations rest on restoring a presumed object to the Suppliant's missing right hand, e.g., a sword (Laodameia), a snake (Erinys), a pitcher (Alkmene), a sandal (Danae); see bibliography *supra*, n. 81.

83 Dörig, *supra*, n. 79, pp. 145, 148–50, 153; Ridgway, *supra*, n. 36, p. 113.

84 Cf. the alluring partial breast exposure of Aphrodite on the impression of a Classical relief in Berlin, *supra*, n. 39.

85 The time frame of Polygnotos' painting, "Troy taken," is assessed well by,

among others, Robertson, *supra*, n. 25, pp. 248–52 and Castriota, *supra*, n. 24, pp. 112–17.

86 Translation by J. J. Pollitt, *The Art of Ancient Greece: Sources and Documents*, 2nd ed., Cambridge, Cambridge University Press, 1990, p. 132. The term "rape" as applied to Archaic and Classical representations of Kassandra implies violation of the goddess Athena's sanctuary, see Cohen, *supra*, n. 4, p. 37; J. B. Connelly, "Narrative and Image in Attic Vase Painting: Ajax and Kassandra at the Trojan Palladion," in P. J. Holliday (ed.), *Narrative and Event in Ancient Art*, Cambridge, Cambridge University Press, 1993, pp. 95, 107–9; and see now Stewart, *supra*, n. 17, p. 83.

87 M. D. Stansbury-O'Donnell, "Polygnotos's *Iliupersis*: A New Reconstruction," *American Journal of Archaeology*, 93, 1989, p. 209, fig. 4; C. Robert, *Die Iliupersis des Polygnot, Hallisches Winckelmannsprogramm*, 17, Halle, 1893, reprinted by Stansbury-O'Donnell, p. 204, fig. 1. The 1893 and 1989 reconstructions both show Kassandra's draperies swirling outwards behind her back, but do not clearly indicate an unfastened shoulder of her garment or an exposed breast. See Stansbury-O'Donnell, pp. 207, 210–11, on the location and central importance of Kassandra in Polygnotos' composition.

88 Cohen, *supra*, n. 4, and Connelly, *supra*, n. 86, pp. 88–129.

89 Despines, *supra*, n. 80, p. 67; the heel of the statue's left foot and the bottom of her *chiton* are lower than her right foot, thus the surface beneath the right foot did not continue to extend at the same level.

90 See S. B. Matheson, "Polygnotos: An *Iliupersis* Scene at the Getty Museum," *Occasional Papers on Antiquities*, 2, *Greek Vases in the J. Paul Getty Museum*, 3, Malibu, 1986, pp. 105–6; Connelly, *supra*, n. 86, pp. 102, 109–10, 114–15.

91 Malibu, J. Paul Getty Museum 83.AE.362, Onesimos, Cohen, *supra*, n. 4, p. 42, fig. 5; Naples, National Museum 2422, hydria, Kleophrades Painter, *ARV*[2] 189, 74; *Beazley Addenda*[2], p. 189; J. Charbonneaux *et al.*, *Archaic Greek Art*, New York, G. Braziller, 1971, p. 386.

92 New York, Metropolitan Museum of Art 56.171.41, Nolan amphora, Ethiop Painter, *ARV*[2] 666, 12; *Beazley Addenda*[2], p. 278. Cf. Bologna 268, volute-krater, Niobid Painter, *ARV*[2] 598, 1; *Beazley Addenda*[2], p. 265; *LIMC* I. 2, pl. 262 (Aias) II, 61; Cambridge, Corpus Christi College, amphora, Group of Polygnotos, *ARV*[2] 1058, 114, *Beazley Addenda*[2], p. 323; *LIMC* I, 2, pl. 261, Aias II 54.

93 See M. Jacob-Felsch, *Die Entwicklung griechischer Statuenbasen und die Aufstellung der Statuen*, Waldsassen/Bayern, Stiftland-Verlag, 1969, particularly pp. 27–32 for Archaic stepped bases, pp. 51–2 for Classical fifth-century stepped bases, which were used primarily for chariot groups, and the "Typentafel der Statuenbasen."

94 See Castriota, *supra*, n. 24, fig. 21, Apulian bell-krater, Lecce, Museo Provinciale Sigismondo Castromediano 681; on pp. 177–8, he emphasizes the Polygnotan flavor of this peculiarly calm, static Kassandra motive. Cf. New York, Metropolitan Museum 53.11.2: Greek gold ring, *c.* 400–380 BC, showing Kassandra, with a bared left breast, kneeling before the base of the cult image as she clings to the palladion-statue; she raises her cloak with her left hand – perhaps an instinctive gesture related to covering her nudity. D. Williams and J. Ogden, *Greek Gold: Jewelry of the Classical World*, London, British Museum Press, 1994, pp. 62–3, no. 16.

95 If the Barberini Suppliant is Kassandra, her missing sandal could be a token of her flight from and struggle with Locrian Ajax and a sign of her failed refuge on sacred ground. Cf. Harrison, *supra*, n. 39, p. 73 on the single ankle guard of the Mattei Amazon.

96 Museo Archeologico Nazionale di Spina, T. 264, *ARV*² 1280, 64, and 1689; *Beazley Addenda*², p. 358; Connelly, *supra*, n. 86, p. 113, fig. 47 and p. 123. For Klytaimestra see F. Viret Bernal, pp. 93–107 in this volume. On the association between Kassandra's nudity and her murder see Stewart, *supra*, n. 17, p. 83. For cults of Kassandra see J. Larson, *Greek Heroine Cults*, Madison, University of Wisconsin Press, 1995, pp. 11–12, 79, 83–4, 144 and 155; G. Salapata, "ΔΡΑ-ΚΟΝΤΩΔΕΙΣ ΚΟΡΑΙ: Erinyes/Eumenides in Lakonia," *American Journal of Archaeology*, 1995, vol. 99, p. 315.

5

WHEN PAINTERS EXECUTE A MURDERESS

The representation of Clytemnestra on Attic vases

Francine Viret Bernal

Writing about Clytemnestra means writing about the monstrous wife, the woman who not only kills her husband but, worse, prefers her lover to her children. She chases Orestes away from his father Agamemnon's palace, where she wishes to rule alone, and treats her daughter Electra like a servant, forcing her into a marriage with a peasant, as Euripides reports. Writing about Clytemnestra also means describing the Greek institution of marriage from another angle, and reconsidering sexual roles and the sanctions taken against those who refuse to comply. Clytemnestra, by choosing her sexual partner and by usurping masculine privileges, presents herself as a destructive element of the established order, simultaneously violating divine and human laws.[1] Furthermore, by her excessive behaviour, she demonstrates her incapacity to fulfil the role she has chosen for herself.

Ancient authors often wrote on this theme, and Homer was one of the first, mentioning Agamemnon's murder several times in the *Odyssey*. In Nestor's and Menelaus' accounts to Telemachus, Aegisthus is held responsible for the murder. He is said to have taken advantage of the king's absence from Argos to seduce his wife and plan his death.[2] But when the shade of the king tells the story to Odysseus, Aegisthus is not the only one who is guilty – the queen takes part in the crime and kills Cassandra herself.[3] In the *Oresteia* by Aeschylus[4] and in the later tragedies, Clytemnestra is explicitly portrayed as the instigator of her husband's murder, the one who organizes it, and, moreover, the one who claims responsibility for it.

The iconographic evidence goes back to the Archaic period. In the earliest figural representations,[5] Clytemnestra is not only present during the killing of her husband, but she even strikes the fatal blow, wielding a sword or a dagger. It is not my intention here to illustrate ancient texts with ancient images, nor to seek a literary origin which can explain all the

93

iconographic elements.[6] Several studies have been devoted to the character of Clytemnestra as she appears in the tragedies.[7] What I intend to do in the present article is to study this figure through visual images, specially those on Attic vases, from the Archaic to the Classical period.[8] These images, like texts, use double-meanings and metaphors the same way that language does. They enlighten our understanding of how vase-painters represented the figure of Clytemnestra to the Athenian public.

There is only one known representation of Agamemnon's murder in Attic pottery of the fifth century BCE, and it is found on the famous krater of the Dokimasia Painter in Boston.[9] On each side of this krater is a scene from the *Oresteia*: the murder of Aegisthus on side B faces the murder of Agamemnon on side A (Fig. 10). When considering the source text, due caution is necessary as vase-painters were concerned with narrating myth and not illustrating a particular literary text. Furthermore, in the case of this vase, the painter could not have drawn on a text that was written much later in time. Because we are dealing with a single representation, the impossibility of placing the scene within a series of similarly decorated vases forces the observer to pay much greater attention to certain iconographic signs, with the attendant risk of exaggerating their meaning.

The scene takes place inside the palace, as is indicated by the pillars supporting the architrave. The center of the image is occupied by Aegisthus, with his long shining beard and carefully arranged hair. He is dressed in a short *chiton* held together by a belt; a *chlamys* is draped over his left shoulder. He has drawn his sword and is about to strike Agamemnon a second time. The latter is seen collapsing gradually, a stream of blood on his chest. Agamemnon is naked, imprisoned in a transparent net which covers him from head to foot. He holds out his hand to Aegisthus, the palm turned upwards, in a gesture of entreaty. Unlike Aegisthus, whose beard appears neatly arranged, his long beard is ragged and his hair untied.

Behind Agamemnon, a woman in a long dress covered by a *himation* extends her right arm, palm upward towards Aegisthus, while holding up her left hand. Her hair flies, carried up by her sudden movement. Behind her, a smaller woman is escaping, gesticulating with her arms. She has short hair and wears a long *chiton* with a belt. She looks back towards the scene of the crime but her left arm and her knee have already passed behind the column and they appear on the other side of the vase. The small size of the character, her cropped hair, and her clothing give her the appearance of a slave, and she may be Cassandra.[10] On the other side of the scene, Clytemnestra can be seen running towards Aegisthus. Her hair, tied in a bun, is held by a ribbon with the ends trailing behind. She wears a long pleated garment and a mantle. In her right hand she carries a double-edged axe, while she holds out her left arm towards her lover, Aegisthus. On the extreme left of the scene, a woman in a long dress and mantle, her hair

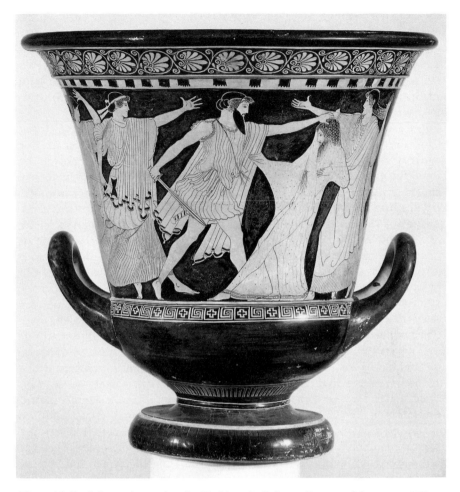

Figure 10 Red-figure krater by the Dokimasia Painter, Boston, Museum of Fine
Arts, inv. 63.1246

dishevelled and arms wide open, seems to be fleeing while looking back
over her shoulder. Like the arm of the figure to the right, her right arm
passes behind the column and appears in the scene of the other murder.
The entire setting depicts an atmosphere of intense agitation.

In this image, the central couple, Aegisthus and Agamemnon, the killer
and his victim, immediately attract the attention of the observer, in
particular the strange cloth that covers Agamemnon. This veil, as fine
and delicate as can be, is clearly intended to imprison and immobilize the
victim trapped in it. The cloth may be analysed from different points of
view. As Emily Vermeule notes, "the particular horror of the robe is that
it combines expensive delicacy and animal cruelty, confining Agamemnon

95

in embroidered ripples more secure than steel."[11] The contrast between the delicacy of the cloth and its use is alluded to by Aeschylus. To express the multiple implications of this criminal trap, Aeschylus uses the language of hunting, fishing, and weaving as metaphors.[12]

First is the woven veil that Cassandra sees in her visions: "She hath caught him in the robe."[13] Then we have the net, but the use of this word may have several meanings. It may evoke the fish net, a net from which one cannot escape: "Round him, like as to catch a hand of fish, I cast a net impassable – a fatal wealth of robe – so that he should neither escape nor ward off doom."[14] The metaphor of the fish net is also employed by Homer to describe the killing of the suitors: "all the host of them, like fishes that fishermen have drawn forth in the meshes of their net from the gray sea upon the curving beach, and they all lie heaped upon the sand, longing for the waves of the sea, and the bright sun takes away their life; even so now the wooers lay heaped upon each other."[15] Whether alone or in company, or even inside the city, one cannot escape from it: "thou who didst cast thy meshed snare upon the towered walls of Troy, so that nor old nor young could o'erleap the huge enthralling net, all-conquering doom."[16]

But it is also with vocabulary from the hunting world that Clytemnestra speaks of her husband's murder: "For how else could one devising hate against a hated foe who bears the semblance of a friend, fence the snares of ruin (πημονῆς ἀρκύστατα) too high to be o'erleapt?"[17] Just so Orestes, when he recalls the killing of his father and is preparing his vengeance: "to the intent that, as by craft they slew a man of high estate, so by craft likewise they may be caught and perish in the self-same snare."[18] And Cassandra, at the very moment of the murder, exclaims: "Ha! Ha! What apparition's this? Is it a net of death? Nay, she is a snare that shares the guilt of murder!"[19] All the terms used here to designate the net (ἀμφίβληστρον, βρόχος, δίκτυον) are those of the hunting world. But in this precise case, we are not dealing with a glorious hunt: "This sort of hunting (the night-hunting) is not to be recommended, nor is the sort . . . where the savage strength of the animals is subdued by nets and traps, rather than because a hunter who relishes the fight has got the better of them."[20] That hunt is twice corrupted, first because its object is a human being, and then because he is captured in a net.

Furthermore, the net is also the metaphoric instrument of the tyrant, as we note on several occasions in the texts of Herodotus.[21] Finally, it is the instrument of the *metis* that Electra and Orestes mention, speaking to their father beside his grave: "And remember how they devised in a strange casting-net for thee."[22] That *metis* "par certains aspects . . . s'oriente du côté de la ruse déloyale, du mensonge perfide, de la traîtrise, armes méprisées des femmes et des lâches."[23]

If we turn again to the scene of the Oresteia krater in Boston, we can see that the cloth through which Agamemnon is only capable of extending a

pleading hand towards his aggressors contains all the meanings that we have already mentioned. Under the aspect of a luxurious veil woven by female hands, enveloping like a fishing net and immobilizing like a hunting net, there is an odious trap used by usurpers and tyrants to eliminate the legitimate king, the instrument of ruse and deceit. Marcel Detienne observes that "Elle agit par déguisement. . . . En elle, l'apparence et la réalité, dédoublées, s'opposent comme deux formes contraires, produisant un effet d'illusion, apaté, qui induit l'adversaire en erreur."[24] The polysemy of the sign is so efficient that its iconography reveals the layered meanings of the scene: the inappropriate use of the veil, a product of weaving and one of the more typical activities of the Greek feminine world, disrupted because of the crime of their queen; and the inappropriate use of the fishing net, a very cowardly form of hunting or attacking an enemy that qualifies the attacker. The victim is at their mercy, and Aegisthus, sword in hand, is ready to finish off the king of Argos.

Clytemnestra is not only present at that moment, but she plays a major part in it. She appears armed with a double-edged ax, πέλεκυς (*pelekus*). The attribution of this weapon to the queen is such that in the absence of other elements, the association between woman and two-edged axe will automatically lead to her identification.[25] To determine whether it is a creation of Stesichorus[26] or that of the vase-painters is not a matter of interest here. In Aeschylus, the weapon that Clytemnestra wields at the time of the murder, whether an axe or sword, is a subject of great debate.[27] In the *Libation-Bearers*, however, it is an axe that she asks for in order to defend her lover: "Someone give me a battle-axe and quick!"[28] In both Sophocles and Euripides, Electra mentions this weapon as that of the crime: "my mother and her bedfellow, Aegisthus, split his head with a murderous axe"[29] and again, "the bitter cut of the axe upon you, father"[30] and Hecuba prophetically places it in Clytemnestra's hands.[31] In each instance it is the term *pelekus* which is employed. But more than the typological identification of the weapon, what is important is its meaning. Agricultural tool and battle weapon, it is also – and here in particular – the instrument of ritual sacrificial slaughter. By associating the double-edged axe with the murderous queen, painters refer to a whole symbolic context. In fact, the double axe can be found on several occasions in scenes of homicidal violence: the Thracian women brandish it when they are about to kill Orpheus. They are also often armed with spits (*oboloi*),[32] which are generally used to roast the meat that the citizens share during sacrificial ceremonies. It is also a *pelekus* that Lycurgus brandishes above the altar when in his madness, he is on the verge of sacrificing his son.[33] The spits and altar strengthen the sacrificial metaphor, so often analysed in Aeschylus' *Oresteia*.[34] The image seems to function here in very much the same manner as in the text: the object, just like the word, refers to a different context, in this case that of the sacrifice. The metaphor is then expressed iconographically,[35] showing that, besides

the murder of her husband, Clytemnestra is fulfilling a sacrilegious act. The victim, reduced to the status of a beast, ignominiously naked, entangled and trapped in a net, is faced by a female executioner holding in her hands a weapon that women are forbidden to possess or use.[36]

The sacrificial world, here associated with Clytemnestra's crimes, is reinforced by the illustration of Cassandra's murder on a cup by the Marlay Painter in Ferrara (Fig. 11).[37] The cup depicts Cassandra, kneeling on the steps of an altar, half naked, wearing a crown of laurel on her head. She stretches out her hand to Clytemnestra in a pleading gesture. Behind her is a laurel tree. Clytemnestra brandishes the axe with both hands above her head thus hiding her face behind her right arm. Around her waist, she has tied an apron, similar to those used by priests at the altar or during a sacrificial slaughter.[38] Her furious gesture has unbalanced the tripod which can be seen falling in the background. The tripod, combined with the laurel crown and trees, evokes the Apollinian world, of which Cassandra is the unfortunate priestess. Cassandra's plea is even more pitiful as her eyes are turned towards Clytemnestra's hidden face, who accomplishes her heinous crime with blind cruelty. Clytemnestra's sacrilegious act is perpetrated not only against Cassandra but also against Apollo himself: it is his priestess who is slaughtered on the steps of his own altar. The queen shows no respect for the sacred place. As in the scene of the murder of Agamemnon,

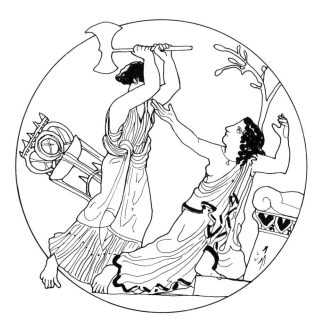

Figure 11 Red-figure cup by the Marlay Painter, Ferrara, Museo Archeologico, inv. T 264

it is a warped sacrifice, where the imploring victim refuses a death which she knows is close at hand, and where the "ceremony" is infused with a violence inconceivable for such a place.[39] This scene, which was painted subsequent to Aeschylus' *Oresteia*, redirects us back to the tragedy. It shows us the almost direct confrontation between Clytemnestra and Apollo, in a most provocative gesture by the queen. How then can she expect from this god, whom she has insulted in his own sanctuary, any discourse other than what he says in the *Eumenides*! This iconographic representation of the Apollinian world foreshadows the vengeance of the god and his full support of Orestes who, according to the Delphic oracles, will kill his mother and avenge his father.

On the Boston Oresteia krater as well as on the Ferrara cup, the two sacrificial "parodies" are not only an offence against the gods, but also an offence against the social order. By taking on the role and the attributes of the executioner, the queen claims a power reserved in ancient times for the chief of the *oikos*, and handed over to the priests later on. In any case, this power was never conferred on a woman. Even in female sacrifices where male participation was generally excluded, it was always a man who slaughtered the beast.[40] Reflecting on this point a little further, Marcel Detienne suggests that

> d'une manière générale, en vertu de l'homologie entre pouvoir politique et pratique du sacrifice, la place réservée aux femmes correspond parfaitement à celle qu'elles occupent – ou plutôt qu'elles n'occupent pas – dans l'espace de la cité. De même que les femmes sont privées des droits politiques réservés aux citoyens de sexe mâle, elles sont tenues à l'écart des autels, de la viande et du sang.[41]

In taking the *pelekus*, an instrument of ritual slaughter, and in killing her husband, Clytemnestra lays political claims. Aegisthus with his sword is only a temporary agent, executing the order of the power-hungry queen.

The role of Aegisthus – or rather the lack of a role – is highlighted in a range of very popular images, dating from the end of the sixth to the middle of the fifth century BCE, that illustrate Orestes' act of revenge (Fig. 12).[42] The way vase-painters chose to represent the scene is most revealing. Apart from a few minor variations,[43] the scheme is always the same: the centre of the action is occupied by the murder of Aegisthus. Orestes appears as a young man, beardless, wearing one or more elements of hoplite clothing and armour,[44] a breastplate, helmet, and shin guards. He is always armed with a sword which he uses to strike Aegisthus. The latter is always seated on a chair, often richly decorated, no doubt the usurped throne which originally belonged to Agamemnon. He is bearded, wears a long garment, and in two instances holds a lyre, or more precisely a *barbitos*.[45] Always armed with a *pelekus*, Clytemnestra is running to help him. Sometimes, she is held back in her flight by a man, who when bearded

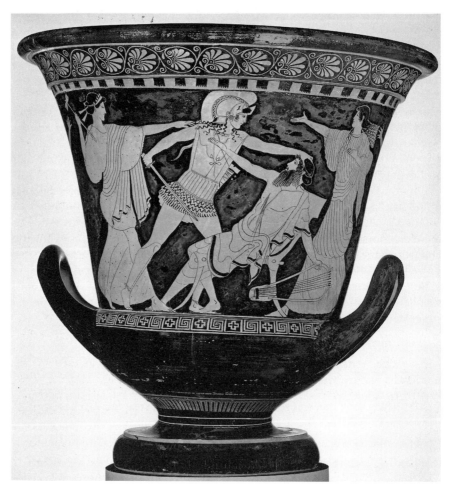

Figure 12 Red-figure krater by the Dokimasia Painter (reverse), Boston, Museum of Fine Arts, inv. 63.1246

could be the pedagogue or herald Talthybius,[46] or when beardless the young Pylades. She is about to strike her son to save her lover. Electra and Chrysothemis, Orestes' sisters, are also represented in the scene, feminine figures displaying signs of panic, whose names sometimes figure on the vases.

In this series of images, three couples oppose each other: Clytemnestra and Aegisthus, the pair of illegitimate lovers; Orestes and Aegisthus, attacker and victim; and Clytemnestra and Orestes, the guilty mother and avenging son. The first opposition, between Clytemnestra and Aegisthus, is clearly expressed by the objects that each one holds: the

axe for Clytemnestra and the *barbitos* for Aegisthus. Although no text describes Aegisthus as a musician,[47] the impression produced by this kind of stringed musical instrument is very meaningful, and it is not entirely by chance that Aegisthus is provided with it. In the *Homeric Hymn to Hermes*, the erotic power of singing is emphasized.[48] Homer uses the verb θέλγω (*thelgo*, to charm, enchant) to express the almost magical power of seduction of the lyre. The same word is employed to evoke the bewitching powers of mermaids or the words that Aegisthus uses when he seduces Clytemnestra.[49]

In Attic iconography, the murder of a player of a stringed instrument brings to mind that of Linos or Orpheus.[50] But these two characters, positive ones, play the lyre. However, the *barbitos*, very popular in Athens at the beginning of the fifth century[51] and a sign of good breeding, held a particular status. Unlike the *cithara*, it was not an instrument intended for competitions or for public performances but rather was played in private circles. In association with wine and the Dionysiac world, it appears in the hands of komasts, while in association with poetry, it can be found in the hands of the Muses. The *barbitos* can also be seen in domestic scenes of the female world, in the *gynaecaeum*.[52] But above all, it is associated with the universe of Eros: the god either holds the instrument in his hand,[53] or else it is seen, isolated, in an erotic context, perhaps with professional implications.[54]

The instrument held by Aegisthus has a seductive aspect which brings to mind Paris and his lyre. Facing Clytemnestra, Aegisthus does not seem very capable of wielding power, preoccupied as he is in the quest for inspiration.[55] Although the playing of a musical instrument cannot be qualified as a sign of idleness, the *barbitos* somehow seems to hold negative connotations. According to Aristotle, this instrument was intended for entertainment and not for education.[56] In interior and seduction scenes, it is always played by women,[57] whereas men use it only in images representing the symposion.

In a passage of the *Iliad*, there is a striking opposition between the attributes of Clytemnestra and Aegisthus. In fact, when Hector points out to his brother the vanity of Aphrodite's gifts and the *cithara* on a battlefield, Paris answers, comparing the heart of his elder to the hardness of the axe.[58] Here we see the opposition of two paradigms, the masculine warrior figure armed with the *pelekus* contrasted with that of the seductive musician. As Jean-Pierre Vernant expresses so well:

> dans le couple Egisthe–Clytemnestre, c'est Clytemnestre l'homme et Egisthe la femme. . . . Dans sa décision de tuer Agamemnon, les griefs qu'elle a pu légitimement invoquer contre son époux ont pesé moins que son refus de la domination masculine, sa volonté de prendre la place de l'homme à la maison . . . dans l'affirmation de sa volonté virile,

la reine prétend se substituer au mâle sur tous les plans: elle revendique
la fonction active dans le gouvernement de l'Etat, dans le mariage . . .
comme elle l'assume, glaive en main [or rather, double-edged ax!] dans
l'exécution d'un crime dont elle laisse à son comparse la part fémi-
nine.[59]

Like Paris, Aegisthus cuts a poor warrior figure by comparison to
Orestes. In the vase-paintings, this opposition is expressed in striking
ways. Aegisthus is bearded whereas Orestes is clean-shaven; he is seated
while Orestes stands; and he is dressed in a long garment whereas his
attacker wears a short *chiton* or is naked. The depiction of Orestes dressed
like a warrior is also meaningful. He has, in fact, no reason to be clothed in
this manner. He should rather conceal himself in the inoffensive garments
of a traveller, as he does when he visits Agamemnon's tomb.[60] But thus
represented, Orestes embodies the virtues of the soldier, courage, and the
values of hoplite combat, the most democratic form of combat in ancient
Greece. Orestes thus appears as the hero who eliminates the tyrant
Aegisthus, pretender to illegitimate power.[61] It is clear that this series of
vases illustrating the murder of Aegisthus, which begins around 510 BCE
and terminates around 460 BCE, cannot fail to remind the viewer of
another political change brought about by bloodshed. At about the same
time, a new Athenian hero was very much in fashion, both in the icono-
graphic programs of public monuments – as, for example, in the sculptural
decoration on temples – and in vase paintings intended for private and
individual use. We refer here to Theseus, of course, the model of the good
king, the democratic king who gives power to the people. Theseus appears
occasionally in vase-painting with the features of one of the tyrannicides,
whose statues used to stand in the Athenian agora.[62] Like Theseus, Orestes
is a hero of the new political rule, and in him we can see democratic values
triumphing over the abusive government of tyrants.

The last relationship, between mother and son, sets the mother at a
disadvantage. She who is going to be Orestes' next victim is represented
again as an attacker.[63] Running up behind Orestes to take him by surprise,
she threatens her son in order to protect Aegisthus, unafraid to show her
preference for her lover. She again uses an implement of slaughter in her
attempt to commit a new murder, a new sacrificial parody. The young man,
wearing hoplite clothing and armed with a sword, is attacked savagely by his
raging mother, who is on the verge of committing infanticide, motivated
more by amorous desire than by blood ties. Orestes, therefore, is absolved
of all guilt and, moreover, he accomplishes a legitimate act of revenge for
the murder of his father, ordered by Apollo. Matricide is thus justified.

The woman represented in these images appears as a creature of vio-
lence, easily recognized by her axe in the scenes where she is ready to kill.[64]
Attacking the father and the son with an instrument intended for sacrificial

use, she simultaneously destroys the social and the divine order. By assuming a masculine role and by laying claims to masculine privileges, she submerges her universe in blood. Through her behaviour, she will bring about her own death. The murder of her husband and her choice of lover over children emphasize the perverted nature of the liaison she forms with Aegisthus. The latter, whose only weapon is his ability to seduce, is unable to defend himself against his enemies other than by trickery – nor can Clytemnestra, who is incapable of maintaining to the end the masculine role that she has chosen for herself. She will not be able to fight a young man invested with the military qualities which form the *andreia*. Her attempt at equality is a failure. We can see that the partners must adhere to the sexual roles assigned to them according to the customs of Athenian society. Trying to change the social order is to endanger a larger order, which men and gods unite to uphold. With their specific iconographic language, vase-painters defend certain values and a certain established order, that of the Greek city. In that order, Clytemnestra embodies every form of danger.[65]

NOTES

1 Cf. F. I. Zeitlin, "The Dynamics of Misogyny: Myth and Mythmaking in the *Oresteia*," *Arethusa*, 1978, vol. 11 (1–2), pp. 149–84.

2 Homer, *Odyssey* III, 193–4; 263–72; 303–12; IV, 521–37.

3 Ibid. XI, 406–53.

4 In Stesichoros already, Clytemnestra seems to have taken an active part in her husband's murder: cf. M. I. Davies, "Thoughts on the *Oresteia* before Aischylos," *Bulletin de Correspondance Hellénique*, 1969, vol. 93, pp. 214–60; A. Lesky, "Die Schuld der Klytaimestra," *Wiener Studien*, 1967, vol. 80, pp. 5–21; A. Moreau, "Les sources d'Eschyle dans l'Agamemnon: silences, choix, innovations," *Revue des Études Grecques*, 1990, vol. 103, pp. 47–51. On the interpretations of the myth before Aeschylus, cf. A. Neschke, "L'Orestie de Stésichore et la tradition littéraire du mythe des Atrides avant Eschyle," *L'Antiquité Classique*, 1986, vol. 55, pp. 283–301.

5 Terracotta plaque from Gortyn, end of the seventh century BCE, Heraklion Museum, 11152, *Lexicon Iconographicum Mythologiae Classicae (LIMC)*, Zürich and München, Artemis, 1984–, s.v. Klytaimestra n. 4, or fragments of bronze shield band from Olympia, 575–550 BCE, Olympia Museum, B 1654, *LIMC*, s.v. Klytaimestra n. 5.

6 On this question, cf. E. T. Vermeule, "The Boston Oresteia Krater," *American Journal of Archaeology*, 1966, vol. 70, pp. 1–22; M. I. Davies, "Thoughts on the *Oresteia*;" A. J. N. W. Prag, *The Oresteia, Iconographic and Narrative Tradition*, Warminster, Aris and Phillips Ltd and Chicago, Bolchazy-Carducci Publishers, 1985.

7 Bibliographic indications are given in the *LIMC*, s.v. Klytaimestra.

8 Only the scenes identified with certainty will be studied here, except for the non-narrative ones. For a more exhaustive list of the representations of Clytemnestra, cf. *LIMC*, s.v. Klytaimestra.

9 Boston, 63.1246, J. D. Beazley, *Attic Red-figure Vase-Painters*, 2nd ed. (*ARV²*), Oxford, Clarendon Press, 1963, 1652. A complete description is given by Vermeule, "The Boston Oresteia Krater," *passim.*

10 Prag, *The Oresteia*, p. 4.

11 Vermeule, "The Boston Oresteia Krater," p. 21.

12 Cf. in particular P. Vidal-Naquet, "Chasse et sacrifice dans l'Orestie d'Eschyle," in J.-P. Vernant and P. Vidal-Naquet, *Mythe et tragédie en Grèce ancienne*, Paris, La Découverte, 1972.

13 Aeschylus, *Agamemnon* 1126–8, trans. H. Weir Smyth, ed. H. Lloyd-Jones, Cambridge, Mass., Harvard University Press and London, W. Heinemann (*The Loeb Classical Library*), 1971 [1926].

14 Ibid. 1382–3.

15 Homer, *Odyssey* XXII, 384–9, trans. A. T. Murray, Cambridge, Mass., Harvard University Press and London, W. Heinemann (*The Loeb Classical Library*), 1919.

16 Aeschylus, *Agamemnon* 357–60. On the comparison between defeated men and fish caught in the net, cf. P. Ceccarelli, "La fable des poissons de Cyrus (Hérodote I, 141): son origine et sa fonction dans l'économie des Histoires d'Hérodote," forthcoming in *Métis.*

17 Aeschylus, *Agamemnon* 1375.

18 Aeschylus, *Libation-Bearers* 555–8, trans. H. Weir Smyth, ed. H. Lloyd-Jones, Cambridge, Mass., Harvard University Press and London, W. Heinemann (*The Loeb Classical Library*), 1971 [1926].

19 Aeschylus, *Agamemnon* 1114–17.

20 Plato, *Laws* 824a, trans. T. J. Saunders, Harmondsworth and New York, Penguin, 1980.

21 I, 62. Cf. Ceccarelli, "La fable des poissons de Cyrus (Hérodote I, 141)," *passim;* C. Catenacci, "Il turannos e i suoi strumenti: alcune metafore 'tiranniche' nella Pitica II (vv. 72–96)," *Quaderni urbinati di cultura classica*, 1991, vol. 68, pp. 85–95.

22 Aeschylus, *Libation-Bearers* 492.

23 M. Detienne and J.-P. Vernant, *Les ruses de l'intelligence*, Paris, Flammarion, 1974, p. 20.

24 M. Detienne and J.-P. Vernant, *ibid.*, p. 29.

25 Lost cup of the Brygos Painter, once Berlin, F 2301 (ex 1610), *ARV²* 378, 129; *LIMC*, s.v. Klytaimestra n. 15.

26 Already in Stesichorus' poem, Clytemnestra probably used the double axe, as the fragments seem to testify: cf. Davies, "Thoughts on the *Oresteia.*"

27 M. I. Davies, "Aeschylus' Clytemnestra: sword or axe?", *Classical Quarterly*, 1987, vol. 37, pp. 65–75; A. H. Sommerstein, "Again Clytemnestra's weapon," *Classical Quarterly*, 1989, vol. 39, pp. 296–301; A. J. N. W. Prag, "Clytemnestra's weapon yet once more," *Classical Quarterly*, 1991, vol. 41, pp. 242–6.

28 Aeschylus, *Libation-Bearers* 889.

29 Sophocles, *Electra* 97–9, ed. and trans. H. Lloyd-Jones, Cambridge, Mass. and London, Harvard University Press, 1994.

30 Euripides, *Electra* 160, ed. and trans. M. J. Cropp, Warminster, Aris and Phillips Ltd, 1988.

31 Euripides, *Hecuba* 1279.

32 For example, double axe: fragment of the Castelgiorgio Painter, Athens, Acr., 297 a–e, *ARV²* 386, 5; amphora by Hermonax, Oxford, Ashmolean Museum, 1966.500, *ARV²* 487, 66; *oboloi*: lekythos by the Brygos Painter, Vatican, 17921, *ARV²* 385, 224. They are also provided with more traditional fighting weapons, e.g. spear: cup by the Brygos Painter, New York MMA, 96.9.37, *ARV²* 379, 156; sword: column krater by the Pan Painter, Munich, 2378,

ARV^2 551, 9; and with a range of unexpected weapons, belonging either to the natural world, such as rocks and branches, or to the feminine domestic sphere, such as a pestle. Cf. for example the stamnos by the Dokimasia Painter, Basel Antikenmuseum, coll. Bolla, ARV^2 1652 (where also appear a spit, spear, sword) or even to the agricultural sphere: a sickle, for example, on the stamnos of Hermonax, Paris Louvre, G 416, ARV^2 484, 17 (also with a spit, double axe, rock, spear). For a more exhaustive list of vases, cf. F. M. Schoeller, *Darstellungen des Orpheus in der Antike*, Freiburg, 1969, and *LIMC*, s.v. Orpheus. In a completely different context, it appears in the hands of heroes like Herakles or Theseus, or as an attribute of Hephaestus, a subject which I shall not be studying here.

33 Cf. the list of representations in *LIMC*, s.v. Lykourgos.

34 F. I. Zeitlin, "The Motif of the Corrupted Sacrifice in Aeschylus' *Oresteia*," *Transactions of the American Philological Association*, 1965, vol. 96, pp. 463–508; "Postscript to Sacrificial Imagery in the *Oresteia*, Agamemnon 1235–1237," *Transactions of the American Philological Association*, 1966, vol. 97, pp. 645–53; A. Moreau, *Eschyle: la violence et le chaos*, Paris, Les Belles Lettres, 1985, especially pp. 86–99. Since the violence of the ritual slaughtering of the ox is never shown on Attic vases, it is all the more striking in metaphorical scenes. Cf. J. L. Durand, *Sacrifice et labour en Grèce ancienne*, Paris, La Découverte et Rome, École Française de Rome, 1986.

35 The interpretation of Prag, *The Oresteia*, p. 82, according to which the axe is usually used for domestic and agricultural purposes and only accidentally employed in an emergency as a weapon, is very restricted; in fact, if there ever was a premeditated murder, it was that of Agamemnon.

36 The comparison with the sacrifice of Iphigenia, given over to Artemis by her father, is inevitable. The analysis of the relation between these two events will be developed in a larger study. However, it should be noted that Clytemnestra's declaration, in which she swears to avenge her daughter, can be accomplished only in a distorted sacrifice.

37 Cup by the Marlay Painter, Ferrara, T 264, ARV^2 1280, 64.

38 For example, the krater by the Chrysis Painter, Boston, 95.24, ARV^2 1159; skyphos by the Euaion Painter, Warsaw, 14.24.64, ARV^2 797, 142; oinochoe of the Leagros Group, Berlin, F 1915, J. D. Beazley, *Attic Black-figure Vase-Painters*, Oxford, Clarendon Press, 1956, pp. 377, 247.

39 The images showing the ox driven to the altar present an unbound victim serenely accepting its fate.

40 M. Detienne, "Violentes eugénies," in M. Detienne and J.-P. Vernant, *La cuisine du sacrifice en pays grec*, Paris, Gallimard, 1979, pp. 183–214.

41 M. Detienne, *ibid.*, pp. 186–7.

42 The list of the vases is in the *LIMC*, s.v. Aigisthos and s.v. Klytaimestra.

43 Krater by the Harrow Painter, Vienna, 1103, ARV^2 277; lost cup of the Brygos Painter, once Berlin, F 2301, ARV^2 378, 129. The painters represented only a part of the scene: in the first case Clytemnestra, double axe in hand, is held back by a bearded man with a *petasos* on his neck, and in the second Clytemnestra is alone with her axe, running towards a door, probably to help Aegisthus. The scene was sufficiently popular with the Athenian public that painters needed to illustrate only a part of it.

44 Orestes is not clothed as a warrior on only two occasions, on two vases that show him naked, with a *chlamys*, by the Aegisthus Painter: the stamnos Bologna, 230, ARV^2 504, 8; and the krater in Malibu, J. Paul Getty Museum, 88.AE.66; *LIMC*, s.v. Klytaimestra n. 17.

45 Krater by the Dokimasia Painter, Boston, 63.1246, *LIMC*, s.v. Aigisthos n. 10; stamnos by the Berlin Painter, Boston, 91.227a, 91.226b, *ARV*² 208, 151. On the identification of the musical instrument, cf. J. McIntosh Snyder, "Aegisthos and the Barbitos," *American Journal of Archaeology*, 1976, vol. 80, pp. 189–90.

46 Named on the pelike by the Berlin Painter, Wien, 3725, *supra*, n. 31.

47 Cf. Vermeule, "The Boston Oresteia Krater," p. 20; J. G. Griffith, "Aegisthos Citharista," *American Journal of Archaeology*, 1967, vol. 71, pp. 176–7.

48 *Homeric Hymn to Hermes* 409ff. On the erotic power of poetry, cf. C. Calame, *I Greci e l'Eros*, Roma and Bari, Laterza, 1992.

49 Homer, *Odyssey* III, 264. Cf. also Z. Ritook, "The Views of Early Greek Epic on Poetry," *Mnemosyne*, IV, 1989, vol. 52, p. 335. As Griffith suggests, "Aegisthos Citharista," p. 176, Helen and Clytemnestra are thus placed side by side, yielding to the same seductive power of music and deceitful words.

50 Cf. F. Hauser, "Orpheus und Aigisthos," *Jahrbuch des Deutschen Archäologischen Instituts*, 1914, vol. 29, pp. 26–32; M. Schmidt, "Der Tod des Orpheus in Vasendarstellungen aus schweizer Sammlungen," in *Zur griechischen Kunst, Antike Kunst*, Suppl. 9 (1973), pp. 96–8; M. I. Davies, "Thoughts on the *Oresteia*, pp. 241–8, tries to find an origin in a lost tragedy evoked by Machon (A. S. F. Gow (ed.), *Machon: The Fragments*, Cambridge, Cambridge University Press, 1965, frag. XI).

51 M. L. West, *Ancient Greek Music*, Oxford, Clarendon Press, 1992, p. 58: "[the *barbitos*] enjoyed a great vogue in certain elegant Athenian drinking circles in the late sixth and early fifth centuries."

52 Cf. M. Maas and J. McIntosh Snyder, *Stringed Instruments of Ancient Greece*, New Haven and London, Yale University Press, 1989.

53 For example the lekythos by the Brygos Painter, Gela, 67, *ARV*² 384, 219.

54 For example, the cup by Onesimos, London, E 44, *ARV*² 318, 2.

55 Cf. F. Frontisi-Ducroux and F. Lissarrague, "From Ambiguity to Ambivalence," in D. M. Halperin, J. J. Winkler, and F. I. Zeitlin (eds), *Before Sexuality: The Construction of Erotic Experience in the Ancient Greek World*, Princeton, Princeton University Press, 1990, especially pp. 220–3.

56 Aristotle, *Politics* 1341 a–b.

57 With the exception of the vases representing music lessons (and in contradiction to Aristotle!), cf. for example the hydria by the Agrigento Painter, London, E 171, *ARV*² 579, 87.

58 Homer, *Iliad* III, 54–5 and 60–2. Even if we are dealing here with the craftsman cutting wood, it is also the word *pelekus* which is used.

59 J.-P. Vernant, *Mythe et pensée chez les Grecs I*, Paris, Maspero, 1981 (1965), p. 134.

60 For example, the skyphos by the Penelope Painter, Copenhagen, 597, *ARV*² 1301, 5.

61 Without attempting to see in Orestes the hero of a particular family, cf. Prag, *The Oresteia*, pp. 103–5.

62 Cf. C. Bérard, "Iconographie – Iconologie – Iconologique," *Études de Lettres*, 1983, vol. 4, pp. 5–37. The placing together of the two heroes is also apparent in the Athenian festivals of the Anthesteria and Oschophoria or in the foundation accounts of the cults dedicated to Dionysos; to the matricidal Orestes corresponds the parricidal Theseus. Cf. C. Calame, *Thésée et l'imaginaire athénien*, Lausanne, Payot, 1990, especially pp. 324–7.

63 If the matricide is represented in south Italian vase-painting, this is not the case in Attic pottery, where none of the scenes can be identified with certainty. Cf. *LIMC*, s.v. Klytaimestra.

64 On a few occasions, Clytemnestra appears in another context, e.g. in a domestic

scene: the pyxis attributed to the circle of Douris, London, E 773, ARV^2 805, 89; or beside Leda's egg: cup by the Xenotinos Painter, Boston, 899.539, ARV^2 1142, 1, where an inscription is necessary for her identification.

65 I wish to thank J. Favrod, D. Castaldo, C. Bron, and A. Loeffler, Professors C. Calame and C. Bérard for their suggestions and enlightened remarks. My thanks also to Lilamani de Soysa and the volume editors for the numerous corrections to the English version of this paper.

6

SAPPHO IN ATTIC
VASE PAINTING

Jane McIntosh Snyder

According to an Oxyrhynchus papyrus dated to the late second or early third century CE, or only some nine hundred years after Sappho's death, Sappho in respect to μορφή ("shape") was εὐκαταφρόνητος and δυσειδεστάτη ("easy to despise" and "unshapely"); in respect to ὄψις ("appearance") she was φαιώδης ("dark-complexioned"); and in respect to μέγεθος ("size") she was μικρά ("small").[1] Such was the disrepute into which Sappho had fallen by the third century CE that her shape, appearance, and size all receive bad marks. And so perhaps began the stereotypical image of the lesbian as too short, dark, and ugly to attract a man.

No doubt influenced by the third-century CE papyrus, one of J. M. Edmonds's early twentieth-century translations of Sappho fr. 52 V paved the way for the short Sappho to enter the realm of proven biographical fact. The fragment in question reads ψαύην δ' οὐ δοκίμωμ' ὀράνω δυσπαχέα, which seems to mean something like "I do not think that I will touch the sky with my two arms." In Edmonds this came out as "This little creature, four feet high, cannot hope to touch the sky."[2] Then in Hermann Fränkel's 1951 survey of Greek poetry, we learn regarding Sappho that "She herself, *by her own account* [italics mine], was small, not very pretty, and dark."[3]

The only reference to Sappho that can be dated to her own lifetime is in a fragment of Alcaeus, fr. 384 V. Unfortunately, the portion of the line in which Sappho's name is mentioned is not entirely clear, but most editors read it as ἰόπλοκ' ἄγνα μελλιχόμειδε Σάπφοι, "O weaver of violets, holy, sweet-smiling Sappho." I take the epithet ἰόπλοκος as a metaphorical reference to Sappho's weaving bouquets of poetry, not as a comment on her hair-do, as those who translate the opening of the line as "O lady of the violet hair" seem to suggest.

What Sappho really looked like is not of much interest compared to her poetry, but it is of interest to examine what people thought she looked like, or might have looked like. The few surviving coins minted on Lesbos that bear Sappho's image and an identifying label offer representations that are too small for fruitful speculation, and there are no clearly identifiable surviving statues.[4] Cicero (*In Verrem* 2.4.126) mentions a fine bronze statue

of her by Silanion (fourth century BCE) that once adorned the town hall in Syracuse, but charges that Verres stole it for his own personal enjoyment while he was governor of Sicily during the years 73–71 BCE. We do, however, have four surviving inscribed Attic vase-paintings that depict Sappho in a variety of poses, and it is to these four representations that I now turn.

A quick overview of the four vases in chronological order will be useful before we turn to questions of the narrative position of the Sappho figure and issues of gender construction. As you will see, the four representations bear little resemblance to one another.

The earliest portrait, on a hydria dated to about 500 BCE now in Warsaw, shows Sappho wearing *chiton* and *himation*, standing alone, and facing to the right (Fig. 13).[5] She is playing the *barbitos*, her left hand behind the strings and her right hand just completing the stroke of the *plektron* across the strings. This is the name vase of the so-called "Sappho Painter." Decorated in "Six's technique" with a combination of incised lines and added white paint, the painting shows clearly the inscribed label, PSAPHO, just above the *plektron*. Although none of the conventional signs of singing is present (open mouth, head thrown back, or a "cartoon balloon" issuing from the singer's mouth), it appears that the painter is trying to emphasize Sappho's role as a musician by showing her playing her lyre.

A slightly later inscribed portrait, this one dated to about 480 BCE, appears on a red-figured kalathoid krater in Munich by the Brygos Painter (Fig. 14). This time Sappho is shown standing together with Alcaeus, who stands facing right with his head lowered while he plays his *barbitos*. From his mouth issue five small circles, intended to show that he is singing.[6] The figures are labelled ALKAIOS and SAPHO. Both figures wear elegantly pleated, transparent Ionian *chitons*, and Alcaeus wears a *mitra* around his head, while Sappho is shown with a decorated fillet around hers. She stands looking at Alcaeus, shown turning to him in a relatively unusual three-quarter view. She holds her *barbitos* in her left hand more or less in playing position, but her right hand holds the *plektron* down and in front of her, well away from the instrument. She seems not to be playing or singing at the moment captured by the Brygos Painter, but rather to be listening to Alcaeus.

A third depiction of Sappho, holding the same type of lyre, is found on a red-figured calyx-krater in Wuppertal also dated to about 480 BCE and attributed to the Tithonos Painter (Fig. 15).[7] Here Sappho, shown alone, stands with her body facing right, performing a dance step and turning her head backwards towards her extended right arm, which holds the *plektron*. The left arm holds the *barbitos* in playing position. The figure, labelled SAPHO near her head, wears *chiton*, *himation*, and a *sakkos*. An *aulos* bag hangs from the lower arm of the *barbitos*, suggesting the presence of the oboe-like instrument so often seen in sympotic or komastic contexts as the

Figure 13 Detail of Black-figure hydria in Warsaw, National Museum, inv. 142333

110

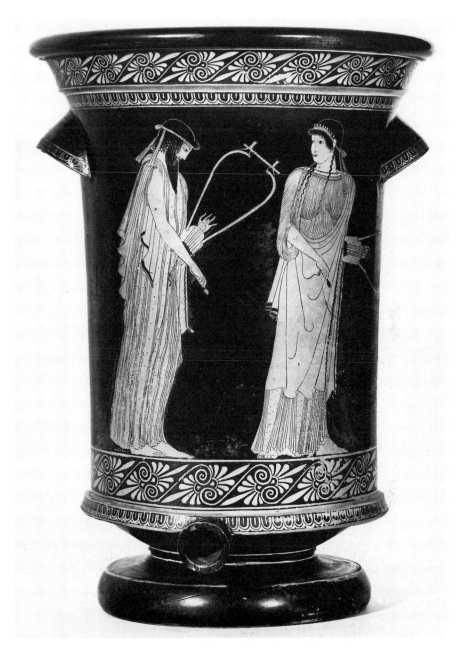

Figure 14 Red-figure kalathoid krater by the Brygos Painter, Munich,
Antikensammlung, inv. 2416

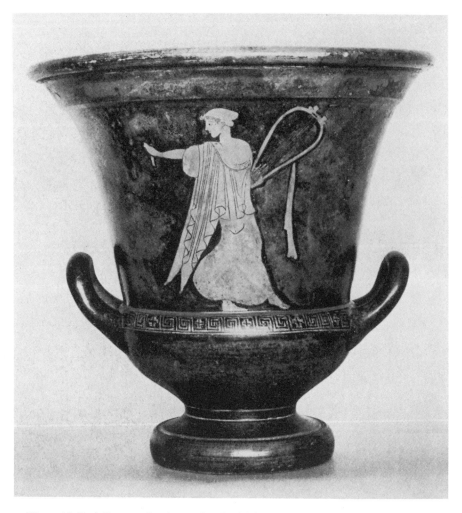

Figure 15 Red-figure calyx-krater by the Tithonos Painter, Wuppertal, Von de Heydt-Museum, inv. 49

companion of the *barbitos*. The emphasis of the scene, however, seems to be on the dance step that the Sappho figure executes, rather than on musical performance *per se*.

The final inscribed scene is of quite different composition, featuring as it does a seated Sappho amongst a group of women. This is a red-figured hydria in Athens dated to about 440–420 BCE and attributed to the group of Polygnotos (Fig. 16). The seated figure, identified by an inscription SAPPOS above her arms, sits in a *klismos* looking at an open book-roll. Beside her on the right stand two women, one of whom (named Kallis)

112

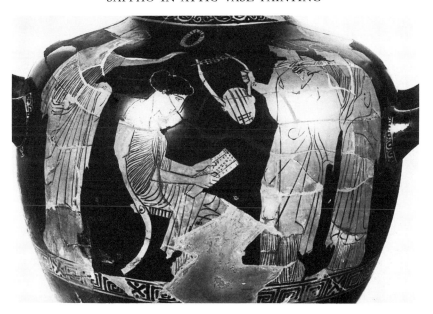

Figure 16 Detail of Red-figure hydria, Athens, National Museum, inv. 1260

extends an ordinary *chelys*-lyre (not the long-armed *barbitos*) towards the seated Sappho. On the left stands a figure named Nikopolis, perhaps preparing to take down a wreath from the wall, presumably to crown Sappho as a victorious poet.[8] The lettering on the book-roll has been studied in detail by J. M. Edmonds, who identified the title of the roll as πτερόεντα ἔπεα, "Winged Words," and the first line as beginning *theoi*, even going so far as to restore several additional words on the basis of enlarged photographs of the vase.[9] This ingenious article, as the author himself admits, is highly conjectural. Edmonds stresses that in this scene Sappho is neither singing nor playing, but reading from a book. Of course, the presence of the lyre being extended towards her may suggest that she is *about* to sing, or that Kallis is about to sing one of Sappho's songs. In any case, in terms of what is actually depicted, Athens 1260 shares in common with Munich 2416 and Wuppertal 49 the fact that the Sappho figure is not shown at the actual moment of performing her songs. Only the Warsaw hydria depicts her in the act of performance.

To sum up, then, we have here two solo Sapphos (Sappho playing the *barbitos* and Sappho dancing), one near-duet (Sappho listening to Alcaeus), and one potential chamber music session (the seated Sappho with a group of women). Despite the paucity of examples, do any patterns emerge here? What do these four scenes reveal about the painters' conception of the poet, whose reputation in Athens seems to have been firmly established at least as early as the time of Solon?[10] And how does the narrative position of

113

the Sappho figure in each scene contribute to our understanding of the painters' construction of gender? Is there any connection between our four vases and the conclusions drawn in a modern analysis of images of men and women in both art and advertising to the effect that "*men act and women appear?*"[11]

Although these four vase-paintings comprise a rather small set of examples, some tentative observations can still be made about them. First, it is indeed a curious fact that none of the paintings shows Sappho actually singing, despite the frequent use of a singing pose in the representations of mythical singers like Orpheus or Thamyris and of other poets such as Anakreon, not to mention Alcaeus himself on Munich 2416.[12] I think it could be argued that these portrayals constitute instances of the "muting" of a female figure as represented by male artists. These four images do not deny Sappho's role as a singer-poet, but none of them emphasizes that role as clearly as they usually seem to in the case of the male poets. At the moment captured by these vase painters, Sappho in effect has no voice. It is as if the painters had taken her words in fr. 31 V just a bit too literally – the part where she says "for the instant I look upon you, I cannot anymore / speak one word, / But in silence my tongue is broken . . .".

Secondly, the narrative position of the Sappho figure in at least three of these paintings (all but the Warsaw hydria) is considerably weaker than the Sappho persona of the surviving poems would suggest. In the fragments of her songs, Sappho creates herself as a character in the narrative, as for example in her strong presence in the one complete poem that we have left, the *Hymn to Aphrodite* (fr. 1 V). Sappho as a character in her own poetry appears also in fr. 65 V, 94 V, and 133 V.

But when we compare the poetic image with the vase painting images (all but the Warsaw hydria), Sappho's narrative position has in each case been diluted. This dilution is most obvious in the case of Munich 2416, in which Alcaeus seems to be the dominant figure. He is singing and playing, while Sappho holds her *plektron* in abeyance as she leans slightly away from him, as if waiting, perhaps, to respond to his song with one of her own. Her gaze directed towards Alcaeus helps direct the viewer's gaze towards him as the dominant figure in the composition. At the moment captured by the Brygos Painter, it is the male poet whose voice is being heard, while Sappho stands silent, listening and waiting.

When we look again at the Wuppertal calyx-krater, we note that the dance step that the Sappho figure is executing in fact forces her to assume a posture in which she could not possibly play the *barbitos*. Her right foot is slightly raised off the ground, necessitating the counterbalancing gesture with the extended right arm, held far away from the strings of the instrument. The resulting emphasis in the scene on the positioning of her body and the drapery of her *himation* results in a portrait of a dancer, not a poet.

114

Without the identifying inscription, we probably would not have guessed that the painter intended to represent Sappho.

Regarding Athens 1260, Schefold quite rightly points out that Sappho here is shown as a much more subdued figure than is the case in portraits of, say, Orpheus or Thamyris, for she is sitting with bowed head and does not even hold an instrument. Except for the presence of Nikopolis and the wreath, perhaps symbolic of Sappho's status as a successful poet, the composition of this scene is similar to many others that show women performing and singing for each other in an interior space, not in a contest situation but simply for enjoyment in the women's quarters.[13] Despite the symbols of success associated with Sappho in this scene, the vase painter presents Sappho as appearing rather than acting. Slumped in her chair, passively reading from the book-roll, she seems to me more like a muse than a singer. Perhaps she has been co-opted into the framework of the Athenian women's quarters, where a book-roll of her poetry serves as the inspiration for the women's musicale.[14] Indeed, the vase-painter's decision to portray Sappho as reading from a book-roll may indicate that, by the second half of the fifth century, Sappho's poetry was circulating in Athens in book form rather than simply via oral performance and memorization. Alternatively, one could argue that the vase painter has simply taken an ordinary "genre scene," a musicale in the women's quarters, and added to it a celebrity name. The complexity of the iconography in this scene, involving as it does both the book-roll and the lyre, renders it more susceptible to various interpretations than the other three portraits of the famous poet.

What about the clientele for whom these images were created? Again, it would be nice to have a larger sample on which to base any hypotheses, but, on the basis of what we have available, it seems that three of these four vases were probably purchased for a female recipient. The Warsaw vase and the Athens vase, both being hydriai, were more than likely used by women for their household chores. As T. B. L. Webster notes, the Munich kalathoid vase, although it is a vessel used for the mixing of wine, is influenced in its shape by a woman's workbasket, and was very likely given to a woman.[15] Only the Wuppertal vase, a calyx-krater of the sort routinely used for the mixing of wine and water, seems a less likely gift for a woman. Its rather anomalous image of Sappho as dancer was perhaps suitable for the komastic occasions on which it was used. As for the other three images, I offer the speculation that these presented what was considered by Athenian standards an "appropriate" model of a woman poet — subdued, passive, and in fact at least momentarily silent.

Scholars such as Schefold and Webster have been quick to connect the scene on the Munich vase with the report in Aristotle's *Rhetoric* of a poem of Sappho's that he claims was written in response to Alcaeus' statement "I wish to say something, but shame [*aidos*] prevents me"[16] Sappho's reply was supposed to have been, "If you had a desire for the good and the

beautiful, and your tongue were not stirring up something bad to say, shame would not cover your eyes, but you would speak" Aside from the textual difficulties of this fragment (137 V), including the doubts raised by Stephanus' commentary about the identity of the speakers in what he takes to be a dialogue composed by Sappho (not a reply by her to a poem by Alcaeus), it seems like grasping at straws to try to connect a specific vase-painting with a specific short fragment. At least in this instance, such a connection may also distort our own perception of the image. Is this an Alcaeus overwhelmed with shame, reluctant to speak and subjected to rebuke by a morally superior Sappho?[17] Or is it an Alcaeus caught at the moment of performance of his song, his words coming from his lips as the strings of his *barbitos* sound their accompaniment, while Sappho politely waits, attentive and silent?

I leave that for the reader's decision, and close with two somewhat more modern images of our poet, one not unlike the Munich vase in some ways, the other very different indeed. The first is a painting by Sir Lawrence Alma-Tadema, an oil on canvas dated to 1881 and entitled *Sappho and Alcaeus*, now in the Walters Art Gallery in Baltimore (Fig. 17). In a theater overlooking the sea, Alcaeus sits on the right playing the *cithara*, while Sappho, in rapt attention, stares dreamily at the performer, leaning on her arms and surrounded by four of her "girls," all but one of whom seem equally spellbound by the performance. No lyre, no scroll for Sappho,

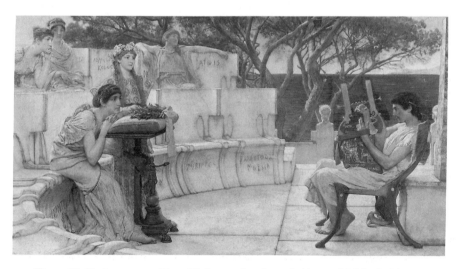

Figure 17 Sir Lawrence Alma-Tadema, *Sappho and Alcaeus* (1881), Baltimore, Walters Art Gallery

116

nothing but a cushion with a wreath on it, which seems destined for Alcaeus. The passivity of which we have seen indications in the Attic vase painters' renditions of Sappho is – in Alma-Tadema's vision – total.

The other image is the Sappho plate from Judy Chicago's 1979 monumental art work called *The Dinner Party*, a huge triangular banquet table with

Figure 18 Judy Chicago, Sappho dinner plate from *The Dinner Party* (1979)

117

thirty-nine place settings, each representing a major female figure from Christine de Pisan to Sojourner Truth, from Sappho to Georgia O'Keefe (Fig. 18).[18] The table rests on a large triangular floor made of 2,300 porcelain tiles, on which are written the names of 999 additional women. Sappho's place-setting includes the motif of a Greek temple and the suggestion of a lyre woven in to the *S* of Sappho's name – along with a bold floral expression of the female body. Who knows, it may be that Judy Chicago comes much closer to the heart of Sappho's poetry, with its sensuous images of trembling bodies, soft beds, purple headbands, roses and honey-lotus, garlands and perfume, and the rosy-fingered moon, than did the Athenian vase-painters, striving to create images that would please the Athenian men who wanted to please their wives with a suitable – and suitably safe – gift.[19]

NOTES

1 P. Oxy. 1800 fr. 1; see fr. 252 V. The present paper focuses on the relationship between the image of Sappho in Athenian vase painting and her image in her own poetry. For a more general discussion, including theoretical issues, see J. McI. Snyder, "Sappho and Other Women Musicians in Attic Vase Painting," forthcoming in A. Buckley (ed.), *Sound Sense: Essays in Historical Ethnomusicology*, Études et Recherches Archéologiques de l'Université de Liège, Liège. See also M. Robertson and M. Beard, "Adopting an Approach," in T. Rasmussen and N. Spivey (eds), *Looking at Greek Vases*, Cambridge, Cambridge University Press, 1991, pp. 1–35. As Beard claims (p. 21), "Images of women on Athenian pots served to define proper female behavior."

2 Attributed without specific citation to J. M. Edmonds by D. M. Robinson, *Sappho and Her Influence*, Boston, Marshall Jones, 1924, p. 36. The version in Edmonds's 1922 Loeb translation (his fragment 53) reads "A little thing of two cubits' stature like me could not expect to touch the sky."

3 H. Fränkel, *Dichtung und Philosophie des frühen Griechentums*, American Philological Association monograph no. 13, New York, American Philological Association, 1951, p. 231: "Sie selbst war, nach ihren eignen Angabe, klein und unansehnlich von Gestalt und dunkel."

4 For a summary of the available representations of Sappho and a list of non-extant portraits recorded, see G. M. A. Richter, *The Portraits of the Greeks*, abridged and revised by R. R. R. Smith, Ithaca, Cornell University Press, 1984, pp. 194–6. Besides the coins and the four vase paintings, there is also a Roman-period mosaic found at Sparta that shows an inscribed bust of Sappho; cf. *Bulletin de Correspondance Hellénique*, 1966, vol. 90, pp. 794–5.

5 Goluchow, inv. 32, now Warsaw, 142333, *ARV*[2] 300, *Paralipomena* 246. For a detailed description of the vase, see J. D. Beazley, *Greek Vases in Poland*, Oxford, Clarendon Press, 1928, pp. 8–10.

6 Munich, 2416, *ARV*[2] 385 and 1649, *Paralipomena* 367. On portrayals of singers (including ones from whose mouth issue intelligible words), see F. Lissarrague, *The Aesthetics of the Greek Banquet: Images of Wine and Ritual*, translated by A. Szegedy-Maszak, Princeton, Princeton University Press, 1990, pp. 123–39. See also E. Csapo and M. C. Miller, "'The Kottabos-Toast' and an Inscribed Red-

Figured Cup," *Hesperia*, 1991, vol. 60, pp. 367–82, especially the appendix on "Singers of Lyric Verse in Attic Red Figure."

7 See N. Kunisch, *Antike Kunst aus Wuppertaler Privatbesitz*, Wuppertal, Heydt Museum, 1971, number 49 (not in Beazley).

8 Athens, 1260, *ARV*² 1060, *Paralipomena* 445. On the identification of the two labelled standing figures, see J. D. Beazley, "The Hymn to Hermes," *American Journal of Archaeology*, 1948, vol. 52, p. 339, and H. R. Immerwahr, "Book Rolls on Attic Vases," *Storia e Letteratura*, 1964, vol. 93, p. 26; cf. also his *Attic Script: A Survey*, Oxford, Oxford University Press, 1990.

9 J. M. Edmonds, "Sappho's Book as Depicted on an Attic Vase," *Classical Quarterly*, 1922, vol. 16, pp. 1–14.

10 An ancient tradition portrays the statesman-poet Solon (*c.* 639–559 BCE) as an ardent admirer of Sappho's verse; cf. Aelianus *apud Stobaeus Anthologion*, 3.29.58.

11 J. Berger, *Ways of Seeing*, Harmondsworth and London, Penguin and British Broadcasting Corporation, 1972, p. 47. For a more recent study along similar lines, see V. Malhotra Bentz and P. E. F. Mayes (eds), *Women's Power and Roles as Portrayed in Visual Images of Women in the Arts and Mass Media*, Lewiston, Edwin Mellen, 1993.

12 On the portrayals of such musician-poets, see M. Maas and J. McI. Snyder, *Stringed Instruments of Ancient Greece*, New Haven, Yale University Press, 1989, pp. 118–20, 172, and *passim*.

13 See K. Schefold, *Die Bildnisse der antiken Dichter, Redner, und Denker*, Basel, Schwabe, 1943, p. 56.

14 On domestic scenes showing women engaged in reading and singing, see H. Immerwahr, "Book Rolls on Attic Vases," pp. 26–7. In connection with Athens 1260, he points out the significance of the wreath and the name Nikopolis ("Victory-City") as indicative of Sappho's fame.

15 T. B. L. Webster, *Potter and Patron in Classical Athens*, London, Methuen, 1972, p. 60. The vase is also inscribed with a *kalos* name, Damas, who may have been the individual who ordered the vase.

16 K. Schefold, *Die Bildnisse*, p. 54 and T. B. L. Webster, *Potter and Patron*, p. 60. See also C. Picard, "Art et littérature, I: Sur la rencontre d'Alcée et de Sappho," *Revue des Études Grecques*, 1948, vol. 61, pp. 338–44, who thinks that the painting reflects an actual encounter between the two poets; he believes that Alcaeus is depicted as a rejected lover and that Sappho dominates the scene.

17 See G. Ferrari, "Figures of Speech: The Picture of *Aidos*," *Métis*, 1990, vol. 5, pp. 185–200, who shows that *aidos* is most typically represented by an enveloping mantle, not just a downward glance. Professor Timothy J. McNiven has kindly provided me with a list of eighty-one vases (from his forthcoming lexicon of gestures in Attic vase painting) that fall under the category of "head down" portrayals; of these, he identifies fifty-seven as portraying sorrow or shame, and twenty-four (including Munich 2416) as simply indicating some form of concentration, as in listening to someone or singing. He identifies an additional group of "head down" gestures as indicating modesty. See also his *Gestures in Attic Vase Painting: Use and Meaning, 550–450 B.C.*, Ph.D. diss., University of Michigan, 1982, pp. 63–5.

18 J. Chicago, *Embroidering Our Heritage: The Dinner Party Needlework*, Garden City, Anchor, 1980.

19 Grateful thanks are owed to several scholars who offered me helpful criticism of this paper, particularly Timothy J. McNiven, Anna S. Benjamin, and Marilyn B. Skinner.

GENDER AND SEXUALITY IN THE PARTHENON FRIEZE

John G. Younger

It is generally accepted that the subject of the Parthenon frieze is broadly the Greater Panathenaic procession.[1] The East frieze's central scene depicts the Olympian deities attending a culminating ceremony, while the other three sides carry some of the major events in the procession, though Boardman[2] adds the idea that the equestrians there comprise the 192 Marathon heroes about to be welcomed by the gods on the east.

About the central scene above the doorway (Fig. 19), however, opinions have diverged widely. We see five figures, a girl on the left (E block V.31), a maiden (V.32), a matron (V.33), a bearded man (V.34), and a child (V.35). The figures are divided into two groups; the bearded man and child seem concerned with a piece of cloth that should be the *peplos* of Athena,[3] while the matron seems concerned with the stool that the maiden carries and perhaps eventually with the stool and other object that the girl also carries.[4] The entire scene should depict one or two moments, depending on how connected the figures are to one another.

But there are questions concerning all these aspects. More questions, however, concern the identity of the participants in the central scene and therefore the occasion of the action, either the myth-historical past or the approximate present.[5] From the myth-historical past the scene could refer to the founding of the festival, with the man as Kekrops and the matron as Ge, the child as Erechthonios, the maiden as Pandrosos.[6] For the approximate present, we would see the man as the priest-magistrate of Athens, the *archon basileus*, the matron as either his wife the *basilinna* or the priestess of Athena Polias, and the girl and child as young *Arrhephoroi*[7] and/or *paides amphithaleis*,[8] general helpers in cult affairs about whom we have little specific knowledge.

For the girls there is a third possibility. We know from the ancient sources that, in the actual Panathenaic procession, the daughters and wives of resident aliens in Athens (*metics*) followed the basket-bearers (*kanephoroi*) and carried parasols (as *skiaphoroi*) and stools (as *diphrophoroi*) for the Athenian women in the procession.[9] That the girl and the maiden carry stools is not in doubt,[10] but the girls are here at the focus of the entire

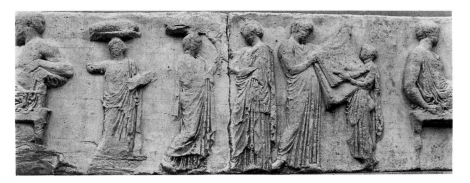

Figure 19 Parthenon East frieze block V, central *peplos*-folding scene

frieze, not following the basket-bearers who have been identified instead among the maidens farther along in slab VII, especially figures 50 and 51.[11] It therefore seems scarcely possible for the girl and the maiden to be non-citizen, *metic*, resident aliens; the one assumption that we should be able to make safely is that this focal scene concerns a theme central to Athenian society. Thus, since these two girls carry just two stools, the simplest explanation is that they are for the important adults immediately next to them, the priestess of Athena Polias and the *archon basileus*; and that would make the girls Athenians, specially chosen for this honor.

In any case, there has not yet been an identification of these people and their roles that has satisfied all conditions and all scholars,[12] and this paper will not attempt yet another one. Instead, it takes a totally different tack and concentrates instead not on what the scene represents as narrative but on what the scene presents as a social document.[13] I assume that the planners of this frieze and the craftsmen who executed it chose, consciously or subconsciously, to portray the figures on it either as respectable members of central Athenian society or as the divinities made in their image. We should be able, therefore, to detect their values and ideals reflected in the aspects and attitudes of the figures themselves, regardless of their individual identities.

Rather than insisting on knowing their function and title, let us instead examine these figures merely as Athenians. We see in the center a bearded adult man, presumably a citizen, back to back with a young adult woman, also presumably Athenian;[14] to either side are two children and to the left of the woman an adolescent female. In these terms, we have an ideal and intimate group of Athenians:[15] an adult man and woman together at the center surrounded by (cultic) children, a girl and maiden at the left and a child at the right.

The composition of the central scene, however, does not unite this group of typical Athenians, but divides it: the females at the left, the man and

child at the right – the two adults back to back as if splitting the scene into two opposing, though complementary halves. The characters in the left half are female, but of the right half only the sex of the bearded man is certain. And before this analysis can continue, the question of the sex of the child (Fig. 20) must be resolved.

The question is not new. Over the last twenty years, various scholars have engaged in a debate over the sex of the child, but recently the controversy has become heated:[16] Boardman points to the Venus rings on the neck of the child and calls it a girl; Clairmont points to its exposed buttock and calls it a boy.

Of course the interpretation of the narrative meaning of the central scene also hinges on the sex of this child. If a girl, then she might be one of the young *Arrhephoroi* who helped or will help weave Athena's *peplos* for the Greater Panathenaia; or she might be some other girl altogether, perhaps the youngest of Erechtheus' daughters preparing to sacrifice herself for the state – the garment being handed over would then be her shroud.[17] If the child is a boy, then he could be a member of the Praxiergidai clan which safeguarded the *peplos*, or a young male participant in the cult, a *pais amphithales*, or a specific individual like Erichthonios the founder of the Panathenaia.[18]

To bolster these narrative interpretations scholars point to various aspects of the child. Those who see a boy emphasize how the garment draped over its left shoulder reveals the child's nudity beneath,[19] which would be inappropriate for proper females who did not expose their buttocks publicly.[20] Those who see a girl emphasize the appropriateness of her age as an *Arrhephoros*, point to Venus rings on her neck as attributes of femininity, cite parallels for the drapery as one of the rare open-sided *peploi*, and, adducing how young girls might have danced naked at the Brauronia,[21] question the modern ascription of total feminine modesty to ancient practice.[22]

It is well known and well attested that male children are usually depicted totally nude[23] but female children are always portrayed clothed in a *chiton* or tunic.[24] The identification of an open-sided *peplos* that exposes the buttocks of the girl on the "Girl with Doves" stele[25] is not much help since the drapery on the Parthenon child is different, longer, more open and bulkier at the shoulder. This garment on the Parthenon resembles more the *himation* that children usually drape over their shoulder; girls wear a *chiton* under it, boys do not.[26]

Venus rings are more difficult because they appear and disappear depending on how the sculpted figures are lit. When the light comes only from above, as it does naturally and artificially in the Duveen gallery in the British Museum, the shadows produce Venus rings (see even my own photograph, Fig. 20); but where Allison Frantz has added two floodlights to the right of her camera, one close and one farther away, both lighting the

frieze horizontally, we see only simple incisions on the child's neck.[27] There seems to be some difference of opinion as to whether many women on the frieze have Venus rings (or Venus creases), or whether none does.[28] Their value in deciding the issue diminishes in any case since Venus marks not only do not appear on the girl portrayed in the "Girl with Doves" stele but do appear on some men even within the frieze.[29]

Aside from the problematic issue of gender, the controversy itself is ironic. Unless completely specific social and physical attributes are depicted, the gender of children is often ambiguous and often deliberately so in order to avoid imparting to them an inappropriate sexuality, even in many modern cultures.[30] Without a narrative context, the child in the East frieze's central scene turns ambiguous, and, rather than citing the presence of, or questioning the lack of, specific social or physical attributes

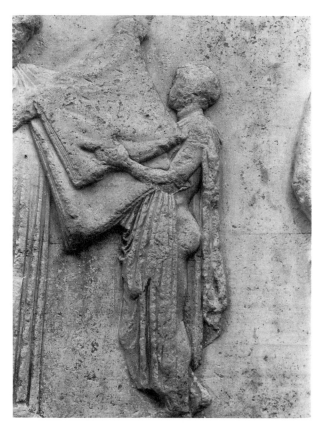

Figure 20 Parthenon East frieze block V, the child V.35

in order to buttress narrative choices, it might be more productive to inquire how the gender of this child was constructed in the first place. We may take several paths to discover this,[31] but it is also possible to trace the origin of this child as a compositional motif within the Parthenon frieze itself.

In the West and North friezes there are two other children (N XLII.134 [Fig. 21] and W XII.24 [Fig. 22]) and one adolescent (W III.6 [Fig. 23]). In many respects they resemble the East child closely:[32] they stand at the right edge of their composition, face left, the one visible arm held horizontally with the hand advanced,[33] their weight on the left leg, the right foot drawn slightly back with heel raised. While the youth W III.6 is taller (therefore older) and nude, the two younger boys N XLII.134 and W XII.24 have a bunch of drapery clinging to the left shoulder, and they are about the same height, and therefore about the same age, as the East child;[34] their buttocks are exposed too.[35] It seems obvious that in general all four figures were probably based on the same preliminary cartoon[36] and this should imply that the East child (Fig. 20) was based on the sketch of a boy and probably therefore was meant to be read as a boy.

We can go further. Comparing the three young males, W III.6, W XII.24, and N XLII.134, we notice that they belong to the same larger composition, which occurs in its simplest form on West frieze block XII (Fig. 22; Fig. 28).[37] There we see, from left to right, a cloaked but otherwise nude ephebe (XII.22);[38] a young man (XII.23); a horse to left in the farther plane; and at the right edge the cloaked boy as squire (XII.24) with

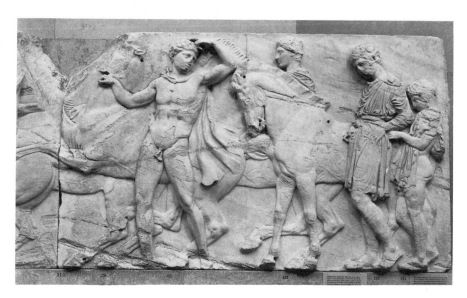

Figure 21 Parthenon North frieze block XLII

124

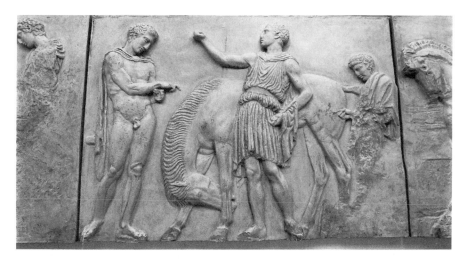

Figure 22 Parthenon West frieze block XII (cast)

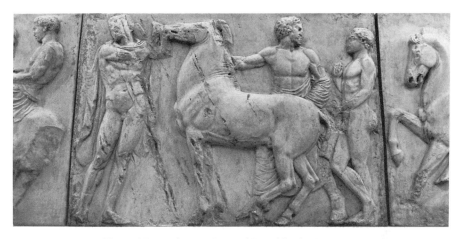

Figure 23 Parthenon West frieze block III (cast)

moderately long hair. All three individuals stand in contrapposto, the ephebe exaggeratedly, the man and squire more casually.

North block XLII (Fig. 21; Fig. 30)[39] repeats the composition with some differences. For one thing, the block is longer for architectural reasons[40] and therefore adds figures in the farther plane and at the left edge. Other differences are minor: the ephebe (XLII.131) motions his comrades to hurry up, the man (XLII.133) is a youthful adult in a *chiton* who stands farther to the right, immediately in front of his nude young squire (XLII.134).

125

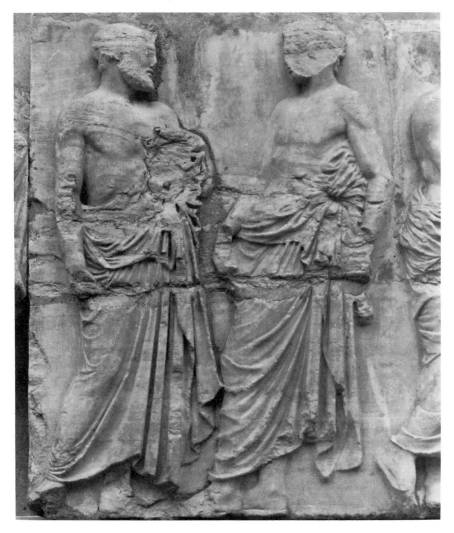

Figure 24 Parthenon East frieze block IV ("Eponymous Heroes")

West block III (Fig. 23; Fig. 29)[41] repeats the composition with greater variety: the bearded older adult (III.5) steps awkwardly to his right but looks left; the horse stands tensely; and, as we have seen, the squire (III.6) is older, a youth, and completely nude. His left arm hangs down, his hand (now in Munich) holding something usually identified as reins but more likely a wreath (see n. 42), his right arm up to grasp an object, perhaps a spear.

The striking differences in the repeating composition here in West block III suggest a narrative. The man moves appreciably to our right, and his

126

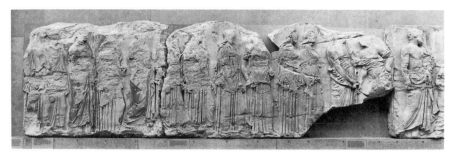

Figure 25 Parthenon East frieze block III (*parthenoi*)

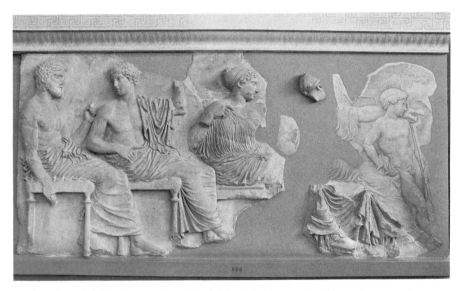

Figure 26 Parthenon East frieze block VI (Artemis, Aphrodite, Eros)

close proximity to the youth and awkward pose both suggest that he is in the act of abruptly shifting his attention from the ephebe at the left to the slightly younger youth at the right. The youth's complete nudity and the positions of his hands, and the more advanced ages of both males, may all be connected. If this scene appeared on vases of an earlier generation, for instance, we would interpret it as homoerotic.[42] For exactly the same reason, we should see the East frieze's Eponymous Heroes (Fig. 24), bearded men paired with youths, as similarly based on homoerotic vase compositions.[43]

If the East child is based on the boys and youth of the West and North friezes, and those young males belong to the same composition that is repeated in those three blocks with some variations, we should expect the

127

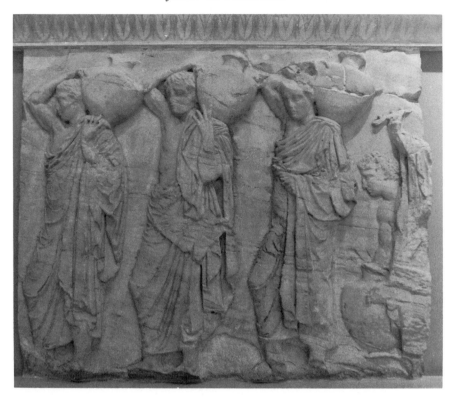

Figure 27 Parthenon North frieze block VI (*hydriaphoroi*)

same composition therefore to form the basis of the central *peplos*-folding scene (Fig. 19). We may notice that most of the composition, from the boy left, occupies the same amount of space as do the compositions on the other blocks but with a change in the individual figures. If we lay the repeating composition over the *peplos*-folding scene, aligning the squire with the boy, we see it extending to the left to overlap only the four figures V.32–5 (Fig. 31),[44] from maiden to boy. The repeating composition's ephebe in contrapposto and the East maiden V.32 occupy the same place; the matron E V.33 corresponds to the horses; and the adult man overlaps the bearded man V.34.[45] Finally, outside the scene, at the left, beyond the figures based on the repeating composition, the girl E V.31 represents an addition – we shall return to her later.

Since this central scene is compositionally based on the repeating composition seen in W III and XII and N XLII, and its figures share placement, pose, and mass with the figures in the repeating composition, it is likely that they also share its theme. In all three examples the ends are occupied by an ephebe at the left and a boy or youth at the right. The focus of the

128

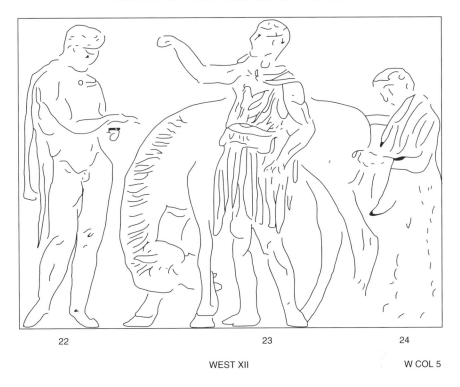

22 23 24

WEST XII W COL 5

Figure 28 Parthenon West frieze block XII

composition, however, is on the central male and his attention directed towards one or the other of the two males who flank him – as a young man he gestures towards the ephebe (W XII) or stands close to the boy (N XLII), but as a bearded adult citizen (W III) he shifts his attention to the nude youth. The composition seems therefore in all three instances to involve the central man's sexual desires.

In the East's central scene, therefore, we can expect to find a similar set of desires. First, from the apparent homoerotic overtones in W III we can detect an intimate homoerotic relationship that underlies the action shared by the bearded man and boy at the right. There is a difference, however, in the two males in the East: the boy is younger and the attention the man gives him is total and more intimate.

The development of Greek homoeroticism[46] and its role in society are issues that are too complex to discuss in this study, but it might be worthwhile to mention some general points about which there has been some consensus. First, we know more about male homoeroticism than female, mostly for the reason that we know more from the men than from the women.[47] Second, male homoeroticism was popularly considered in the

129

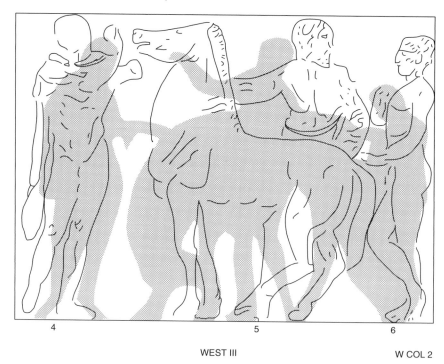

4 5 6

WEST III W COL 2

Figure 29 Parthenon West frieze block III over a silhouette of W XII
(both at same scale)

Classical period to be linked closely to the Dorian states, especially Sparta
and Crete, where it was associated with military training.[48] Third, in Athens
male homoeroticism can be well documented from the sixth century BCE
on,[49] when the practice had early aristocratic overtones with both affirming
and subordinating aspects.[50]

Of the Athenian version of male homoeroticism we have more detailed
information and consequently it appears more complex. While faithful and
abiding love was certainly possible,[51] more often than not the homoerotic
relationship lasted only as long as the younger partner, the *eromenos*
(ἐρώμενος), stayed young. While military cohesion may have functioned as
an excuse in the Dorian states, in Athens education in general seems to
have been a desired goal, at least in Plato's early writings,[52] in which the love
and pursuit of a beautiful youth becomes metaphoric for a similar love and
pursuit of beauty and truth.[53] The sexual element was certainly a compo-
nent, but while the older *erastes* (ἐραστής) could actively pursue and take
pleasure, the younger *eromenos* was expected to maintain both his emotional
and physical distance.[54]

130

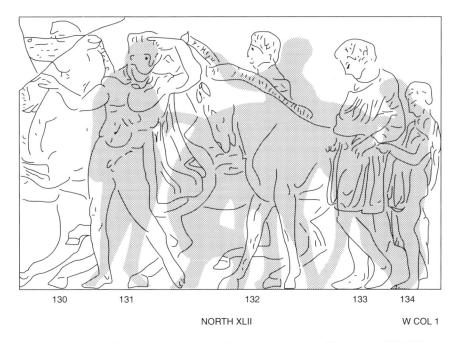

130 131 132 133 134

NORTH XLII W COL 1

Figure 30 Parthenon North frieze block XLII over a silhouette of W XII
(both at same scale)

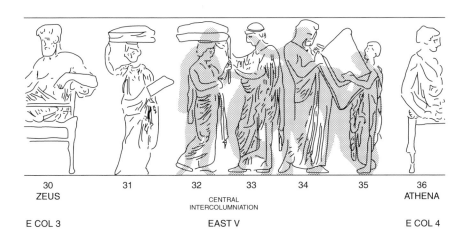

30 31 32 33 34 35 36
ZEUS ATHENA
 CENTRAL
 INTERCOLUMNIATION

E COL 3 EAST V E COL 4

Figure 31 Parthenon East frieze block V, central figures over silhouette of W XII
(both at same scale)

131

Given these general tendencies, we might describe male homoeroticism in Athens as a channel for transmitting male culture from the mature adult to the pre-pubescent boy. The educational element might serve as context: older men taught boys and youths various skills, including war, hunting, music, and cult, and introduced them to male political and military society. And the age difference between the two may have served this pedagogical goal: the more youthful the beloved,[55] the longer the educational process, and the greater the age of the lover, the richer the experience he could bestow. In the Parthenon's East frieze the boy's extreme youth and the man's serious attention emphasize the positive cultural values of this homoerotic relationship whose educational quality is expressed in the ritualized shared folding of Athena's *peplos*. But whatever the educational goal, a pederastic relationship still involves an older adult, citizen man and an immature, non-citizen youth; the relationship thus centers on the same political inequalities as those between an Athenian man and woman. And the many differences between the two participants imply an Athenian sexualization of these socio-political inequalities.[56]

The similarly attentive scene in the East frieze between matron and maiden should reflect a corollary transmission of female culture from older experienced woman to younger inexperienced woman. As depicted, however, the two processes are completely separate, literally back-to-back. And not only separate, they are different. Here the two women seem almost the same age, as if they cannot be separated by more than a decade, probably less. Even granting that women married soon after reaching a conventional puberty, at about the age of fifteen or sixteen,[57] it would seem unlikely that the matron depicted here is old enough to have had a daughter who even approaches that age. More likely the two bracket the age when a woman turned adult and became marriageable, the matron perhaps close to twenty, the maiden fourteen.[58] The two resemble ideal sisters, and, if they were enrolled at the university where I teach and were living in a sorority, they would have been paired as Big Sister and Little Sister, the elder educating the younger in the finer details of a woman's social life on campus, how to express herself amongst other women, how to suppress herself amongst men. The age that they span is telling, for this is the age when a girl becomes a woman, and the changes it brings are sweeping: the onset of menarche, menstruation, and then marriage with its abrupt separation from home and family, along with other climacterics.

The social relationship between the two women at the center of the frieze is therefore focused on a specific set of experiences, here rendered as a metaphor: the matron helping ease the maiden's burden. The slightly elder and experienced woman thus gives solace, advice, and comfort to the younger about to enter this dramatic transformation. It may therefore be no coincidence that compositionally this more, presumably sexually, experienced woman occupies the place of the horse in the repeating composition,

for there was a popular connection between women, horses, and unbridled desire.[59]

The relationship between the two women is also more equitable; since it does not hinge on a marked inequality of age and thus of power but on a shared experience, it has few, if any, of the political overtones that shaped the relationships between the males. It is possible, of course, for this apolitical and intimate relationship to have had a lesbian dimension;[60] since the common experience that these women share and since much female culture was genitally centered (puberty, menarche, marriage, and birthing), much of their common discourse would have been located in the sexual.

These two young women find themselves replicated in the twenty-nine *parthenoi*[61] who stand in procession at either side of the East frieze (Fig. 25). These wait; a few hold libation bowls (E. II.2–6, VIII–IX.60–3), jugs (III. 7–10, VIII.58 and 59), an incense-burner (VIII.57), or other objects now indistinct, while two (VII.50 and 51) may have already handed their basket over to a marshal. Several appear in pairs (e.g., III.7+8 and 16+17, VII 50+51 and 53+54), as if linked in what we might anachronistically term "romantic friendships,"[62] relationships that enabled them to appear in public without seeming stray and accostable. The large number of these young women, their passivity emphasized by their bent heads and static poses immobilized by their bulky garments with monotonous drapery lines,[63] all reduce them to a repetitious anonymity, each one depersonalized, unremarkable, a nonentity mechanically reproduced.[64] The men who introduce them (E I.1) or terminate their procession (VII 49 and 52) stand more energetically in contrapposto and with gesturing arms; other men converse engagedly in pairs – in contrast, these young *parthenoi* exhibit no personality.[65]

Goddesses comprise the remaining women in the frieze. We expect the conventional complement of female Olympians:[66] Demeter, Hera, Athena, Artemis, Aphrodite. Like the male marshals, the male gods sit in more active poses: Hermes expectant, Dionysos garrulous, Ares impatient, Hephaistos and Apollo conversing, Zeus grand. Two of the goddesses sit internalized or passive: Hera, goddess of marriage, spreads her veil,[67] while Demeter sits anguished for her daughter. Both, it would seem, are given static personalities characterized by the solid *polis* values of marriage and motherhood.

More interesting is the last series of divinities (Fig. 26). A bearded adult Poseidon introduces the group, and the conversation he conducts with an attentive, half-draped, youthful Apollo, his wreath upon his head, sets the sexual stage. The woman sitting next to Apollo should be his twin sister, Artemis, who in turn faces Aphrodite with her son Eros. Because of the conventional differences between these two goddesses, one might not expect them even to be sitting together, let alone with Artemis's left hand resting in the crook of Aphrodite's right arm.[68] They seem instead

close friends, sharing even attributes.[69] Aphrodite is the fuller, more fleshy figure; her relaxed pose complemented by her *chiton* lying loosely off her shoulders. She is also veiled, a sure sign of respectability (as Aphrodite Ourania?), even though she does not offer it, as Hera does. Artemis may be identified as huntress through her attribute, the bow, on the tip of which her right hand may once have rested.[70] But if so, she seems to have acquired sexuality, perversely so for a chaste virgin:[71] she, like Aphrodite, wears a broad head-kerchief, the *sakkos*, that ties up her hair, a covering that is otherwise associated with parties and marriage. Even more, her sheer *chiton* slips off her left shoulder negligently.

It is as if the sexualities of these two goddesses, the chaste Artemis and the passionate Aphrodite, had become blended. If we think of them not as goddesses but as stand-ins for Athenian women, the elder Aphrodite would then resemble the East frieze's matron, innately sexual as wife and mother, but, at the same time, de-sexualized as a proper woman of the *polis*. The younger Artemis would represent the maiden there, unapproachable as adolescent Athenian female, yet sexualized and desirable. And the close intimacy that the two goddesses share also seems to reproduce the intimacy between the matron and maiden in the East frieze.

Just to the right of the East frieze's central scene, Athena, by contrast, looks distinctly boyish with her short hair and exposed side. Her *aegis*, usually worn prominently across her chest, lies here in her lap, almost invisible amongst the folds of her *peplos*. In her hair are small holes probably for attaching a metal wreath, and a spear would have passed through her left hand; as Athena Polias, this goddess seems to be a seated and relaxed replacement for one of Beazley's homoerotic youths with spear and wreath (n. 43). It is therefore fitting that Hephaistos leans in to talk to her like the other bearded men in the frieze who lean in to talk to their youths.

In these three goddesses, as elsewhere in the frieze, we find three reflections of the different objects of male desire: de-sexualized wives and partners, nubile but inaccessible adolescent females, and obtainable homoerotic youths.

The last divinity on the East frieze is Eros, nude and as young as the three boys in the North, West, and East friezes. In one sense, then, he functions as another homoerotic object of male desire. Within his own context, however, Eros also performs a task, supporting, even though languidly, a parasol that protects Aphrodite's left arm as she points out the participants in the Panathenaia. If this respectable, matronly Aphrodite may stand in for Athenian women, then Eros with his parasol represents the wives of the resident aliens (*metics*), who, as *skiaphoroi* in the actual Panathenaic procession, held sunshades over the wives of citizen men.[72] These parasols were not a mere convenience, to protect citizen women from the hot August sun at the Panathenaia. Sunshades[73] came originally to Greece from Lydia or Persia, and they therefore served as symbols of the

otherness and femininity of the foreign *metic* women who carried them, and carrying them for citizens in that procession demonstrated their inferiority and servitude to the adult women of the *polis*. Among women, then, it is possible that socio-political inequalities were not sexualized, as in male–male relationships, but expressed in terms of tensions between mistress and servant that had to be publicly dramatized.

If Eros is a replacement figure for a *metic* woman shading Aphrodite, a metaphor for a woman of Athens, then the homoerotic quality of Eros, young and nude, should signal an erotic construction for *metic* women. Athenian *parthenoi* as basket-bearers (*kanephoroi*) had to be beyond reproach,[74] and the fact that the *metic* maidens of equal age were allowed only to shade them with parasols and carry their stools implies that virginity and good birth were not criteria for this function. This construction, that it was permissible for *metic* women to be viewed as objects of sexual desire, is confirmed by their second requirement for participating in the Panathenaic procession: carrying water jars (*hydriai*).[75]

Fetching water from the public fountains was one of the stereotypical female occupations,[76] for it afforded one of the few occasions when men could view women publicly, walking in groups from house to fountain, a water jar on their head as their *laisser-passer* through an alien world of the male gaze. There are many representations of *hydriaphoroi* (women carrying water jars) from the Late Bronze Age on.[77] A common topos in the sixth century concerns Achilles' ambush of Polyxena at the fountain house and the subsequent rape of Troilos,[78] confirming the vulnerability of this location and its sexual construct.[79]

While there are many vase paintings of women at fountains, often appearing appropriately on hydriai, only two, apparently, depict men at fountains: a late sixth-century BCE black-figure hydria in Leyden by the Antimenes Painter depicts a man and youth bathing within the fountain house, the man obviously ogling the shy youth, while two pairs of youths flank the building, conversing and oiling their bodies;[80] and a contemporary but early red-figure hydria by Phintias portrays, on the body, an adult man ogling youths fetching water at a fountain, and, to clarify the implication, on the shoulder, a man and youth reclining together at a symposion.[81] One more red-figure lekythos in a private collection in Metairie, Louisiana, carries a satyr drawing water at a fountain.[82] It is clear that portraying males fetching water was considered inappropriate, but the three that do, link the femininity of the task, the passive nature of the youths, and their sexuality all explicitly.

Just as the frieze depicts a *skiaphoros* but replaces the *metic* woman who carried the parasol with a nude Eros, so it depicts *hydriaphoroi* but replaces the *metic* daughters with youths who carry the water jars (N VI, Fig. 27). This substitution has bothered scholars;[83] but since the preceding block, N V, portrays youths as *skaphephoroi*, tray-bearers whom we hear mocked in

comedy as *metic* sons in the actual procession,[84] it cannot be the presence of *metics* alone which the frieze refuses to depict – it is the presence of *metic* women.[85]

Even within just the Parthenon frieze, therefore, we can see in broad outline the adult male citizen's views on sexuality. It would seem that youths, whatever their status, citizen or *metic*, were sexually attractive and acceptable for depiction in state art as homoeroticized recipients in the transmission of a specifically aristocratic male culture. The citizen youths within the frieze might all be heroically nude while the *metic* youths of N V and VI are loosely draped, but all of them, citizens and *metics*, were erotically accessible. In pairs, the citizen adult and his youthful pre-citizen lover stand idealized next to the gods over the front entrance to the Parthenon.

The relationship between an adult citizen and a metic, on the other hand, seems strained. The Parthenon frieze does not apparently pair a citizen adult man with a metic youth; the metic youths we see are segregated at the east end of the North frieze where they are depicted in stigmatized and effeminizing occupations, bearing trays and water jugs. And metic women are banished from the frieze altogether, being replaced by the nude Eros and the youths bearing water jars.

Citizens were constrained in their sexual behavior, desires, and practices: sexual sophistication went by foreign names – *lesbiazein, chalkidizein*, among others; it was not acceptable for a citizen *eromenos* to be sexually penetrated;[86] and citizens who prostituted themselves could be disenfranchised.[87] Such injunctions reflect the corollary that non-citizens could be freer in their sexual expressions and may therefore have been viewed by the citizen male with conflicted feelings of taboo and desire.[88] That is, the greater the inequality between the citizen male and an other person, the more sexualized the relationship. In fact, this male sexualization of political and social inequality makes it likely that *metics*, in general, as foreigners and as exotics, were considered erotic.[89]

One problematic area in the citizen male's construct of desire was the need to de-sexualize the Athenian object of that desire. The *eromenos* in the homoerotic relationship was expected not to pursue, not to be eager, not to feel pleasure – the *erastes* could be more certain of this tranquil passivity by courting the youngest boy possible, the one farthest removed from his own incipient sexuality.

Women, on the other hand, not girls, were the female objects of male desire. *Metic* women do not appear on the frieze, which should tell us something about the degree of conflict with which citizen men viewed them. Athenian women are, however, represented. The adult women of the *polis* whom we see on the frieze are wives and mothers, symbolized by a matronly de-sexualized Aphrodite, mother of Eros. Athenian women, when sexualized, are young and made unobtainable like the East frieze's swathed

maidens grouped in herds and in mutually protective pairs; the male's conflicted and frustrated desire for them is symbolized here in the frieze both by an androgynous homoerotic virgin Athena and by a dangerously sexualized chaste Artemis.

Historically, a sexually expressive woman of Athens was not only rare but may have been viewed as having crossed beyond normal limits, immersing herself in environments, including *metic* environments, that were otherwise taboo. Elpinike, for instance, the daughter of Miltiades, sister of Kimon, had married a rich man in order to pay the exorbitant fine levied against her father. As an extremely wealthy aristocratic woman, daughter of the savior of Athens at Marathon in 480 BCE, she was reported to have moved so easily in male society that she was also thought capable of committing incest with her brother and taking on a *metic* man (the muralist Polygnotos) as her lover.[90] Another sexually expressive woman, the *metic hetaira* Aspasia, was undoubtedly thought to be acting merely to hybristic form when she became the mistress of Perikles, who, as virtual head of state, could actually persuade the assembly to legitimize their sons contrary to the citizenship law he himself had promulgated in 451.

In this light, we should not expect to see *metic* women anywhere in the Parthenon's frieze, for here we find memorialized Athenian *citizen* values. The participation of *metic* women in the Panathenaic festival emphasizes not their right to express themselves as members of the Athenian state, but instead their passive femininity as water-fetchers and their exotic servility as sunshade-bearers. Their replacement figures, Eros and youths, in the frieze makes clear the connection between "attainable passive *metic* women" and "accessible homoeroticized youths." Both of these are constructed as highly sexual beings, a quality which Athenian women were neither granted nor allowed to display.

There is one figure in the East frieze that we have not looked at in detail, the girl to the left of the central scene. In terms of the original composition, she is an add-on, either separately important to the narrative sense or inconsequential as filler. While she and the boy-child on the other side provide sculptural balance, the boy is integral to the narrative of the scene whereas the girl apparently is not.[91] Still, she is interesting: she stands slightly apart, between gods and family, her head turned slightly towards the former, her body slightly towards the latter; she seems wistful, indecisive, and alone.[92]

We know from literature and vase paintings that girls were educated for a while with the boys and then they stayed at home to receive domestic instruction.[93] But here within the context of the frieze the important instruction to a girl is conveyed not when she is young but later, when she is an elder maiden about to pass into womanhood. While the boy receives attention at an obviously young age,[94] this girl seems abandoned. The figures that frame her further emphasize her separation. The maiden

has turned away to receive her most intimate instruction; Zeus sits oblivious.

This girl lacks a quality which all other figures in the frieze exude, whether desired or denied: sexuality. The other figures express their sexuality amongst themselves, like Artemis and Aphrodite or the *parthenoi* and their friends, or they constitute objects of present or assumed male desire. She can do neither: she has no friend, no one attends to her, and, alone, she half-stares out at us, asserting a subjectivity that forbids us from viewing her merely as object. She has no sexuality, not because she is a pre-gendered child whose sexuality is not yet constructed – the boy on the other side exposes his buttocks to his adult male colleague, symbolizing his passive role as *eromenos*. She alone of all the figures in the frieze has no sexuality, either present or imminent, simply because she is a girl; she will receive her sexuality, like the maiden, later, at the onset of actual or conventionalized puberty. Until then, she stands apart from the group of idealized Athenians, apart even from the spiritual world of the gods nearby, an asexual being completely isolated from a sexualized society.

In contrast with the boy on the other side, who not only has an occupation but also a social role as educable *eromenos*, and a sexuality long before his puberty, this girl has not one of these qualities, for the boy's situation makes it clear that adults bestow these gender roles on children, and the maiden's situation makes it clear that it will be a slightly older woman who will bestow her her roles in time. But not now.

So how did this girl come to be here? The mystery is not that the figure exists here at all, for we do need something here to fill the space between gods and Athenians; the mystery is that the figure combines the two most marginalized elements of Athenian society, child and female.[95] I think the simplistic explanation is again the technical one. Here was a space to fill, one suitable only for a totally superfluous figure, and we can imagine the male planners of the frieze not hesitating, not blinking an eye as they "naturally" drew the only totally superfluous human being they knew, a girl.

She is, I think, the most poignant of the figures on the frieze: lost, alone, a blank not yet impressed with social meaning. It is a miracle that she is here at all. But she is, and her face, almost frontal,[96] almost directed at us, invites us to consider what she is, the daughter of an Athenian man, and what she is to become, a sexually unexpressive Athenian wife and mother of his Athenian sons. As she averts her gaze from looking beyond her isolation, we almost see this girl, now and for always, as a real person.

NOTES

I am grateful to Paul Rehak for suggesting that I write this study, and for his many helpful comments and suggestions. I also wish to thank Lin Foxhall for suggestions and criticisms. I am greatly indebted to the staff

of the Department of Greek and Roman Antiquities of the British Museum who allowed me to study and photograph sculpture from the Parthenon and other buildings in detail in August 1992. A less detailed version of this paper was published in M. Casey, D. Donlon, J. Hope and S. Wellfare (eds), *Redefining Archaeology: Feminist Perspectives. Proceedings of the Third Australian Women in Archaeology Conference*, ANH (Australian National University) Publications, Canberra, 1998, pp. 182–90. The photographs and drawings are by the author. Figs 22 and 23 are photographs of the Elgin casts of West blocks III and XII now on display in the British Museum cafeteria.

1 M. Robertson and A. Frantz, *The Parthenon Frieze*, New York, Oxford University Press, 1975, pp. 10–11, present the standard interpretations; also see J. Boardman and D. Finn, *The Parthenon and its Sculptures*, Austin, University of Texas Press, 1985, pp. 12ff. and 222–4. F. Brommer, *Der Parthenonfries*, Mainz, Philipp von Zabern, 1977, pp. 147–9 and *passim*, gives a brief summary of the more important individual interpretations; I. Jenkins, *The Parthenon Frieze*, Austin, University of Texas Press, 1994, pp. 18–30, brings them up to date and assesses several of the more intriguing views. R. Osborne, "The Viewing and Obscuring of the Parthenon Frieze," *Journal of Hellenic Studies*, 1987, vol. 107, pp. 98–105, turns the standard interpretation around: the subject of the frieze is not its own static procession but rather its reflection of the viewer's actual procession around to the front of the building.

2 J. Boardman, "The Parthenon Frieze – Another View", in U. Höckmann and A. Krug (eds), *Festschrift Frank Brommer*, Mainz, Philipp von Zabern, 1977, pp. 39–49.

3 E. J. W. Barber in two studies, *Prehistoric Textiles*, Princeton, Princeton University Press, 1991, pp. 361–3, and "The Peplos of Athena", in J. Neils (ed.), *Goddess and Polis: The Panathenaic Festival in Ancient Athens*, Princeton, Princeton University Press, 1992, pp. 103–17, esp. pp. 112ff., presents detailed descriptions of what we know about Athena's *peplos*. The *peplos* here is either the old one or the new one; see Brommer, *Parthenonfries*, p. 261.

4 E. Simon, *Festivals of Attica: An Archaeological Commentary*, Madison, University of Wisconsin Press, 1983, p. 67, concludes that the stools are for Ge Kourotrophos and Pandrosos, while T. Schäfer, "Diphroi und Peplos auf dem Ostfries des Parthenons: Zum Kult Praxis bei den Panathenäen in klassischer Zeit," *Mitteilungen des Deutschen Archäologischen Instituts, Athenische Abteilung*, 1987, vol. 102, pp. 185–212, believes they are for Poseidon and Athena, the one for Athena to lay her *peplos* on.

5 Simon, *Festivals of Attica*, pp. 55–72.

6 Boardman, "The Parthenon Frieze – Another View," p. 41, for the two adults; cf. Simon, *Festivals of Attica*, pp. 67–9. Ch. Kardara, "Ἡ Ζωφόρος τοῦ Παρθενῶνος: Ὁ Κύριος Μυθικὸς τῆς Πύρην καὶ τὸ Πανελλήνιον Πρόγραμμα τοῦ Περικλέους," *Archaiologike Ephemeris*, 1982, pp. 1–60; cf. J. Dörig, "Τὸ Πρόγραμμα τῆς Γλυπτῆς Διακοσμήσεως τοῦ Παρθενῶνα," *Archaiologike Ephemeris*, 1982, pp. 187–214. Most recently, J. B. Connelly, "The Parthenon and Parthenoi: A Mythological Interpretation of the Parthenon Frieze," *American Journal of Archaeology*, 1996, vol. 100, pp. 53–80.

7 Two girls, age seven to eleven, were chosen *Arrhephoroi* by the *archon basileus* from four nominated by the Athenian people (Simon, *Festivals of Attica*, p. 39). The two *Arrhephoroi* helped the women *ergastinai* weave the *peplos* over the nine

months from the end of Pyanopsion (late November) until the Plynteria at the end of Thargalion (late June), two months before the Panathenaia (late August). During the intervening month Skirophorion (late June to late July), the last month of the Athenian year, the annual office of the two girls culminated in a secret rite, the Arrhephoria (Simon, *Festivals of Attica*, pp. 39–45). It is possible, though not likely, that the two girls E V.31 and 32 are taller and seem older than the seven to eleven year old *Arrhephoroi*, because they are the two from the previous year now in attendance during the installation of the robe which their successors helped weave. Jenkins, *The Parthenon Frieze*, p. 38, sees their assistance with the weaving of the *peplos* as an apprenticeship amounting to a rite of passage.

8 *Paides amphithaleis* were girls and boys both of whose parents were still living. Brommer, *Parthenonfries*, p. 269, relates the anecdote about Cyprian (*c.* 300 CE) who, when ten years old, served as a temple boy nurturing Pallas Athena's sacred snake.

9 Aristophanes' *Birds*, 1550ff. and scholion; Hesychius s.v. διφροφόροι (*diphrophoroi*); Aelian VI.1. Also see Pauly–Wissowa, *Real-Encyclopädie der klassische Altertumswissenschaft*, Stuttgart, Alfred Druckenmüller, 1939, vol. 18.3, s.v. "Panathenaia," cols 457–89f., for a general discussion.

10 K. DeVries, "The Diphrophoroi on the Parthenon Frieze", *American Journal of Archaeology*, 1994, vol. 98, p. 323 (abstract). E. G. Pemberton, "The Gods of the East Frieze of the Parthenon", *American Journal of Archaeology*, 1976, vol. 80, pp. 113–24, esp. p. 123, seems to agree with D. B. Thompson's earlier identification of the stools as Persian booty, "Persian Spoils in Athens", in S. S. Weinberg (ed.), *The Aegean and the Near East: Studies Presented to Hetty Goldman*, Locust Valley, NY, J. J. Augustin, 1956, pp. 281–91.

11 Simon, *Festivals of Attica*, p. 60.

12 Brommer, *Parthenonfries*, pp. 112–16; pls 174, 176, 177; and pp. 263–5, where he tabulates the various specific identifications.

13 As an archaeological approach this study is of course not new; archaeologists and social historians commonly use vases and grave stelae, to choose the more obvious media, to help reconstruct aspects of everyday Classical life. There are, however, few studies that link architecture and sculpture to social issues. Jenkins, *The Parthenon Frieze*, *passim*, uses a vocabulary on occasion that reveals feminist influence, and Osborne, "The Viewing and Obscuring of the Parthenon Frieze," relates the frieze to aristocratic Athenian male citizen values, but neither goes into detail. A few other studies use the Parthenon frieze as an artifact. Two articles, R. S. Stanier, "The Cost of the Parthenon," *Journal of Hellenic Studies*, 1953, vol. 73, pp. 68–76, and R. H. Randall, Jr, "The Erechtheum Workmen," *American Journal of Archaeology*, 1953, vol. 57, pp. 199–210, form the basis for my own "Planning the Parthenon Frieze," *American Journal of Archaeology*, 1991, vol. 95, p. 295 (abstract) and "The Periklean Building Program as Public Works Project," *American Journal of Archaeology*, 1993, vol. 97, p. 309 (abstract); and I am grateful to the American School of Classical Studies for allowing me to read the unpublished study by W. B. Dinsmoor, "Parthenon Frieze: Evidence for Carving In Situ," with the assistance of Dr Anastasia Dinsmoor, in July 1993.

14 N. Loraux, *The Children of Athena. Athenian Ideas of Citizenship and the Division between the Sexes*, Princeton, Princeton University Press, 1993, esp. ch. 2, pp. 72ff., notes, that, while men were called οἱ Ἀθηναῖοι (men of the city Athens) or οἱ πολῖτες (male citizens), there were no similar words for the women of

Athens; instead of αἱ Ἀθηναῖαι (women of the city Athens), there is αἱ Ἀττικδί (women of the land Attica). The word ἡ πολῖτις (female citizen), according to Liddell and Scott's *Greek–English Lexicon*, Oxford, Oxford University Press, 1968, p. 1435, appears only towards the end of the fourth century BCE. Instead, women, like Pandora, belong to τὸ γένος τῶν γυναικῶν, "a race of women."

15 Jenkins, *The Parthenon Frieze*, p. 25, describes the figures in the frieze as "a generalized portrayal of the contemporary Athenian community."

16 Most earlier scholarship had agreed that the child is a boy. In 1975, Robertson and Frantz, *The Parthenon Frieze*, p. 34, and, almost at the same time, M. Robertson, *History of Greek Art*, Cambridge, Cambridge University Press, 1975, p. 308, initiated the present controversy by identifying the child as a girl. J. Boardman, "The Naked Truth," *Oxford Journal of Archaeology*, 1991, vol. 10, pp. 119–21 ("girl") answering C. W. Clairmont, "Girl or Boy? Parthenon's East Frieze Figure 35," *Archäologischer Anzeiger*, 1989, pp. 495–6 ("boy"), which in turn was criticizing the identification "girl" in J. Boardman, "Notes on the Parthenon East Frieze," in M. Schmidt (ed.), *Kanon: Festschrift Ernst Berger* (*Antike Kunst* Beiheft, vol. 15), Basel, Vereinigung der Freunde antiker Kunst, Archäologisches Seminar der Universität, 1988, pp. 9–14.

17 Most recently, Connelly, "The Parthenon and Parthenoi," claims that Euripides' lacunose play, *Erechtheus*, provides the key to interpreting the *peplos*-folding scene as Erechtheus' daughters preparing to sacrifice themselves for the state.

18 Kardara, "Ἡ Ζωφόρου τοῦ Παρθενῶνος," expands upon her earlier "Τὸ Θέμα τῆς Ζωφόρου τοῦ Παρθενῶνος," *Archaiologike Ephemeris*, 1961 (published 1964), pp. 115–58.

19 There has been some controversy over the type of garment represented. It is clear that the North and West boys have thrown their *himation* over their left shoulder. The cloth on the child E V.35 has been identified as the mantle of the *archon basileus* (Brommer, *Parthenonfries*, p. 269, citing Michaelis), a cloth envelope for the *peplos* (Clairmont, "Girl or Boy? Parthenon's East Frieze Figure 35"), and a plain *peplos* (Boardman, "Notes on the Parthenon East Frieze").

20 L. Bonfante, "The Naked Greek," *Archaeology*, 1990, vol. 43, pp. 28–35, discusses the appropriateness of nudity for men in the gymnasium and in the military, but for women in central Athenian society she concludes it was taboo.

21 Simon, *Festivals of Attica*, p. 83, presents the conventional interpretation of the Brauron *krateriskoi* showing older girls racing nude. G. Ferrari Pinney, "Fugitive Nudes: The Woman Athlete," *American Journal of Archaeology*, 1995, vol. 99, pp. 303–4 (abstract), has recently interpreted these scenes as belonging to the mythical past, not to contemporary events, and thus refutes the long-held notion that girls danced naked at the Brauronia: the vases therefore "explain why a female display of nudity that would signal a state of equality with men has no place in fifth-century Athens."

22 Boardman, "Notes on the Parthenon East Frieze," is right to decry imposing modern values on Classical society, but in this case it seems unlikely that nudity for citizen Athenian females of whatever age was ever appropriate.

23 Nude boys in ancient art, as far as I am aware, are put in poses that usually expose their genitalia. S. MacAlister, "Gender as Sign and Symbolism in Artemidoros' *Oneirokritika*: Social Aspirations and Anxieties," *Helios*, 1992, vol. 19, pp. 140–60: "male anatomical difference is made to signify the masculine." (p. 146) Also see M. McDonnell, "The Introduction of Athletic Nudity:

Thucydides, Plato, and the Vases," *Journal of Hellenic Studies*, 1992, vol. 102, pp. 182–93: male exercising in the nude was probably introduced into Athens in the mid-sixth century, a little earlier in Sparta and at the Olympic games. L. Bonfante, "Nudity as Costume in Classical Art," *American Journal of Archaeology*, 1989, vol. 93, pp. 543–70, discusses male nudity as a distinctive social and political, as well as erotic, marker of male culture, separating the Greek citizen from barbarians; she concludes: "At the same time, the sight of the naked body has a great magic power. . . . Its meanings change over time, but not its power, which reminds us . . . of our own animal nature and our mortality." This statement implies that heroes, heroically nude and striving for greatness, must do so only as they are completely vulnerable at the same time to their mortality.

24 A. Klein, *Child Life in Greek Art*, New York, Columbia University Press, 1932, pp. 35–6. Compare MacAlister, "Gender as Sign and Symbolism in Artemidoros' *Oneirokritika*:" "Female anatomical difference . . . tends to be signified by something else – an object or an activity."

25 New York, Metropolitan Museum of Art, Fletcher Fund 27.45; J. Mertens (ed.), *Greece and Rome*, New York, New York Metropolitan Museum, 1987, title page. Her hairstyle, long hair parted and gathered in back, assures us she is a girl (Klein, *Child Life in Greek Art*, p. 36). Compare a similar tombstone from the Chalkidike portraying another girl with buttocks exposed (*Archaeological Reports*, 1981–2, vol. 28, p. 37, fig. 74). A third stele, the so-called Giustiniani stele in Berlin, however, presents the same girl (and same height), holding out a box; the stacked folds of her short Ionic *himation* here, however, obscure her buttocks. See B. Ridgway, *The Severe Style in Greek Sculpture*, Princeton, Princeton University Press, 1970, pp. 46–8, and compare her figs 66, the stele "Girl with Doves," and 67, the "Giustiniani" stele: the sculptor of "Doves" started with drapery like that of "Giustiniani" but cut out a window, as it were, to "expose" the buttocks of the girl with the doves. The act was deliberate, though the reasons remain obscure.

26 Klein, *Child Life in Greek Art*, p. 35.

27 Robertson and Frantz, *The Parthenon Frieze*, detail no. 4, p. 33, apparently were the first to see Venus rings on the child. As Brommer points out (*Parthenonfries*, p. 269, n. 137), the child does not exhibit swollen torus-like bulges on the neck, but rather simple incisions. As to what kind of lighting the planners and sculptors must have had in mind, the actual lighting of the frieze in place would have been dim and diffuse, coming from all angles except from above. R. Stillwell, "The Panathenaic Frieze," *Hesperia*, 1969, vol. 38, pp. 231–41, tries to excuse the difficulties created by the angles from which the frieze would have been viewed; Osborne, "The Viewing and Obscuring of the Parthenon Frieze," accepts them and incorporates them into his interpretation.

28 Brommer, *Parthenonfries*, p. 269, n. 137: "Bei den gesicherten weiblichen Gestalten des Frieses kommen Venusringe nicht vor," an assertion that Boardman, "Notes on the Parthenon East Frieze," p. 9, and pls 4.2–6 and 5.1, contests.

29 Brommer, *Parthenonfries*, pl. 178, illustrates Venus rings on Apollo E VI.39 on the right and Artemis E VI.40 on the left, both with Boardman's "lightly but decisively scored" Venus creases. Simon, *Festivals of Attica*, p. 66, n. 50, notes Venus marks on the *skaphephoros* S XXXVII*.106 (Brommer, *Parthenonfries*, pl. 152.2). For three more examples, see the men N VI.16 (*Parthenonfries*, pl. 58) and N XVII.57 (*Parthenonfries*, pls 73 and 74, right), and the Louvre head (*Parthenonfries*, pl. 194, lower right).

30 Children can be regarded as having a kind of third gender, or a duality of the

two genders, or a kind of a pre-gender, implying that a specific adult gender is acquired or accentuated as the child grows and socializes. M. Golden, *Children and Childhood in Classical Athens*, Baltimore and London, Johns Hopkins University Press, 1990, pp. 26ff., suggests that children seem to be a gender apart, perhaps pre-gender, and as the child grows up it acquires gender which is fully recognized in one or more coming-of-age ceremonies or passages. A modern observation might help here. Young modern children are publicly permitted to bathe naked at swimming pools and on the beach; such permission implies a general, albeit tacit, agreement among the adults not to see the children as sexual. The trunks that young children may also wear confirms this general agreement, for when young children wear trunks their gender (as well as their sex) is outwardly ambiguous unless otherwise marked. I find it disturbing therefore when some parents insist that their little girl must also wear a halter top, thereby imprinting a premature sexuality on the child by directing attention to its chest, otherwise indistinguishable from the chests of boys, where secondary sexual characteristics will mark the girl only later as a woman.

31 Certainly one such would be to analyze the social roles of children and how they might develop or change as they grow up. Another analysis might concentrate on initiation and how it may help grant gender. While age grades can be documented for boys, girls seem not to go through them; Pinney, "Fugitive Nudes: The Woman Athlete," begins with "The idea that there existed in Athens initiation rituals for female children comparable to those of the males rests largely on the evidence of the 'Brauron krateriskoi'," and then demonstrates that these do not depict actual or contemporary events. Since girls are not as frequently portrayed as boys are, it is possible that the male child may also then stand in for both genders (that is, if an Athenian were in doubt as to the true sex of a child, it (note the American usage) might be generically referred to as "he"), and, if so, then the male child as feminine–masculine must eventually divest itself of that femininity in order to assert a sole masculinity; publicly acknowledging that femininity and publicly eschewing it might lie behind Athenian *paiderastia*. Concomitantly, the female child, subsumed under the rubric "male," would have to take on her femininity as a totality. A. E. Hanson, "Conception, Gestation, and the Origin of Female Nature in the *Corpus Hippocraticum*," *Helios*, 1992, vol. 19, pp. 31–71, describes the Hippocratic view of a girl's pubescence: "The body of the little girl was masculinate and resistant" (p. 40). We shall see something of this process at the end of this paper when we examine the juxtaposition of the East frieze's girl and maiden. In this light, the gender of children, at least in modern America, incorporates a denied sexuality.

32 Boardman, "The Parthenon Frieze – Another View," compares the child E V.35, his pl. 5.2, with the boy N XLII.134, his pl. 5.3. After a detailed anatomical description of the differences between an adult man's buttocks and an adult woman's, complete with a line drawing contrasting the two, Boardman then places photographs of the two children side by side. Such a line of reasoning cannot decide the issue: children are not adults, and, in any case, I discern no difference between the profiles of their adolescent buttocks, a point which Clairmont, "Girl or Boy? Parthenon's East Frieze Figure 35," does not mention. And both Boardman, "Notes on the Parthenon East Frieze," fig. 2, and Clairmont, "Girl or Boy? Parthenon's East Frieze Figure 35," p. 496, compare these figures to the stele "Girl with Doves" (n. 25). Such comparisons suggest that these children are not unique but may have been based on an earlier prototype, perhaps dating to the Severe period.

33 For E V.35 and N XLII.134 this is the left arm; for W XII.24, apparently both arms were held horizontally (see Brommer, *Parthenonfries*, p. 18, fig. 2, after Hartig) but it is the clenched right hand that is now legible.

34 The height of squire 134 on N block XLII is 81 cm, and that of squire 24 on W block XII is 83.8 cm; the child 35 on E block V, at 82 cm tall, presents the approximate average.

35 The lower part of W XII.24's body had been badly abraded even before Stuart and Revett drew the frieze, but it is possible to make out the profile line of the boy's buttocks.

36 Osborne, "The Viewing and Obscuring of the Parthenon Frieze," pp. 102–5, interprets the uniformity of human type in the frieze as arising from a propagandistic desire to depict Athenian society as a democratic ideal "where distinctions are abolished and all are equal." From the point of view of the craftsmen, these repeating figures and compositions were based on cartoons; see Younger, "Planning the Parthenon Frieze." That the squires and child are all based on a single identical composition can be further demonstrated by a single detail, their extended hands. To give the squire W XII.23 something to do, he has been conjectured to hold the horse on a rather long set of reins (cf. Brommer, *Parthenonfries*, p. 29, citing Passow), while, apart from the seemingly coy fiddling with the garment of the young man in front of him, there does not seem to be anything at all for the squire N XLII.134 to do (cf. Brommer, *Parthenonfries*, p. 70: "Mit der nicht durchbohrten Linken [Hand] fasst er nach vorn"). The child E V.35, however, has the *peplos* to manage with the left hand. Moreover, the *peplos*'s near right corner joins the child's upper chest exactly where the youth's left elbow on N XLII touches the squire 134 and where the horse tail on W XII passes behind the squire 23. These two areas, then, the projecting hand and the cloth–corner/youth–elbow/horse–tail, function like tabs, fixing the child/squire on to the right side of a repeated composition. But in East block V these tabs have become part of the narrative, the folding of the *peplos*.

37 Brommer, *Parthenonfries*, pp. 17–19, pls 36–8.

38 In the following discussion, "ephebe," "man" or "young man" or "adult man," and "squire" are used to designate conveniently the three main figures of this repeating composition; the terms are not meant to identify the functions of these figures within the frieze or within the Panathenaic procession which the frieze reflects.

39 Brommer, *Parthenonfries*, pp. 68–70, pls 107–108. Fig. 3 superimposes a scale drawing of N XLII over a silhouette of W XII.

40 The average length of the medial blocks in both North and South friezes is 1.30 m. All three blocks at both ends of the two long friezes are longer. For an illustration, see A. K. Orlandos, "Ἡ Ἀρχετεκτονικὴ τοῦ Παρθενῶνος," Athens, *He en Athenais Archaiologike Etaireia*, no. 86, 1976, vol. A, pl. 42. The four corners of the frieze (E IX/N I is no longer extant) are occupied by header-stretcher blocks that are the longest (L. 1.64 m) in the entire frieze. The penultimate blocks next to them are the second longest blocks (L. approx. 1.40 m), and both together were made deliberately long in order for them to span, atop the epistyle, the free space between porch antae and angle columns. To ease the visual transition between the blocks over this span and the medial blocks, the propenultimate blocks were also made slightly longer (L. 1.33 m).

41 Brommer, *Parthenonfries*, pp. 5–7, pls 11–12. Fig. 2 superimposes a scale drawing of W XIII over a silhouette of W XII.

42 J. D. Beazley, "Some Attic Vases in the Cyprus Museum," *Proceedings of the*

British Academy, 1947, vol. 33, pp. 195–244, esp. pp. 198–223, inserts into a discussion of Attic vases from Cyprus a catalogue of three classes of homosexual courting scenes: first, the *eromenos* (young beloved) stands generally nude, at the right facing left, his left hand down often holding a wreath, his right hand up often holding a spear, and the *erastes* (older lover) beseeches from the left, his hands in the "up and down" position, left hand "up" towards the face of the *etomenos*, the right hand "down" towards his genitals; second, the presentation or acquisition of animals as love tokens; and third, embraces or actual depictions of intercrural copulation. Dover, *Greek Homosexuality*, London, Duckworth and Cambridge, Mass., Harvard University Press, 1978, p. 94, presents these three groups more narratively; and M. F. Kilmer, *Greek Erotica*, London, Duckworth, 1993, discusses and illustrates them in detail.

Beazley further describes his first group, remarking that most of the scenes occur in black-figure where the *erastes* is a bearded man and the *eromenos* a youth, but in early red-figure the two are younger, the *erastes* a youth and the *eromenos* a boy. Some Attic red-figure vases, however, do present bearded men with youths, though Beazley does not include them (cf. Dover's vases R520, R684, R934, etc.). In this light, we might better read Brommer's description of the holes in the left hand of the squire in W III (*Parthenonfries*, p. 7, penultimate paragraph: "sie zwischen Daumen und Zeigefinger, sowie zwischen dem kleinen und dem ihm benachbarten Finger durchbohrt ist") as being just as appropriate for the *eromenos*'s usual wreath as for a squire's reins.

Homoerotic courtship, of course, continued through the fifth century; the many literary references, such as in the *Symposion*, make it clear that such courtship flourished, even if it was rarely depicted. H. A. Shapiro, "Courtship Scenes in Attic Vase-painting," *American Journal of Archaeology*, 1981, vol. 85, pp. 133–43, esp. p. 143, remarks on the rarity of these depictions in the period "between 470 and 400, and there are virtually none datable to the first thirty years of that period." This makes the composition of W III all the more remarkable, but we may see the vase painting tendency, seen in early red-figure, to make both lovers younger in the youthful man and boy squire of N XLII.133 and 134.

43 K. DeVries, "The 'Eponymous Heroes' on the Parthenon Frieze," *American Journal of Archaeology*, 1992, vol. 96, p. 336 (abstract).

44 Fig. 4 superimposes a scale drawing of E V over a silhouette of W XII.

45 In fact, the man W XII.23 seems a mirror image of E V.34.

46 I specifically use this term because the term "homosexuality" (apart from its infelicitous formation from two languages by Karoly Maria Benkert in 1869) has been used to categorize contemporary persons from the late nineteenth century on as a socially identifiable group. It is generally agreed that before the Industrial Revolution people identified specific sexual acts without grouping the individuals who performed them. B. D. Adam, *The Rise of a Gay and Lesbian Movement*, New York, Twayne, 1995, ch. 1, gives a convenient "Origins of a Homosexual People;" and G. Hekma, "A History of Sexology," in J. Bremmer (ed.), *From Sappho to De Sade: Moments in the History of Sexuality*, New York, Routledge, 1989, pp. 173–93, gives a more anecdotal account. To some extent this consensus is correct, but from late antique times on there were terms for people who were caught committing anal intercourse (e.g. "buggers" from the late medieval heretical sect "Bulgars") or who habitually committed such acts (e.g. "catamites;" compare the sixteenth-century Italian artist Bazzi who demanded to be called "Il Sodoma," a nickname that art historians today continue to honor). There are, however, some indications that homoerotic



JOHN G. YOUNGER

activity was also considered something apart in Classical Greece: some men
may have thought of themselves as different because they preferred members
of their own sex exclusively (Plato's Pausanias, *Symposion*, e.g. 184c and 193b,
may reflect one such type of self-realization), and the social and political
stigmatization, especially of effeminate men and those who played passive
roles in anal intercourse, might have made these men feel self-conscious about
being singled out.

47 Our primary sources for female homoeroticism are few. Sappho's poetry
speaks of her intense love of and desire for other women. Anakreon fr. 358
not only confirms such feelings but also associates them popularly with the
island Lesbos (I translate here the second quatrain):

ἡ δ', ἐστὶν γὰρ ἀπ' εὐκτίτου
Λέσβου, τὴν μὲν ἐμὴν κόμην,
λευκὴ γάρ, καταμέμφεται,
πρὸς δ'ἄλλην τινὰ χάσκει.

But she's from well-built
Lesbos, and she spurns me
For my hair, it's white,
And gapes after another

Some read ἄλλην τινά (feminine) to refer to "another type of hair," i.e.
pubic, but such an interpretation misses the point of his "white" hair, and
forces ἄλλην τινά to mean "another type of hair on someone else;" the poem
is too direct for this, and ἄλλην τινά should therefore amplify "Lesbos" to
mean "some one else, and female, too."

Aristophanes' myth in the *Symposion* (191e) assumes a female homoeroticism
equal to the male. Plutarch, *LycougRos* 18.4, explicitly reports female homoer-
oticism in Sparta, and Athenaeus 13.602de confirms it.

For three modern attempts to retrieve Greek lesbian behavior, see, in
general, Dover, *Greek Homosexuality*, pp. 171–84; and, in specific, both Kilmer,
Greek Erotica, pp. 26–30, and A. Lardinoi, "Lesbian Sappho and Sappho of
Lesbos", in Bremmer, *From Sappho to De Sade*, pp. 15–35, and M. B. Skinner,
"Nossis Thēly Glōssos: The Private Text and the Public Book", in S. B.
Pomeroy, *Women's History and Ancient History*, Chapel Hill and London, Uni-
versity of North Carolina Press, 1991, pp. 20–47. In many discussions of
female homoeroticism, there is a marked tendency to conflate it with prostitu-
tion: Dover, *Greek Homosexuality*; H. Licht, *Sexual Life in Ancient Greece*, New
York, Barnes and Noble, 1963, pt II, ch. III, "Tribadism," pp. 316–28; and
E. C. Keuls, *The Reign of the Phallus: Sexual Politics in Ancient Athens*, Berkeley,
University of California Press, 1993, pp. 85–6.

One depiction that seems obviously homoerotic occurs in the tondo of a
red-figure kylix by Apollodoros, now in Tarquinia (J. D. Beazley, *Paralipomena:
Additions to Attic Black-figure Vase-painters and Attic Red-figure Vase-painters*,
Oxford, Oxford University Press, 1972, p. 333, no. 9 *bis*); one nude woman
sits on the ground before a standing nude woman and applies perfumed oil
to her vagina. Keuls, *The Reign of the Phallus*, p. 170, fig. 151, acknowledges
the homoeroticism but prefers to concentrate on a possible goal of this
perfuming and to categorize the women as *hetairai*; Kilmer, *Greek Erotica*, in
scholarly contrast, concentrates sensitively on the homoerotic act itself.

48 In the Dorian states, male homoeroticism may have been encouraged in order
to produce tightly knit bands of warriors. Dover, *Greek Homosexuality*, ch. IV,

gives a detailed summary. Also see P. Cartledge, "The Politics of Spartan Pederasty," *Cambridge Philological Society, Proceedings*, 1981, vol. 27, pp. 17–36; K. J. Dover, "Greek Homosexuality and Initiation," in K. J. Dover (ed.), *Greek and the Greeks: Collected Papers*, Oxford, Blackwell, 1988, vol. II: *The Greeks and Their Legacy*, pp. 115–34.

49 For earlier aspects of Greek homoeroticism, see J. Bremmer, "An Enigmatic Indo-European Rite: Paederasty," *Arethusa*, 1980, vol. 13, pp. 279–98; and Dover, *Greek Homosexuality*, pp. 1f. and *passim*. E. Gibbon, *The Decline and Fall of the Roman Empire*, Dublin, Luke White, 1776–88, vol. 4, p. 837, n. 192, challenged future scholars: "A curious dissertation might be formed on the introduction of pederasty after the time of Homer, its progress among the Greeks of Asia and Europe." J. A. Symonds accepted this challenge in sections I–V of *A Problem in Greek Ethics* (written 1873; privately printed 1883; post-humously published in part in H. Ellis and J. A. Symonds, *Sexual Inversion*, 1897, London, Wilson and Macmillan; and in full in 1908 by the AREOPAGITIGA [*sic*] Society, London); in broad outlines his history has been generally accepted though rarely credited (e.g. Dover cites Symonds in his bibliography but not in his text).

50 M. Golden, "Slavery and Homosexuality at Athens," *Phoenix*, 1984, vol. 38, pp. 308–24, esp. pp. 319–20, reminds us that the lower class, non-aristocrat probably viewed homoeroticism with some suspicion since the political in-equalities between *erastes* and *eromenos* resembled the political inequalities between aristocrats and the lower classes, and the sexualization of the one might imply a sexualization of the other.

51 Plato's Pausanias, as *erastes*, seems to have stayed with his *eromenos* Agathon for over a decade (Dover, *Greek Homosexuality*, n. 43 p. 84, compares Plato's *Protagoras* 315de with the *Symposion*).

52 Cf. Dover, *Greek Homosexuality*, p. 202: "Indeed, the philosophical *paiderastia* which is fundamental to Plato's expositions in *Phaedrus* and *Symposium* is essentially an exaltation, however starved of bodily pleasure, of a consistent Greek tendency to regard homosexual eros as a compound of an educational with a genital relationship."

53 It is this development which allowed early modern apologists to ignore the physical act of sex in these homoerotic relationships and to treat Athenian pederasty as a "figure of speech" for the educational process (as Benjamin Jowett called it in a letter cited by J. A. Symonds in his letter to E. Gosse, dated 25 January 1890, and now in the Duke University Library, Special Collections, forthcoming in *Victorian Newsletter* 1999). This metaphor seems peculiarly appropriate in describing the early stage of the institutionalization of education in Athens towards the end of the fifth century, when even Sappho was credited with running a school; cf. W. A. Percy, III, *Pederasty and Pedagogy in Archaic Greece*, Urbana and Chicago, University of Illinois Press, 1996.

54 Dover, *Greek Homosexuality*, pp. 81–91, again presents a concise summary.

55 Straton of Sardis (Antonine period) starts *Palatine Anthology* 12.4 by singing the charms of a twelve-year-old boy – if he is counting inclusively then the boy would be eleven; he finishes the poem losing interest, however, when the youth passes beyond seventeen (sixteen perhaps by our reckoning). Also see Dover, *Greek Homosexuality*, pp. 85f., and Golden, *Children and Childhood in Classical Athens*, pp. 56ff.

56 As far as I know, William Mure, "Sappho and the Ideal Love of the Greeks," *Rheinisches Museum*, 1857, vol. 12, pp. 564–93, is the first to understand the implications of these inequalities. "In the strictly normal Attic relation, the

Erastes was a man of the average age when the physical attributes of manhood are in their highest maturity. The Eromenos was a youth in whom those attributes were yet immature. In the Eromenos the quality of beauty was indispensable, but not in the Erastes. The ground of these distinctions . . . is, that in paederastian intercourse, the feeling which youth and beauty inspired and gratified was not mutual. A connection more opposite than this to friendship can hardly be conceived." (p. 580)

And while Mure concedes the occasional educational worth of such relationships (p. 581), he sounds distinctly modern as he realizes that the inequality involved a manipulation of the *eromenos* that could not be always beneficial. More recent studies have enlarged upon the basic observation; see Golden, "Slavery and Homosexuality at Athens," pp. 312ff.

57 S. G. Cole, "The Social Function of Rituals of Maturation: the Koureion and the Arkteia," *Zeitschrift für Papyrologie und Epigraphik*, 1984, vol. 55, pp. 233–44, reconstructs the *koureion* as initiation and gives the conventional age of puberty at about sixteen. Golden, *Children and Childhood in Classical Athens*, p. 98, summarizes the evidence for typical ages at marriage: about thirty for men and about fifteen for women.

58 The relative ages of the two may be reflected in what remains to be seen of their breast development: the maiden seems slightly chesty, the matron has distinct breasts. For a discussion of the interconnection between woman's puberty and her marriage, see G. Sissa, "Maidenhood without Maidenhead," in D. M. Halperin, J. J. Winkler, and F. Zeitlin (eds), *Before Sexuality: The Construction of Erotic Experience in the Ancient Greek World*, Princeton, Princeton University Press, 1990, pp. 339–64.

59 D. Castriota, *Myth, Ethos, and Actuality: Official Art in Fifth-Century B.C. Athens*, Madison, University of Wisconsin Press, 1992, p. 53 and *passim*.

60 Mure, "Sappho and the Ideal Love of the Greeks," again shows a precocity here: "Let us imagine . . . two Greek ladies, of naturally warm temperaments; their society despised and their beds deserted, often for weeks at a time, by their husbands, each engaged in attendance on his favorite Eromenos; their other opportunities of social, not to say sexual, enjoyment, limited to the narrow circle of their gynaecea. Let us imagine these two women, fondly attached to each other, by mutual sympathy as well as affection, solacing themselves by Sappho[']s 'eros lysimeles' . . . for the privations and indignities to which they were subjected by the heartless tyranny of the other sex" (pp. 586–7).

61 G. Sissa, *Greek Virginity*, Cambridge, Mass., Harvard University Press, 1990, describes the Greek concept of virginity as more diffuse than our modern one which abstracts it to "not-having-been-sexually-penetrated," although intercourse and pregnancy were seen as ways of completing and ensuring the maturation process (Hanson, "Conception, Gestation, and the Origin of Female Nature in the *Corpus Hippocraticum*," p. 40). Jenkins, *The Parthenon Frieze*, p. 33, describes the status of *parthenos*: "The girls shown in the frieze . . . are in a peculiar class of their own, being past puberty but not yet married. They seem to provide a counterpoint to the youthful male warriors (ephebes) at the other end of the procession, who are past puberty also but have not yet won full citizen status." Jenkins's next sentence begins promisingly, "These socially marginalized groups . . . ," but goes on to introduce a new subject.

62 L. Faderman, *Surpassing the Love of Men: Romantic Friendship and Love between Women from the Renaissance to the Present*, New York, Morrow, 1981, esp. pp. 85–102.

63 Hanson, "Conception, Gestation, and the Origin of Female Nature in the *Corpus Hippocraticum*," notes "The popular equation between woman and fleece – above all, wet, but also unstructured and amorphous" (p. 38), a connection that underlies a joke in Aristophanes' *Clouds* (343–4) comparing women to clouds; it is women's bodies that men thought shapeless, and their bulky clothing here in the East frieze would reflect it.

64 Osborne, "The Viewing and Obscuring of the Parthenon Frieze," p. 103, reduces the male and female figures in the frieze to "a binary model for the men [adult and youth] and a single category for the women". The *parthenoi* here are all reduced to a single category, but they are not the only type of female in the frieze. As to the passivity of these figures, I mean their demureness, their refusal to project an engaged personality. R. Osborne, "Looking on – Greek Style: Does the Sculpted Girl Speak to Women, Too?," in I. Morris (ed.), *Classical Greece: Ancient Histories and Modern Archaeologies,* Cambridge, Cambridge University Press, 1994, distinguishes the interactive *korai* of the sixth century who, as they offer their flower or libation bowl, engage themselves with the viewer, participating, like stakes in negotiations of estate and marriage, in their viewer's construction of them; the classical woman, on the other hand, is constructed as a passive, non-participant in such social and economic transactions, and presented in art as reserving herself merely as a disinterested object of male sexual desire. Osborne is correct that by refusing to confront male sexual desire the classical woman makes that desire the self-consciously framed topic. Such passivity thus becomes active, and apparent since it is a clever stance from which to mock that desire. B. Lavelle, "The Nature of Hipparchos' Insult to Harmodios," *American Journal of Philology,* 1986, vol. 107, pp. 318–33, observes the parallel between Perikles' remark in the Funeral Oration (Thucydides II.45.2) that "the best Athenian woman was the one least talked about whether for good or for evil" and modern Greek attitudes: a citizen woman's fame (κλέος) lies in her not having any, an excellent foil for exposing the vanity of men. In epigrams, women, like Nikandre, often cite their male relations; occasionally they break into their own voice. Kyniska (Pausanias III 8.1 and 15.1, V 12.5), victor in the Olympic chariot race (*c.* 390–380 BCE), put up her bronze statue group. The fragmentary inscription on the base is preserved (Olympia Museum, L160), but it was well known in antiquity (*Palatine Anthology* XIII.16); note the triumphant change from the three lines of dactylic hexameter to the last line of pentameter when she boasts of her achievement:

Σπάρτης μὲν Βασιλῆες ἐμοῖ πατέρες καὶ ἀδελφοί
δμματι δ᾿ ὠκυπόδων ἵππων νικῶσα Κυνίσκα
εἰκόνα τάνδ᾿ ἔστασε μόναν δ᾿ ἐμ φαμὶ γυναικῶν
Ἑλλάδος ἐκ πάσας τόνδε λαβεῖν στέφαναν.

My fathers and brothers are kings of Sparta,
But I, Kyniska, won with a chariot of swift horses,
And I set up this statue, the only woman,
I say, of all Greece, I took the crown. (my translation)

65 V. Songe-Møller, "The Definition of 'Male' and 'Female' – an Unsolved Problem," *Studia Theologica*, 1989, vol. 43, pp. 91–8: "Outside home woman has no function to fulfill, she herself is reduced to nothing In relation to man and the culture which he represents, woman is first and foremost a negation: woman is 'otherness,' which breaks up the imaginative unity of masculine society." (p. 97)

66 For a general discussion of the gods, their gestures, and their placement, see Pemberton, "The Gods of the East Frieze of the Parthenon;" and, for a political ordering, A. Linfert, "Die Götterversammlung im Parthenon-Ostfries und das attische Kultsystem unter Perikles," *Mitteilungen des Deutschen Archäologischen Instituts, Athenische Abteilung*, 1979, vol. 94, pp. 41–7. Between Hera and the left edge of block V, the youthful head of a winged goddess (Iris or Nike) was added.

67 Pemberton, "The Gods of the East Frieze of the Parthenon," p. 116, n. 21.

68 Jenkins, *The Parthenon Frieze*, p. 80, for an excellent photograph; and Brommer, *Parthenonfries*, p. 117, fig. 47, and pls 164.VI (Carrey) and 179 (a composite photograph).

69 Pemberton, "The Gods of the East Frieze of the Parthenon," pp. 116–17, discusses these two goddesses in detail, and suggests that the Aphrodite here is Aphrodite Pandemos and the Artemis is a complicated confection of Artemis–Agrotera–Eukleia–Nemesis, a combination of Artemis and Aphrodite. Even though Nemesis here should be anachronistic, since Agorakritos' statue at Rhamnous ought to be later than the Parthenon frieze, Pemberton's complex reconstruction of Artemis's persona reflects the difficulties presented by her costume and pose.

70 Pemberton, "The Gods of the East Frieze of the Parthenon," p. 118.

71 See Brommer, *Parthenonfries*, pp. 119 and 262, where it is stressed that scholars have identified her as "Artemis" only because she sits next to Apollo, that some scholars have expressed concern over the lack of the expected attributes, and that Furtwängler has seen in Artemis's *sakkos* a reference to an Aphrodite aspect of Artemis Brauronia.

72 See above and n. 10. Brommer, *Parthenonfries*, pp. 30 and 217. Aelian VI.1 tells us that the maiden daughters of *metics* "were compelled" (ἠνάγκαζον) to carry sunshades for daughters of Athenian men, and their wives for wives of Athenian men. Robertson and Frantz, *The Parthenon Frieze*, p. 33, speak of them being "allowed" to carry these parasols, but M. C. Miller, "The Parasol: an Oriental Status-Symbol in Late Archaic and Classical Athens," *Journal of Hellenic Studies*, 1992, vol. 102, pp. 91–105, esp. p. 104, understands the verb to imply either a special decree or a further interpretation of the Kleinias Decree. D. Whitehead, *The Ideology of the Athenian Metic*, Cambridge, Cambridge Philosophical Society, 1977, pp. 87–8, traces influences on Aelian's choice of verbs to New Comedy where metics are clearly derided and their liturgies were specifically designed to humiliate.

73 Parasols date as early as the Old Kingdom in Egypt: H. G. Fischer, "Sunshades of the Market Place," *Metropolitan Museum Journal*, 1972, vol. 6, pp. 63–8. Miller, "The Parasol: an Oriental Status-Symbol in Late Archaic and Classical Athens," sees the parasols as a feminine attribute and as a social class marker: "In the Panathenaic procession parasols served the social function of elevating daughters of Athenian citizens above the daughters of resident foreigners who carried them . . . [The parasol] rapidly came to be considered the feminine implement *par excellence* . . . highlighting the relationship of mistress to slave" (pp. 104–5).

Sunshades were also popularly connected with the east: the Great King of Persia had parasols held over his head (see the representation in the Nereid monument: W. A. P. Childs and P. Demargne, *Fouilles de Xanthos*, vol. 8: *Le Monument des Néréides: Le Décor Sculpté*, Paris, Éditions Klincksieck, 1989, s.n. BM 879); and bearded men, "Booners," wore eastern costumes (probably considered feminine by the Athenians) and held sunshades as they danced

with mannered gestures at symposia (J. Boardman and D. Kurtz, "Booners," *Greek Vases in the J. Paul Getty Museum*, 1986, vol. 3, pp. 35–70).

74 Lavelle, "The Nature of Hipparchos' Insult to Harmodios," reconstructs the requirements for *kanephoroi*: they had to be Athenian, "well born and of the city" (αὗται δὲ τῶν ἀστῶν καὶ τῶν εὐγενῶν ἦσαν), and "unmarried girls of repute" (αἱ ἐν ἀξιώματι παρθένοι). Lavelle's point is that Hipparchos must have disqualified Harmodios' sister as a *kanephoros* to her face with her brother present by impugning her reputation (διὰ τὸ μὴν ἀξίαν εἶναι).

75 Pauly–Wissowa, *Real-Encyclopädie der klassischen Altertumswissenschaft*, vol. 18.3, cols 465–6.

76 M. Y. Goldberg, "Deceptive Dichotomy: Two Case Studies," in M. Casey, D. Donlon, J. Hope and S. Wellfare (eds), *Redefining Archaeology: Feminist Perspectives. Proceedings of the Third Australian Women in Archaeology Conference*, ANH (Australian National University) Publications, Canberra, 1998, pp. 107–12.

77 C. Doumas, *The Wall Paintings of Thera*, Athens, The Thera Foundation, 1992, pl. 28, left page center, from the West House, Akrotiri, Thera, late seventeenth century BCE. This is one of the extremely rare everyday scenes in Aegean art.

78 Achilles had fallen in love with Troilos while fighting him in battle. Since Troilos had to die before he reached the age of twenty in order for the Greeks to win at Troy, Achilles killed him in the precinct of Apollo, Troilos' father (see Pauly–Wissowa, *Real-Encyclopädie der klassischen Altertumswissenschaft*, vol. 7A.1, s.v. Troilos). One version of Troilos' death calls for Achilles to ambush him while he was exercising his horse and guarding Polyxena at the fountain house at the same time – it is this version that appears on the François Vase; Achilles then chases him into the temple precinct where he kills him either by cutting off his head or by raping him violently, both being a castration of sorts, the one symbolically, the other politically.

79 Lavelle, "The Nature of Hipparchos' Insult to Harmodios," p. 323, finds that both ancient and modern Greek sources agree, "girls were never sent to draw water from a spring if a married woman was available, since fetching water, young girls, and illicit sex were all linked in the minds of the folk."

80 Leyden, XVe28; J. D. Beazley, *Attic Black-figure Vase-painters*, Oxford, Oxford University Press, 1966, p. 266, no. 1. The hydria is frequently published, and in color in J. Charbonneaux, *Archaic Greek Art*, London, Thames and Hudson, 1971, fig. 348, and in M. Robertson, *Greek Painting*, Geneva, Éditions d'Art Albert Skira S.A., 1979, p. 87.

81 British Museum, E159; the hydria is occasionally published: see, for convenience, M. Robertson, *Art of Vase Painting in Classical Athens*, Cambridge, Cambridge University Press, 1992, fig. 21.

82 H. A. Shapiro, *Art, Myth, and Culture: Greek Vases from Southern Collections*, New Orleans, New Orleans Museum of Art, 1981, no. 18.

83 Brommer, *Parthenonfries*, pp. 30 and 217, cites Michaelis's collection of the ancient sources, notes the substitution, quotes Murray's puzzled statement, "We do not know why boys were chosen," and wonders if the practice had changed from the time of the frieze to the time of the later sources. Simon, *Festivals of Attica*, pp. 63–4, facilely removes the male *hydriaphoroi* from the Panathenaic procession altogether, and makes them the winners in the annual torch race run the night before, with one winner, still tired, resting his prize hydria on the ground.

84 *Skaphephoroi* may also have been depicted in the South frieze, block XL (Jenkins, *The Parthenon Frieze*, p. 70, S XL.120, and "The South Frieze of the Parthenon. Problems in Arrangement," *American Journal of Archaeology*, 1995,

vol. 99, pp. 445–6). Whitehead, *The Ideology of the Athenian Metic*, discusses the derisive use of σκαφεῖς (*skapheis*) as a label for *metics* because metic youths carried these trays in the Panathenaic procession. What may have started off as an honor apparently turned into an insult.

85 S. Rotroff, "The Parthenon Frieze and the Sacrifice to Athena," *American Journal of Archaeology*, 1977, vol. 81, pp. 379–82, locates the procession of the frieze at the sacrifice, where stools and parasols, and thus *metic diphrophoroi* and *skiaphoroi*, would not have been needed. This teleological approach to the narrative problems in the frieze makes sense, even if it does not concern the frieze as social icon. Castriota, *Myth, Ethos, and Actuality*, pp. 185–229, takes great pains to show the frieze as an anti-Persian re-working of the Apadana reliefs and thus finds no recognizably different *metics* in the frieze at all ("the frieze makes no apparent effort to distinguish [*metics*] from the resident Athenians or their overseas colonists" [p. 190]; and "the ambiguous treatment of the figures . . . is . . . no accident. Athenian citizens, cleruchs, or allies could all have recognized themselves." [p. 210]).

86 Anal copulation between citizens was not acceptable; see Dover, *Greek Homosexuality*, pp. 140–7 and *passim*. Lavelle, "The Nature of Hipparchos' Insult to Harmodios," pp. 328–9, cites two stories: "Periander of Corinth . . . was killed by his catamite, when, in his cups, he asked the catamite if he was yet with child" (Aristotle, *Politics* 1311b, 1–2); and Peisistratos' youngest son Thessalos may have added another insult to Harmodios directly by calling him μαλακός (*Athenaia Politeia* 18.2), "soft," "effeminate."

87 J. Winkler, *The Constraints of Desire*, New York, Routledge, 1990, ch. 2, "Laying Down the Law: The Oversight of Men's Sexual Behavior," pp. 45–70, esp. 54ff., relates the four points of δοκιμασία, a scrutiny which the publicly active man could be subjected to: he could not be found guilty of abusing his parents, of avoiding military service, of having prostituted himself (i.e. of having submitted to passive anal intercourse for money), or of having eaten up his patrimony. If he had committed any one of these affronts, he had to withdraw from public life, and if he did not he could be disenfranchised. See C. Reinsberg, *Ehe, Hetärentum und Knabenliebe im antiken Griechenland*, Munich, C. H. Beck, 1989, pp. 151–3, for female prostitution, pp. 201–12 for male prostitution; thus prostitutes, male or female, were either non-citizens (i.e. metics) or freed slaves (and thus classed among the *metics*), or ex-citizens reduced to metic status by their sexual behavior.

88 Aeschines makes the sexual distinction between citizen and metic clear: he calls upon the jurors to "make a law that those who hunt for boys who easily are caught, would have to betake themselves to metics and foreigners so, while they don't have to be deprived of their predilection, they don't have to corrupt you." (1.195, my translation) H. N. Parker, "Love's Body Anatomized: The Ancient Erotic Handbooks and the Rhetoric of Sexuality," in A. Richlin (ed.), *Pornography and Representation in Greece and Rome*, New York and Oxford, Oxford University Press, 1992, pp. 90–111, discusses how slaves and prostitutes, i.e. non-citizens, would constitute "a class the audience would expect to have a wider sexual experience than citizen wives."

89 In Herodotus, nations far removed from civilization are reported as having licentious sex practices: Egypt and Greece were the only nations not to allow copulation in temples (2.64.4); the Nasamones men all "enjoyed" the bride at the wedding feast and the women wore leather bands around their ankles, one for every man they had had (4.172.10–13; the fillet that Athenian prostitutes tied around one thigh may account for Herodotus' interpretation); and "the

women of the tribe [Auses in Libya] are common property – there are no married couples living together, and intercourse is casual – like that of animals" (κτηνηδόν τε μισγόμενοι; 4.180.22), translation by de Selincourt. For more examples, see Keuls, *Reign of the Phallus*, ch. 13, "Sex Among the Barbarians," pp. 320–8.

90 Plutarch, *VitKimon* 4.5.
91 *Pace* Boardman, "The Parthenon Frieze – Another View," p. 41.
92 J. Stuart and N. Revett, *Antiquities of Athens*, London, John Haberkorn, 1794, vol. II, ch. I, pl. XXIV, focus on her pivotal transition. For an ingenious psychological description that seems to mirror this girl's indecision, see M. Querlin, *Women Without Men*, London, Dell, 1965, ch. 5: while a boy simply substitutes another woman to love instead of his mother, a girl "must undergo a complete psychological reversal," substituting a man for her mother; she "has gradually to transfer part or all of her sexual sensibility." Such a "complete reversal" of one's orientation should make anyone pause. Hanson, "Conception, Gestation, and the Origin of Female Nature in the *Corpus Hippocraticum*", p. 40, describes the Hippocratic view of a girl's pubescence: "The body of the little girl was masculinate and resistant, but the process of 'opening her up' and 'breaking her down' began at puberty when blood first forged its way to her uterus in anticipation of menarche. Next the accumulated menses had to discover their path of exit." The anticipation of such violence within the body again might cause hesitation.
93 Golden, *Children and Childhood in Classical Athens*, pp. 72–4.
94 Golden, *Children and Childhood in Classical Athens*, p. 56: "Men took a more active interest in boys' sex lives . . . boys were identified as sexual beings from an early age."
95 E. Eyben, "Family Planning in Antiquity," *Ancient Society*, 1980–81, vols 11–12, pp. 5–82, expands on the common sentiment that the ideal Athenian family consisted of "at least one son and at most one daughter," and gives evidence for the common practice of drowning or exposing superfluous daughters. If the central *peplos*-folding scene were to be read on a red-figure vase and the five figures were to be interpreted as a family, with the first child the eldest daughter and the second child a longed-for son, the presence of a girl as the surviving third child would be unusual.
96 There are at least two other unusual depictions of *en face* girls: on a white ground lekythos by the Timokrates Painter in the National Museum in Athens, inv. no. 12771, an *en face* girl carries a boy who reaches out to his mother (J. D. Beazley, *Attic Red-figure Vase-painters*, 2nd ed., Oxford, Clarendon Press, 1963, p. 743, no. 1; illustrated in Robertson, *The Art of Vase Painting in Classical Athens*, fig. 188); and on a tomb stele in the New York Metropolitan Museum, inv. no. 11.100.2, Rogers Fund, 1991, a father Demoteles records the deaths of his two daughters, one of whom, Demokrateia, might be the diminutive, *en face*, girl at the lower right; G. M. A. Richter, *Catalogue of Greek Sculptures*, New York and Cambridge, Mass., Metropolitan Museum of Art and Harvard University Press, 1954, pp. 56–7, no. 83, pls 67–8. In the Classical period, frontal faces carry a range of meaning; see Y. Korshak, *Frontal Faces in Attic Vase Painting of the Archaic Period*, Chicago, Ares Publications, Inc., 1987. But in the Bronze Age, frontal faces denote death, as they may do for these two examples; L. Morgan, "Frontal Face and the Symbolism of Death in Aegean Glyptic," in W. Müller (ed.), *Sceaux minoens et mycéniens* (*Corpus der minoischen und mykenischen Siegel*, Beiheft 5), Berlin, Gebr. Mann Verlag, 1995, pp. 135–49.

8

NAKED AND LIMBLESS

Learning about the feminine body in ancient Athens

Joan Reilly

Among the sculptured images of children that appear on Athenian grave monuments during the Classical period there are scenes of a young or adolescent girl who holds a small figure of a female that has been called a "doll." This image first appeared in Athens in the late fifth or early fourth century BCE and continued throughout the fourth century until the sumptuary legislation of Demetrios of Phaleron effectively ended sculptured grave reliefs.[1] Three types of "dolls" appear on the grave reliefs; one type is a clothed and seated figure.[2] Most grave reliefs, however, depict girls holding figures of naked females. There are two types of naked figures: a fully limbed figure and a truncated figure. The fully limbed one looks, to our eyes, like an ancient version of the Barbie doll (Fig. 32); it appears on only three grave reliefs.[3] The truncated figure is shown more frequently; the legs are cut off above the knees and the arms above the elbows, leaving little more than a torso or trunk with a head (Fig. 33).[4] The reliefs that depict these naked figures are the focus of this paper.

The grave reliefs that carry this image have been the object of description, study, and comment for many years.[5] In 1909 Kastriotes made the first iconographic study of the type; he identified seven reliefs that carried the scene of a girl holding a "doll."[6] The reliefs were restudied in 1988 by Cavalier, who identified sixteen Attic reliefs that carry the image.[7] The reliefs with this scene have also been discussed within the framework of investigations into the lives of children in antiquity, especially regarding their toys and games.[8]

Current scholarship identifies the figure depicted on the grave relief as a "doll," that is, a toy, and compares it to a commonly found type of terracotta figure known as an articulated or jointed doll.[9] The remains of these terracotta dolls have been found at a number of sanctuaries and shrines, for example at Delos, at Corinth, and on the Athenian Acropolis,[10] in terracotta factories,[11] and in tombs.[12] The earlier terracotta figures have arms attached at the shoulder and legs attached to projecting spurs at the

154

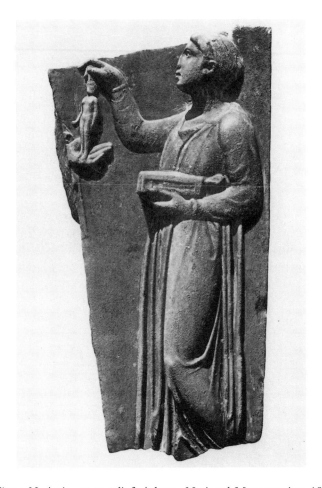

Figure 32 Attic grave relief, Athens, National Museum, inv. 1993

hip or upper legs; they often wear a short *chitoniskos* (Fig. 34). In the fourth century BCE there is a change in the design. The arms are attached at the shoulder as earlier, but the legs are attached at the knees without the projecting spur and the figure is now nude (Fig. 35). Many of these figures hold *krotala* (castanets) or cymbals and, accordingly, they have been inter-preted as dancers.[13]

The interpretation of the grave reliefs proceeds from the acceptance of the figure as a toy.[14] In accordance with the identification of the figure held by the girls as a "doll," the image is read in one of two ways. First, the "doll" allows one to read the relief as a sorrowful reminder of the marriage

155

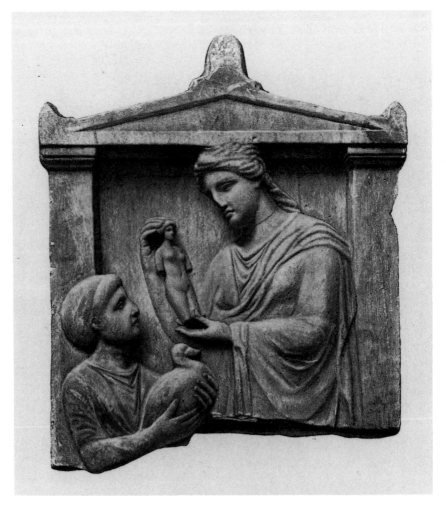

Figure 33 Attic grave relief, Avignon, Musée Calvet, inv. E32

she never attained. In this interpretation scholars connect the image of the "doll" with the custom of the *proteleia*, the pre-wedding sacrifice, citing an epigram in the *Palatine Anthology* as evidence for the dedication of dolls before marriage.[15] In the widely accepted interpretation of this epigram, Timareta, a girl of unspecified age, dedicates her doll, the doll's clothes, a ball, a tambourine, and her *kekryphalos* (a hair net or snood).[16] In light of this epigram, scholars propose that the grave reliefs show a girl holding the "doll" that she would have left behind some day, according to custom.[17] The "doll," owing to its role in premarital dedications, supposedly adds a poignancy that no other toy could add, because it marks her as having died

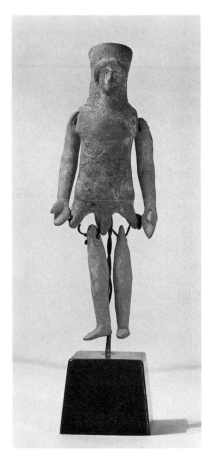
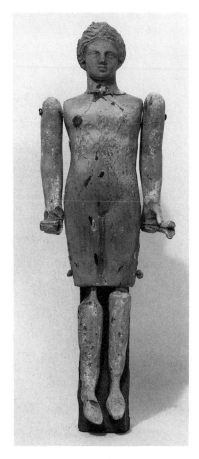

Figure 34 Early style terracotta doll; Princeton University Art Museum, inv. 47–205

Figure 35 Later style terracotta doll; Bowdoin College Museum of Art, inv. 1913.28

agamos, unmarried, similar to the marking of the grave of the unwed with a loutrophoros.[18] She is supposedly shown with the toy that she would have dedicated, if only she had lived.

This explanation has been accepted for the grave reliefs that depict older girls, possibly adolescents, whose age would be appropriate for such a dedication. Some scholars, however, have been reluctant to see overtones of marriage in the reliefs because some of the girls seem far too young to make such a dedication (Fig. 36).[19] As an alternative explanation, they propose that the grave reliefs may refer only to the youthfulness of the deceased and that the image is to be read as a girl at play.[20]

These explanations offered for the meaning of the image accept the figure as a toy or something that imitates a toy. Are we in fact looking at a

Figure 36 Attic grave relief, Cambridge, Mass., Sackler Museum, inv. 1961.86

plaything, a "doll?" Although Greek children had toys, we are looking at a different type of object on the grave reliefs. Such objects, in fact, were crafted as votives and their intended function was not play. This motif tells us far more about the lives and beliefs of ancient Athenians than has been previously suspected; it reveals a complex of ideas about a female's body and about an especially female concern, the achievement of menarche. The child is depicted with a dedication to ensure her healthy development and functioning as a woman.

Three points argue against the interpretation of these reliefs as references to marriage. The first is that the girls are depicted with a figure we call a "doll," but there is no ball, tambourine, hair net, or doll's dresses that we can securely identify. The girls are not shown with the complex of toys and other objects listed in the epigram of Timareta.[21] Second, some of these girls are obviously too young to be brides. On these reliefs some girls appear to be quite small; many are depicted as flat-chested. A few may perhaps be said to be adolescents, but many are too young for marriage, even according to ancient practice. Third, although doll-like figures were certainly dedicated in sanctuaries by the ancient Greeks, the dedication of "dolls" at the *proteleia* should be questioned.

The epigram of Timareta is the only evidence that connects the dedication of "dolls" specifically to the *proteleia*, and Georges Daux has challenged the commonly accepted reading of the Timareta epigram in two articles. He argues that Timareta does not present her dolls and their clothing, but rather her hair and her own maiden garments. He points out that the manuscript was emended in the past; the word *komas* (hair) in line 3 was changed to *koras* (girls, "dolls").[22] If Daux's interpretation that Timareta was dedicating her hair and clothing is accepted, there is no support for the dedication of "dolls" specifically in association with the ancient Greek wedding. The dedication of hair and clothing, on the other hand, has ample support, both literary and epigraphic.[23]

The explanation that the reliefs depict a child at play is also difficult to accept when one closely examines the figures that they hold. The manner in which these figures are rendered raises problems about their purpose and meaning. These "dolls" are extraordinary for their nudity and for the truncation of some figures. The nudity, which is especially striking in a society that normally did not depict female nudity, reveals and emphasizes a female body with mature proportions and developed breasts. Both the fully limbed and the partial figures clearly show us that these are not "baby dolls."[24] More puzzling is the fact that most of these girls proudly hold up a partial figure. It occupies a prominent position on some reliefs; it is held with great care and delicacy, admired and gazed upon, but not used like a toy.

The comparison of these figures to the articulated dolls does not stand up to close scrutiny. The shape of the fully limbed doll on the grave reliefs

is quite unlike the earlier type of terracotta figure that had limbs attached to a spur at the hip. The fully limbed figures depicted on the Attic grave reliefs also lack any indication of leg joints; they cannot even be compared to the later, fourth-century design.[25]

The association of the truncated figure on the reliefs with the articulated doll also needs to be reexamined. The grave relief in Avignon (Fig. 33), for example, gives a very clear picture of the so-called "doll." First, the figure on the grave relief shows no sign of lower limbs to correspond to the attached legs of the articulated dolls. Second, the arms of the truncated figure on the grave reliefs are constructed differently; they are incomplete and there is no indication of attachment at the shoulders, whereas the arms on the articulated dolls are complete and attached at the shoulders. The figures on the grave reliefs are consistently truncated in this same manner; it is not damage to the grave relief that gives this doll its strange appearance. A close inspection demonstrates that the figures on the reliefs are not the terracotta jointed dolls to which they have been compared.

Objects that match the figures on the grave reliefs, however, exist in the archaeological record. It is difficult to find a figure that is comparable to the fully limbed figures that these girls hold, although the closest comparative material seems to be votive. This may be due to the fact that such figures were made out of materials that are now lost.[26] Comparative material for the truncated figures on the grave reliefs, however, is more abundant; there are many corresponding figures made of terracotta and even marble (Fig. 37).[27] The truncated or torso figure in terracotta first appears in Attica about the mid fifth century BCE. It is mould-made, hollow in the center and put together from two pieces, front and back. Like its counterpart on the grave reliefs, it depicts a naked female with the legs cut off above the knees and arms above the elbows. This naked female torso is not pierced for the addition of lower limbs, but is complete in itself.

Questions about the curious design of the figure and doubts about its function as a toy have occasionally been raised.[28] Some scholars have proposed that the terracotta truncated figure was a votive, but continued to interpret the truncated figure represented on the grave reliefs as a toy. Kate Elderkin, for example, recognized the terracotta figure as a possible dedicatory object, but suggested that the truncated figures on the grave reliefs were represented without their limbs so that these would not be confused with infants or sacred images.[29] Others have stoutly maintained the function of the truncated figures as toys, even by proposing ingenious but unproved solutions for their strange appearance. Higgins suggested that perhaps the terracotta figures were supposed to be dressed in clothes that contained the missing limbs.[30] The reliefs, however, do not depict these figures as dressed or being dressed by the girls; what is prominent about them is their nudity. It has been suggested that these curious figures were to be dressed in swaddling clothes, a suggestion that runs contrary to

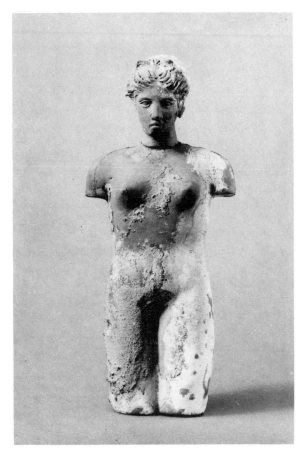

Figure 37 Terracotta figure, truncated type, New York,
Metropolitan Museum of Art, inv. 20.205

the mature figure revealed by its nudity.[31] Schweitzer, noting the peculiarity
of the figure, suggested that the figure is a descendant of the Boeotian
terracotta idols with "arm stumps," but still considered it a doll, suggesting
that over time its function changed from cult dedication to toy.[32]

What is this oddly amputated "doll?" Its peculiar appearance provides an
important clue to the meaning of the reliefs and its explanation can be
found in ancient Greek worship. Ancient Greeks worshipped a number of
healing gods, and Asklepios was the foremost although not the only
medical deity. These gods received offerings from their worshippers, and
a category of votives connected closely with their worship is the anatomical

161

votive. Numerous sites throughout Greece have yielded these peculiar body parts, often made of terracotta. The site of Corinth, for example, has produced an impressive collection of legs, arms, hands, and feet, as well as more private parts of human anatomy, such as breasts and genitalia.[33] These anatomical parts were dedicated either in gratitude for a cure or as an appeal to heal the afflicted part.[34]

In the Acropolis Museum in Athens, a marble votive plaque dedicated to Herakles, who in Attica was credited with healing powers, shows a woman kneeling before the figure of the hero (Fig. 38).[35] Representations of several anatomical votives are depicted on the wall, dedications in his sanctuary: a set of arms, a set of legs and the naked lower and upper halves of a woman's body. The lower half comprises the body from waist to knees and the upper half presents a torso, a head, and stumps of arms. These body halves, if put together, would constitute one of the truncated "dolls" held by little girls on the grave reliefs. The truncated figures on the grave reliefs, I propose, are in actuality anatomical votives.[36] The truncation of the figure, similar to the anatomical votives dedicated to healing gods, signifies its votive function.

Epigraphical and archaeological evidence informs us that anatomical votives were also made out of precious metal.[37] Inscriptions that have survived from sanctuaries list the valuable metal objects given to the deities, and in these inscriptions we may have a name for the truncated figures. The

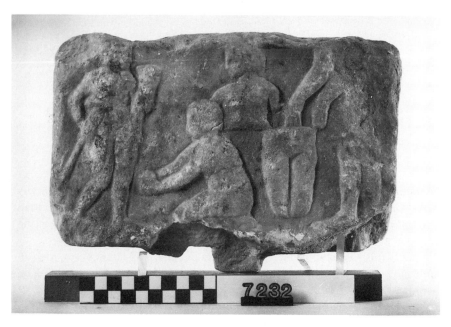

Figure 38 Marble votive plaque, Athens, Acropolis Museum, inv. 7232

162

inscribed inventories of the Athenian Asklepieion list dedications, many of gold and silver, and there is an occasional notation of the dedication of a "body," a *soma* or a *somation*.[38] The dedication inscriptions several times list the offering of a "woman's body," at least one of which is described as moulded or cast.[39] Van Straten, in a study of ancient votives, suggests that such a *soma* may have been a body represented nude, or perhaps a human trunk depicted without the extremities.[40] The girls are depicted with their dedication, the *soma* or *somation* of the inscriptions. The truncated "doll" on the grave relief is the *soma gunaikos* mentioned in the inscriptions.[41]

To summarize then, we see that the evidence indicates that the small figures shown on the grave reliefs were dedications, not toys. The two types of naked figures, the fully limbed and the truncated, have been called toys, but they cannot in actuality be compared to the terracotta articulated dolls; rather both types are votives. The fully limbed figure that appears on the reliefs was a votive for which we have little directly comparable material; the depiction on the grave relief may represent a votive in a perishable or expensive material. The truncated figure is also for dedication; it is an anatomical votive, a *soma gunaikos*. Therefore, the depiction of a child with a figure of a female for dedication could mark an important activity in her short life, rather than an "everyday scene" of a child at play or a statement about a marriage never attained.

The person who dedicates a votive either thanks the god for services rendered or hopes to achieve something.[42] The fact that these girls are shown with figures of naked, mature females provides an important clue to the purpose of the dedication. Both the fully limbed and the anatomical type emphasize the female body by depicting it naked rather than clothed. The anatomical votive, particularly, informs us that it is to be taken to a deity concerned with human health and because it is a representation of a female torso, that the concern is about female health. Furthermore, anatomical votives often depict specific parts of the body, such as a foot, a leg, or a hand.[43] The truncated figure, the *soma* of a woman, however, lacks this specificity. Instead it emphasizes the body, representing more than one part and an external view that corresponds to more than one organ. The truncated figure held by the girls suggests a concern with mature, functioning breasts and womb.[44] What hopes or concerns would be answered by the dedication of such figures?

Ancient Greek medical texts demonstrate that there was a concern, even a fear, that a girl would not achieve menarche. A. E. Hanson has discussed this concern as it appears in the Hippocratic corpus.[45] The ancient work titled *Diseases of Young Girls* describes a malady that supposedly attacks a young girl as a result of excess menstrual blood that is unable to leave the uterus. It was believed that, prior to menarche, the blood could spill over from a too-full uterus and collect at the center of her body. According to ancient medical belief, it then exerted pressure on her vital organs, which

made the young girl suicidal; she would be likely to hang herself or to throw herself down a well. In other words, there was a belief that a young girl might not achieve menarche, the first menstrual period, and that this failure of the female body to function properly could lead to madness. In the opinion of the doctor it is useless for female relatives to dedicate garments on her behalf to Artemis, apparently a ritual practice. Her cure comes, the doctor argues, "whenever nothing impedes the downward flow of blood."[46] The Hippocratic cure is to sleep with a man. The prepubertal intercourse that is recommended by the doctor would, most likely, be effected through marriage.

This so-called medical knowledge need not, of course, have any basis in fact, but rather expresses cultural fears and expectations regarding the female body and the premenarchal girl. The Hippocratic construction of a girl's physiology gives a supposedly rational explanation for cultural beliefs and supports social mores.[47] The same behaviors described in the Hippocratic corpus are described in Greek myth. The Danaids, in their refusal to marry, demonstrate their reluctance by exactly this type of madness: they threaten to hang themselves, like votive tablets adorning the statues of the gods.[48] The traditional reluctance to marry displayed by girls in Greek myth is given a supposedly rational explanation in ancient medical theory. There existed, then, a belief in ancient Greece that a young girl would be reluctant to marry and would attempt suicide. It is also apparent that dedications to deities were believed to be prophylactic, that is, to ward off possible madness (as well as the reluctance to marry) and to bring the girl successfully into womanhood.

These dedicatory figures were a response to this fear. The so-called "dolls" on ancient Athenian grave reliefs are not toys, but are votives. The figure is to be dedicated to insure the attainment of a healthy, functioning female body that produced and nourished children, the ideal of ancient Greek femininity. These figures were probably dedicated to ask for a safe arrival into maturity or in gratitude for the fulfillment of this desire. The clearest evidence for this proposal is the limbless figure of a naked woman that the girls hold, an anatomical votive like those dedicated to the healing gods.[49] The truncated figure was probably developed under the growing influence of healing cults in which anatomical votives were used. The terracotta truncated figures have been dated to about the mid fifth century BCE,[50] which is also when the healing cults gained popularity. The cult of Asklepios, for example, was accepted into Athens in 420/19 BCE,[51] and he joined several other healing deities who had preceded him.[52] Both types of naked figures, the truncated and the fully limbed, show us a mature female body and probably represent a desire for the same.

This imagery is evidence for social practices concerned with a girl's development into a woman. These figures were icons or emblems of the desired qualities of femininity.[53] In dedicating her votive she probably

learned the appropriate attitudes towards her body and sexuality. These figures taught her to desire the body that would enable her to fulfill the roles of bride, wife, and mother. The anatomical votive in particular, an image of the important parts, taught her the parts that really mattered.

This image on a gravestone was not only a message to the passer-by about the girl's youthful innocence: it was also about a daughter's proper upbringing and the girl's participation in a socio-religious custom that was designed to direct her character as well as her body into correct feminine lines, even at so young an age. The image makes a statement about the piety of the family, their belief and participation in social customs and mores, and their love for their daughter.

NOTES

I have used the following abbreviations:

Cavalier: O. Cavalier, "Une stèle attique classique au Musée Calvet d'Avignon," *La Revue du Louvre et des Musées de France*, 1988, vol. 4, pp. 285–93.

Clairmont: Ch. W. Clairmont, *Classical Attic Tombstones*, Kilchberg (Switzerland), Akanthus, 1993.

Conze: A. Conze, *Die attische Grabreliefs*, vols 1–4, Berlin, W. Spemann, 1893–1922.

Dörig, "Puppen": J. Dörig, "Von griechischen Puppen," *Antike Kunst*, 1958, vol. 1, pp. 41–52.

Dörig, *EAA*: J. Dörig, s.v. "Giocattolo," *Enciclopedia dell'arte antica, classica e orientale*, vol. III, pp. 905–10.

Elderkin: K. Elderkin, "Jointed Dolls in Antiquity," *American Journal of Archaeology*, 1930, vol. 34, pp. 455–79.

Higgins, *Terracottas*: R. A. Higgins, *Catalogue of the Terracottas in the Department of Greek and Roman Antiquities, British Museum*, vols 1–2, London, British Museum, 1964.

Kastriotes: P. Kastriotes, "Ἀνάγλυφα ἐπιτύμβια μετὰ πλαγγόνος," *Archaiologike Ephemeris*, 1909, cols 121–32.

Schweitzer: B. Schweitzer, "Eine attische Tonpuppe," *Mitteilungen des Deutschen Archäologischen Instituts, Römische Abteilung*, 1929, vol. 44, pp. 1–25.

Van Straten: F. T. Van Straten, "Gifts for the Gods," in H. S. Versnel (ed.), *Faith, Hope and Worship: Aspects of Religious Mentality in the Ancient World*, Leiden, Brill, 1981, pp. 65–151, figs 1–64.

Walter: O. Walter, "Eine Athenastatuette mit beweglichen Armen," *Classical Studies Presented to Edward Capps on his Seventieth Birthday*, Princeton, Princeton University Press, 1936, pp. 347–55.

Woysch-Méautis: D. Woysch-Méautis, *La représentation des animaux et des êtres fabuleux sur les monuments funéraires grecs: De l'époque archaïque à la fin du 4ᵉ siècle av. J.-C.*, *Cahier d'archéologie romande*, no. 21, Lausanne, Bibliothèque Historique Vaudoise, 1982.

1 Cavalier, p. 287, in her study of the Avignon relief and similar reliefs that depict girls with "dolls," dates the preserved examples to the fourth century BCE; she places the earliest preserved reliefs in the first quarter of the fourth century BCE.

2 The seated, clothed female appears on only two grave reliefs and is not considered here because the figure is not identified as a "doll" by many scholars; for example, Walter, p. 353 (a statuette, a votive), and Ch. Picard, *Manuel d'archéologie grecque, IV, 2: La sculpture, période classique – IV^e siècle*, Paris, A. & J. Picard, 1963, p. 1351 (an idol). The reliefs that depict the seated type of figure are: Edinburgh, National Gallery of Scotland, NG 686, Stele of Aristomache, Conze no. 817, vol. 2, pp. 174–5, pl. 154, and Athens, National Museum, 776, Conze no. 818, vol. 2, p. 175, pl. 157.

3 A figure of a naked, fully limbed female appears on three reliefs. (1) Athens, NM 1993, Conze no. 882, vol. 2, p. 188, pl. 171; Clairmont, vol. 2, pp. 137–8, no. 2.204; Dörig, "Puppen," pp. 45–6, pl. 23, 3. (2) Athens, NM 7527; Conze no. 816, vol. 2, p. 174, illustration in text; Woysch-Méautis, p. 121, no. 219, pl. 31; Clairmont, no. 1.263, vol. 1, p. 283. (3) Paris, Louvre MND, inv. 777 (Ma 4556), Cavalier, p. 287, fig. 3; G. Hoffmann, *La jeune fille, le pouvoir et la mort dans l'Athènes classique*, Paris, De Boccard, 1992, pl. 1; Clairmont, vol. 1, p. 316, no. 1.329.

4 A figure of a naked female with truncated limbs appears on the following twelve reliefs. (1) Athens, Kerameikos P 1140, I 161, Stele of Kallistonike, Cavalier, p. 287, fig. 4; Clairmont, vol. 1, pp. 172–3, no. 851. (2) Athens, NM 2103, Conze no. 814, vol. 2, p. 174, pl. 154; Kastriotes, pl. 4, 1 (left); Clairmont, vol. 1, p. 301, no. 1.296. (3) Athens, NM 2771, Kastriotes, fig. 4; Clairmont, vol. 1, p. 309, no. 1.312. (4) Athens, NM 2775, Stele of Kallikrite, Kastriotes, pl. 4, 2 (right); Woysch-Méautis, p. 113, no. 98, pl. 31; Clairmont, vol. 1, p. 206, no. 0.918.5) Avignon, Musée Calvet E31, Conze no. 880, vol. 2, p. 188, pl. 170; Cavalier, p. 286, fig. 1; Clairmont, vol. 1, p. 430, no. 1.757. (6) Boston, Museum of Fine Arts 66.971, Stele of Aristomache, C. Vermeule and M. B. Comstock, *Sculpture in Stone. The Greek, Roman, and Etruscan Collections of the Museum of Fine Arts, Boston*, Boston, Museum of Fine Arts, 1976, p. 46, no. 66; Cavalier, p. 289, fig. 7.7) Cambridge (Mass.), Harvard University, Sackler Art Museum, 1961.86, Stele of Melisto, Cavalier, p. 289, fig. 8; J. G. Pedley, "An Attic Grave Stele in the Fogg Art Museum," *Harvard Studies in Classical Philology*, vol. 69, 1965, pp. 259–67, pls I–III; Clairmont, vol. 1, pp. 204–5, no. 0.915. (8) Eleusis Museum, inv. no. 5201 (possibly a truncated figure); Clairmont, vol. 1, pp. 458–9, no. 1.840. (9) Malibu (California), J. Paul Getty Museum, 82.AA.135, Clairmont, vol. 1, pp. 308–9, no. 1.311.10) Munich, Glyptothek 199, Stele of Plangon, Conze no. 815, vol. 2, p. 174, pl. 156; Cavalier, p. 288, fig. 6; B. Vierneisel-Schlörb, *Klassische Grabdenkmäler und Votivreliefs: Glyptothek München, Katalog der Skulpturen*, Band III, Munich, Beck, 1988, pp. 65–71, pls 25–6; H. Rühfel, *Das Kind in der griechischen Kunst von der minoisch–mykenischen Zeit bis zum Hellenismus*, Mainz am Rhein, P. von Zabern, 1984, pp. 173–5, fig. 72.11) Piraeus, Museum, 1703, Woysch-Méautis, p. 121, no. 218, pl. 31; Clairmont, vol. 1, p. 277, no. 1.247. (12) Piraeus, Museum, 1778, Walter, p. 349, fig. 7.

5 For example, the Avignon relief (Fig. 33), once part of the Nani collection in Venice, was mentioned as early as the eighteenth century; Cavalier, p. 290 and n. 50. In the late nineteenth and into the early twentieth century Conze illustrated and described many of these reliefs: see Conze.

6 Kastriotes, cols 123–4, items α′ to ζ′, and col. 132.

7 Cavalier, pp. 285–93, includes sixteen reliefs in her study.

8 Elderkin, in her study of ancient jointed dolls, refers to the grave reliefs that show girls holding "dolls;" Elderkin, pp. 464–5. Likewise, J. Dörig's study of ancient Greek dolls draws comparisons between terracotta figures and seven grave reliefs that carry the image of girls holding similar figures; Dörig, "Puppen," pp. 45–6, nn. 28–32, 36. Also, Dörig, *EAA*, pp. 905–10, esp. 908–10; M. Golden, *Children*

and Childhood in Classical Athens, Baltimore and London, Johns Hopkins University Press, 1990, pp. 54 and 74–5; A. E. Klein, *Child Life in Greek Art*, New York, Columbia University Press, 1932, pp. 14–15; R. Schmidt, *Die Darstellung von Kinderspielzeug und Kinderspiel in der griechischen Kunst*, Vienna, Österreichischen Museen für Volkskunde, 1977, pp. 114–28, esp. 119–22 and pp. 124–7; E. Schmidt, *Spielzeug und Spiele der Kinder im klassischen Altertum*, Meiningen, Staatlichen Museen Meiningen, 1971, pp. 40–1; C. Daremberg and E. Saglio, *Dictionnaire des antiquités grecques et romaines*, Paris, 1875, s.v. "Pupa," vol. 4 (1), pp. 768–9. General works: M. Bachmann and C. Hansmann, *Dolls the Wide World Over*, New York, Crown Publishers, 1973, trans. R. Michaelis-Jena, p. 38; A. Fraser, *The History of Toys*, New York, Spring Books, 1966, p. 8.

9 For example, Elderkin, pp. 464–5, and p. 464, n. 2; she compares the figures on several reliefs to an articulated doll. Also, Vermeule, *supra*, n. 4, p. 46 and *Aspects of Ancient Greece*, Allentown Art Museum, 16 September to 30 December 1979, Allentown, Allentown Art Museum, 1979, pp. 252–3.

10 Rouse reports the find of dolls on Delos, the shrine of the hero Amynos, and the Athenian Acropolis, as well as other sites; W. H. D. Rouse, *Greek Votive Offerings: An Essay in the History of Greek Religion*, New York, Arno Press, 1975, pp. 249–50. For seated, naked female "dolls" found on Delos: A. Laumonier, *Exploration archéologique de Délos*, vol. 23, *Les figurines de terre cuite*, École Française d'Athènes, Paris, De Boccard, 1956, pp. 148–50, nos 404–25, pls 44–5. Jointed terracotta figures were frequent finds at the sanctuary of Demeter and Kore at Acrocorinth: R. S. Stroud, "The Sanctuary of Demeter and Kore on Acrocorinth, Preliminary Report I: 1961–1962," *Hesperia*, 1965, vol. 34, p. 18. For a jointed terracotta figure found at the shrine of a healing god (Amynos) near the Acropolis of Athens, see A. Koerte, "Bezirk eines Heilgottes," *Mitteilungen des Deutschen Archäologischen Instituts, Athenische Abteilung*, 1893, vol. 18, p. 244, item f ("weibliche nackte Puppe mit besonders angesetzten Armen").

11 A mould for an articulated doll was found at Olynthus: D. M. Robinson, *The Terracottas of Olynthus Found in 1928: Excavations at Olynthus IV*, Baltimore, Johns Hopkins University Press, 1931, p. 98, no. 415, pl. 57. Also, A. N. Stillwell, *Corinth vol. XV, Pts 1–2: The Potters' Quarter: The Terracottas*, Princeton, American School of Classical Studies at Athens, 1948, pt 1, p. 106, nos 66–7, pl. 41, and Princeton, 1952, pt 2, pp. 149–50, nos 5, 10, 11, 18, 19, pl. 31.

12 For example, a number of articulated dolls now in the British Museum were found in tombs: Higgins, *Terracottas*, p. 249, no. 913, pl. 132 (a Corinthian articulated figure found in tomb 252, Camiros, Rhodes), p. 252, no. 924, pl. 133 (also a Corinthian articulated figure, tomb 122, Camiros, Rhodes), and p. 253, no. 929, pl. 133 (a Corinthian articulated figure found in an Athenian tomb). Also Laumonier, *supra*, n. 10, p. 105, pl. 25, nos 258–60; these were found in the purification trench on Delos and in a tomb at Rheneia.

13 Elderkin, pp. 455–79, for numerous examples. Also, *Aspects of Ancient Greece*, *supra*, n. 9, pp. 244–5, and pp. 252–3, Higgins, *Terracottas*, p. 197, no. 734, pl. 97, E. Rohde, *Griechische Terrakotten*, Tübingen, E. Wasmuth, 1968, p. 42, fig. 19b, inv. no. T.C. 6908, 25.1 cm, *c*. 350 BCE.

14 Dissenting voices can be heard from Walter, pp. 352–3; he suggested that the grave reliefs depict girls holding not real dolls, but dedicatory dolls. Also, Picard sees in these figures funerary idols or apotropaic statuettes destined for the tomb: Ch. Picard, *supra*, n. 2, pp. 1414–18. G. W. Elderkin interpreted a fully limbed figure as a statuette, probably an offering to Aphrodite: G. W. Elderkin, "Aphrodite and Artemis as Dolls," *Art in America*, 1945, vol. 33, pp. 129–30.

15 For example, "Maidens before marriage, originally perhaps at puberty, were accustomed to dedicate along with their hair the dolls and other toys of their past childhood:" Rouse, *supra*, n. 10, p. 249. Similarly, E. Pernice, "Griechisches und römisches Privatleben," in A. Gercke and E. Norden (eds), *Einleitung in die Altertumswissenschaft*, vol. 2, pt 1, Leipzig, B. G. Teubner, 1932, 1, p. 55, and Golden, *supra.* n. 8, p. 54.

Toys could certainly become dedicatory objects. Several epigrams mention the dedication of toys by boys: *AnthPal* VI, 309 (Leonidas), the dedication of a ball, a rattle, knucklebones, and a spinning top to Hermes; *AnthPal* VI, 282 (Theodorus), a dedication of a ball and other objects. Girls dedicate balls on the terracotta *pinakes* found at Locri: see H. Prückner, *Die Lokrischen Tonreliefs*, Mainz am Rhein, P. von Zabern, 1968, pp. 46–50, fig. 7, pls 6–8.

16 *AnthPal* VI, 280 (anonymous). "Timareta, the daughter of Timaretus, before her wedding, hath dedicated to thee, Artemis of the lake, her tambourine and her pretty ball, and the caul that kept up her hair, and her dolls, too, and their dresses; a virgin's gift, as is fit, to a virgin Dian. But, Daughter of Leto, hold thy hand over the girl, and purely keep her in her purity." (*The Greek Anthology*, vol. 1, Cambridge, Mass., Harvard University Press, 1960, p. 449, trans. W. R. Paton). See also A. S. F. Gow and D. L. Page (eds), *The Greek Anthology, Hellenistic Epigrams*, Cambridge, Cambridge University Press, 1965, vol. 1, p. 208, vol. 2, p. 580.

17 The epigram has been frequently mentioned in discussions of this image, for example: A. Michaelis, "Griechische Grabreliefs," *Archäologische Zeitung*, 1872, p. 42; Vierneisel-Schlörb, *supra*, n. 4, p. 67; Rühfel, *supra*, n. 4, pp. 175–6; Kastriotes, cols 126–7, Dörig, "Puppen," p. 44; Walter, p. 353.

18 For example: Vierneisel-Schlörb, *supra*, n. 4, p. 67, "ein geradezu topisches Attribut junger, unvermählt (ἄγαμοι) verstorbener Mädchen." Rühfel, *supra*, n. 4, p. 176, "Manche der vor der Hochzeit verstorbenen Mädchen sehen wir auf den Grabreliefs in den Anblick der Puppe versunken, deren Weihung an Artemis ihnen das Schicksal nicht gewährt hatte." Similarly, M. Bachmann and C. Hansmann, *supra*, n. 8, p. 38, "Grave reliefs of the fourth century show pretty young girls charmingly engaged with their playmates of clay, indicating that these girls died before marriage, and unfulfilled." Dörig, "Puppen," p. 45; R. Schmidt, *supra*, n. 8, p. 120; Walter, p. 353. Also G. W. Elderkin, *supra*, n. 14, pp. 129–32, interprets the image on a grave relief as a marriage interrupted by death.

19 The grave relief of little Melisto in Cambridge, *supra*, n. 4, is an example of the very young age of the girls. Melisto's youth is indicated by several features: her childlike proportions, that is, a head large in comparison to the body, the high girding of her *chiton* that accentuates her rounded belly, her short, curly hair, and her playful action.

A child's distinct proportions – a head and trunk that are large in comparison to the total height – have been used to represent youthfulness: for example, see the discussion of children's proportions in fifth-century vase iconography in C. Sourvinou-Inwood, *Studies in Girls' Transitions: Aspects of the Arkteia and Age Representation in Attic Iconography*, Athens, Kardamitsa, 1988, pp. 37–8. See also the same conventions in Hittite art: J. V. Canby, "The Child in Hittite Iconography," *Ancient Anatolia, Aspects of Change and Cultural Development: Essays in Honor of Machteld J. Mellink*, Madison, University of Wisconsin Press, 1986, pp. 54–69.

20 Cavalier, pp. 290–1, notes that most girls are quite young and that there is an element of play on many reliefs, that some reliefs are paradigms of childhood.

Walter, p. 353, also points out that some of the girls are too young to be making a pre-wedding sacrifice to Artemis. Hirsch-Dyczek suggests that the image depicts the life of the child, engaged in an activity most typical for its age: O. Hirsch-Dyczek, "Les représentations des enfants sur les stèles funéraires attiques," *Prace Archeologiczne*, 1983, vol. 34, p. 23. Elderkin, p. 465, sees the "doll" as an indicator of childhood: "The presence of the doll serves to indicate, as in the tombs of maidens, that this nearly grown figure is intended to represent a child." Hoffmann sees such accessories (e.g. doll, bird) as signals of age: Hoffmann, *supra*, n. 3, pp. 323–4.

21 Only the Munich stele of Plangon, *supra*, n. 4, depicts what may be toys, possibly a bag of knucklebones on the wall.

22 The first four lines of the epigram of Timareta are as follows,

Τιμαρέτα πρὸ γάμοιο τὰ τύμπανα τάν τ᾽ ἐρατεινάν
σφαῖραν τόν τε κόμας ῥύτορα κεκρύφαλον
τάς τε κόρας (or κόμας), Λιμνᾶτι, κόρα κόρα, ὡς ἐπιεικές,
ἄνθετο καὶ κορᾶν ἐνδύματ᾽, Ἀρτέμιδι.

The emendation was perhaps made to resolve the difficulty raised in line 4 where *koran*, a genitive plural, is used instead of an accusative plural. Daux suggests that *komas* should be retained in line 3 and that the genitive plural should be read as a class of garments, that is, Timareta dedicates her virginal or maiden garments rather than "the garments of the dolls." G. Daux, "*AnthPal* VI 280 (Poupées et Chevelure, Artemis Limnatis)," *Zeitschrift für Papyrologie und Epigraphik*, 1973, vol. 12, pp. 225–9, and G. Daux, "Les ambiguïtés de Grec KOPH," *Comptes rendus des séances de l'Academie des inscriptions et belles-lettres*, 1973, pp. 389–93. The interpretation of the epigram is problematical. Compare the first four lines of the translation of the epigram by Paton, op. cit., n. 16, to the following which accepts Daux's arguments: "Timareta, the daughter of Timaretos, before her wedding, has dedicated her tambourine, her pretty ball, the net that shielded her hair, her hair, and her girls' dresses to Artemis of the Lake, a girl to a girl, as is fit." J. H. Oakley and R. H. Sinos, *The Wedding in Ancient Athens*, Madison, University of Wisconsin Press, 1993, p. 14.

23 The dedication of hair is attested in numerous sources: for example, Pollux records the dedication of hair to Hera, Artemis, and the Fates before marriage, at the *proteleia*, a pre-wedding sacrifice. ταύτῃ γὰρ τοῖς προτελείοις προυτέλιζον τὰς κόρας, καὶ Ἀρτέμιδι καὶ Μοίρις. καὶ τῆς κόμης δὲ τότε ἀπήρχοντο ταῖς θεαῖς αἱ κόραι. (For in these *proteleia* [to Hera] they offer preliminary marriage sacrifice for the girls, and to Artemis and to the Fates. And the girls make an offering of their hair to the goddesses.) Pollux, iii, 38. E. Bethe, *Pollucis Onomasticon*, Stuttgart, Teubner, 1967, vol. 1, pp. 166–7. Also, Alcibia dedicates her hair to Hera when she enters wedlock, *AnthPal* VI, 133 (Archilochus). The maidens of Troizen dedicate their hair to Hippolytus: Pausanias, 2, 32, 1, and Euripides, *Hippolytus*, 1425–6. The brides and grooms of Megara dedicate their hair to Iphinoe, Pausanias, 1, 43, 4. On Delos the youths and brides dedicate their hair to the Hyperborean maidens: Herodotus, 4.34, and Callimachus, *Hymn to Delos*, 296–9. Also, Van Straten, pp. 89–90 and pp. 96–8. For the custom reflected in sculpture see E. B. Harrison, "Greek Sculptured Coiffures and Ritual Haircuts," in R. Hägg, N. Marinatos, and G. C. Nordquist (eds), *Early Greek Cult Practice, Skrifter utgivna av Svenska Institutet i Athen*, 4, 38, Stockholm, 1988, pp. 247–54. For a Centuripe vase that has been interpreted as a *proteleia* scene with the sacrifice of a lock of hair, see P. Deussen, "The

Nuptial Theme of Centuripe Vases," *Opuscula Romana*, 1973, vol. 9, pp. 126–9, figs 1–3.

The dedication of garments by girls and women appears in epigrams of the Anthology and the records of the treasury of Brauron. T. Linders, *Studies in the Treasure Records of Artemis Brauronia Found in Athens, Skrifter utgivna av Svenska Institutet i Athen*, 4, 19, Stockholm, 1972. Van Straten, p. 99. *AnthPal* VI, 207 (Archias), five girls all of one age, dedicate sandals, a purple hair net, a fan, a veil, and a gold snake anklet to Aphrodite γαμοστόλε, that is, Aphrodite of wedding preparations. Also, for example, *AnthPal* VI, 208, and VI, 276.

24 A number of scholars have noted that there seems to be no "baby doll" among ancient Greek toys. For example, Cavalier, p. 290; Dörig, *EAA*, p. 908; E. Schmidt, *supra*, n. 8, p. 42; Vierneisel-Schlörb, *supra*, n. 4, p. 67.

25 Dörig made this observation earlier regarding Athens, NM 1993; he concluded that the sculptor may have been depicting a wax doll. Dörig, "Puppen," pp. 45–6.

26 A naked terracotta doll found in Cyrenaica is comparable and it has a hole in the head for a string, a feature suggesting that it was a votive. Higgins, *Terracottas*, p. 259, no. 953, pl. 134. A terracotta figure from a sanctuary in central-west Greece (Spolaita Trixonidas) is also similar, depicting a fully limbed, naked female (now headless): *Archaiologikon Deltion*, 1987, vol. 42, B 1, Chronika, p. 177, pl. 90 d. Terracotta figures of naked females are among the dedications at the Thesmophorion at Eretria: I. R. Metzger, *Das Thesmophorion von Eretria: Funde und Befunde eines Heiligtums, Eretria Ausgrabungen und Forschungen VII*, Bern, Francke, 1985, p. 92, pl. 29, nos 1566–7.

27 A number of scholars have compared the truncated figures depicted on the grave reliefs to the truncated terracottas, rather than articulated dolls, for example, Dörig, "Puppen," pp. 46–7; Michaelis, *supra*, n. 17, pp. 140–1; Schweitzer, pp. 4–5; Vierneisel-Schlörb, *supra*, n. 4, p. 67; Walter, p. 351.

Examples of the truncated figure are abundant, but many are without a precise provenience. Copenhagen, Danish National Museum, inv. no. 1639, H. 15.7 cm, *c.* 450–425 BCE, from Athens, N. Breitenstein, *Catalogue of Terracottas, Cypriote, Greek, Etrusco-Italian and Roman. Danish National Museum, Department of Oriental and Classical Antiquities*, Copenhagen, E. Munksgaard, 1941, p. 28, no. 266, pl. 29. London, British Museum, inv. no. 43.5-7.786, H. 10 cm, provenience unknown, *c.* 450 BCE, Higgins, *Terracottas*, p. 182, no. 683, pl. 89. Paris, Musée du Louvre, inv. no. CA2982, H. 15.3 cm, from Attica, *c.* 450 BCE, S. Mollard-Besques, *Catalogue raisonné des figurines et reliefs en terre-cuite grecs, étrusques et romains*, Paris, Editions des Musées Nationaux, 1954, vol. 1, p. 84, cat. no. C12, pl. 56. Frankfurt, Liebieghaus, inv. no. 469, H. 16 cm, from Attica, *c.* 450–425 BCE, P. C. Bol, *Bildwerke aus Terrakotta aus mykenischer bis römischer Zeit*, Liebieghaus-Museum alter Plastik Antike Bildwerke, Band III, Melsungen, Gutenberg, 1986, pp. 82–5, no. 44, figs 44, 1–3. University of Königsberg Collection, H. 16.6 cm, from Athens, Schweitzer, pp. 2–3, figs 1–2, pls 1–3, and a terracotta figure in Würzburg, see pl. 4. Truncated female figure in New York, Metropolitan Museum of Art, Terracotta no. 20.205, Klein, *supra*, n. 8, pl. 16, D. For a truncated female figure of marble, see Berlin, Staatliche Museen, inv. no. 1864 (K 258), from Athens, *c.* 400 BCE, H. 13.5 cm, C. Blümel, *Die klassisch griechischen Skulpturen der Staatlichen Museen zu Berlin*, Berlin, Akademie-Verlag, 1966, p. 95, no. 113, figs 180–1. A similar marble figure was found in a child's burial in Athens: *Archaiologikon Deltion*, vol. 29, B 1 Chronika, 1973–4, p. 122, tomb III, pl. 94 γ.

There are also variations with either the legs or arms truncated. For

example, a terracotta found at Theangela depicts a seated, naked female with arm stumps. The figure was found in a *bothros*, on the northern slope of the acropolis. F. Işik, *Die Koroplastik von Theangela in Karien und ihre Beziehungen zu Ostionien, zwischen 560–270 v. Chr., Istanbuler Mitteilungen*, Suppl. 21, 1980, pp. 174–5, 186, 244, no. 204, pl. 28. A fragmentary terracotta figure found at Theangela depicts a naked female with arm stumps and complete legs positioned in such a manner that it is described as "dancing:" Işik, pp. 175, 187, 244–5, no. 205, pl. 28. Also, a seated figure with truncated arms found at the Necropolis of Locri Epizephyrii, *Notizie degli Scavi di Antichità*, Suppl., vol. 8, 1911, pp. 18–20, tomb 117, fig. 18, and W. Amelung, "Studien zur Kunstgeschichte Unteritalien und Siziliens," *Mitteilungen des Deutschen Archäologischen Insituts, Römische Abteilung*, 1925, vol. 40, pp. 207–8, fig. 19. Also the naked female figures with "truncated" legs found at Locri Epizephyrii. These figures may have been immersed in water from the knees down, therefore, these figures do not have truly truncated legs but were understood as seated with their legs folded beneath them. L. von Matt, H. Hoffman, and U. Zanotti-Bianco, *Magna Graecia*, New York, Universe Books 1962, p. 131, figs 124–5.

28 For example, Vierneisel-Schlörb, *supra*, n. 4, p. 67. Schweitzer, pp. 5–6, also notes the strange absence of lower arms and legs. Walter, pp. 351–2; he accounted for the unusual form by suggesting that the truncated figures are imitations of play dolls, depicted in this form in order to avoid confusion with statuettes of gods.

29 Elderkin, p. 465. "Occasionally dolls are represented on stelae complete with arms and legs, but usually the extremities are missing to mark their character as dolls rather than infants or sacred images."

30 R. A. Higgins, *Greek Terracottas*, London, 1967, p. 75. Conze, vol. 2, p. 174, no. 814, also suggested that the "dolls" were to be dressed.

31 C. Friedrichs and P. Wolters, *Die Gipsabgüsse antiker Bildwerke*, Berlin, W. Spemann, 1885, pp. 337–8, no. 1024. The notion of swaddling clothes is also discussed by Schweitzer, p. 6, and Walter, pp. 349–50. Walter points out as evidence against it the shortened length, the mature figure, and the fact that they are not shown clothed or wrapped.

32 Schweitzer, pp. 6–9. The Boeotian idols, however, are not naked, nor are their legs truncated; their length, as well as shoes that are sometimes rendered at the base of the skirt, suggest that they were understood to have complete legs and feet. For example, note the separately attached feet on a Boeotian figure in the British Museum, Higgins, *Terracottas*, p. 212, no. 792, pl. 107.

33 C. Roebuck, *Corinth, vol. XIV: The Asklepieion and Lerna*, Princeton, American School of Classical Studies at Athens, 1951, pp. 111–28, pls 33–46. M. Lang, *Cure and Cult in Ancient Corinth*, Princeton, American School of Classical Studies at Athens, 1977, p. 14, fig. 14, and Van Straten, fig. 51.

34 Van Straten, p. 105.

35 Athens, Acropolis Museum, 7232, a marble relief, 16 cm high, *c.* fourth century BCE; as Van Straten points out, all of the pieces would form a complete female body. Van Straten, p. 106, fig. 50. O. Walter, *Beschreibung der Reliefs im kleinem Akropolismuseum in Athen*, Vienna, Holzel, 1923, pp. 61–2, no. 108, fig. 108 (inventory number given here is 4901).

36 In the nineteenth century, A. Bötticher identified the figure held by the girl on a relief as an anatomical votive; he doubted that the relief was funerary. His suggestion was quickly dismissed and has remained in obscurity. See Michaelis, *supra*, n. 17, p. 141.

37 Archaeological evidence confirms the use of precious metal; examples of metal

votives survive from a sanctuary of Demeter in Mesembria; Van Straten, p. 127, nos 22.1–22.12, figs 59–60.

38 Van Straten, pp. 108–10, no. 1.25–1.31.

39 σῶμα κατάμακτον γυναικὸς ὅ ἀνέθηκεν Παυσιμάχη ("Moulded body of a woman which Pausimache dedicated"). S. B. Aleshire, *The Athenian Asklepieion, the People, their Dedications, and the Inventories*, Amsterdam, J. C. Gieben, 1989, p. 181, l. 68, and p. 199. On the other hand, the term κατάμακτοι has been interpreted as relief or repoussé technique by Van Straten, pp. 79–80.

40 Van Straten, p. 110.

41 The excavation of the Asklepieion at Athens did not reveal any truncated female figures in either precious metal or terracotta. The excavation recovered only a few terracottas, but among the finds there are busts of a male with the arms cut off in a manner similar to the truncated figures. J. Martha, *Catalogue des figurines en terre cuite du musée de la société archéologique d'Athènes*, Paris, E. Thorin, 1880, p. 27, cat. nos 120–1. The excavations apparently did not reach the early levels of the foundation of the sanctuary and much archaeological information may be missing: Aleshire, *supra*, n. 39, pp. 5–6.

42 Van Straten, pp. 72–4.

43 For example, see Athens, NM 3526, the marble plaque of Lysimachides, who is depicted dedicating a large model of a left leg with a varicose vein, Van Straten, p. 113, no. 2.1, fig. 52, and J. Travlos, *Pictorial Dictionary of Ancient Athens*, London, Thames and Hudson, 1971, p. 78, fig. 100.

44 The depiction of internal organs is rare in Greece (although it does occur); an internal complaint was represented by a corresponding view of the exterior. Van Straten, p. 150.

45 A. E. Hanson, "The Medical Writers' Woman," in D. M. Halperin, J. J. Winkler, and F. I. Zeitlin (eds), *Before Sexuality: The Construction of Erotic Experience in the Ancient Greek World*, Princeton, Princeton University Press, 1990, pp. 323–4; also see Hoffmann, *supra*, n. 3, pp. 303–11.

46 The translation is by Hanson, *supra*, n. 45, p. 323.

47 Hanson, *supra*, n. 45, pp. 313–20. Geoffrey Lloyd has found a considerable overlap between the everyday suppositions of society and the rational explanations of ancient medicine. Hanson, p. 313, and G. E. R. Lloyd, *Science, Folklore and Ideology*, New York, Cambridge University Press, 1983, pp. 62–86 and 168–200.

48 Aeschylus, *The Suppliant Maidens*, 463. See lines 455–65, for the exchange between the King and the Danaids who threaten to hang themselves by the breastbands and girdles that they wear; an earlier suicide threat appears at line 160. Plutarch also reports that at Miletus the *parthenoi* once had a yearning for death that manifested itself in a desire to hang themselves. All attempts to stop the mass suicide were ineffective until a law was passed stating that, if a young woman hanged herself, her corpse would be carried naked through the market place to her burial. Plutarch, *Moralia* 249 b–d. Hanging seems to be an especially feminine form of death in ancient Greek literature; N. Loraux, *Tragic Ways of Killing a Woman*, Cambridge, Mass., Harvard University Press, 1987, pp. 6–30, trans. A. Forster.

49 The medical function of torsos with arm and leg stumps can also be seen at some sites in Italy where terracotta male torsos were dedicated. Some torsos are rendered with the chest opened to reveal the internal anatomy. E. Holländer, *Plastik und Medizin*, Stuttgart, F. Enke, 1912, pp. 200–1, figs 111–12, pp. 204–7, figs 116–19; M. Fannelli, "Contributo per lo studio del

votivo anatomico: i votivi anatomici di Lavino," *Archeologia Classica*, 1975, vol. 27, p. 216, pl. 41.

50 Higgins, *Greek Terracottas*, *supra*, n. 30, p. 75. Higgins dates the appearance of this type of "doll" in the mid fifth century BCE.
51 Aleshire, *supra*, n. 39, pp. 7–8.
52 For example, Athena Hygeia is known at Athens in the early fifth century BCE: Aleshire, *supra*, n. 39, pp. 11–12. A sanctuary to a healing hero, the Amyneion, existed on the south slope of the Areopagus since the sixth century BCE: Travlos, *supra*, n. 43, p. 76. There was apparently resistance to the introduction of the cult of Asklepios at Athens from the *genos* of the Kerykes who controlled property in the Pelargikon and supported the Amyneion: see Aleshire, *supra*, n. 39, pp. 8–9. Also, F. Kutsch, *Attische Heilgötter und Heilheroen*, Giessen, A. Topelmann, 1913.
53 The truncated female figure was so much an icon or emblem of femininity that it could also have a decorative function. See a pair of gold earrings, London, British Museum, GR 1877.9-10.18-19, *c.* 330–300 BCE: D. Williams and J. Ogden, *Greek Gold, Jewelry of the Classical World*, New York, Harry N. Abrams, Inc., Metropolitan Museum of Art, 1994, p. 97, no. 50.

NURSING MOTHERS IN CLASSICAL ART

Larissa Bonfante

A consideration of the figure of the nursing mother suckling the child and exposing her naked breast to view in the art of the classical period brings out clear differences between Classical Greek art and the art of Italy. An examination of the possible reasons for the absence of this motif in Classical Greek art in contrast to its remarkable importance in the art of Italy at all periods may bring us closer to the social and religious complexities of the Mediterranean world in the period before the unifying influences of the Hellenistic period.

Nursing the baby at the breast is the natural first act of a mother towards her child the world over. Accustomed as we are to seeing the Renaissance image of the Virgin with the Christ child at her breast, we are at first surprised to realize that the gesture occurs regularly, as a motif in art, only in the cult of Isis and the cult of the Virgin Mary.[1] In classical art, which concerns us here, most of the figures of nursing mothers are found in Italy, in the art of Etruria, south Italy, and Sicily. These were the regions of Italy where the concept of a mother goddess who ruled fertility and the birth of children never ceased to be important. In fact, even examples of nursing mothers in Greek art are nearly all from the Greek cities of Sicily and southern Italy. By contrast, in the Classical Greek art of the mainland the motif is practically non-existent.[2] Greek myth, as well as art, shows divine babies handed over to foster mothers or tutors, to be nursed by nymphs or animals. *Kourotrophoi*, "nurses," are just as likely to be male tutors or dry nurses as wet nurses, and the chances of mythological babies being nursed by their own mothers are very slim. They are much more likely to drink at the breasts of nurses, human or animal.[3] Groups of the "holy family," with father, mother, and child, are almost unknown as a motif in Greek art.[4] After the little Mycenaean "divine nurses" of the thirteenth century BCE, even images of mothers and children are rarely found in Greek art before the Hellenistic period.[5]

We note, in any case, that the image of the nursing mother had connotations in Greek art quite unlike those current among us today.[6] Let us take one instance in particular, a scene in Attic vase painting which looks at

first sight like a quiet family scene of a seated mother nursing her child. The implications of the image turn out to be quite different from what is first imagined when the context becomes apparent. An inscription identifies the mother as Eriphyle, wife of Amphiaraos.[7] According to the myth, Amphiaraos, who foresaw his own death before Thebes, was sent to his death by Eriphyle after she had been bribed by the necklace of Harmonia. To one who knows the story, the foreshadowing of death and destruction implied by the picture is powerful. We can compare the figure of Andromache giving the breast to her son Astyanax, doomed to die a horrible death, in Polygnotus' *Iliupersis*.[8] In both cases mortal danger lies ahead for husband and son, and the destruction of the family. The horror to come is underscored by the private, moving scene of the mother nursing the child, an image of vulnerability not normally shown, and therefore special.

Women exposing their breasts regularly bring up feelings of a world awry, of anxiety and nightmarish danger. In mythological scenes in Greek art, women appear with bared breasts in moments of great danger, to indicate their weakness and vulnerability. An ivory group of two women from before the middle of the seventh century BCE represents the daughters of Proetus, mad and disrobing: one has exposed her breasts, the other unties her belt.[9] Before the arrows of Artemis and Apollo the Niobids flee naked and defenseless. Iphigenia is half naked before those who will sacrifice her. Helen bares her breasts before Menelaos, Clytemnestra before Orestes, Hecuba before Hector. Cassandra, about to be raped by Ajax, is naked in front of the statue of Athena in Troy on the Kleophrades Painter's *hydria*.[10] Polyxena exposes her naked breasts, "bare and lovely like a sculptured goddess" in the moment preceding her death.[11]

Greek art shows many scenes of private life, so that the absence of the motif of the nursing mother is particularly striking. Nor is the motif of mother and child frequent. We often see the wet nurse, *titthe*, hand the child to the mother.[12] But often the woman with the child could be the nurse, rather than the mother. On one funerary stele, which at first sight seems to show a mother with her child, inscriptions inform us that it is the grandmother, portrayed with her dear grandchild. Another shows an older sister with her little brother.[13] Exceptions to the rule (usually not from Attica or the mainland) are rare and controversial. A recently discovered stele with a scene of a baby actually nursing at the breast comes from northern Greece (Fig. 39).[14] On painted vases of south Italy or Sicily of the fourth century BCE, the image of the nursing mother was used almost exclusively for figures of Aphrodite with her child, Eros,[15] and the motif gave rise to some remarkable compositions. An Apulian lekythos of the early fourth century BCE pictures Aphrodite nursing an Eros, while nearby a whole flock of Erotes come out of a chest; a beautiful painted pyxis by the Lipari Painter (late fourth century BCE) shows the goddess suckling the baby Eros at her naked breast (Fig. 40).[16]

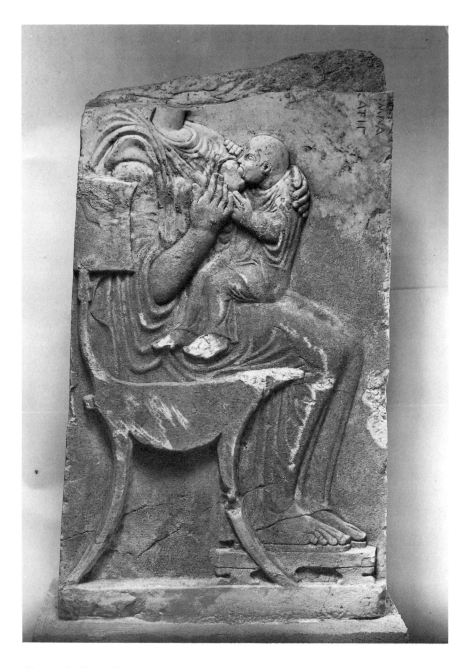

Figure 39 Thessalian grave stele from Larisa, showing a woman nursing a child.
c. 425–400 BCE Larisa, Archaeological Museum

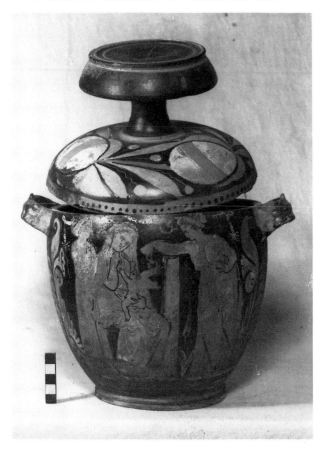

Figure 40 South Italian red-figure pyxis by the Lipari Painter, goddess suckling the baby Eros. Late fourth century BCE Museo Archeologico Eoliano, Lipari

Avoided in the classical Greek art on the mainland, the nursing scene was important in Italy, including Etruscan art and that of its neighbors.[17] The earliest image of a female figure nursing a child found so far in Italy appears on a bronze object from a rich tomb at Decima, in Latium, near the border of Etruria (Fig. 41). This horse trapping was placed in a woman's tomb, together with the chariot that indicated her high status, at the end of the eighth century BCE.[18] Two human figures are represented: a man with two birds pecking his eyes, and the woman nursing a child. It is a couple; but it is hard to tell whether the artist meant to represent a divine, mythological, or mortal couple.

Later some archaic and early "Classical" Etruscan monumental *kourotrophoi* appear, images of women or goddesses holding children: the terracotta figure from Veii of Leto with the baby Apollo, fleeing from the

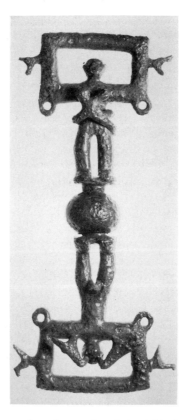

Figure 41 Bronze horse trapping, from a female burial in Decima (Latium), woman nursing a child. Late eighth century BCE, Museo Nazionale, Rome

Python, and the so-called Mater Matuta from Chiusi, a seated funerary statue of a woman with a baby, of the early fifth century BCE.[19] Probably influenced by Greek artistic models, they hold the children, but do not nurse them.

Another monumental figure, from Sicily, an impressive mid-sixth-century BCE life-size limestone statue of a mother nursing two babies, was found in 1956 over a large underground tomb in the cemetery of Megara Hyblaia, unfortunately without the head. Like the statue from Chiusi, it was a funerary monument. The realistic representation shows the slits in the dress for the children to reach their mother's breasts, with the large nipples represented in relief. The style of this figure, and the contrast between this detail and the stylized manner in which the mantle is shown as a stiff, hard shell protecting the children, has often been commented upon.[20] The iconography of two or more babies had a long history in Italy. Twins are found on the Ara Pacis (see below), and many centuries later, in Renais-

sance representations of Charity. On the statue of Charity by Tino di Camaino, we also see once more the realistic detail of the dress with slits at the breast.[21] The statue from Megara Hyblaia, today in the museum in Syracuse, has recently been identified as Night, the nurse of Sleep and Death, on the basis of Pausanias' description, on the Chest of Kypselos at Delphi, of "a woman represented carrying a white boy asleep on her right arm: on her other arm she has a black boy who is like one that sleeps: the feet of both boys are turned different ways. The inscriptions show, what it is easy to see without them, that the boys are Death and Sleep, and that Night is nurse to both."[22] Pausanias may have meant that anyone looking at the monument would recognize a well-known reference to Sleep and Death, the children of Night (Hesiod, *Theogony* 211–12, 756–9). Possibly the motif was meant to suggest death.[23] We have seen that the word "nurse," *kourotrophos*, is ambiguous in Greek – it refers to either a wet nurse or a dry nurse.

Their quality and quantity make it clear that statues of mothers holding or nursing children were made for religious reasons. On the so-called Maffei statue, an impressively monumental, life-size votive statue from Volterra, the child was added to a well-known, fourth-century Greek type.[24] The fourth to the second centuries BCE saw a proliferation of images of nursing mothers, in a variety of forms, functions, sizes, styles, iconography, and contexts that reflect the local importance of the motif. There was no single Greek model, but rather the impelling need for such an image for the devout. Out of the thousands of votive statuettes from sanctuaries all over Italy, many are *kourotrophoi*, holding or nursing babies.[25]

Etruscan art, in fact, is characterized by the appearance of breasts in unexpected contexts. A remarkable late sixth-century BCE terracotta model of a bed-chest from the Banditaccia necropolis in Cerveteri is decorated with rows of breasts all around below.[26] Sometimes they were used as decorative motifs.[27] There was a taste for showing animals with swollen teats, even in the case of males,[28] and for animal nurses: a lioness nursing a child, a wolf on a stele from Bologna.[29] The Capitoline wolf nursing two children belongs in this Italic world.[30]

An Etruscan vase by the Settecamini Painter reverses the relationship, illustrating a charming scene, Pasiphae with the baby Minotaur. "Even the monster was once a dear child."[31] Beazley was quite taken with this "port-hole view of an otherwise obscure period in the life of whom some at least of my readers would probably describe as their favorite character in fiction." He points out that the jewelry shows the woman to be Pasiphae rather than a nurse, as some had thought, and the Minotaur is not new-born, but between two and four years old.

The delightful little fellow has passed his hand round his mother's waist, between the two garments, where it is warm. Several episodes

from the story are represented in antiquity. Etruscan Hellenistic urns of the Hellenistic period show Minos when he first sets eyes on the infant – a tense moment. In Euripides' play we hear him raging, and hear Pasiphae's tremendous defense. Then there is silence: but after all the Minotaur survived. Someone gave him a beautiful name, Asterios; and someone must have reared him: why not his mother?[32]

An especially striking image is that of Hera nursing Herakles. Although the *Greek Anthology* refers to a Greek image, apparently a statue, of Hera nursing Herakles,[33] the motif is known in art only on monuments in Italy. This scene of Uni nursing Herakles in preparation for his presentation in Olympus appears on four Etruscan mirrors and a south Italian vase.[34] Herakles' entrance into Olympus is a Greek myth, and so is Hera's adoption of Herakles. But the manner of representing the rite of adoption with the image of nursing at the breast of the goddess is purely Italic, not Greek. Obviously the ritual scene of Herakles nursing, avoided in Greece, was important for the religious art of ancient Italy.

There was no single model for all four Etruscan representations of this scene. The mirror from Volterra, the most ambitious of the four, shows Uni, equivalent to the Greek Hera, offering her breast to a muscular, bearded Herakles, the Etruscan Hercle. A solemn assembly of divinities witnesses the ritual adoption scene. Neptune, not labelled, but recognizable by his trident, points to a tablet which documents the ceremony in Etruscan: "This image shows how Hercle, Hera's son, drank milk."[35] The artist's quiet, heavy figures and severe style are appropriate for the religious significance of the scene on the mirror: the goddess transforms the hero as she confers immortality on him with her milk. Though carelessly engraved by an inexperienced craftsman, another recently published late fourth-century mirror from Tarquinia (Fig. 42) reflects in its iconography an equally ambitious, but different, model. Uni, her head covered by her mantle, offers her breast to a youthful Hercle in the presence of two other female figures; one of these, a winged Nike-like figure, holds up the crown with which to mark his apotheosis.[36] A mirror in Bologna shows a simpler scene, a young Hercle nursing at the breast of an attractive Uni, with a youth, probably Hercle's companion, Iolaos, standing by.[37]

Judging from the Etruscan artistic representations, the scene of Hera nursing Herakles was interpreted in different ways in Greece and in Etruria. In the Greek myth Hera is tricked into nursing the baby Herakles, and angrily withdraws her breast when she discovers the trick; the Etruscan Uni, in contrast, gives him divinity and makes him acceptable among the gods.[38] The difference points to a different origin. The symbolic meaning of this act could have come to Italy from the Phoenician world, just as the figure of the Etruscan Hercules, or Hercle, was influenced by that of the Phoenician god Melkart.[39]

180

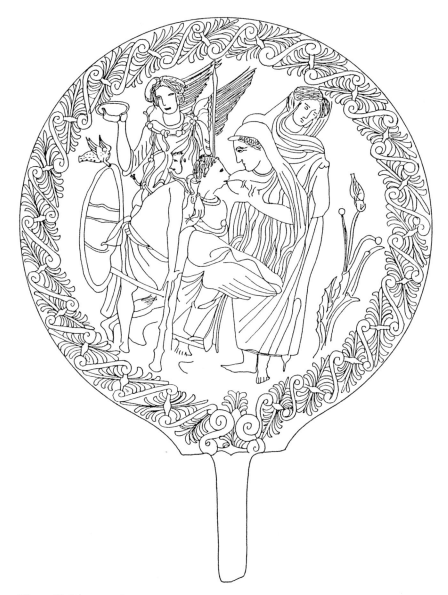

Figure 42 Etruscan bronze mirror, with Hera nursing the grown Herakles. Late fourth century BCE, Museo Archeologico Nazionale, Tarquinia

The scene survived into later art. In the Hellenistic period the motif of a grown man nursing at a woman's breast appeared, in a totally different context, on monuments from Pompeii. A statuette illustrates the story of Pero and Micon, the daughter who nursed her starving father with her own

181

milk (Fig. 43).[40] At the same time sentimental and sexually disturbing, this scene of father and daughter is typically Hellenistic. There is no longer any trace of the earlier religious, ritual significance of the scene on the Etruscan mirrors. Later, Italian painters re-interpreted this motif, creating the image

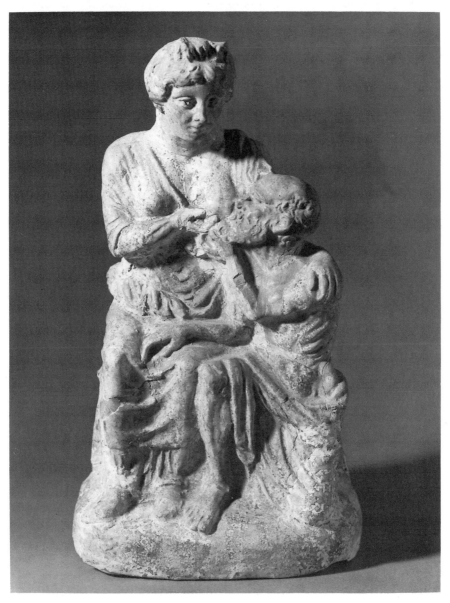

Figure 43 Terracotta statuette of Pero and Micon from Pompeii. Hellenistic. Museo Archeologico Nazionale, Naples

of the *Carità Romana*, the noble Roman daughter who saved her old father from death. One of the most beautiful examples of this image so much in favor in the Baroque period is found in a detail of a painting by Caravaggio (1606), now in Naples. Rubens took up the scene of the adoption of Herakles in a far less disturbing manner than the picture on the Etruscan mirror. A baby Herakles is nursing at Hera's ample breast, instead of an adult, bearded hero. All around them milk spreads out to form the Milky Way, according to an ancient literary version of the Greek myth. By Rubens's time, the motif of the nursing mother was not unusual in any way.[41]

In the Roman period in Gaul, workshops modelled images of their *Dea Nutrix* nursing two tiny infants, slender and delicate, in the "French" style.[42] Found throughout the Celtic area, from Gaul to Britain, and in Germany as far as Salzburg, the statuettes show the popularity of this type. Clearly it represented the figure of a divinity which was of great importance in the local cult. It has been suggested that the model for such Gallic figures of the mother goddess was a monument like the statue of Megara Hyblaia, also a seated figure nursing twin babies, completely covered by a wide mantle which protects them like a cocoon.[43]

Roman tradition preserved features of this protective mother figure. The emperor Caligula is said to have followed an Etruscan custom when he placed his little daughter Drusilla, immediately after her birth, at the breast of the sacred statue of Minerva, for the goddess to nurse her so she would grow healthy; and indeed the Etruscan Minerva appears more than once as a *kourotrophos*.[44] The motherly aspect of a Minerva who nursed or watched over babies certainly contrasted with the character of Athena, so notoriously gingerly in her dealing with the baby Erichthonius.[45] Cicero also says that the statue of the baby Jupiter sitting together with his sister Juno on the lap of Fortuna, reaching for her breast, was an object of cult for married women ("Iovis pueri, qui lactens cum Junone Fortunae in gremio sedens mammam appetens castissime colitur a matribus:" Cicero, *de Div.* 2.85).

The Ara Pacis relief shows the child reaching up for the breast of Tellus, as in Cicero's description ("mammam appetens"). But the children – there are two, according to the Italic tradition – do not actually nurse: the artist follows the Greek classical model. The meaning of this public, official monument is not so different from that of the earlier humble, private terracotta votive figurines: indeed private and public merge in the representation of the family of Augustus. The image of the mother with children represents a prayer for fertility, for the birth and health of the children and their families.[46] Such a representation belongs in the context of Italic art, though expressed in a Greek style and form.

Because Roman art adopted Greek artistic traditions, Roman scenes of actual nursing are rare, as they were in Greek art. When they are shown, it is not surprising to find an emphasis on the family. Two second-century

sarcophagi, in Paris and Rome, illustrate the dead boy's childhood and education, and show him nursing at his mother's breast; in one case, his father looks on.[47] On a fragment of a later sarcophagus is a bucolic scene: a young mother, wearing a kerchief on her head, nurses a naked baby, while the father, a shepherd, watches them affectionately.[48] These nursing scenes on Roman sarcophagi are rare examples of a non-Greek, native motif. A more common motif is that of the barbarian captive, with one breast uncovered. Such pitiful figures of captive mothers and children as those that speak of the horrors of war on the column of Marcus Aurelius[49] are linked to earlier representations of the vulnerability of slaves and prisoners, and the primitive, uncivilized aspect of barbarians and other wild creatures.

The image of the Madonna and Child, which enters the repertoire of Christian art in the twelfth century, becomes normal in the Trecento, and lasts over three hundred years, fits into this context. Though many have seen in the image of the Virgin Mary nursing the divine child at her breast a continuity with the motif of Isis Lactans, in fact its significance is the opposite. While the goddess Isis makes the baby immortal by nursing him, Christ's gesture of nursing at the breast of Mary shows his humanity, his participation in animal nature and flesh. In both cases, this powerful image carries with it a religious message of great import: but it is a very different message in each of the two religions.[50]

REASONS FOR DIFFERENCE

Possible reasons for the difference between classical Greek art and the art of Italy in their use of the figure of the nursing mother suckling the child and exposing her naked breast can be listed under three headings: social, religious, and magic.

Social reasons

The absence of the image of breast-feeding in classical Greek art perhaps mirrored real life, at least to the extent that aristocratic, or respectable "bourgeois" Greek – and, later, Roman – ladies rarely nursed their babies themselves.[51] They had wet nurses, often slaves from their own households, as we know from Greek art, especially from funerary stelae, where a nurse hands the baby to the mother, and from literature.[52]

As in other periods and societies, the mother may not have wanted to risk ruining her figure.[53] Greek literature shows that there was an aesthetic aspect to this aversion towards the sight of the nursing mother. Large breasts were considered to be ugly: so Lucretius (4.1168) observes of a woman "tumida et mammosa". Terence, *Eunuchus* 2.3, informs us that mothers bound their daughters' breasts to make them fashionably slender (*gracilae*).[54] In art, terracotta statuettes of wet nurses show them as big-

breasted, old, and ugly.[55] An old woman with pendulous breasts, probably a death demon, attends Alcestis on an engraved mirror in the Metropolitan Museum in New York.[56] Greek society was obsessed with youth, and artists regularly "rejuvenated" male figures. The preference for the image of the youthful female body, boyish-looking, with small breasts, parallels the taste for the image of young boys, whose small penises are contrasted to the large penises of old men and satyrs.[57]

It was also a sign of civilization for a lady to be freed from this embarrassingly physical necessity, all too reminiscent of our lowly animal nature. The iconography of nursing the young as symbol and sign of a primitive, barbarian world is characteristic of the social significance of this image. In Greek and formal Roman art, only barbarians and wild creatures, such as female centaurs, nurse their young. Zeuxis painted a famous picture of a centaur mother suckling her babies.[58] This concept of breast-feeding as a primitive, barbaric gesture survived: in the Middle Ages the Earth was represented this way, contrasting her simple, harsh nature with civilized ways, and in the Renaissance the motif was used, for example, by Dürer to represent the primitive world of satyrs and nymphs.[59] Some of these connotations may well have been involved in the representations of classical art; but they would not account for the sharp contrast we see between the art of Italy and of mainland Greece.

Religious reasons

A religious basis for this opposition seems much more likely. Clearly Greek art refused to admit this scene of nursing in its repertoire as part of the normal, civilized world ruled by Zeus and Athena. The gesture belonged to the world of the Furies, the Eumenides, of blood, of man's animal nature. The gods are aristocratic, civilized – they hand their divine babies over to nurses of a lower social order than their goddess mothers.

In Etruscan and Italic art, on the other hand, images of the nursing mother, and even of mother and child, break through the iron-clad Greek convention so universally accepted by a world that wanted to be considered "civilized." The art of Italy ignores the symbols in Greek culture distinguishing Greek from barbarian – an unusual reaction that can be explained only by the force of local religion and cult. This indifference to the Greek model accounts for the importance of the image of the mother in Italy on expensive public monuments, made by important artists, as well as on humble votive terracottas reflecting the life and beliefs of the poor. The motif appears on cult statues, votive statuettes, funerary images, bronze instruments, and horse trappings; on objects dating from the eighth century to the first century BCE and beyond; on monuments from Etruria, Latium, Sicily, Magna Graecia, and other regions of Italy, where different languages were spoken, but where Great Goddesses were worshipped.

The Greek colonists evidently had married native wives and taken on local customs and beliefs. These were women's cults, and the contrast here is striking between the male-dominated religion known to us from Greek – specifically Athenian – monuments and these images relating to women's cults.[60]

The tradition of a pre-Indo-European or Mediterranean goddess, submerged in Greece after the arrival of the Indo-European gods, was still alive in Italy. Coming down from the north not long after 2000 BCE, the Greeks had brought with them a male sky god. Greek myth tells us how this god married, or was adopted by, the many local goddesses wherever he arrived:[61] Athena, Hera, and other Great Goddesses became wives, concubines, or daughters. They were in any case demoted. The Great Goddesses were not Indo-European: there is no trace of their cult among the original Indo-Europeans. There were not even any names for such goddesses, in contrast with the Indo-European name of the god: Zeus, *deus*, *divus*, Iuppiter (Jupiter, "Zeus pater"). In Italy and Gaul – but not in Greece – the cults of the local goddesses finally won out over those of the new gods. The type of the mother goddess always remained the principal divinity. We no longer think of a single great goddess, however. Many different goddesses were venerated; we know the name of some of them. "The goddess" had many names, and many different aspects. The gold tablets from Pyrgi speak of Uni Ishtar, who helped the king of Caere reign for three years. In Italy it was therefore Uni (Juno or Hera) who was identified with Ishtar, rather than Turan/Aphrodite, as we would have expected. Other goddesses of birth and motherhood are known: Damia and Mater Matuta, in whose sanctuaries were dedicated votive statuettes of mothers and babies, Eileithyia, Leucothea, Turan ati ("Aphrodite the mother"), Demeter, and Minerva.[62] The goddesses' epithets confirm the difference between Greece and Italy, including Magna Graecia. In Greece the word for "nurse," *kourotrophos*, which can mean either "nursing" or "raising" a child, a *kouros* or *kore*, is used for both male and female "caretakers." The Greek word for wet nurse, *titthe*, belonging to baby language and therefore a "vulgar" word (the word is Indo-European, English "teats," "titty," Italian "tetta"), was never used for a goddess.[63] (Nymphs, as minor divinities, can occasionally function as divine nurses.) In contrast, the Latin epithet for the mother goddess, *nutrix*, refers explicitly to the breast feeding of the baby, an action that can be carried out only by the mother (or by a mother acting as a wet nurse). The Celtic mother goddess was a Dea Nutrix. The name of the island of Giannutri (off the coast of Tuscany) derives from "Diana Nutrix" – there was evidently at one time a sanctuary of Diana, that is Artemis in her aspect as mother.[64] As in figurative art, therefore, the epithets of the goddess in Italy and in Greece reveal a basic contrast in the relation between the divinity and the hero or mortal placed under her protection.

Outside of Greece – in Etruria, ancient Italy, and Gaul –this was a direct relation, as between mother and son.[65] In Greek myth and art, on the other hand, the *kourotrophos* who raises the child is rarely the mother. Athena acts – briefly – as *kourotrophos* for Erichthonius, Zeus is raised by nymphs, Dionysos by Hermes. Zeus acts as a "mother" in giving birth to Dionysos, and to Athena (after eliminating Metis, a Titaness belonging to the earlier generation of goddesses, by swallowing her). The mothers *par excellence*, Latona and Demeter, are alone and exceptional.[66]

The word for "son" is also different in Greek and in Latin, perhaps a sign of a different way of conceiving of the human relationship between parents and children. Latin *filius* derives from the Indo-European root meaning "suckling." Greek υἱός, on the other hand, like almost every other Indo-European language, derives from the root *su-*, "to generate" (as in English, for example, "son"). The importance of the child nursing at the mother's breast is preserved in the Latin word, in contrast to the Greek. How can we explain this difference, which seems to focus on the relationship of the Roman child to its mother? (Later, the word *liber* was used to distinguish the legitimate son from the slave. *Filius* is an ancient word, perhaps older than the Greek υἱός.)[67]

Magic

Closely related to the religious is another aspect of the image of the nursing mother: its magical power. The goddess's milk has a special power. Because it can bestow divinity or protection, the act of breast feeding is an important ritual, and its representation a powerful religious image. The goddess – or the votary, whether she is presenting herself to the goddess or representing herself in her image – bares her breast. She is partially naked. Nudity always has a magic power, a power that can destroy, or else protect from evil in case of danger.[68] That is why the sight of the naked breast is a sign of the power of the goddess, and of her protection. Only goddesses, and gods, can usually afford to be naked.[69] In mortal women, it signifies vulnerability. In Greek art, the sight of a woman's naked breast was, as we have seen, reserved for moments of great danger. This attitude of awe and fear before the sight of the naked breast existed in other cultures as well. Tacitus, in the *Germania* (8.1), tells of the women of a tribe who bared their breasts before their own men in battle when they saw that they were losing: they hoped to give them courage and strength with the magic sight of their nudity.[70] This magic power of the image of the woman's naked breast can help to explain its special meaning in Greek artistic representations in mythological scenes, and its absence in genre scenes. Evidently it was too important a gesture to be shown with impunity.

Much has been written in recent years about the special relationship between men and women in classical Greek society, on the separation of

the women's private life from public life, in which only men took part, on the importance of homosexual relations, in the *symposion* and elsewhere. In this context the importance assumed by the symbolism of male nudity and of the phallus in general in Greek myth and religion is not surprising.[71] The absence of female nudity in the art of Athens, where the male nudity of the youthful *kouros* reigned, can be explained by its fearful symbolism. It is related to the power of the eye and the frontal face of the Medusa, who kills with a look.[72]

Two taboos are involved in the representation of the nursing image, nudity and milk; two images of women, sexual and maternal.[73] The feeling of awe at the sight of the naked breast is a reaction to a taboo. The emotions roused by nudity and related taboos are universal, but different cultures deal with them in different ways.[74] Because of its sexual force and magic power, its importance in the women's cults in Italy is the other side of the coin of the terror it held for the Greeks. The breast is a symbol of life and death.

The Greeks wanted to emulate not sexless angels, but their male gods. Embarrassed by the image of the woman nursing, which reminded them too much of their animal nature, they eliminated it from Classical art, relegating it to wild figures, barbarians, or animals.

In Italy, on the other hand, the image of mother and child was deeply important, while male nudity, which was embarrassing in spite of its "Classical" cachet, was not used in real life, and only sparingly in art, in definite and limited contexts. This contrast between ancient Greece and Italy, evidently involving customs, attitudes, and symbols that are deep-rooted and powerful, is reflected in the monuments that have come down to us. We cannot fully understand the complex reasons for the difference in the two regions. Nor can we ourselves understand the deep and complex emotions we feel at the sight of the naked body and of the mother nursing, related to vulnerability and the fear of death.

NOTES

1 The significance of the gesture is discussed by V. Tam Tinh Tran, *Isis Lactans: Corpus des monuments gréco-romains d'Isis allaitant Harpocrate*, Études préliminaires aux religions orientales dans l'empire romain, Leiden, Brill, 1973; cf. my review in *American Journal of Archaeology*, 1976, vol. 80, pp. 104–5. Millard Meiss identified the motif of the nursing Virgin in "The Madonna of Humility," in *Painting in Florence and Siena after the Black Death*, New York, Harper & Row, 1951, pp. 132–56. See also Chapter 4 of this volume by Beth Cohen.

2 B. Shefton in P. Arias and M. Hirmer, *A History of 1000 Years of Greek Vase Painting*, New York, H. N. Abrams, 1962, pp. 389–90, no. 238.

3 T. H. Price, *Kourotrophos: Cults and Representations of the Greek Nursing Deities*, Leiden, Brill, 1978, pp. 71–7. See reviews: R. Higgins, *Journal of Hellenic Studies*, 1979, vol. 99, p. 213, who points out that the *kourotrophos* in Greek art is "rare and unpredictable," and E. Simon, *Gnomon*, 1981, vol. 53, pp. 217–19. Exceptions (Leto, Artemis) date back to Minoan cult: R. F. Willets, *Cretan Cults and*

Festivals, London and Westport, Routledge and Kegan Paul, 1962, pp. 176, 186, 190, and *passim*. For children and nurses see M. Robertson, *The Art of Vase-Painting in Classical Athens*, Cambridge, Cambridge University Press, 1992, pp. 168–70, 176–7. For the motif of nursing, see G. A. S. Snijder, "de forma matris cum infante sedentis apud antiquos," diss. Academia Rheno-Traiectina, Vindobona, 1920; G. Wickert-Micknat, *Die Frau, Archaeologica Homerica*, Göttingen, Vandenhoeck and Ruprecht, 1982, R 112; P. Berger, *The Goddess Obscured*, Boston, Beacon Press, 1985, pp. 41, 44–6, 152. Two recent books on children in ancient Athens are H. Rühfel, *Kinderleben im klassischen Athen*, Mainz, P. von Zabern, 1984, with many illustrations; M. Golden, *Children and Childhood in Classical Athens*, Baltimore and London, Johns Hopkins University Press, 1990.

4 E. H. Harrison, "Alkamenes' Sculptures for the Hephaisteion: Part III, Iconography and Style," *American Journal of Archaeology*, 1977, vol. 81, p. 411. An exception such as the group of Athena and Hephaistos as "the proud and slightly anxious parents of a newborn child" serves to prove the rule about odd births, for Erichthonius is presented to the two by their surrogate mother and "experienced nurse," Gaia: E. D. Reeder, *Pandora: Women in Classical Greece*, Baltimore and Princeton, Princeton University Press and Walters Art Gallery, 1995, pp. 255–6, no. 68.

5 For Mycenaean "divine nurses" see E. French, "The Development of Mycenaean Terracotta Figurines," *Annual of the British School at Athens*, 1971, vol. 66, pp. 101–87. For mothers and children see A. Furtwängler, *Die Sammlung Sabouroff: Kunstdenkmäler aus Griechenland*, Berlin, A. Asher and Co., 1883–7, text to pl. 771; Shefton, in Arias and Hirmer, *History of Vase-Painting*, pp. 389–90; Reeder, *Pandora*, pp. 250–76: Athena and Erichthonius, Danae and Perseus.

6 For an account of different attitudes to motherhood in a modern and a Roman context, see S. Dixon, *The Roman Mother*, Norman, University of Oklahoma Press, 1988. For Egyptians as particularly fond of children see Tran Tam Tinh, *Isis Lactans*, p. 18. See Strabo 17.2.5, who says they "accept all the children who were born." For Egyptian nursing mothers see E. Brunner Traut, "Die Wochenlaube," *Mitteilungen des Instituts für Orientforschungen*, 1955, vol. 3, pp. 11–30.

7 Vase in Berlin, *c.* 440 BCE: I. Krauskopf, *Lexicon Iconographicum Mythologiae Classicae*, Zurich, Artemis Verlag, 1981, s.v. Amphiaraos, p. 697, no. 27. Cf. Robertson, *Art of Vase-Painting*, p. 192, on Amphiaraos and Eriphyle; and see now F. Lissarrague, in P. Schmitt Pantel (ed.), *A History of Women: From Ancient Goddesses to Christian Saints*, Cambridge, Mass., Harvard University Press, 1994, pp. 182–3, fig. 27.

8 Pausanias, 1.25–7. M. Robertson, *A History of Greek Art*, Cambridge, Cambridge University Press, 1975, p. 248. In Euripides' *Ion* (319, 760), the context is also tragic: the abandoned Ion was not nursed at the breast, and Creusa is told she will never be able to suckle a child. Ion must have been bottle-fed, as babies were while they were weaned from the breast: see D. Gourevitch, with the collaboration of J. Chamay, "Femme nourrissant son enfant au biberon," *Antike Kunst*, 1992, vol. 35, pp. 78–81. I thank Bernard Goldman for the reference.

9 Robertson, *Art of Vase-Painting*, p. 141, pl. 8b; the subject also appears on one of the metopes from Thermon. Arias agrees with Gisela Richter's earlier identification of the two figures as Aphrodite and Peitho: review of H. A. Shapiro, *Personifications in Greek Art*, Zurich, Akanthus, 1993, in *Gnomon*, 1995, vol. 67, pp. 376–7.

10 B. Cohen, "The Anatomy of Kassandra's Rape," *Source: Notes in the History of Art*, 1993, vol. 12 (2), pp. 37–46: "In the Archaic period, female nudity for

mortal women was generally a sign of vulnerability to physical violence." Cf. L. Bonfante, "Nudity as a Costume in Classical Art," *American Journal of Archaeology*, 1989, vol. 93, p. 560. The scene of Clytemnestra baring her breast before Orestes' sword is illustrated on a mid-fifth-century BCE Attic red-figure *hydria* in the Nauplia Museum: 'Από τή Μήδεια στή Σαπφώ; Ανυπότακτες γυναίκες στήν αρχαία Ἑλλάδα, Athens, 1995, pp. 62–3, fig. on p. 63, and *LIMC*, 1992, vol. 6, Klytaimnestra no. 36: Aeschylus, *Choe*. 896–8. See also a mid-fifth-century Etruscan mirror, E. Gerhard, *Etruskische Spiegel*, Berlin, Reimer, 1840– 97, pl. 237; G. Heres, *Corpus Speculorum Etruscorum, Deutsche Demokratische Republik*, 1986, vol. 1, no. 4; S. Stopponi, *Archeologia Classica*, 1991, vol. 43, pp. 1145–6, fig. 25. For the vulnerability of the female nude, see C. M. Havelock, *The Aphrodite of Knidos and her Successors*, Ann Arbor, University of Michigan Press, 1995, p. 32. Elsewhere (e.g. p. 36), however, Havelock suggests that the ancients did not share the modern sense of nakedness as humiliating, shameful, and a sign of vulnerability. I discuss these questions in Bonfante, *American Journal of Archaeology*, 1989, pp. 543–70; *Source*, 1993, vol. 12, "Introduction;" and the forthcoming book on *Nudity as a Costume in Ancient Art*.

11 Euripides, *Hecuba* 560–1, trans. W. Arrowsmith, *Euripides* III, New York, 1968. Here, as often, Euripides anticipates the Hellenistic period: he seems to be describing a statue of the naked Aphrodite.

12 For the word *titthe*, see below, text and n. 63. For grave reliefs with a servant (or "close relative") handing the baby to the mother, who is seated, see C. Clairmont, *Classical Attic Tombstones*, Kilchberg, Switzerland, Akanthus, 1993, nos 2.625, 2.725, 2.730, 2.778, 2.780, 2.780a, 2.786, 2.797, 2.810; there is often some question as to whether the artist was actually an Athenian.

13 F. Johansen, *Attic Grave-Reliefs*, Copenhagen, E. Munksgaard, 1951, p. 24, p. 44, fig. 23. A stele showing man, woman, and child turns out to represent grandfather, daughter, and granddaughter: Clairmont, *Classical Attic Tombstones*, no. 2.747.

14 A. Batziou-Efstathiou, "Two New Grave Stelae of Larisa Museum," *Athens Annals of Archaeology*, 1981, vols 14–15, pp. 47–54; cited in Bonfante, *American Journal of Archaeology*, 1989, vol. 93, p. 568, with thanks to Brunilde Ridgway for the reference.

15 Shefton, in Arias and Hirmer, *History of Vase-Painting*, pp. 389–90. For Hellenistic art, see J. Charbonneaux, "Le mythe humanisé dans l'art hellénistique," *Comptes Rendus des Séances de l'Académie des Inscriptions et Belles-lettres*, 1965, vol. 23, p. 9. Bonfante, *American Journal of Archaeology*, 1989, pp. 567–8.

16 Shefton, in Arias and Hirmer, *History of Vase-Painting*, pp. 389–90, no. 238. M. Cavalier, *Nouveaux documents sur l'art du Peintre de Lipari*, Publications du Centre Jean Bérard, vol. 3, Naples, 1976, pl. 7. Cf. M. O. Jentel, "Eros turbulent," *Echos du Monde Classique/Classical Views*, 1985, vol. 29, pp. 281–8.

17 Much of the following draws on my article, "L'iconografia della madre nell'arte dell'Italia antica," in A. Rallo (ed.), *Le donne in Etruria*, Rome, "L'Erma" di Bretschneider, 1989, pp. 85–106, with earlier bibliography; my review of Tran Tam Tinh, *Isis Lactans*, in *American Journal of Archaeology*, 1976, vol. 80, pp. 104– 5; and "Dedicated Mothers," in *Visible Religion*, Institute of Religious Iconography, Leiden, Brill, 1984, pp. 1–17.

18 A "horse separator," or *distanziatore di cavalli*, A. Bedini, in "Lazio Arcaico e Mondo Greco," in *Parola del Passato*, 1977, vol. 32, pp. 297–303; and 1981, vol. 36, pp. 23–8. Bonfante, in Rallo (ed.), *Le donne*, pp. 86–7. For the chariot, Bartoloni-Grottanelli, "I carri a due ruote nelle tombe femminili del Lazio e dell'Etruria," in Rallo (ed.), *Le donne*, pp. 55–68.

19 M. Sprenger and G. Bartoloni, *The Etruscans*, New York, Abrams, 1983, pp. 129–30, pls 182–3; Bonfante, in Rallo (ed.), *Le donne*, p. 87, with references. J. R. Jannot, "Images humaines, images divines," *Ktema*, 1982, vol. 7, pp. 269–72.

20 E. Langlotz and M. Hirmer, *Kunst der Westgriechen*, Munich, Hirmer, 1963, pl. 17. For the monument's "astounding" style, see B. S. Ridgway, *The Archaic Style in Greek Sculpture*, Princeton, Princeton University Press, 1977: "The figure is so different from any Greek work that it must represent indigenous art," p. 135; cf. p. 151.

21 E. Simon, *Ara Pacis Augustae, Monumenta Artis Antiquae*, 1, Tübingen, 1967; G. Koeppel, *Aufstieg und Niedergang der römische Welt*, Berlin, De Gruyter, 1982, vol. 12.1, pp. 483–6 for bibliography; D. Strong, *Roman Art*, 2nd ed., R. Ling and J. Toynbee (eds), Harmondsworth, Penguin, 1989; orig. ed. 1976, pp. 80–4.

22 Pausanias, *Description of Greece*, 5.18.1 (trans. J. G. Frazer, London, Macmillan, 1913). The chest of Kypselos must have dated from the seventh or sixth century BCE. The identification is made by Ross Holloway in *The Archaeology of Ancient Sicily*, London, Routledge, 1991, pp. 64, 82, and accepted by M. Bell III, *American Journal of Archaeology*, 1993, vol. 97, p. 366. But R. J. A. Wilson, *Journal of Hellenic Studies*, 1994, vol. 114, pp. 217–18, argues against it, pointing out that the scene showed Night *holding* the twins, not nursing them; "nothing in the iconography of Hypnos or Nyx supports H.'s interpretation."

23 In Greek art, children appear in connection with death on funerary stelai, and on white-ground lekythoi: Clairmont, *Classical Attic Tombstones*, pp. 257–60; Robertson, *Art of Vase-Painting*, p. 203, fig. 213, and p. 205, fig. 216.

24 R. Bianchi Bandinelli, *L'arte etrusca*, Rome, Editori Riuniti, 1982, pp. 298–312; Bonfante, in Rallo (ed.), *Le donne*, pp. 88–9.

25 L. Bonfante, "Votive Terracotta Figures of Mothers and Children," in J. Swaddling (ed.), *Italian Iron Age Artefacts in the British Museum*, London, British Museum, 1985, pp. 195–203.

26 From Cerveteri, by a workshop related to that of the sarcophagus of the Bride and Groom. The form is one used for women: M. Moretti (ed.), *Nuove scoperte e acquisizioni nell'Etruria meridionale*, Rome, Artistica, 1975, pp. 5–7, no. 1, pl. 2; S. Steingräber, *Etruskische Möbel*, Rome, Giorgio Bretschneider, 1979, p. 291, nos 489–90; G. Proietti (ed.), *Museo Nazionale Etrusco di Villa Giulia*, Rome, Edizione Quasar, 1980, p. 131, fig. 166 (color).

27 N. Spivey, *The Micali Painter and his Followers*, Oxford, Oxford University Press, 1987, p. 67, no. 140, pl. 24: "on one of his vases the Micali Painter detaches the teats from a bodily context (where they are readily understandable as symbols of growth and sustenance) and uses them almost like a Greek pomegranate border."

28 For the Micali Painter, see Spivey, *The Micali Painter*, p. 12, p. 67, nos 48, 55, pls 2, 9b, 11a, 29; a male feline, no. 84, pl. 12. See the tomb of the Lionesses in Tarquinia; the breasts on the sphinxes of the throne of the so-called Mater Matuta from Chianciano, Sprenger and Bartoloni, *The Etruscans*, pp. 129–30, pls 182–3; the eight-breasted sphinx on a Faliscan calyx crater by the Nazzano Painter, in Zurich, Hirschmann Collection, 370–360 BCE: M. Martelli, *Ceramica Etrusca*, Novara, De Agostini, 1987, p. 316, no. 145. Unusual, too, is a female Chimaera on an Etruscan mirror in New York: I. Krauskopf, *LIMC*, 1986, vol. 3, p. 266, Chimaira (in Etruria) no. 70, pl. on p. 216; L. Bonfante, *Corpus Speculorum Etruscorum*, USA 3, forthcoming.

29 F. Jurgeit, "Aussetzung des Caeculus-Entrückung der Ariadne," in H. Cahn and E. Simon (eds), *Tainia: R. Hampe zum 70 Geburtstag 2 Dez. dargebracht*, Mainz,

LARISSA BONFANTE

P. von Zabern, 1978, pp. 272–4; O. J. Brendel, *Etruscan Art*, Harmondsworth and Baltimore, Penguin, 1978, p. 376, fig. 291.

30 For animal *kourotrophoi* in Greece, see Price, *Kourotrophos*, pp. 81, 73–4, 189.

31 Brendel, *Etruscan Art*, p. 344, fig. 268.

32 Beazley, *Etruscan Vase-painting*, Oxford, Clarendon Press, 1947, p. 6, p. 54, pl. 10, 3.

33 *A.P.* 9.589, Incerti. "In statuam Iunonis lactantis Herculem. Plane novercam effinxit: ideo mammam / in spuriam sculptor non indidit lac." And again: "De imagine Iunonis Herculem lactans. Ubera sicca vides. Ars est imitata novercam, / Atque ideo mammas, sed sine lacte, dedit." Cf. Pausanias, 9.25.2: "A place is pointed out where the Thebans say that Hera was beguiled by Zeus into giving the breast to the infant Hercules."

34 W. Déonna, "L'allaitement symbolique," *Latomus*, 1954, pp. 140–66; Price, *Kourotrophos*, p. 39, no. 314; Bonfante, in Rallo (ed.), *Le donne*, pp. 89–90; S. Schwarz, *LIMC*, 1990, vol. 5, s.v. Herakles/Hercle, nos 402–4 (mirrors), cf. 401. For the Etruscan context of this motif, see M. Harari, "La preistoria degli Etruschi secondo Licofrone," *Ostraka: Rivista di Antichità*, 1994, vol. 3, pp. 271–3.

35 Gerhard, *Etruskische Spiegel* 5.60; A. J. Pfiffig, *Religio Etrusca*, Graz, Akademische Druck, 1975, p. 345; de Grummond, *Guide*, 1982, p. 156, fig. 100. G. Bonfante and L. Bonfante, *The Etruscan Language*, Manchester and New York, Manchester University Press, 1983, no. 26, fig. 20. The mirror from Vulci in Berlin (Gerhard, *Etruskische Spiegel*, 5.59, Bonfante, in Rallo (ed.), *Le donne*, pl. 37), with another group of four gods – Tinia, Menrva, Turan, and Mean – witnessing the event has a similar composition and may derive from the same original. Cf. the witnessing and "adoption" of the egg of Helen by the assembled family group in a mirror from Porano (Orvieto) in Perugia: Gerhard, *Etruskische Spiegel*, 5.77.

36 F. R. Serra Ridgway, *I corredi del Fondo Scataglini a Tarquinia*, Milan, Comune di Milano, 1996, pp. 21–2, p. 37, pls 49, 140. S. Schwarz, *LIMC* 5, 402, p. 238.

37 Sassatelli, *Corpus Speculorum Etruscorum* Italia 1, *Bologna* 1.15.

38 "A familiar theory in psychoanalytic developmental psychology holds that the development of teeth 'converts' the receptive (passive) to the sadistic (active) form of orality. The idea of the complex interactions between mother and nursling is condensed and simplified in the Heracles nursing story": William Greenstadt, discussion report of the Interdisciplinary Colloquium on Mythology and Psychoanalysis of the New York Psychoanalytic Institute, October 1991.

39 Herakles' name means the "glory of Hera," a meaning which implies a different relationship from the one the two have in classical Greek times. In Italy Hercle and Uni have a much closer relationship, perhaps akin to that of the Near Eastern goddess and her young lover. Bibliography in G. Dumézil, "The Religion of the Etruscans," *Archaic Roman Religion*, Chicago, University of Chicago Press, 1970, p. 434: "A Phoenician theory . . . has been encouraged by the discoveries at Pyrgi;" cf. p. 680. Jean Bayet, *Hercle*, Paris, Bibliothèque de l'École Française, 1926, studies the representations of Hercle on vases and mirrors, and finds cases in which Etruria modified the Greek tradition under the influence of the Phoenician Melkart.

40 R. Kékulé von Stradonitz, *Die antiken Terrakotten I: Die Terrakotten von Pompei*, Stuttgart, W. Speman, 1880, pp. 57–60, pl. 47. Bonfante, in Rallo (ed.), *Le donne*, pp. 89–90.

41 W. F. Friedländer, *Caravaggio Studies*, Princeton, Princeton University Press, 1955, pp. 208–9, no. 34, pl. 49. R. Oldenbourg and A. Rosenberg, *P. P. Rubens:*

des Meisters Gemälde in 538 Abbildungen, Stuttgart, Deutsche Verlags-Anstalt, 1921, pl. 388. Bonfante, in Rallo (ed.), *Le donne*, p. 90.

42 They used the same clay as for their *terra sigillata*. F. Jenkins, "Romano-Gaulish Clay Figurines as Indications of the Mother-Goddess Cults in Britain," *Hommages Grenier: Collection Latomus*, 1962, vol. 58, II, "Dea Nutrix," pp. 836–53; H. von Petrikovitz, "Ein Mädchenkopf und andere Plastiken aus dem heiligen Bezirk in Zinsheim", *Bonner Jahrbücher*, 1965, vol. 165, pp. 192–232; J. Gricourt, "À propos de l'allaitement symbolique: le monde irlandais," *Hommages Déonna*, Brussels, *Latomus*, 1957, pp. 249ff. Bonfante, in Rallo (ed.), *Le donne*, pp. 91, 102.

43 A wide mantle also covers mother and child on a fourth-century Praenestine mirror with mother, baby, and nurse: the mother's enveloping mantle may have a funerary significance as the garb of a mourner. Possible identifications have included Penelope with Telemachus as a baby, or Andromache with Astyanax: U. Höckmann, *Corpus Speculorum Etruscorum, Bundesrepublik Deutschland 1*, Munich, Hirmer Verlag, 1987, pp. 54–5, no. 31a.

44 She is represented on mirrors and *cistae* watching over babies: Pfiffig, *Religio Etrusca*, pp. 347–52; G. Hermansen, "Mares, Maris, Mars and the Archaic Gods," *Studi Etruschi*, 1984, vol. 52, pp. 145–59; Bonfante, in Rallo (ed.), *Le donne* p. 101; L. Bonfante, "Caligula the Etruscophile," *Liverpool Classical Monthly*, July 1990, vol. 15.7, pp. 98–100.

45 J. Neils, "A Greek Nativity by the Meidias Painter," *Bulletin of the Cleveland Museum of Art*, 1983, vol. 70, pp. 274–89; J. H. Oakley, "A Calyx-Krater in Virginia by the Nikias Painter with the Birth of Erichthonius," *Antike Kunst*, 1987, vol. 30, pp. 123–30.

46 *Supra*, n. 20. N. de Grummond, "Pax Augusta and the Horae on the Ara Pacis Augustae," *American Journal of Archaeology*, 1990, vol. 94, pp. 663–77.

47 R. Calza and M. Bonanno, *Antichità di Villa Doria Pamphili*, Rome, De Luca, 1977, pp. 241–2, no. 291. A. Borghini, "Elogia Puerorum: testi, immagini e modelli antropologici," *Prospettiva*, 1980, vol. 22, pp. 2–11; G. Becatti, "Rilievo con la nascita di Dioniso e aspetti mistici di Ostia pagana," *Bollettino d'Arte*, 1951, vol. 36, pp. 4–5, on the nursing motif.

48 K. Weitzmann (ed.), *The Age of Spirituality*, Princeton, Metropolitan Museum of Art, 1980, p. 255, no. 237. It is not clear whether the sarcophagus was Christian or pagan. In the third century, the Christians were adopting motifs from pagan art: a favorite was the bucolic scene with shepherds.

49 D. E. Strong, *Roman Imperial Sculpture*, London, Alec Tiranti, 1961, p. 58, fig. 102.

50 Tran Tam Tinh, *Isis Lactans*, pp. 40–9, and my review in *American Journal Archaeology*, 1976, vol. 80, pp. 104–5. Leo Steinberg, "The Signal at the Breast," *The Sexuality of Christ in Renaissance Art and in Modern Oblivion*, New York, Pantheon Books, 1983, pp. 127–30, correctly sees in the image "the sense of a message conveyed, as if to say, 'I live with food like you – would you doubt my humanity?'" See also Millard Meiss, "The Madonna of Humility," *Painting in Florence and Siena after the Black Death: The Arts, Religion, and Society in Mid-fourteenth Century*, Princeton, Princeton University Press, 1964, p. 146.

51 The issue of breast-feeding by the mother in various cultures and civilizations has been the subject of a number of studies: see Bonfante *American Journal of Archaeology*, 1989, vol. 93, p. 568, n. 145; Rallo (ed.), *Le donne*, pp. 97–8; V. Fildes, *Breasts, Bottles and Babies: A History of Infant Feeding*, Edinburgh, Edinburgh University Press, 1986, pp. 1–77.

52 *Supra*, n. 12. For wet nurses in antiquity see S. Pomeroy, *Goddesses, Whores, Wives*

and Slaves: Women in Classical Antiquity, New York, Schocken, 1975, pp. 83, 163, 191, and 212; M. Lefkowitz and M. B. Fant, *Women's Life in Greece and Rome*, 2nd ed., Baltimore, Johns Hopkins University Press, 1992, index, s.v. breast-feeding, nursing, wet nurses.

53 François Clouet's painting, showing Diane de Poitiers with naked, firm breasts, while a full-bosomed nurse breast-feeds the baby in the background, informed the viewer that the king's mistress was free to resume the social life interrupted by her pregnancy and childbirth, and that her figure had not suffered. *National Gallery of Art, Summary Catalogue of European Paintings and Sculpture*, Washington, DC, National Gallery of Art, 1965, pp. 22, 29, no. 1370.

54 Cf. Juvenal, *Sat.* 13.162–3: "quis . . . miratur . . . in Meroe crasso maiorem infante mamillam?" "Who will be surprised to see . . . in Meroe, a breast larger than the fat baby?" D. S. Wiesen, "Juvenal and the Blacks," *Classica et Mediaevalia*, 1970, vol. 31, pp. 144–5.

55 D. B. Thompson, "The Origin of Tanagras," *American Journal of Archaeology*, 1966, vol. 70, p. 56, pl. 17, and R. Higgins, *Greek Terracottas*, London, Methuen, 1954, p. 103, pl. 44b.

56 Inv. 96.18.15. G. M. A. Richter, *Greek, Etruscan, and Roman Bronzes*, New York, The Gilliss Press, 1915, p. 279, no. 802; J. D. Beazley, *Etruscan Vase-Painting*, Oxford, Oxford University Press, 1947, p. 134; and L. Bonfante, *Corpus Speculorum Etruscorum* USA 3, no. 6, New York, Metropolitan Museum of Art, forthcoming.

57 K. J. Dover, *Greek Homosexuality*, London, Duckworth and Cambridge, Mass., Harvard University Press, 1978, pp. 126, 134–5; E. Keuls, *The Reign of the Phallus*, Berkeley, University of California Press, 1993, pp. 274–99; Bonfante, *American Journal of Archaeology*, 1989, pp. 549, 551–2, with references. D. Gerber, "The Female Breast in Greek Erotic Literature," *Arethusa*, 1978, vol. 11, pp. 203–12, esp. p. 208, for small bosoms. For fear of women, see P. E. Slater, *The Glory of Hera*, Boston, Beacon Press, 1968.

58 Price, *Kourotrophos*, no. 755; Lucian, *Zeuxis*, 3.

59 E. Panofsky, *Albrecht Dürer* II, Princeton, Princeton University Press, 1943, fig. 21, and "The Centaur's Family;" L. Schneider, "The Iconography of the Wild Man," *Source: Notes in the History of Art*, 1982, vol. 1.2, pp. 15–17, with bibliography.

60 I owe this idea to Fritz Graf and Angelos Chaniotis.

61 B. C. Dietrich, *The Origins of Greek Religion*, Berlin and New York, de Gruyter, 1974, p. 4, on the "mother goddess" in Mycenean religion and the conflict with the Indo-European god Zeus. W. Burkert, *Greek Religion*, Cambridge, Mass., Harvard University Press, 1985, p. 244: "the Kourotrophos . . . exists only in ritual." Burkert also notes the presence of obscenity and blood at the women's festivals, and the use of such rituals and taboos for magic and fertility. For the wet nurses of divine babies, and Demeter and Aphrodite as exceptions, who do suckle babies, see F. Cassola, *Inni Omerici*, Fondazione Lorenzo Valla, Mondadori, 1975, pp. 230–3, 476–7, p. 577, notes to *Homeric Hymns* 2, 19, 20, 26, 30. The earth cult was rare in Greece: Plato, *Crat.* 397 cd, says it is characteristic of barbarians (Cassola, pp. 431–2).

62 For references, see Bonfante, in Rallo (ed.), *Le donne*, p. 101. For votive offerings to *ati*, "mother," see L. Bonfante, in "Rivista di Epigrafia Etrusca" (*REE*), *Studi Etruschi*, 1993 [1994], vol. 59, pp. 269–70, no. 26, pls 47–8.

63 See Liddell and Scott, s.v. "titthe." When a goddess sets out to breast-feed, like Hera with Herakles (above), the situation ends in a disaster. Demeter, too, fails to confer immortality on Damophon: *Hymn to Demeter* 141–2, 235–6.

64 For the Celtic Dea Nutrix, see above, n. 42. Giannutri was called Dianium, or

Artemisium, Pliny 3.81; cf. Pauly–Wissowa, *Real-Encyclopädie*, s.v. Dianium. The etymology was suggested by Giuliano Bonfante.

65 Yet see the Italian ceremony of the Matralia, in which the aunt took over the child: M. Bettini, *Antropologia e cultura romana: parentela, tempo, immagini dell'anima*, Rome, La Nuova Italia Scientifica, 1986, pp. 86–112.

66 C. G. Jung and C. Kerényi, *Essays on a Science of Mythology: The Myth of the Divine Child and the Mysteries of Eleusis*, Princeton, Princeton University Press, 1963.

67 Walde-Hoffman, *Lateinisches Etymologisches Wörterbuch*, s.v. *filius, felo*; Ernout-Meillet, s.v.; *Oxford Latin Dictionary, filius*, Umbrian *feliuf*, Greek *thele*, "female." G. Bonfante, "Puer, filius, filia," *La Parola del Passato*, 1981, pp. 312–14. Of interest, too, is the fact that in early Rome the word "nursling" was also used for a grown man: "No wonder in Rome there existed the *ius vitae et necis* of the father over his children, a custom not found in Greece or anywhere else, except the Celts" (G. Bonfante).

68 Bonfante, *American Journal of Archaeology*, 1989, pp. 544–5, 568–9, with further references. S. Freud, *Totem and Taboo*, New York, Norton, 1950, pp. 14, 31, and *passim*. Among recent studies see L. Di Stasi, *Mal Occhio: The Underside of Vision*, San Francisco, North Point Press, 1981, with review by Anthony Burgess, *Times Literary Supplement*, 4 September 1981, p. 999. M. Douglas, *Purity and Danger: An Analysis of Concepts of Pollution and Taboo*, London, Routledge and Kegan Paul, 1966, is useful for the connection between ritual and taboo, and the distinctions between male and female, humans and the wild, and for bodily magic, invested with power and danger. See now Mary DeForest, "Clytemnestra's Breast and the Evil Eye," in Mary DeForest (ed.), *Woman's Power, Man's Game: Essays on Classical Antiquity in Honor of Joy K. King*, Wauconda, Bolchazy-Carducci, 1993, pp. 129–48.

69 Greek "heroic" nudity is an exception: Bonfante, *American Journal of Archaeology*, 1989, pp. 543–70; *Nudity as a Costume in Ancient Art*, forthcoming.

70 Cf. *Germania* 19.2; Tacitus praises the German custom of raising the children "nudi et sordidi," and having them nurse at their mothers' breasts rather than handing them over to wet nurses: a reference to healthy, "primitive" customs contrasting with the Romans' civilized, decadent corruption. On the other hand in Caesar's account of the Gallic matrons of the conquered town who lean over the walls with naked breasts and outstretched hands ("pectore nudo prominentes passis manibus," *BG* 7.47.5), the women bare their breasts to implore mercy, as a sign of vulnerability and defeat. See *supra*, n. 10.

71 Keuls, *The Reign of the Phallus*; Dover, *Greek Homosexuality*; Slater, *The Glory of Hera*.

72 L. Adams Schneider, "Ms. Medusa: Transformation of a Bisexual Image," *The Psychoanalytic Study of Society*, vol. 9, New York, 1981, pp. 105–53.

73 Evelyn Harrison has noted, in Greek iconography, the tendency for the left breast to refer to motherhood or the care of babies, while the right breast has an erotic significance: Aphrodite in the East pediment of the Parthenon is about to uncover her right breast, while the Venus Genetrix uncovers her left breast. E. Harrison, "Two Pheidian Heads," in D. Kurz and B. Sparkes (eds), *The Eye of Greece*, Cambridge, Cambridge University Press, 1982, pp. 86–7.

On an early example, a copper statuette showing a mother nursing a boy baby, and the possible significance of a variation between left breast and right breast nursing in Egyptian art of the XII Dynasty, see J. Romano, "A Statuette of a Royal Mother and Child," in *Mitteilungen des Deutschen Archäologischen Instituts, Abteilung Kairo*, vol. 48, 1992, pp. 131–43. On the taboo of nudity, see L. Bonfante, *American Journal of Archaeology*, 1989, vol. 93, pp. 543–70, with

bibliography and references. On the taboo of milk, see G. Bonfante, "Il cibo degli Indoeuropei," forthcoming.

74 Even in our own sophisticated, "liberated" times, male nakedness and uncovered breasts still shock: recent examples include the refusal of Jerusalem to accept a copy of Michelangelo's *David* as a gift from the city of Florence, *Messaggero*, 27 July 1995, p. 12; and the controversy on the appropriateness of using breasts in advertisements for mozzarella in Catania, *Giornale*, 22 July, 1995, p. 9.

10

MAKING A WORLD OF DIFFERENCE

Gender, asymmetry, and the Greek nude

Nanette Salomon

The project of re-evaluating ancient art from a feminist perspective can have no better starting place than Praxiteles' Knidian Aphrodite.[1] This important sculpture, produced in the mid fourth century BCE, stands as the very first monumental female cult statue to be represented completely nude. Moreover, and not coincidentally, it is the first monumental female nude sculpture to be positioned with her hand over her pubis, a condition assigned the highly interpretive label *pudica* or so-called modest pose (Fig. 44). Literature, dating from antiquity to the present day, has hailed the Knidia as "the most popular of all statues in antiquity," emphasizing its enormous influence on Western art from its own time to ours.[2] The Knidian Aphrodite's popularity was expressed not only in the accolades of ancient writers, but more significantly in the countless sculpted copies, adaptations, and derivations inspired by Praxiteles' concept.[3] This sculpture continued and continues to spawn a massive number of works in the Western tradition representing female nudes fashioned as covering their pubis. In fact, Praxiteles' Aphrodite stands at the head of a long, labored list of canonical works from every period of European and American art from its appearance to our present day including examples in the art of Botticelli, Titian, Cranach, Rembrandt, Greuze, Canova, Manet, Renoir, Picasso, Valadon, Matisse . . . the list is endless.

The endemic presence of artistic female nudes depicted as covering their pubis in Western cultural history from *c.* 340 BCE to 1996 CE presents several crucial problems of methodology and interpretation. The problem of where to locate oneself in terms of the investigative project, there and then or here and now, is among the most difficult of these concerns. Moreover, each reiteration of the *pudica* pose in art has meaning that is specific to the cultural/social power negotiations of its own historical moment. Yet to deny their shared meaning as a group, that is, to ignore the accrued force of their collective strength, would be to overlook the political use of the canon, its history, and its continuities.

197

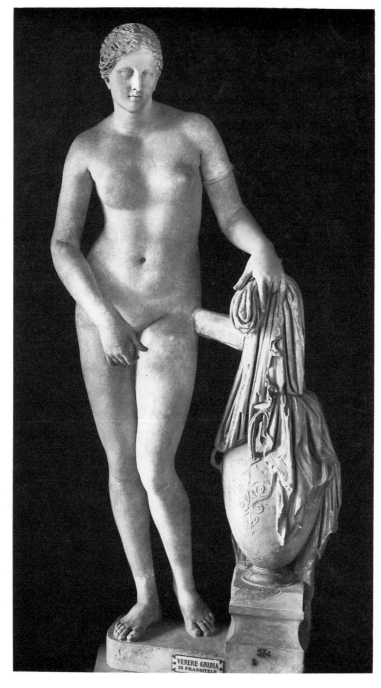

Figure 44 Aphrodite Knidia, Vatican 812

Fragments from history in the form of works of art testify by their very survival to their continuing social viability and, thus, sustain their validity as historically significant. So that while granting the profound impossibility of retrieving an accurate and objective account of the past, we are continually seduced by these fragments to try do so. This is especially true in the case of the Knidia since it spearheads a Western tradition of female nudes covering their pubises in endless variants and with an unbroken continuity. The potency of this Greek cultural invention is, indeed, multiplied by the high status conferred on classical antiquity in general as a "reservoir of powerful archetypal images which lay claim to some privileged kind of truth about human nature."[4]

The past and current significances of this pose and its position as a site for the construction of social *qua* sexual "realities" have, thus, much in common despite their occurrence in different historical periods. Throughout, the pose has become so normalized, so "natural," that is, made invisible or transparent, through the combined efforts of incessant artistic repetition and the concomitant art-historical critical apparatus that sustains it, that its "influence" reaches into the profound preserves of personal sexual identities.

My goals in this paper are, then, to render visible or, rather, to reinstate to vision the political significance of the visual language of this lost, yet all important work; to underscore the sculpture's work in the ongoing construction of female sexuality; and to make clear the power relationships inherent in the terms of that sexuality. It seems necessary, if not urgently so, to undertake this analysis at this time. While some scholars of classical antiquities have begun to address the Knidia as a gender problem, for the most part, even in recent feminist literature, it is treated with the same litany of stories and explanations that occlude the political implications of the *pudica* pose.[5] We must move against the grain, against our training, against the unspoken "gentlemanly" agreement to continually remove the artistic female nude from conscious consideration as a dynamic component in establishing power relations expressed in sexual terms. The continued and incessant idealization of female humiliation in the Western tradition from *c.* 340 BCE to the present is the real subject of this paper. Praxiteles is interesting only insofar as his configuration initially gave form to this concept. Rather than supporting an ideologically loaded conceptualization of "innovation" and "influence," the bread and butter of traditional art-historical analysis, we can use them as signal designates for considering aspects of the sculpture's work in the cultural construction of power hierarchies.

INNOVATION

A consideration of the innovative aspects of the Knidian Aphrodite directs us to consider the introduction of female nudity in official Greek art and

thus to appreciate the implications of its long-lived suppression before that moment. Despite popular misconceptions that the female nude was the classical subject *par excellence*, it was, in fact, the male nude which dominated the Athenian artistic avant-garde in the Archaic and Classical periods. It is there we must seek the connections and constructions which inform the advent of female nudity into the mainstream of Western culture. This is especially true, given the heterogenous nature of the Greek artistic project of the sixth and fifth centuries BCE. Pursuing this course makes far more sense than seeking the Knidia's origins in the diminutive, atavistic, and marginal prehistoric, Mesopotamian, or Cretan/Cypriote Archaic fertility figurines.[6] While they may have some associative value for the figure, they cannot constitute its "source." Rather, the formation of the self-conscious female nude as a monumental image in ancient times is intricately related to its counterpoint, the monumental image of the male nude. Such an approach is founded on the conviction that the culturally constructed terms of femininity and masculinity in the ancient world were mutually dependent and reflexive fabrications whose definition depended upon their socially assigned differences, one from the other. Thus, the social definition of what is natural and normal for "woman" is construed in terms of what is not, that is the domain of "man" and vice versa. This holds true despite the differentiated echelons within the category "man" itself, divided as it was in ancient Greece along the lines of class and, within class, of age. Therefore, in order to come to some understanding of the sexual and erotic assignments of the female nude in Greek art, we must explore/expose those of the male nude.

Praxiteles' Aphrodite was created at least three centuries after the introduction of the monumental male nude statue.[7] A survey of Greek monumental sculpture of men and women in the sixth and fifth centuries readily reveals the gender differences already inherent in their definition. In the sixth century the patterns are firmly established by the *kouroi* and *korai*, for, although they were not the only subjects of men and women to be treated in monumental sculpture, they are surely the most consistent and representative.[8] For the Archaic period, the *kouroi* (athletic male youths) were fabrications of an idealized humanity defined as male, youthful, and heroically nude.[9] The corresponding female *korai*, by contrast, were consistently draped.[10] Further, given the persistently collaborative nature of Greek art demonstrable over generations, the male anatomy continued to be the form in which primary creative energy was invested in fifth-century classicism. Its treatment is ever more precisely scientifically and mathematically informed, culminating in Polykleitos' Doryphoros, which was referred to in antiquity as "the canon."[11]

The corresponding development trackable in monumental female sculpture, by contrast, demonstrates ever greater virtuoso handling of drapery and the progressively plastic implications of hair arrangement. In short, the

male figure is portrayed as coherent and rational from within; the female figure is portrayed as attractive from without. The male body is dynamically explored as an internally logical, organic unity; the female body is treated as an external surface for decoration.

The demeanor of the *kouroi* and the *korai* in their ritual services were, despite the parity implied by their names, also radically different. The dissimilar positions of their arms and hands signal their overall differences. The *kouroi* generally have their fists clenched and their arms slightly bent by their side. The *korai*, by contrast, have one arm placed across their breast or more often extended, almost always with a detachable forearm which served up an offering to Athena or some other goddess. The gestural language of the *kouroi* celebrates the most valued aspects of Greek manhood honoring athletic and/or military heroic, male youths. That of the *korai* are those of gratitude and defined these glorified handmaidens dedicated to female deities on the Acropolis in Athens or elsewhere.[12]

The asymmetrical treatment of the nude male and clothed female in Archaic and Classical Greek sculpture coincides with the, by now, well-documented legal inequities of men and women in ancient Athens.[13] In the formation of the polis, women were legally positioned somewhere between slaves and citizens, under the law falling closer to slaves than to citizens.[14] The disfranchised state of women led to a progressive condition of total seclusion even within the walls of the home.[15] Greek literary traditions, mythological, scientific, and philosophical, from Homer to Aristotle, focused on gender differences and mutually corroborated the misogynistic position that women were less than men.[16]

The differentiating artistic practices also generally coincided with physically marked differentiated social practices of the Athenian city-state where the public nudity of youthful aristocratic males was commonplace in religious rituals, military and athletic events.[17] As noted, women were always clothed and, even in their clothes, were regularly sequestered out of sight. Andrew Stewart remarks that "by the fifth century at least, male nudity was accepted as a differentiating device."[18] Yet for him, as evidenced in the Greek sources he cites, the Greeks were distinguishing themselves as separate from "barbarians," that is, from men in other ancient cultures.[19] He does not consider the function of nudity in defining gender roles within Greek society itself. Greek women are invisible to him here. The degree to which nudity could be seen to differentiate men and women in the Greek mind is conveyed in the passage in *The Republic* by Plato where he hypothesizes equality for the sexes:

"If, then, we are to use the women for the same things as the men, we must also teach them the same things." "Yes." "Now music together with gymnastic was the training we gave the men." "Yes." "Then we must assign these two arts to the women also and the offices of war

and employ them in the same way." "It would seem likely from what you say," he replied. "Perhaps, then," said I, "the contrast with present custom would make much in our proposals look ridiculous if our words are to be realized in fact." "Yes, indeed," he said. "What then," said I, "is the funniest thing you note in them? Is it not obviously the women exercising unclad in the palaestra together with the men?"[20]

For Plato in this passage, the most ridiculous image resulting from parity between the sexes is the sight of women's bodies seen next to those of the men.

Finally it must be said that these social practices, as the artistic production of the idealized male nude youth, are related to the ancient Greek value ascribed to homoerotic desire and sexuality. Much has been written recently on Greek "homosexuality," and its practice, while certainly qualified and non-exclusive, clearly has bearing on the cultural fabrication and dissemination of heterosexual desire embedded in the histories of the Knidia.[21] Homoerotic impulses were considered natural ones in ancient Greece, and surely that socially legitimate desire contributed to the formation of the male nude as an ideal. Recent studies investigating the artistic manifestation of this aspect of ancient Greek life focus primarily on narrative scenes on Greek vases.[22] In fact, general considerations of the relationship between sexuality and ancient Greek art are conventionally relegated to the narrative sphere of vase painting where explicit images of sexual acts can be found.[23] If, however, the cultural construction of sexuality can be seen to find signification in the full spectrum of cultural expression from high to low, to be inscribed in all its levels, the homoerotic pleasure of monumental Greek sculptures of beautiful, youthful nude boys must take its place in the annals of the sexual history of art. The problem here involves the definitions of the sexual as an expression of its practice, as in narrative or as a condition of pleasure which may be metaphysical.

Unlike Christian values where procreation is the sole justification for sexual activity, in ancient Greece the pleasure or enjoyment of beauty, as Boswell observed, was sexuality's primary, legitimate aim.[24] Moreover, idealized beauty as a concept was clearly defined specifically as a male attribute. Fostered by the highly mimetic foundation of Greek art, it was a characteristic as much of youthful male bodies as of their representation.[25] Here, as in nearly all cases where the object of "aesthetic" admiration is the human form, the enjoyment of the male body is conjoined with erotic desire. Evidence for the slippage between beloved boys and representations of youths on vases or reliefs is vested in their shared term of admiration, *kallos*. This word has a complex of meanings, "the good" or "the perfect" or "the beautiful" according to Pollitt[26] and "good, fair, upper-class," according to Stewart.[27]

For the Greeks the body of desire was not only aristocratic, it was young,

the body of the boy. Adonis, Apollo, Ganymede, and Antinous are among the many artistic examples of beautiful Classical youthful subjects that unproblematically stirred homoerotic arousal. The freedom to indulge in this arousal was restricted to the adult free male in the ancient world, precisely the group that produced the politics, philosophy, poetry, and art which have served as the defining inspirations for Western high culture. Interwoven concepts of the pleasure of mathematical measure, the prescient moment, aristocratic possession, longing, and libidinal awareness were inscribed into the Greek homosocial culture's production of "natural" desire.

In our context, it is significant that overt sexual references are not part of the conventions or codes of monumental sculptures of nude men. That is to say, male sexual organs are presented as any other body part, having no special claim to our attention. In fact, Polykleitos' notion of *kallos* is that beauty resides not in any particular aspect of the body, but in the mathematical symmetry and harmony of all its parts in relationship to one another.[28] A boy's sexual attractiveness was defined by the youthfulness, gracefulness, and coherence of his entire being, rather than fixed on his genitals. This is, however, not the case when the monumental female nude is introduced into Greek sculpture.

As a prelude to this change, modern literature on Praxiteles' sculpture often remarks on the changing attitude towards the female body apparent in the artistic style which developed towards the end of the fifth century. The so-called "wet drapery" style, exhibited in various female characters, was first demonstrated in the East pediment of the Parthenon. In this monument, hailed to be the most perfect culmination of Greek rationalism, we find, quite to the contrary, the most irrational, that is, unexplained and unexplainable, combination of nude male and clothed female deities assembled in congress to witness the birth of Athena. Adding to its irrational aspect is the so-called "wet drapery" style which is used for the women whose diaphanously clinging drapery exposes the body beneath as if through a thin, wet veil. The application of this style to representations of Nike where there is rapid movement or placement in fountains as on the mast of a ship may rationally account for the clinging drapery. But the goddesses on the Parthenon pediment are "wet" for no logical reason.

Unlike its predecessors, Praxiteles' Aphrodite is in the condition of both complete nudity and self-conscious nakedness. As early as the second century CE, in the pseudo-Lucian's account of the sculpture, she is noted as seen in the full extent of her beauty, that is, her nudity is complete, without cover, except for the fact that she holds one hand in front of her pubis.[29] According to Pliny's *Natural History* of the first century CE, Praxiteles' shocking innovation was initially rejected.[30] He says that for reasons of tradition and decorum, the city of Kos chose instead a draped Aphrodite by the artist. The nude one was then bought by the citizens of

Knidos which gave the sculpture its name. Despite its initial rejection, the idea of Praxiteles' nude Aphrodite covering her pubis became an immediate success, generating an endless stream of derivatives, imitations, and replicas. The Knidia can be seen as the starting point of a new history in art; one which privileges the female nude over the male nude, and conditionally ties her to her sexuality.

A cursory comparison between Praxiteles' Hermes with the Baby Dionysos (Fig. 45), representing the end of one tradition, and the Knidian Aphrodite, representing the beginning of another, immediately reveals the asymmetrical terms of their nudity. It establishes the artistic codes of female nudity as sexually fetishized and provides the basis for unequal power relations. In contrast to the heroic, unselfconscious nudity of Hermes, the Knidia, more naked than nude, is sexually coded by the ambiversive placement of her right hand in front of her pubis. The issue of whether she, like the various pre-Archaic, Mesopotamian, or Mesopotamian-inspired Greek Archaic statuettes, points to herself as to her powers of fertility, or whether she is, in fact, covering herself before the eyes of an intruder, can never be resolved.[31] Praxiteles' intentions, like his original work, have long since disappeared.

INFLUENCE

We can only seek significance in the gesture found in copies and derivatives, themselves interpretations and inflections which often differ from the original, sometimes unconsciously, in order to conform to the ideological needs of their own times. Influence here is not the artistically insular expression of admiration for Praxiteles and his aesthetic conception. Rather, it testifies to the ongoing viability of the social and political ideologies Praxiteles participated in when he initiated their most cogent artistic formulation in the Knidia.

Whether the female nude is portrayed covering her pubis or pointing to it, the result is the same. The hand that points also covers and that which covers also points. We are, in either case, directed to her pubis which we are not permitted to see. Woman, thus fashioned, is reduced in a humiliated way to her sexuality. The immediate and long-term implications of this fiction in the visual arts are incalculable. The form taken for Aphrodite reincarnate results in an endemic and unending exposure of woman whose primary definition is as someone who fears having her genitals seen. What is at stake here, then, is fundamental to our understanding of ourselves and our images of self. We are defined as primarily sexual, as vulnerable in our sexuality, and deployed as a shamed "other" through the conditioning of culture.

An aspect of the critical literary history of the Knidia becomes particularly relevant here. The history of the Knidia's reception is plagued by a

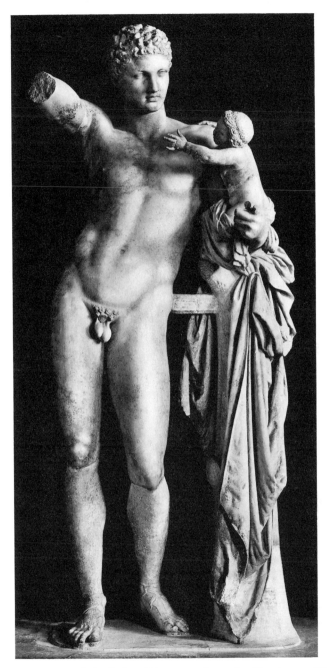

Figure 45 Hermes and the infant Dionysos, from the Heraion at Olympia,
Olympia Museum

vacillation between appreciating it as a work of art and as a real woman. It informs, although it does not thoroughly explain, how realistic works like this affect expectations and evaluations of real women. Praxiteles, in particular, was renowned for naturalizing the gods, making them more human and lifelike than ever. His virtuoso ability transformed marble miraculously into the look of real flesh, vulnerable and sensual. This contraction and collapse of meanings is especially dire in Praxiteles' Aphrodite. As an underlying principle, the idealized naturalism of all Greek art must stand as a contributing factor. Yet while the shared terms of admiration elevated both the artistic male nude and the actual young male athletes, the conflation of real women and the Knidia ultimately reduces both.

Ancient legends retold by Pliny, the pseudo-Lucian, and others add to the implosion of meaning of art and life, profoundly confusing the approach to a sculpted Greek goddess, albeit the goddess of love, and the approach to a sexually vulnerable woman.[32] The most often retold story is the one of a young man who was so enamored of the Knidia that he contrived to be locked in the shrine with her overnight, leaving semen stains on the sculpture as a testimony of his lust.[33] While sexual liaisons between gods and mortals are central to many Greek myths, the consummation of such a one-sided desire would never have gone unpunished.[34]

Moreover, this particular anecdote is given in Pliny directly after he says that her shrine, with her consent, allowed her to be admired from all sides. He goes on to write, "Nor is one's admiration of the statue less from any side."[35] Pliny was not the only one to remark on this aspect. The discussion in the pseudo-Lucian's *Erotes* is interesting in this regard as in others:

The temple had a door on both sides for the benefit of those also who wish to have a good view of the goddess from behind, so that no part of her be left unadmired. It's easy therefore for people to enter by the other door and survey the beauty of her back. And so we decided to see all of the goddess and went round to the back of the precinct. Then, when the door had been opened by the woman responsible for keeping the keys, we were filled with an immediate wonder for the beauty we beheld. The Athenian who had been so impassive an observer a minute before, upon inspecting those parts of the goddess which recommend a boy, suddenly raised a shout far more frenzied than that of Charicles. "Herakles!" he exclaimed, "what a well-proportioned back! What generous flanks she has! How satisfying an armful to embrace! How delicately moulded the flesh on the buttocks, neither too thin and close to the bone, nor yet revealing too great an expanse of fat! And as for those precious parts sealed in on either side by the hips, how inexpressibly sweetly they smile! How perfect the proportions of the thighs and the shins as they stretch down in a straight line to the feet! So that's what Ganymede looks like as he pours out the

nectar in heaven for Zeus and makes it taste sweeter. For I'd never have taken the cup from Hebe if she served me." [The story of the stain follows.][36]

The view of her buttocks and their stimulating qualities, as the eventual assault, all go far to diminish the divine status of this cult statue. The Greek's fixation with the buttocks of a mortal is, of course, not incompatible with homoerotic discourse in general and the Knidia's buttocks in particular are brought into that discourse by the analogy made to Ganymede. Yet once again, the fixation on the buttocks plays itself out exclusively in the artistic variations of the female nude.[37] Examples include the Three Graces type where two nudes face front and the middle nude faces back, allowing for the objectifying surveillance of all sides to be made at one glance. Another type is the so-called Aphrodite Kallipygos, where the female nude strains around to view her own buttocks. The Sleeping Hermaphrodite is another interesting example where the female side is the side of the buttocks, while the front side reveals the male genitalia (see Ajootian, *infra*, pp. 220–42). The exposure and "admiration" of the Knidia's buttocks contribute to her sexualized objectification and diminishes her powers as a divinity.

On another level of myth-making and adding further dimensions to the sexual discourses of the work is the ancient story told of Phryne, a courtesan renowned for her beautiful breasts, who as Praxiteles' lover served as the Knidia's model.[38] This ties the Knidia's sexualized history to that of the depiction of female nudity on Attic vases in the century before Praxiteles, where female nudity primarily represented prostitution.[39] The ideological implications of identifying the "real" model for a representation of the female figure, defined sexually, positions the viewer's empathy with the artist, in his studio, with his creation. Here, so positioned, mastery is shared over the female body, as it is so many centuries later with another famous *pudica*, Manet's *Olympia*, through the recognition of Victorine Meurend just as the Greeks recognized Phryne.[40]

Such discursive activity which abets, as Martin Robertson put it, "the indistinguishability of the statue from a beautiful and desirable woman" ideologically sets the conditions of that desirability for women and causes them to appear "natural." The specific conditions of Praxiteles' creation shed light on its enduring popularity as a bench-mark for the construction of woman in Western European art. The Knidia is portrayed holding drapery above a vase, in her left hand. These details, like the work as a whole, function on the level of both icon and narrative. Iconically, they recall Aphrodite's connection with water as she was born from the sea. On the level of narrative, they communicate that she, as a grown woman, was in the process of bathing. The rest of her body language, such as the slight crouch of her body, the turn of her head to one side, and the way she pulls

her free leg in firmly to press her legs together, weight a narrative over an iconic reading. The Knidia shares this characteristic with Praxiteles' other works, his Hermes with the Baby Dionysos or the Apollo Sauroktonos, all of which indicate his investment in developing narrative as a condition of monumental cult art.[41] The Knidia's narrative, however, is the only one which threatens her own bodily well-being.

The most telling gesture is that of the right hand before the pubis. This gesture, which so dominates the sculpture, gave rise to the name *pudica*, meaning shame or modesty, a term specifically associated with the Knidia in the pseudo-Lucian's *Erotes* of the second century CE which will be discussed presently. The term and gesture construct a sexual narrative of protective fear that is conveyed by her body language as a whole. As she leaves her bath, the Goddess hears someone coming and in "modesty" and fear urgently protects herself. Praxiteles has created a goddess vulnerable in exhibition, whose primary definition is as one who does not wish to be seen. In fact, being seen is here undeniably connected with being violated. Praxiteles has installed in us much more than the controlling male gaze. He has transformed the viewer into a voyeur, a veritable Peeping Tom. We yearn to see that which is withheld. The viewer's shameful desire to see matches the sculpture's "shameful" desire to not be seen.

Created after several centuries of repressed female nudity, the sculpture commands a situation loaded with titillating and erotic possibilities. It stimulates desire by fashioning a sexual reading on to the nude female body and into the sight of the spectator. By covering her pubis, Praxiteles makes her pubis the most desirable thing to see/have; the unjaded viewer *cannot not* think about her pubis while standing before her. We, however, as habitual viewers of an art tradition that is so saturated with this gesture, ingest but no longer *see* Aphrodite's pubis.

The immediate response to Praxiteles' innovation in subsequent ancient sculpture puts emphasis on the aspects of his work which were considered the most rewarding and exciting. A Hellenistic bronze sculpture now in the Metropolitan Museum of Art eliminates any trace of ambiguity in the motivation behind the gesture and presents instead an explicitly defensive one (Fig. 46).[42] The open hand laid across the pubis can be interpreted only as protective, just as the rest of this work's visual language describes a true surge of "fight or flight" adrenaline. The crouch of her body and turn of her head are pronounced and produce with great unity an image of protective fear against unwelcome surveillance. She is titillating and provocative in her overt sexual vulnerability.

More insidious still are the many artistic derivations of the Knidia which repeat the gesture without any of the other visual indications of the narrative.[43] The female nude, thus, has her hand placed over her pubis and sometimes also over her breasts in a completely abstract way, with no other apparent explicative gesture or expression. Aside from this covering,

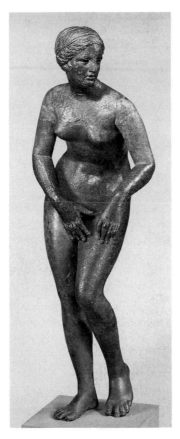

Figure 46 Bronze statuette of Aphrodite, New York, Metropolitan Museum of Art

they express neither pride in the source of their fertility nor shame of their exposed sexual organs. In fact, a peculiar feeling of vacuousness charac- terizes the representation of women in these works. This form of dissim- ulation results in the disenfranchised gesture which can then be understood only as some sort of deep and enduring attribute of women in general rather than a momentary reaction to a specific situation.

While the term *pudica*, shameful or modest, often describes this gesture, it does not actually convey the motivation behind the body language.[44] The term does, however, define an aspect of female sexuality as it was con- structed in the ancient world. It does so by configuring the female as the opposite of the aggressive unseen adult male. Foucault, and Dover before him, discusses Greek sexual relations as always "being of the same type as the relationship between a superior and a subordinate, an individual who dominates and one who is dominated, one who commands and one who complies, one who vanquishes and one who is vanquished."[45] Again,

clearly, this type of relationship was equally operative in the love of boys and women. But it is a testimony to the defining powers of representation that in monumental Greek sculpture they find expression only in the female form. This indicates the "reality" of differences inscribed along the divide of gender, which were to be so fruitful for the subsequent development of the Western world.

The word *pudica* is etymologically related to *pudenda* meaning both shame and genitalia.[46] This unfortunate combination goes back to the doubled meaning of the Greek root word *aidos, aidoios*.[47] It is, in fact, the Knidia's *aidos* that she covers with her right hand, according to the *Erotes* by the pseudo-Lucian.[48] His ideological, political choice of word for that body part has given the posture its art-historical name ever since.[49] It should, then, be revealing to explore, if only summarily, what is communicated by the ancient Greek notion. The etymological connection situates those "things about which one must have *pudor*, modesty, shame, and respect" with sexual demeanor.[50] Although *aidoios* is used for both male and female sexual organs, tracking the differentiated significance of the ethical term for men and women confirms those differences seen in their artistic formations. It also reminds us that cultural sexuality is a discursive cipher for so much more than "actual" sexual relationships.

Aidos is a virtue to be taught as part of a young boy's education between the ages of fourteen and twenty to balance his natural tendency to *hubris* or arrogance.[51] Plato defines this modesty as the fear of seeming perverse when we do or say something that is not good.[52] It is commonly applied to the sexual realm. Moreover, *aidos* is related to the all important Greek notion of *sophrosyne*, meaning soundness of mind, sobriety, and self-restraint, the trait which allows one to master one's desires by exerting rational control.[53] While the term is used with complex and profound implications for the male's physical and psychological well-being, feminine *sophrosyne* "always includes, and is frequently no more than, chastity."[54] When *sophrosyne* does concern both male and female chastity, as it comes to in the second half of the fifth century, the conditions of that chastity are differentiated. "Masculine chastity derives from self-control, the opposite of *hybris*, feminine chastity from obedience."[55] Aristotle makes clear that for the man *sophrosyne* is rational self-control, for the woman it is dutifulness and obedience. Control, for the man, comes from within, for the woman, since she cannot control herself, it must be exerted from the outside.[56] He finds that women are equally incapable of possessing *aidos*, and that society must work to impose modesty on them.[57]

There is here a strangely familiar construction, parallel to those artistic ones manifest in the differences between the nude, male youth, the *kouros*, investigated and developed from within, and the clothed female *kore*, contained by the socially coded drapery from without. The construction is consistent as we move into the realm of the female nude. When

representations of Greek athletic boys do communicate *aidos*, they do so by lowering their heads to express modest contemplation, as does the athlete on the Sounion stele.[58] There *aidos* is an expression of a virtue internalized and pervasive throughout the boy's being. The Knidia's *aidos* is a sexual matter, indeed collapsed into her sexual organ itself. She covers her pubis from view; she is paradoxically separated from her sex and completely identified by it.

Finally, this leads us to query the conditions that gave rise to such a potent invention; one which served and continues to serve power relationships through culture's definition of heterosexuality in the Western world. Recent scholarship has attempted to locate the male, nude youth within the political discourses and definitions of the evolving polis and its citizens.[59] The male, nude youth became the paradigmatic art form for the Greeks at the same moment that the polis became its predominant social institution. Stewart observes, "just as the independent, close knit, and male-dominated *polis* represented the triumph of cohesion and order in society, so too was the male nude, autonomous and robust, singled out as the prime vehicle to display these ideals in art."[60]

Praxiteles' configuration of the female nude was made in the mid-fourth century. At that time Greece experienced the breakdown of the autonomous city-state system and its replacement by the dynastically structured rule of the Macedonians, first Philip and then his son Alexander. Within this new political organization women's role in the production of true heirs put them in a new, more favorable ideological position. Their new status, however, came with a dual edge. In a positive vein, women were more greatly valued in the Hellenistic age and many authors have noted their enhanced legal and social position.[61] Yet, in a negative vein, their sexuality required more vigilant patrolling.[62] The Knidian Aphrodite's stance as the vigilant guard of her single most precious gift on behalf of its rightful owner can be seen as contributing to this discourse.

But there is more to her and more to the endless copies and derivations of Praxiteles' ingenious invention. The Knidia is much more than the image of policing female sexuality, it is first and foremost a producer of desire. The *pudica* pose produces the kind of heterosexual desire that we might assume was natural and therefore would not require the relentless inundation of art and artifice to create and advance with such force. Merely by placing the hand of the woman over her pubis, Praxiteles – and every artist since him who used this device – creates a sense of desire in the viewer. The sensation of desire is installed in all types of viewers, male and female, heterosexual and homosexual. It is clearly, however, male heterosexuals who are encouraged to translate that desire into socially sanctioned acts. These acts are not to be confused with private acts of sexual behavior. They are, rather, the publicly displayed appreciation for the totally sexualized female form. As high culture this appreciation is synonymous with the

appreciation of a work of art signified by a female nude; as low culture, this appreciation is synonymous with lewd remarks made to women on the street by men in groups. In the end, the high and low forms of appreciation conditioned by the *pudica* pose create special opportunities for publicly shared male sexual experience without overt homosexual overtones.

Some insight may be found in the historical circumstances of the newly reorganized world of Hellenism where cultural and social conditions collaborated to give shape to a modern world. In Praxiteles' time, the traditional site for male allegiance and belonging, the warrior defined city-state, had been rendered essentially non-functional. The fractionalized division of the Hellenistic empire into classed hierarchies of far greater complexity than the citizen/slave structure of the polis necessitated a more flexible and, in a sense, more "universal" site for fraternal bonding. A solution was suggested by Stoic philosophers as they redirected the energies of man who was no longer effective in shaping the affairs of public life, to develop an inner framework, a private realm in which to exercise control and establish stability. The regulated sexuality of the female body was the perfect private project.

In fact, the *pudica* gesture directly addresses and continues to address many needs of an increasingly intricate male community which were new and modern in the fourth century. The female nude as the site and the public display of heterosexual desire is the medium for a male bonding ritual.[63] It is, moreover, a site which effectively overrides male differences of nationality, class, or age without destroying the power relationships inherent in those differences. The representation of "pudicated" women therewith allowed for the diversification of the Hellenistic male population into power hierarchies by providing them all with a common "natural" and "essentially manly" site of mastery. It continues to serve as a shared bond which ultimately gives access to membership in the hegemonic club of cosmopolitan manly heterosexuals.

NOTES

1 The ideas for this paper were first presented in February 1990, as "The Knidian Aphrodite by Praxiteles: Disclosure from the Outside," College Art Association annual meeting, New York, and in December 1994 as "Making a World of Difference: Gender, Asymmetry, and the Greek Nude," Archaeological Institute of America annual meeting, Atlanta, Georgia, in a session chaired by Shelby Brown. A brief discussion of the Knidia's importance in the art-historical canon can be found in my article "The Art Historical Canon: Sins of Omission," in Joan E. Hartman and Ellen Messer-Davidow (eds), *(En)gendering Knowledge: Feminists in Academe*, Knoxville, University of Tennessee Press, 1991, pp. 222–36. See also my article "The Venus Pudica: Uncovering Art History's 'Hidden Agendas' and Pernicious Pedigrees," in Griselda Pollock (ed.) *Generations and Geographies in the Visual Arts. Feminist Readings*, London, Routledge, 1996, pp. 69–87. This paper was a long time in the making and I have many people

to thank. I wish to acknowledge the help I received from the staff of the Thomas J. Watson Library of The Metropolitan Museum of Art. Ellen Davis gave generously of her advice and support in the early stages of this project. Elizabeth Millaker provided important bibliographical references. Deep gratitude goes to Shelby Brown and to the editors of this volume, Claire Lyons and Ann O. Koloski-Ostrow, for their intelligent suggestions and counsel. I want also to thank Stephen Zwirn and Griselda Pollock for being constant sources of all forms of feminist support, intellectual and emotional.

2 The ancient author is Pliny, *Natural History,* quoted and translated in J. J. Pollitt, *The Art of Ancient Greece: Sources and Documents,* Cambridge, Cambridge University Press, 1990, p. 84. The modern author is Martin Robertson, *A History of Greek Art,* vol. I, London, Cambridge University Press, 1975, p. 390.

3 The sculpture was first extensively studied by Chr. Blinkenberg, *Knidia: Beiträge zur Kenntnis der Praxitelischen Aphrodite,* Copenhagen, Levin and Munksgaard, 1933. See pp. 118–89 for a list of the copies and pp. 190–3 for some literary sources. A more complete list of copies, derivations, adaptions, can be found in *Lexicon Iconographicum Mythologiae Classicae* (hereafter *LIMC*), vol. 2, part 1, "Aphrodisias–Athena," Zurich and Munich, Artemis Verlag, 1984. A more complete compilation of the ancient literary sources can be found in Pollitt, *The Art of Ancient Greece,* pp. 84–6. Derivations are discussed in an important book which analyzes the social function of sculptures of Aphrodite in the Hellenistic world: Wiltrud Neumer-Pfau, *Studien zur Ikonographie und gesellschaftlichen Funktion hellenistischer Aphrodite-Statuen,* Bonn, Dr Rudolph Habelt GMBH, 1982. A new study has been published by Christine Havelock, *The Aphrodite of Knidos and Her Successors,* Ann Arbor, University of Michigan Press, 1995.

4 Froma Zeitlin, "Configurations of Rape in Greek Myth," in Sylvana Tomaselli and Roy Porter (eds), *Rape,* Oxford, Basil Blackwell, 1986, pp. 122–51, especially p. 123.

5 The political aspects of the female image in ancient art in general and the Knidia specifically is signalled in Shelby Brown, "Feminist Research in Archaeology: What Does it Mean? Why Is It Taking So Long?," in Nancy Sorkin Rabinowitz and Amy Richlin (eds), *Feminist Theory and the Classics,* New York and London, Routledge, 1993, pp. 238–71. Although Robin Osborne's essay, "Looking On – Greek Style: Does the Sculpted Girl Speak to Women Too?," in Ian Morris (ed.), *Classical Greece: Ancient Histories and Modern Archaeologies,* Cambridge and New York, Cambridge University Press, 1994, pp. 81–96, pinpoints some of the same issues, his interpretation differs significantly from mine especially on the issue of sexual construction and its relationship to narrative. Osborne's speaks of a male sex drive or what he calls "the male appetite" in an essentialist way, *passim* especially p. 84. He seems, moreover, to be unaware of either my work on this subject or Brown's.

There are two examples of recent feminist books that reproduce the ancient "stories" with little or no critical distance or analysis of their implications for sexual politics. One is Elaine Fantham, Helene Peet Foley, Natalie Boymel Kampen, Sarah B. Pomeroy, and H. A. Shapiro, *Women in the Classical World: Image and Text,* New York and Oxford, Oxford University Press, 1994, p. 174, where the authors contribute to the problem by treating the work in a positive and positivistic manner. "As the first entirely nude female in Classical sculpture, the Knidia gave rise in antiquity to many *romantic* [emphasis my own] anecdotes: Praxiteles' mistress, Phryne, was said to be the statue's model; a man supposedly became enamored of the statue, Pygmalion-like, and made love to it; and the goddess Aphrodite herself, on seeing the statue, allegedly asked indignantly,

'Where did Praxiteles see me naked?'" The second is Sue Blundell, *Women in Ancient Greece*, London, British Museum Press, 1995, pp. 194–5, where the Knidia and its response are treated almost as afterthoughts.

Lynda Nead's *The Female Nude: Art, Obscenity, and Sexuality*, London, Routledge, 1992, while discussing some ancient sculpture, never mentions Praxiteles' or the *pudica* pose. The most recent book, *Sexuality in Ancient Art*, Natalie Boymel Kampen (ed.), New York, Cambridge University Press, 1996, seems for most of the essays to represent a rather literal view of sexuality and treats the Knidia only in one of its strangest manifestations as the body for portraits of Roman matrons. See the essay there by Eve D'Ambra, "The Calculus of Venus: Nude Portraits of Roman Matrons," pp. 219–32, where the politics of the body language remains unanalyzed.

6 They do, however, remind us that there is never really a "first," and "original." The designation of the Knidia as one is a political one. The Archaic and Archaistic statuettes are discussed in Blinkenberg, *Knidia*, pp. 205–12.

7 According to Andrew Stewart, *Greek Sculpture: An Exploration*, vol. 1, New Haven and London, Yale University Press, 1990, p. 105, "By *c.* 750 male nudity is all-pervasive in sculpture and painting, whether the subject be god or mortal, warrior or mourner; women, on the other hand, are now decorously draped."

8 J. J. Pollitt, *Art and Experience in Classical Greece*, Cambridge, Cambridge University Press, 1972, pp. 6–7.

9 The standard work on the history of the *kouroi* remains Gisela M. A. Richter, *Kouroi, Archaic Greek Youths: A Study of the Development of the Kouros Type in Greek Sculpture*, reprint edition, New York, Hacker Art Books, 1988.

10 Here too, the standard work remains Gisela Richter, *Korai. Archaic Maidens: A Study in the Development of the Kore Type in Greek Sculpture*, reprint edition, New York, Hacker Art Books, 1988.

11 For the relationship between the Doryphoros and Polykleitos' lost theoretical text entitled *The Canon* see Ernst Berger, "Zum Kanon des Polyklet," and Hans von Steuben, "Der Doryphoros," in *Polyklet: Der Bildhauer der griechischen Klassik*, exhibition catalogue, Liebieghaus, Frankfurt am Main, Museum alter Plastik, 1990, pp. 156–84 and pp. 185–98 respectively.

12 The meaning of the *korai* is taken from Richter, *Korai*, pp. 3–4. While these are generally held definitions of the *kouroi* and *korai* as given for example in Pollitt, *Art and Experience*, p. 6, or H. A. Groenewegen-Frankfort and Bernard Ashmole, *Art of the Ancient World*, Englewood Cliffs, Prentice-Hall, 1987, pp. 219–29, the discussion in Stewart, *Greek Sculpture*, vol. I, "Kouroi and Korai: Form, Function, and Meaning," pp. 109–10, considers the various explanations given for these figures unconvincing. The social functions of the figures were so diverse and the figures themselves often so generic, the only conclusion to be drawn is that they were in of themselves "basically meaningless." His primary concern is the *kouroi*, only occasionally throwing the *korai* in "as well." Nevertheless, his remarks on the homosexual innuendo of the statues makes clear that his main interest and observations pertain specifically to the "form, function, and meaning" of the male figures.

I disagree with Osborne, "Looking On," p. 88, that the gestural language of the *korai* is more conducive to a narrative reading than that of the *kouroi*. He, moreover, amazingly gives no significance to the disparity created by the difference of being nude or draped. I believe this to be a greater fault-line than his imagined narrative constructions and therefore consider the so-called "Amelung Goddess" to be infinitely closer to a *kore* than to the Knidia. See Osborne, *passim*.

13 While women's legal position changed from period to period as from city-state to city-state, the dominant role played by the classical Athenian legal system, which determined much of the imagery, has often been acknowledged. See M. R. Lefkowitz and M. B. Fant, *Women's Life in Greece and Rome: A Source Book in Translation*, Baltimore, Johns Hopkins University Press, 1982; Roger Just, *Women in Athenian Law and Life*, London, Routledge, 1991; and Eva Cantarella, *Pandora's Daughters: The Role and Status of Women in Greek and Roman Antiquity*, Baltimore, Johns Hopkins University Press, 1987.

14 See Just, *Women in Athenian Law and Life*, ch. 3, "Legal Capabilities," pp. 26–39, and Cantarella, *Pandora's Daughters*, ch. 3, "Exclusion from the *Polis*," pp. 38–51.

15 Cantarella, *Pandora's Daughters*.

16 See note 11. See also Lesley Dean-Jones, "The Cultural Construct of the Female Body in Classical Greek Science," in Sarah B. Pomeroy (ed.), *Women's History and Ancient History*, Chapel Hill, University of North Carolina Press, 1991, pp. 111–37.

17 This subject has been studied by Larissa Bonfante in a number of places. Oddly, she does not discuss the Knidia. Larissa Bonfante, "Nudity as a Costume in Classical Art," *American Journal of Archaeology*, 1989, vol. 93, pp. 543–70; "The Naked Greek: the Fashion of Nudity in Ancient Greece," *Archaeology*, Sept.–Oct. 1990, vol. 43, pp. 28–35; and "Introduction," *Source: Notes in the History of Art*, guest edited by Larissa Bonfante, winter 1993, vol. 12 (2), pp. 7–11. As for the practice of nudity in the Olympic games, Stewart, *Greek Sculpture*, relates that the first athlete recorded as naked (and then only by accident) is documented in 720 BCE, that is after the convention is introduced in art (p. 105).

18 Stewart, *Greek Sculpture*, pp. 105–6.

19 *Ibid.*; Bonfante, "Nudity as a Costume," p. 544: "As it developed, Greek nudity came to mark a contrast between Greek and non-Greek, and also between men and women." She later cites Herodotus and Thucydides as evidence that the Greeks saw their nudity as differentiating themselves from not only "barbarians" but also from their own past (p. 546).

20 Plato, *The Republic*, Paul Shorey (trans.), London, Loeb Classical Library, 1930, Book V, p. 435. The dialogue does go on to say that once the Greeks themselves "thought it was disgraceful and ridiculous, as most of the barbarians do now, for men to be seen naked" (p. 337).

21 For the history of homosexuality in ancient Greece see K. J. Dover, *Greek Homosexuality*, 1978 reprint edition, New York, Vintage, 1980, and, more recently, Michel Foucault, *The Use of Pleasure: The History of Sexuality*, Robert Hurley (trans.), vol. 2, New York, Pantheon, 1985. Debates continue whether the term "homosexual" is of any descriptive use at all for an understanding of ancient proclivities, given the late date of its introduction in the nineteenth century. See John Boswell, "Revolutions, Universals and Sexual Categories," *Salmagundi*, fall 1982/winter 1983, vols 58–9, pp. 106–9, and the introduction to David M. Halperin, John J. Winkler, and Froma I. Zeitlin (eds), *Before Sexuality: The Construction of Erotic Experience in the Ancient Greek World*, Princeton, Princeton University Press, 1990, pp. 3–20. See also Jasper Griffin's review of the literature, "Love and Sex in Greece," *The New York Review*, 29 March 1990, pp. 6–12.

22 Among the earliest is Dover's famous study, *Greek Homosexuality*. More recently see H. A. Shapiro, "Eros in Love: Pederasty and Pornography in Greece," in Amy Richlin (ed.), *Pornography and Representation in Greece and Rome*, New York, Oxford University Press, 1992, pp. 53–72, and John R. Clarke, "The Warren

Cup and the Contexts for Representations of Male-to-Male Lovemaking in Augustan and Early Julio-Claudian Art," *The Art Bulletin*, June 1993, vol. 75 (2), pp. 275–94.

23 Examples here would include Eva C. Keuls, *The Reign of the Phallus: Sexual Politics in Ancient Athens*, New York, Harper and Row, 1985, and Catherine Johns, *Sex or Symbol?: Erotic Images of Greece and Rome*, London, British Museum Publications and Austin, University of Texas Press, 1982.

24 Boswell, "Revolutions, Universals and Sexual Categories," pp. 106–9. Stewart, *Greek Sculpture*, notes Pindar's remark that athletic beauty stimulates love (*Nemean Ode* 8.1–5), p. 52.

25 For the stake in artistic "realism" in ancient Greece and its relationship to "reality" see J. J. Pollitt, *The Ancient View of Greek Art: Criticism, History, and Terminology*, New Haven, Yale University Press, 1974, pp. 170–200. I would not agree with Stewart's characterization of the relationship between the admiration of an athlete and his depiction in sculpture (*Greek Sculpture*, p. 52) that "Homosexual satisfaction from athletes was considerable, and quite deliberately *exploited* by sculptors" (emphasis mine), but rather would see these as reciprocal expressions of a shared ideology.

26 Pollitt, *Ancient View*, p. 20.

27 Stewart, *Greek Sculpture*, p. 368. Bonfante, "Nudity as a Costume," states that the *kouros* "embodied the *arete* or glory of an aristocratic youth, who was *kalos k'agathos*, 'beautiful and noble'" (p. 544).

28 Pollitt, *Ancient View*, pp. 14–15.

29 The precise wording is significant and translated by modern authors slightly differently. The term for her pubis and its implications will be discussed below. Pseudo-Lucian, *Amores*, pp. 13–14, 120–200 CE.

30 Pliny (29–79 CE), *Natural History*, 36.20, translated by Pollitt, *The Art of Ancient Greece*, p. 84.

31 The pros and cons are discussed in Neumer-Pfau, *Studien*, pp. 166–72, where the Knidia copy in the Vatican is analyzed for evidence of either nonchalance (relaxation) or adrenalized vigilance (tension). I agree with her conclusion that although both exist the latter seems to dominate. See also the much abbreviated version of her argument: Wiltrud Neumer-Pfau, "Die Nackte Liebesgöttin; Aphroditestatuen als Verkörperung des Weiblichkeitsideals in der griechisch-hellenistischen Welt," *Visible Religion*, 1985–6, vol. 4/5, pp. 205–34, and Hans von Steuben, "Belauschte oder unbelauschte Göttin? Zum Motiv der Knidischen Aphrodite," *Istanbuler Mitteilungen*, 1989, vol. 39, pp. 535–46.

The issue of the sculpture's meaning in the eyes of her female devotees often comes up. While I cannot wholeheartedly agree with Osborne, "Looking On," p. 85, that the Knidia has nothing at all to say to women, I do agree that "the recuperation of the female genitals as the imagery of a celebratory affirmative exposure of female sexuality is highly problematic" (p. 95, note 2): see his references there to the work of Griselda Pollock and Lisa Tickner.

32 See Blinkenberg, *Knidia*, pp. 190–2.

33 Pollitt, *The Art of Ancient Greece*, p. 84.

34 I know of only one mythological example of a sexual attack on a goddess by a mortal, Ixion on Hera mentioned by Zeitlin, "Configurations of Rape," p. 122. Ixion's punishment was immediate and severe.

35 The translation is from Pollitt, *The Art of Ancient Greece*, p. 84.

36 The quote is from Lucian, *The Loeb Classical Library*, M. D. MacLeod (trans.), Harvard University Press, vol. 8, 1967, pp. 171–3. Interestingly, Pollitt, *The Art of Ancient Greece*, p. 86, cuts short the quote from the *Erotes*, avoiding the graphic

description of her buttocks, while Stewart, *Greek Sculpture*, p. 280, cuts it short, avoiding the mention of Ganymede. Osborne, "Looking On," p. 82, gives the quote to the mention of Ganymede. Michael Jameson's "Response" to Osborne's essay, which was published in the same volume, acknowledged the homosexual discourse, and laments that Osborne had not "developed his thoughts on Lucian's pederastic view of the Knidian Aphrodite as seen from the rear" (p. 196).

37 Many of these are catalogued in *LIMC*; see lists on pp. 5–9.

38 Athenaios 13.590 (*c.* 200 CE) from Pollitt, *The Art of Ancient Greece*, p. 86.

39 Bonfante, "Nudity as a Costume," p. 359; Keuls, *The Reign of the Phallus*, p. 88.

40 I develop the ideas of the later conditions and consequences of the *pudica* pose in Western art in "The Venus Pudica: Uncovering Art History's 'Hidden Agendas' and Pernicious Pedigrees," in Griselda Pollock (ed.), *Generations and Geographies in the Visual Arts: Feminist Readings*, London, Routledge, 1996, pp. 69–87.

41 This characteristic is, in fact, first seen in the *Eirene and Ploutos* by Praxiteles' father, Kephisodotos. See Pollitt, *Art and Experience*, pp. 151–5.

42 This work is discussed and analyzed by Arielle P. Kozloff and David Gordon Mitten (organizers), in *The God's Delight: The Human Figure in Classical Bronze*, The Cleveland Museum of Art in cooperation with Indiana University Press, 1988, no. 15, pp. 106–10. "In an effort to conceal her sex, she holds her outspread right hand across the front of her groin and pulls her left leg, with the knee flexed, closer to her right" (p. 106).

43 *LIMC*.

44 The term *pudica* for the type is traditionally defined by the double gesture of covering both the breasts and the pubis, as in the Capitoline Aphrodite. Yet the term is often used for the Knidia as well. In *LIMC*, p. 49, the Knidia is the first in the list under "3. Umwandlungen des 'Pudica'-Typus vom 4. Jh. v. Chr. an."

45 The quote is from Michel Foucault, *The Use of Pleasure*, vol. 2 of *The History of Sexuality*, Robert Hurley (trans.), New York, Pantheon Books, 1985, p. 215.

46 See J. N. Adams, *The Latin Sexual Vocabulary*, London, Duckworth and Baltimore, Johns Hopkins University Press, 1993, pp. 51 and 55–6. I have not been able to find the word *pudica* as an art term in any Latin or Italian dictionary. Nor does the word appear in any dictionary of art terms so far as I know. It is, however, frequently used and only sometimes defined, and then with only a phrase or sentence that is more of a description than definition. The only examples I have found are Bianca Maria Felletti Maj, "'Afrodite Pudica': Saggio d'arte ellenistica," *Archeologia Classica*, 1951, vol. 3, pp. 33–65, and *LIMC*, p. 49.

The term makes an interesting contrast with the term "contrapposto" which like *aidos* could theoretically refer to both male or female figures, but is consistently discussed in the art-historical literature as a pose seen in the representation of men. The term is given a highly developed art-historical and intellectual apparatus in, for example, the dense and heavily footnoted article by David Summers, "Contrapposto: Style and Meaning in Renaissance Art," *The Art Bulletin*, September 1977, vol. 59, no. 3, pp. 336–61. Standing for the masculine model, the term is explained as rational, mathematical, philosophical, and authoritative. The term *pudica* is applied to female figures, most often without any sense that a definition, a history of the term, or even an explanation is required.

47 Adams, *Latin Sexual Vocabulary*, p. 51. *A Greek–English Lexicon*, compiled by Henry George Liddell and Robert Scott, new edition revised and augmented

by Sir Henry Stuart Jones, Oxford, Oxford University Press, 1940, p. 36. Bonfante, "Introduction," p. 11: "As in the Bible, the mention of sexual organs was avoided by using euphemisms. The Greek word for 'sexual organs,' *aidoia*, means 'things to be ashamed of,' the equivalent of the Latin *pudenda*, 'things about which one must have *pudor*, modesty, shame, and respect.'" Rather than interpreting this information as an avoidance of mentioning sexual organs, I would say that sexual organs are given social meaning by this "euphemism." Similarly, the rather complicated connection of the word with the act of covering and uncovering should not, in my view, be confused for any "natural" or "intuitive" associations with the sexual organs as in Gloria Ferrari, "Figures of Speech: The Picture of Aidos," *Métis: Revue d'anthropologie du monde grec ancien: Philologie – Histoire – Archéologie*, 1990, vol. 5, pp. 185–200, especially p. 189, but again rather as a form of ideological regulation of sexuality. While I am here concerned only with the two most common uses of the root word *aidos*, its use as a sign of vulnerability and disadvantage as well as its connection with *phobos*, fear, are relevant to my argument. For these and other ancient uses and associations see Ferrari, pp. 191–3, and the sources she cites as in her note 15, p. 191.

48 Lucian, *Loeb Classical Library* (13), p. 168. Given the loaded doubled meaning of this word and the fact that English is the only language which does not combine these concepts linguistically, it is interesting to see how modern authors translate Lucian's text into English. The *Loeb Classical Library* uses the sophomoric (yet oddly equivalent) euphemism "private parts" (p. 169). Pollitt, *The Art of Ancient Greece*, p. 86, translates, "for her nudity is complete except insofar as she holds one hand in front of her to hide her modesty." Similarly, Stewart, *Greek Sculpture* (p. 280): "except that she unobtrusively uses one hand to hide her modesty." In Osborne, "Looking On" (p. 82), "she nonchalantly conceals her crotch."

I encountered this language problem when my first article (as in note 1) which summarily investigated the Knidia from a feminist perspective was translated into German and I insisted that the word *Scham* was an unsatisfactory translation for *pubis* as it reinscribed the very ideology I was trying to undo. See Nanette Salomon, "Der kunsthistorische Kanon – Unterlassungssünden," in *Kritische Berichte: Zeitschrift für Kunst und Kulturwissenschaften*, guest editor Kathrin Hoffmann-Curtius, 1993, vol. 4, p. 36 and n. 51 p. 40.

49 See note 36 above.

50 The definition is taken from Bonfante, "Introduction," p. 11, and differs from her own in "Nudity as a Costume," where she says that sexual organs were "shameful things" (p. 545 and n. 14).

51 Jean-Paul Vernant, "Between Shame and Glory: The Identity of the Young Spartan Warrior," in Froma I. Zeitlin (ed.), *Mortals and Immortals: Collected Essays, Jean-Paul Vernant*, Princeton, Princeton University Press, 1991, p. 242.

52 Plato, *Laws* 1.647a8–11, quoted from Vernant, "Between Shame and Glory," p. 242, n. 46.

53 See Helen North, *Sophrosyne: Self-Knowledge and Self-Restraint in Greek Literature*, Ithaca, Cornell University Press, 1966.

54 Anne Carson, "Putting Her in Her Place: Woman, Dirt, and Desire," in *Before Sexuality*, p. 142.

55 North, *Sophrosyne*, p. 76, n. 105.

56 Aristotle, *Politics*, 1260a20–24; 1277b20–24, cited in Carson, "Putting Her in Her Place," p. 142.

57 *Ibid.*

58 Stewart, *Greek Sculpture*, p. 52. This may also relate to the "proverbial notion that aidos resides in the eyes," Aristotle (*Rhetoric* 1384a) cited in Ferrari, "Figures of Speech," p. 188. "Just as the look of *aidos* sits well on a woman's face, as on the countenance of children, beggars, and suppliants, it is most inappropriate for a man" (Ferrari, p. 199).
59 Stewart, *Greek Sculpture*, pp. 311ff., and John J. Winkler, "Phallos Politikos: Representing the Body Politic in Athens," *Differences: Sexuality in Greek and Roman Society*, spring 1990, vol. 2 (1), pp. 29–45.
60 *Ibid.*
61 See note 13.
62 For Greek attitudes to female virginity see Giulia Sissa, *Greek Virginity*, Arthur Goldhammer (trans.), Cambridge, Mass., Harvard University Press, 1990. Sissa does not differentiate between periods of Greek culture, sometimes even quoting Roman sources in her argument.
63 My ideas have been stimulated by Eve Kosofsky Sedgwick, who investigated homosocial bonding in English literature in *Between Men: English Literature and Male Homosocial Desire*, New York, Columbia University Press, 1985.

11

THE ONLY HAPPY COUPLE
Hermaphrodites and gender

Aileen Ajootian

According to Horace Walpole, Lady Townsend described his modern bronze copy of an ancient Sleeping Hermaphrodite sculpture as the only happy couple she had ever seen.[1] This sculptural type we recognize in some ten Roman replicas and variants, most of them found in Italy, and several, like the Hermaphrodite Borghese now in the Louvre (Fig. 47), above ground at least since the seventeenth century.[2] Some of these sculptures have undergone changes at the hands of modern collectors and artists. The Louvre Hermaphrodite, for example, sleeps on a tufted cushion sculpted for it by Bernini.[3] This comfortable bed replaced the rocky outdoor setting in which these figures originally slept.

The group of Roman copies is thought to derive from a lost Greek Hellenistic original connected with Pliny's reference (*Natural History* 34.80) to a famous bronze hermaphrodite sculpted by the second-century Greek artist Polykles.[4] Since we have no idea of what Polykles' hermaphrodite looked like, however, the attribution remains tentative. The Sleeping Hermaphrodite type is traditionally assigned to an increasingly problematic group of Hellenistic sculptures, so-called "genre" figures, works that do not fit neatly into the categories of divine images or imperial portraits. Our traditional interpretation of genre pieces in general may prevent us from comprehending them. These sleepers still have dramatic power. When their plinths are preserved, they are more detailed and built up on the side presenting the back of the figure, and it is likely that this view was the primary one. The observer encounters a nude, sleeping woman from behind; moving around her to see more, male genitals are obvious, carved in relief on the plinth. While the Sleeping type is the best known hermaphrodite in ancient art, it is not the only one, nor is the addition of male genitals to a clearly female body the earliest, or most widespread, tradition of hermaphrodite iconography.

The origins of this intriguing personage in Greek art and culture can be traced back at least as far as the fourth century BCE, appearing first, from the surviving evidence, in Attica and Athens. A small inscribed base said to be from Vari, now in Münster, preserves the earliest dedication to a

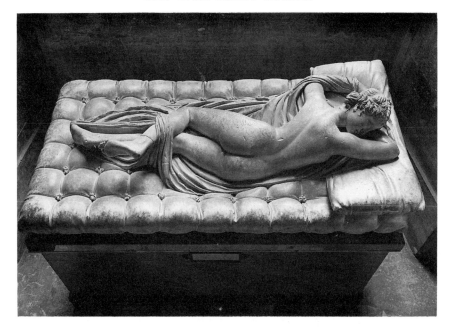

Figure 47 Hermaphrodite Borghese, Paris, Musée du Louvre

personage called Hermaphroditos.[5] The inscription has been dated by letter forms to early in the fourth century BCE, and there is a small square cutting in the top of this support. The earliest mention of the name Hermaphroditos in ancient literature occurs in Theophrastus' *Characters* 16 (late fourth century BCE). His Superstitious Man, in addition to many other compulsive acts of piety, performed special rites on the fourth and seventh days of each month, hanging garlands on Hermphroditos.[6] Alciphron (second or third century CE), whose pastoral *Letters* are set in Greece of the fourth century BCE, has the shepherdess Epiphyllis place a crown of flowers on Hermaphroditos in the Attic deme of Alopeke.[7]

From Athens itself comes the earliest surviving image of Hemaphroditos. The fragment of a clay mould for a terracotta figurine found in the Athenian Agora preserves a critical portion of Hermaphrodite anatomy, and probably would have produced figures of the so-called *anasyromenos*, or revealing, type.[8] Characteristically, hermaphrodites *anasyromenoi*, represented chiefly by small-scale versions in terracotta or marble, stand frontally, their female breasts clearly defined beneath drapery, or partly revealed (Fig. 48). They raise the skirts of their long garments revealing male genitals, the small phallus occasionally erect. At the upper edge of the Agora mould fragment, remnants of fists hold bunched drapery above bared thighs and male genitals. Lacking the rest of the mould, we cannot be sure that it produced hermaphrodite figurines, but, to judge from the small penis, it is

221

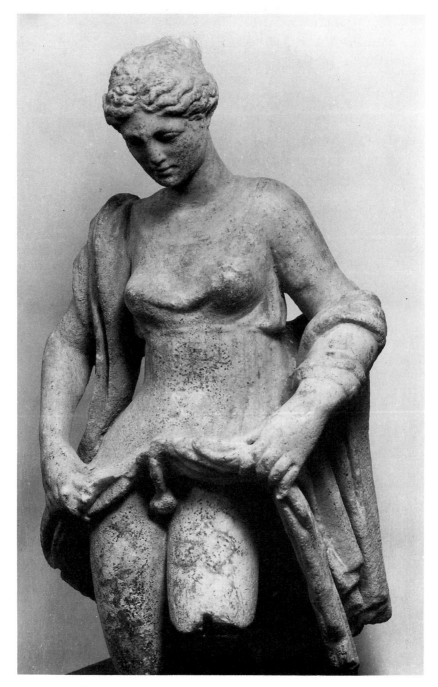

Figure 48 Hermaphrodite statuette, Rome art market

unlikely that it was meant for images of Priapus, who shares *anasyromenos* imagery with Hermaphroditos.[9]

The *anasyromenos* pose, however, was not invented in the fourth century BCE. Hermaphroditic figures of this type draw on a much earlier iconographic tradition employed for female divinities. Syrian goddesses expose their genitals on engraved gems dated in the second half of the second millennium.[10] Later Daedalic terracotta versions on Crete, a channel for eastern imagery and iconography to the Greek mainland, appear at several sites. Seventh-century goddesses on relief plaques from Axos, Kato Syme, and Itea part the panels of their wrap-around skirts.[11] Also at Axos, a group of terracotta female figurines, the earliest of Geometric date, includes at least eight similarly posed. After these Daedalic figures, there is a chronological gap in the evidence. It picks up again in the fifth century BCE with a peculiar terracotta in the Archaeological Museum at Gela in Sicily. This woman lifts her dress, exposing her genitals and swollen belly (Fig. 49).[12] Then, apparently some time during the fourth century, and possibly in Athens, a venerable tradition of female iconography was adapted to create a

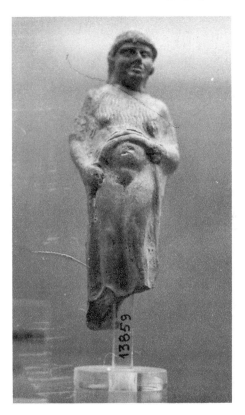

Figure 49 Terracotta figurine, Gela, Museo Archeologico Nazionale, inv. 13859

new image for a new divinity. This reworking of an existing motif is itself an intriguing phenomenon; clearly the revealing gesture is as significant for the new god as for the older one, but perhaps its meaning goes beyond this, linking the new personage functionally with these established divinities.[13]

The epithet *anasyromenos*, assigned by modern commentators to this pose, derives from the verb ἀνασύρομαι ("to pull up one's clothes") and reflects its ancient meaning. According to Herodotus (2.60), Egyptian women traveling by boat on the Nile to a festival for Artemis at Bubastis lifted their dresses and yelled obscenities at local women standing on shore. These Egyptian women, deliberately exposing themselves, have long been linked with the curious Greek figure of Baubo, who dispelled Demeter's grief over the loss of Persephone apparently by lifting her own dress and displaying her *pudenda*.[14] There is a discrepancy between the literary and visual traditions connected with Baubo. In the testimonia her revealing gesture is central to Demeter's recovery, but many terracotta figurines identified as images of Baubo customarily take the form of a woman's head superimposed on the lower half of a nude female body with genitals clearly shown.[15] Both garment and the *anasyromenos* pose are missing. If these figurines, many of them from Priene, do indeed depict Baubo, her body itself was compressed visually into its essential components; her sex itself, not the lifting of the dress, central to her meaning. Olender has suggested that Baubo's act may also have been apotropaic; that both the release of Demeter's barren grip on the world caused by the sight of Baubo's genitals and the protective quality of the exposed sex were required for the earth to bloom again.[16]

While we lack a literary aetiology for Hermaphroditos *anasyromenos*, the images themselves may provide an explanation for the gesture. Costume and pose are linked, depicting a specific moment and a precise message. The manipulation of drapery in these figures can tell us something about the pose, apparently borrowed from female predecessors who deliberately reveal their sex to emphasize the source of their power. In Greek art drapery generally serves as an attribute, although it also can function as a costume or disguise. For mortal males in ancient art, drapery has complex meanings. Certain athletes, like charioteers, or civic officials, like scribes, are customarily covered, but their sex is usually clearly defined beneath the fabric. The Delphi Charioteer is notably without any modelling of the lower body, so he remains an exception; his counterpart the Motya Charioteer is clearly male beneath the clinging garment. Women's clothes, occasionally donned as a disguising costume by men in ancient art and literature, deliberately concealing their masculinity, and superficially altering their sex, has ambivalent implications.[17] Certain men, like Achilles and Herakles, put on feminine garb without diminishing their manly strength and virtue; concealing their masculinity does not negate it. Being covered, as Bassi

notes, may even be safer in some cases; Odysseus, for example, is unwilling to reveal his body to Circe, because naked he might be vulnerable.[18]

The female attire sported by Anakreontic dancers, costumes worn in the context of performance on a series of late sixth- to mid-fifth-century Athenian vases, however, may have conveyed a different message.[19] Their turbans, earrings, *chitons*, parasols – and false beards – have been interpreted variously. Frontisi-Ducroux and Lissarrague see, in the Ionian costume worn by Athenian symposiasts on Anakreontic vessels, "the regulated approach of otherness;" a temporary escape from the constrictions of Greek aristocratic culture.[20] They thus explain the men of Athens who donned foreign costume, effeminate to Athenian eyes, in the context of a *komos*, as remaining essentially masculine, even though conventional Athenian maleness was temporarily disguised. Price, however, interpreted Anakreontic costume and performance at Athenian symposia as a burlesque means of undermining the masculinity, and therefore the strength, of the Greeks' eastern foes; Athenians parodying, not imitating, the other.[21]

Whatever the meaning of Anakreontic performance may have been, it is clear on the vases that the men are in "drag;" there is little doubt about their gender, though there may be room for speculation about their sexuality. Female costume, when used more conventionally as a sign for female gender, covers, but identifies by its type what is concealed beneath. The reluctance of Greek artists to bare women's bodies, except in specific contexts, does not make it difficult to recognize them when draped.[22] In the case of Hermaphroditos *anasyromenos*, however, wearing a high-belted *chiton* and feminine coiffure, its unique identity would not be established without deliberately baring the male genitals, or at least having them show clearly through clothes, which was apparently not done in ancient representations. The revealing gesture is essential to the identification of what otherwise would be female, based on costume. *Anasyromenos* figurines, in other words, adhere to the classical convention for female nudity, the body not exposed gratuitously, and usually remaining partially draped.

In ancient art and apparently in actual rites, women, both divine and mortal, sometimes exposed themselves to emphasize their sex. Hermaphroditos' borrowed *anasyromenos* pose provides both emphasis and identification. But Hermaphroditos is not a woman, even though the matrix of its double sex is sometimes female. Images of Priapus, occasionally sharing *anasyromenos* costume and imagery with Hermaphroditos, employ the gesture in yet another way, drawing attention to the enormous phallus, which occasionally lifts the garment by itself. There is little question about this god's gender, however. The clash of Priapus' long dress, head scarf, developed pectorals, the infants he occasionally cradles, with his full beard and huge penis, stresses his role as a patron and guardian of fertility. While the reasons for Hermaphroditos' pose differ from Priapus' or Baubo's,

discussed above, some elements of meaning may be shared with these other personages.

The origins of the divine personage Hermaphroditos in the Greek world provide some clues to its distinctive character. Its source may be embedded in sixth-century cosmological treatises.[23] These early texts in Greek described the origins of the universe, with bisexual entities playing essential roles. In earlier eastern theogonies, Sidonian, Zoroastrian, and Indian, one primordial deity procreated with itself, bringing forth the next, divine generation.[24] Pherecydes, in his mid-sixth-century prose account of the creation, may be the first Greek philosopher to synthesize these eastern concepts. His scheme included the presence of a being, who was able, by itself, to produce immortal offspring. According to Pherecydes there were three primordial forces: Zas (Zeus), Chthonie (Ge), and Chronos. The first two entities mated with each other to beget divine prodigy, but bisexual Chronos did this on its own. Chronos may be associated with the early eastern bisexuals, and West suggests that this concept was developed in the Orphic cosmography; the earliest surviving Orphic poems have been dated to around 500 BCE.[25]

Playing a critical role in the Orphic creation of the universe was a bisexual creature variously called Phanes, Protogonos, Bromios, Zeus, and Eros in different Orphic fragments.[26] In this system, Phanes was not the first link in the cosmic genealogy. Here, Time in the form of a serpent mated with Ananke, producing Aither and a Chasm. In the Aither, Time created an egg from which Phanes is born. Possessing both male and female genitals, Phanes by itself created Night and several other divinities in the next generation. Then, mating with Night, Phanes produced Oceanus and Ge, the sun, the moon, and the homes of men and gods. Zeus ultimately swallowed Phanes and recreated, as it were, this early form of the cosmos, complete with deities, humankind, and the physical universe.

Empedocles of Akragas (c. 495–435 BCE), in the hexameter poem *On Nature*, also mentions creatures endowed with both sexes; these personages, however, were not gods, but represented an early phase of mortal evolution.[27] In this stage, unattached body parts, human and animal, combined in surprising ways, producing two-headed Janus-like creatures, individuals composed of both animal and human components, and still others in which male and female elements were fused. At a more advanced level of human development, some of these peculiar forms disappeared and the men–women were split in half. It is possible that these entities, in some way, foreshadow the appearance of the Greek divinity Hermaphroditos, who first appeared in art and literature a few centuries later.

The fate of Empedocles' bisexuals presages that of the most familiar human examples in ancient literature, Aristophanes' Androgynes (*Symposium* 189b ff.), who may represent an early fusion of the theoretical and the visual. According to Aristophanes, the first human beings were globe-

shaped creatures composed variously of two male halves (progeny of the sun), two female halves (progeny of the earth), or a half-male/half-female version; this last type was produced by Selene, the moon, also considered bisexual here (189d–190b). Aristophanes called the third form, composed of both sexes, Androgynes. Extinct in his day, Aristophanes says, they were remembered only by the name, reduced at that point to a term of reproach, yet the Androgynes, actually the first heterosexual couples, were once responsible for producing generations of mortals who worshipped the gods. This shift in meaning is significant since it points up an essential difference between the ancient Androgynes, sexually complete, possessing discrete elements of both genders, and human "bisexuals" at the time of the *Symposium*.[28]

The excessive pride of all the globe-shaped creatures caused Zeus to have them cut in half, and later other surgical adjustments were made by Apollo, allowing the severed androgynous halves to mate, ensuring future mortal generations (190c). According to Aristophanes, all the halves, deprived of their original mates, were driven ever after by Eros to seek their original, lost complements; in the case of the Androgynes, members of the opposite sex. In their earliest appearances in Greek cosmographies, entities possessing both sexes, or able to reproduce by themselves, played an essential role in the creation of the universe. As noted above, the Aristophanic Androgynes produced offspring. Plato described in physical terms a phase of human development which had been superseded, but which in fact provided an etiology for contemporary behavior. Perhaps ideas about divine creatures possessing characteristics of both sexes, current in Greek thought at least since the sixth century BCE, then made their way into a more popular level of cultural expression. These figures may, on some level, all be the predecessors of a *daimon* called Hermaphroditos who first appeared in Greece early in the fourth century BCE; not sexually ambiguous, but embodying discrete elements of both genders.

Some distinctions should be recognized between the earlier group of pre-Socratic entities and Hermaphroditos as depicted in Greek and Roman sources. Unlike most of its precursors, Hermaphroditos did not, at least according to the surviving testimonia, bear children. The archaeological evidence, however, suggests that Hermaphroditos did preside over human fertility. Securely dated votive deposits testify to the widely popular cult connections and importance Hermaphroditos may have held, both in Greece and Italy, by the Hellenistic period. At Paestum in Sicily, a deposit of votives dated to the third to second century BCE connected with the Temple of Athena contained a terracotta figure of the *anasyromenos* type.[29] A similar terracotta has recently been excavated at the Demeter sanctuary at Mytiline, Lesbos, also in a votive context dating late in the third or early second century BCE.[30] The Agora mould fragment discussed above, in fact, comes from a well deposit associated with coroplastic activity for the

Eleusinion sanctuary on the North Slope; it could have produced votives for Demeter.[31]

Early examples of the *anasyromenos* type present Hermaphroditos with women's dress, coiffure, and breasts, but with the unmuscled torso and small penis of a pre-pubescent boy, not the body of the shapely woman we see in some Hellenistic and Roman types. Hermaphroditos may have had a close association with young people, sharing with them, as an attribute, their immature bodies. Roman sculptures of Hermaphroditos as a *kourotrophos*, holding a baby or Eros, also attest to a nurturing aspect for this divinity. In addition to the standing, frontal types, with raised garments forming a support for the infant, Roman reclining sculptures of Hermaphroditos nursed one infant while others played nearby, and there are versions of this composition on gems as well.[32] Hermaphroditos' female breasts not only reflect its female aspect but also allude to its *kourotrophic* function.

Why, some time in the fourth century BCE, Hermaphroditos came into its own in Greece, as a deity receiving votive offerings, with a well-established iconography, remains unclear. The evidence, though admittedly sparse, suggests that Hermaphroditos *anasyromenos* may be an Athenian development, since the earliest material comes from Athens and Attica, as we have seen. Perhaps the first images of Hermaphroditos were the products of a local cult in the city itself or possibly in the Attic countryside. Athens in the last years of the fifth century BCE, after thirty years of a disastrous war, two episodes of plague, and a major earthquake, faced social and moral depletion.[33] Towards the end of the century, several new gods, including Adonis, Asklepios, Attis, Bendis, Cybele, Isis, and Sebazius, were worshipped in the city, though not all these gods can be securely connected with reactions to the devastation of disease and warfare. In addition, there is much evidence for religious building projects throughout Attica towards the end of the century, and some of these projects are thought to reflect an Athenian preoccupation with the plague and its aftermath.[34] It is just possible that a cult of Hermaphroditos developed then also, on a popular level. The impetus for the cult of a bisexual divinity and the creation of a new three-dimensional image of this god might be linked to the uncertainties of life in Athens late in the fifth century and scepticism about the power of the Olympians.[35] While too close a connection between religious developments and specific historical events should not be pushed, it is possible that the new cult of Hermaphroditos can be associated with this Athenian trend.

The archaeological record and the literary evidence suggest that Hermaphroditos, embodying both male and female elements, was considered not a monstrous aberration, but a higher, more powerful form, male and female combining to create a third, transcendent gender. An altar found on the island of Kos provides Hellenistic cult evidence. The votive inscription covering all four faces of the monument mentions many divinities. Side (*a*)

lists several major gods connected with healing: Apollo, Asklepios, Herakles, and the Dioskouri; side (*b*) includes Helios, Hemera, the Horai, Charites, Nymphs, Priapus, Pan, and Hermaphroditos.[36] This is only the second inscribed dedication to Hermaphroditos recovered so far, but it must be significant that this god is mentioned along with others who preside over healing, fertility, and children. At least three late Hellenistic marble images of Hermaphroditos have been recovered from Kos, supporting the presence of an established cult there.[37]

While religious activity involving the divinity Hermaphroditos appears to have developed in Greece at least by the early fourth century BCE, in Rome humans possessing physical traits of both sexes constituted a state threat. There, from the later third to the early first centuries BCE, actual occurrences of infants with ambiguous sexual characteristics were considered dangerous portents. Their disposal by the state required elaborate expiatory rituals.[38] How such individuals fared in the Greek world is not so clear, but Diodorus Siculus (32.12.3) reports that early in the first century BCE a woman in Athens possessing male and female sexual features was burned alive.[39]

Just at the time when individuals of a certain physical type were considered harmful portents in Rome, images of beings clearly possessing both male and female sexual features were produced in both Greece and Italy for use as votive offerings. By the first century BCE, Diodorus Siculus (4.6.5–7) articulated the contradictory vision of a powerful god and actual cases of hermaphrodites in nature; these he thought were physical abnormalities and not monstrous phenomena.[40] Some mythological bisexuals, however, were perceived by the Greeks and Romans as having a dangerous side. Agdistis, offspring of Jove and the Phrygian Mount Agdos, was an hermaphroditic creature, wild and destructive, according to Pausanias and Arnobius, until finally subdued through self-castration.[41] Agdistis subsequently became a powerful female divinity akin to Cybele herself, and the name Agdistis was sometimes used as an epithet for the Mother.[42]

Ovid's story of Hermaphroditos, the fullest etiological account, presents a sinister vision of the bisexual. Hermaphroditos started life as a boy, son of Hermes and Aphrodite. In Caria, he encountered a nymph, Salmacis, who lived by a spring with the same name. She fell in love with the youth, who rejected her advances. Reversing an old motif, Salmacis spied from behind the bushes at Hermaphroditos as he swam. She plunged in after him, praying that they might never be parted. In the water, nymph and boy were fused, forming a new entity. But Hermaphroditos' former, masculine nature survived this transformation. Dismayed at his new, feminized persona, he prayed to the gods that henceforth the waters of the spring would emasculate any man who entered them. Vitruvius, aware of this tradition, attempted to redeem the actual spring at Salmacis from its bad reputation.[43]

The god Hermaphroditos perhaps shared a dangerous, portentous qual-ity with actual humans possessing dual sex features, but as a divinity, its power was considered less a threat to humankind's welfare than a force that could be channeled constructively. For the earliest figures, the *anasyromenos* types, several layers of meaning, generative and protective, have been suggested, based on pose and the manipulation of existing iconography. It is likely that all Hermaphrodite images, Greek or Roman, on some level – whether employed as votives or set up in garden, domestic setting, bath, or gymnasium – were perceived as guardians.

One ancient iconographic weapon against the power of the Evil Eye, an embodiment of destructive envy, is the phallus.[44] The inscription on an Egyptian terracotta figurine with the Eye balanced on the tip of the over-sized penis is a threat to sodomize the envious Eye itself. While a constant attribute of hermaphrodites in ancient art is their penis, always deliberately exposed, sometimes erect, it is usually small, unlike the enormous members of Priapus, dwarves and hunchbacks, or the disembodied, erect phalloi normally confronting the Eye. Hermaphroditos' exposed sex and dual gender, however, may have had a different kind of prophylactic power. Plutarch, in his discussion of *Pthonis*, says that *probaskania*, apotropaic objects, attracted the harmful Gaze of the Eye with their strange (*atopia*) appearance, deflecting it from potential victims.[45] Show the Eye a phallus, or show it something surprising. The sexual contradiction embedded in the image of Hermaphroditos, a powerful *daimon*, according to Diodorus Sicu-lus, visible at a glance in *anasyromenos* figures, might have been an effective defence against destructive Envy. Hermaphroditos' defensive powers may derive from its female aspect as well.[46] DeForest equates Clytemnestra's deliberately bared breasts in the *Choephori* of Aeschylus (896–7) with the gaze of the Evil Eye; the nourishing aspect of her woman's body trans-formed by her crime. The more general anthropological equation of breasts and eyes could then be nuanced either for good purposes or for dangerous ones.[47] This protective quality, expressed through the visual fusion of genders, perhaps made Hermaphroditos a guardian of human fertility and vulnerable offspring.

A look at find spots supports Hermaphroditos' role as a defender. As mentioned above, images have been found in a variety of contexts. Public baths and gymnasia were especially dangerous places, where naked bodies were exposed and vulnerable to the Evil Eye.[48] The lurking presence of destructive Envy may be one reason why statues of Hermaphroditos were appropriate decorations in such settings.[49] The most convincing evidence for a protective function in a domestic context is provided by the small marble plaques at Delos (second century BCE), bearing relief images of Hermaphroditos *anasyromenos*. These reliefs were probably once immured in exterior walls of houses close to their entrances, to judge from other panels at Delos, identical in size and construction, adorned with reliefs of Herakles

or just his club. The Herakles panels have been discovered *in situ*, protecting the entrances to private houses.[50]

Let us return to ancient images of Hermaphroditos. How did they function and why did different solutions to the presentation of the bisexual god develop? The impact of the earlier, frontal *anasyromenos* figures depends on the visual incongruity of a split gender identity. *Anasyromenos* figures appear first in Greece, as we have seen, and continued to be produced well into the Roman period. Terracotta figurines of this kind have a wide distribution in Greece and Asia Minor as well as Italy. Large marble versions of Hermaphroditos *anasyromenos* are rare; one important exception is a herm found at Pergamon.[51] With a preserved height of 1.24 m, the now headless figure raises its drapery, exposing the phallus on the shaft below. This work, dated in the second century BCE, was found in a well, its original context unknown.[52]

The Sleeping Hermaphrodite type, possibly inspired by a Hellenistic original, exploits the voyeuristic potential of a torsional pose to reveal its identity, relying on the back view of a vulnerable sleeping woman to engage the viewer in the process of discovery. The identification of this "genre" type with the Phrygian Agdistis has been proposed elsewhere, along with an argument for the Hellenistic original being a creation of the Greek sculptor Polykles after all; not for a Greek setting, however, but for the sanctuary of the Magna Mater in Rome.[53] The proliferation of copies may have begun during the first half of the first century CE in Rome, when some of the more exotic Phrygian elements of the Mother's cult were established in the city.[54] The nature of the replica group points towards an Italian original; most of the copies with known provenience are from Italian contexts.[55] The closest parallel for pose, in fact, is the terracotta figurine of a sleeping woman from a grave (second century BCE) at Taranto.[56]

The group composition of a satyr with a hermaphrodite pinned between his legs employs a similar torsional approach, since seen from the back the satyr's prey looks female (Fig. 50). The so-called Dresden wrestling group was replicated at least twenty-six times in full-sized marble, and two miniature bronzes survive.[57] All replicas with known provenience were found in Italy, several in Rome itself, with the exception of two fragmentary groups from the theater at Daphne near Antioch.[58] The same image was engraved on Roman gems, and one sealing with this image has been recognized, from Cyrene. The twosome also appears in a wall painting at Pompeii. A Greek original is proposed for these Roman works, although we might instead look for earlier parallels in small scale two-dimensional form on Hellenistic south Italian relief ware.[59]

Turning to the meaning of these groups there is the question of the conflict itself. Is the struggle a playful one, as some commentators see it, or should it be considered a more serious and potentially dangerous encounter? And if there is danger, who, ultimately, is the victim? Another

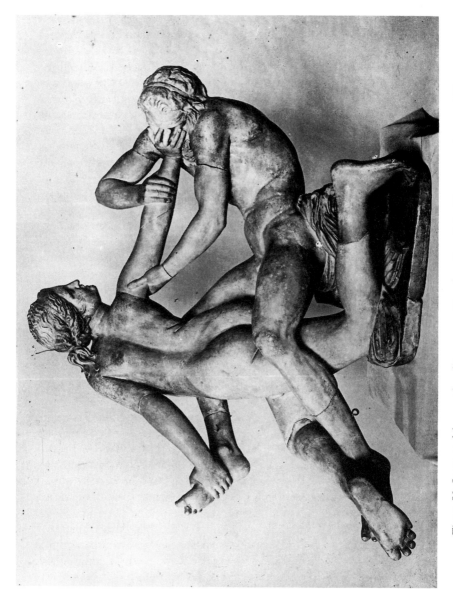

Figure 50 Satyr and hermaphrodite group, Dresden, Staatliche Kunstsammlungen 155

wrestling group, similarly complex in pose and meaning, is represented by at least twelve Roman copies and also has been connected with a Hellenistic Greek prototype. Here a seated hermaphrodite, who reminds us of the nymph from the so-called "Invitation to the Dance" groups, grapples with a smaller satyr (Fig. 51). Again, how are we to understand this encounter, and how do we interpret the noticeably different scales of the opponents?

If Hermaphroditos was a divinity with protective powers, and if we recognize this figure itself as a protagonist in these works, the seemingly playful motif could have a more serious meaning: the satyr, a bestial *mischwesen*, struggling with a divine one. While satyrs customarily are companions of Dionysos or inhabit wild landscapes, there is some evidence for a more dangerous side to their nature. Apollonios of Tyana, according to Philostratus, had to rid an Ethiopian town of a destructive satyr's ghost, and another troublesome satyr in Arcadia raided cattle until he was killed by Argos.[60] On the other hand, satyrs and *silenoi* themselves appeared to have played an apotropaic role in ancient art, so the groups might have functioned in a different way.[61] The torsional hermaphrodite compositions, with a woman's body providing the initial attraction, may be part of the visual arsenal employed to repel the envious Gaze of the Eye; the struggling groups a visual representation of this ongoing conflict. The woman's body here is exploited to surprise the human viewer, and perhaps the Evil Eye as well, as both gradually encounter the figure's true identity.

As for settings, one well preserved example was excavated at Oplontis near its base at the south end of a long pool in the villa garden.[62] Fragments of at least two other groups, third century CE in date, were excavated at the Roman theater at Daphne near Antioch. From the House of the Boat of Psyches some 200 metres south of the theater, a mosaic pavement in front of the dining room included two images of the same wrestling scene, front and back. Reading from left to right along this zone, the first panel depicted a grotesque, ithyphallic dwarf with the partially preserved apotropaic inscription *kai su* ("and [may] you too [suffer harm]") above his head.[63] A geometric segment separates this clearly prophylactic scene from the two other figured panels. It is possible that these two-dimensional versions of the sculptural group represent more than exotica, perhaps providing needed protection in a vulnerable domestic spot.

Hermaphroditos less frequently assumes a pose shared by Hellenistic images of Aphrodite, Apollo and Dionysos; leaning against a support; folds of a mantle slung across the thighs to expose torso and genitals. Again, there are few large versions of this image but one impressive example, now in Istanbul, is also from Pergamon.[64] This work, 1.87 meters in height, has also been dated to the second century BCE and is the largest surviving sculptured hermaphrodite. As Smith has noted recently, the scale suggests that this work must have been an important religious monument.[65] The body type resembles that of a fleshy, undeveloped Apollo or Dionysos, with

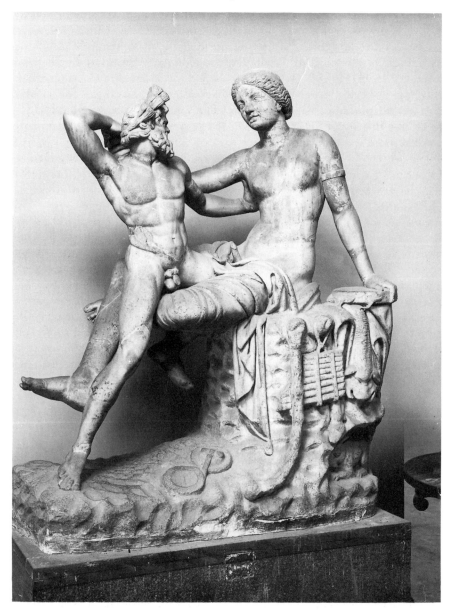

Figure 51 Satyr and hermaphrodite group, Rome, Torlonia Collection

breasts appended. The coiffure, with hair pulled back from a central part and long locks falling on to the shoulders, is worn by divinities of both sexes. Elements drawn from both male and female footwear make the sandals of this figure unique.[66] Other smaller, Hellenistic examples of this

leaning, partly draped type survive, and variants continued to be produced in the Roman period.[67]

Taking the find spots into consideration, it might be possible to distinguish between Greek and Roman varieties – that is, Hermphroditos *anasyromenos* with a boy's physique may derive from the earlier Greek types, while the types characterized by voluptuous female bodies draw on Hellenistic inspirations, possibly from Italy, rather than Greece. In some of the images we have considered, the message is clear at a single glance. These figures are distinct from the torsional ones, whose impact relies on a complex pose and the intentional erotic presentation of a seemingly female body. As for the origins of this second group, Hellenistic Greek prototypes are traditionally assumed, but there is little actual early evidence. We might look instead to Italy and Rome for the origins of these types.

How these sculptures were used, both the hypothesized Greek originals and numerous Roman copies, may help us understand what they meant to their ancient audiences, and how gender, obviously central to the identification of these complex images, was manipulated. There is little doubt about the religious value attached to the *anasyromenos* type: the archaeological contexts of some figurines and the two impressive examples from Pergamon support the presence there of an important Hellenistic cult. As for the other types, as we have seen, there is occasional evidence for provenience that may help determine their meaning. Turning to the viewer's role in the function of these works, the question of intention, and the nature of the "gaze" – that of both artist and viewer – is complex. A back view of the Sleeping Hermaphrodite and the Dresden wrestler leads to the front, the intentional shock of this sight expressed by the Pompeian painting of Pan accosting the recumbent hermaphrodite he has mistaken for a nymph.[68]

Manipulation of the woman's body is essential to the ultimate recognition of Hermaphroditos in these compositions. For the sleeping type, the exploitation of the audience also depended upon the voyeuristic experience of approaching a sleeping, vulnerable woman. This motif is an old one, enacted early in Greek vase painting by satyrs and nymphs; the ancient viewer perhaps was intended to assume the role of intruder. We might read the Dresden type then as the next phase in such an encounter; surprised in sleep, Hermaphroditos struggles with an invading satyr just as earlier generations of nymphs had done. On the other hand, mortals and satyrs were not the only ones who might have been taken in. Assuming that a human audience was the sole receptor of these works also assumes that their function was similarly restricted. If we attribute some additional, protective, purpose to compositions like the Sleeping Hermaphrodite or the Dresden wrestling hermaphrodite, as well as to the more venerable *anasyromenos* images, there may be other reasons why images of "the only happy couple" look and work the way they do.

NOTES

1 The author is indebted to Ann Koloski-Ostrow and Claire Lyons, the editors of this volume.
 See Horace Walpole, *Yale Edition of Horace Walpole's Correspondence*, vol. 18.2, W. S. Lewis (ed.), New Haven, Yale University Press, 1954, p. 342; F. Haskell and N. Penny, *Taste and the Antique*, New Haven, Yale University Press, 1981, no. 48, pp. 234–6.

2 On the Sleeping Hermaphrodite type, see P. Moreno, *Scultura ellenistica*, Rome, Istituto poligrafico e zecca dello stato, 1994, pp. 526–30; E. Stafford, "Aspects of Sleep in Hellenistic Sculpture," *Bulletin of the Institute of Classical Studies*, 1991–3, vol. 38, pp. 105–20; esp. 111–12; B. S. Ridgway, *Hellenistic Sculpture I*, Madison, University of Wisconsin Press, 1990, pp. 329–30; A. Raehs, *Zur Ikonographie des Hermaphroditen*, Frankfurt, P. Lang, 1990, pp. 62–3; A. Ajootian, *Lexicon Iconographicum Mythologiae Classicae (LIMC)*, vol. 5, Zurich, Artemis Verlag, 1990, pp. 268–85; esp. 276–7, nos 56–7, s.v. Hermaphroditos; R. Garland, *The Eye of the Beholder: Deformity and Disability in the Graeco-Roman World*, Ithaca, Cornell University Press, 1995, pp. 119–20.

3 Ajootian, *LIMC*, 1990, p. 56; P. P. Bober, *Renaissance Artists and Antique Sculpture*, Oxford, Oxford University Press, 1986, p. 130, no. 98; Haskell and Penny, *Taste and the Antique*, p. 236.

4 V. Goodlett, *Collaboration in Greek Sculpture*, unpublished Ph.D. dissertation, New York University, Institute of Fine Arts, 1989.

5 L. Threatte, *The Grammar of Attic Inscriptions*, Berlin, W. de Gruyter, 1980, p. 51, no. 7; S. Dow and J. Kirchner, "Inschriften von attischen Land," *Mitteilungen des Deutschen Archäologischen Instituts, Athenische Abteilung*, 1937, vol. 62, pp. 7–8; no. 5, pl. 43; the author thanks Professor R. Stroud for updated information regarding the present location of this base. Also see L. Brisson, "Hermaphrodite chez Ovide," in F. Monneyron (ed.), *L'Androgyne dans la littérature*, Paris, A. Michel, 1990, pp. 24–37; esp. 36, n. 14.

6 R. G. Ussher, *The Characters of Theophrastus*, New York, Macmillan, 1960, and for recent comments see J. Rusten, I. C. Cunningham, and A. D. Knox (eds and trans.), *Theophrastus Characters; Herodas Mimes; Cercidas and the Choliambic Poets*, Cambridge, Mass., Harvard University Press, 1993, pp. 110–11.

7 *Letters* II.35 or III.37. Meineke suggested this reading, although A. R. Benner and F. H. Forbes amend this passage, substituting the name Phaedrias for Hermaphroditos. According to these editors, Epiphyllis places a wreath on the funeral monument of her dead husband Phaedrias (*The Letters of Alciphron, Aelian and Philostratus*, Cambridge, Mass., Harvard University Press, 1979, pp. 138–9).

8 Athens Agora, T1808; D. B. Thompson, "Three Centuries of Hellenistic Terracottas I, A," *Hesperia*, 1952, vol. 21, pp. 116–64; for the dating of the Coroplasts' Dump see S. Rotroff, "Three Centuries of Hellenistic Terracottas, Preface. A Chronological Commentary on the Contents," in *Hellenistic Pottery and Terracottas*, Athens, American School of Classical Studies, 1987, p. 184; Ajootian, *LIMC*, 1990, no. 36. The fragment is made of local Attic clay (D. Fillieres, G. Harbottle, and E. V. Sayre, "Neutron-Activation Study of Figurines, Pottery and Workshop Material from the Athenian Agora," *Journal of Field Archaeology*, 1983, vol. 10, pp. 55–69; esp. p. 64).

9 Hermaphroditos *anasyromenos*: Ajootian, *LIMC*, 1990, pp. 274–6, nos 30–55. Sculptured images of Priapus *anasyromenos* may postdate those of Hermaphroditos. Other divinities who share this iconography include Attis, Baubo, and Isis. The *anasyromenos* pose in art has an ancient literary counterpart. Usually in the

context of a court trial, a woman must raise her dress to confirm her true sex. Agnodike, the Athenian "first female doctor" who practised medicine disguised as a man, revealed her woman's body not only to her female patients but also at the trial where she was accused by jealous male colleagues of seducing the women she cured (G. L. Irby-Massie, "Women in Ancient Science," in M. DeForest (ed.), *Woman's Power, Man's Game: Essays in Classical Antiquity in Honor of Joy K. King*, Wauconda, Bolchazy-Carducci, 1993, pp. 364–5; H. Von Staden, *Herophilos: The Art of Medicine in Early Alexandria*, Cambridge, Cambridge University Press, 1989, pp. 38–41, 53; H. King, "Agnodike and the Profession of Medicine," *Proceedings of the Cambridge Philological Society*, 1986, vol. 32, pp. 53–77). Agnodike, according to Hyginus (*Fabula* 274.13), studied with the Alexandrian physician Herophilus (c. 330/320–260/250 BCE). At least once (Diodorus Siculus 33.10.2), a woman who unexpectedly sprouted male genitals, probably because of a hormonal condition called *hypospadias*, revealed her new condition by exposing herself (Garland, *Eye of the Beholder*, pp. 128–32).

10 E. Porada, *The Collection of the Pierpont Morgan Library: Corpus of Ancient Near Eastern Seals*, vol. 1, Washington, DC, Pantheon, 1948, nos 937–46; S. Böhm, *Die "nackte Göttin,"* Mainz, P. von Zabern, 1990, cites sculptured examples with "cutaway" skirts: from Assur an alabaster figurine (fourteenth century BCE); from Nuzi an ivory statuette (early fifteenth century BCE), pp. 89–90, pl. 34 d–e.

11 Böhm, pp. 89–90, TK 45, pl. 34 a. From Axos: G. Rizza, "Le terracotte di Axos," *Annuario della Scuola Archeologica di Atene*, 1967–8, vols 29–30, pp. 211–302; from Kato Syme: A. Lebessi, "A Sanctuary of Hermes and Aphrodite on Crete," *Expedition*, 1976, vol. 18, pp. 2–13.

12 Gela Museum, inv. no. 13859; approximately 0.1 m high. Gela was founded by colonists from Crete and Rhodes, so perhaps this iconography was a Cretan import.

13 Greek and Roman representations of hermaphrodites can be securely identified by their exposed male genitals and emphatic female breasts, both sexes unambiguously represented. They are "bisexual" in that they obviously possess elements of both genders, yet these attributes constitute a third sex rather than an ambivalent one.

14 M. Olender, "Aspects of Baubo: Ancient Texts and Contexts," in D. M. Halperin, J. J. Winkler, and F. I. Zeitlin (eds), *Before Sexuality: The Construction of Erotic Experience in the Ancient Greek World*, Princeton, Princeton University Press, 1990, pp. 83–113.

15 Th. Karaghiorga-Stathacopoulou, *Lexicon Iconographicum Mythologiae Classicae* (*LIMC*), vol. 3, Zurich, Artemis, 1986, pp. 87–90, s.v. "Baubo."

16 Olender, "Aspects of Baubo," sees Baubo, Hermaphroditos, and Priapus, with his enormous erect penis, as all representing aspects of human sexuality.

17 L. Bonfante, "Nudity as a Costume in Classical Art," *American Journal of Archaeology*, 1989, vol. 93, pp. 543–70.

18 K. Bassi, "Male Nudity and Disguise in the Discourse of Greek Histrionics," *Helios*, 1995, vol. 22, pp. 3–21, esp. pp. 14–15; on modern perceptions of ancient nudity see now C. Chard, "Nakedness and Tourism: Classical Sculpture and the Imaginative Geography of the Grand Tour," *Oxford Art Journal*, 1995, vol. 18, pp. 14–28.

19 D. C. Kurtz and J. Boardman, "Booners," *Greek Vases in the J. Paul Getty Museum*, 1986, vol. 3, pp. 35–70; M. C. Miller, "The Parasol: An Oriental Status-symbol in Late Archaic and Classical Athens," *Journal of Hellenic Studies*, 1992, vol. 112, pp. 91–105.

20 F. Frontisi-Ducroux and F. Lissarrague, "From Ambiguity to Ambivalence: A Dionysiac Excursion Through the 'Anakreontic' Vases," in Halperin, Winkler, and Zeitlin, pp. 213–56.

21 S. D. Price, "Anakreontic Vases Reconsidered," *Greek, Roman and Byzantine Studies*, 1990, vol. 31, pp. 133–75; esp. pp. 167–72.

22 On female nudity and clothing in Greek art see C. M. Havelock, *The Aphrodite of Knidos*, Ann Arbor, University of Michigan Press, 1995, pp. 32–7; S. Blundell, *Women in Ancient Greece*, London, British Museum Press, 1995, pp. 193–5; B. Cohen, "Divesting the Female Breast of Clothes in Classical Sculpture," *infra*, pp. 66–92; "The Anatomy of Kassandra's Rape: Female Nudity Comes of Age in Greek Art," *Source*, 1993, vol. 12 (2), pp. 37–46; also Bonfante, "Nudity as a Costume."

23 Although some elements may already be present in Hesiod's *Theogeny.* G. S. Kirk, J. E. Raven, and M. Scholfield, *The Presocratic Philosophers*, Cambridge, Cambridge University Press, 1983, pp. 35–7.

24 M. L. West, *Early Greek Philosophy and the Orient*, Oxford, Clarendon Press, 1971, pp. 29–36; Kirk, Raven, and Scholfield, *The Presocratic Philosophers*, p. 141.

25 M. L. West, *The Orphic Poems*, Oxford, Clarendon Press, 1983, p. 7; and see now "Ab Ovo: Orpheus, Sanchuniathon, and the Origins of the Ionian World Model," *Classical Quarterly*, 1994, vol. 44, pp. 289–307.

26 West, *The Orphic Poems*, p. 203; R. Turcan, *Lexicon Iconographicum Mythologiae Classicae*, (*LIMC*)vol. 7, Zurich, Artemis Verlag, 1994, pp. 363–4, s.v. Phanes.

27 M. R. Wright, *Empedocles: The Extant Fragments*, New Haven, Yale University Press, 1981, pp. 212–15; D. O'Brien, *Empedocles' Cosmic Cycle*, Cambridge, Cambridge University Press, 1969, pp. 205–7, 228, 234; Garland, *Eye of the Beholder*, pp. 174–7.

28 *Astrateutoi*, a comedy by the fifth-century playwright Eupolis, about men who had not served in the military, was also called *Androgynoi*; perhaps Aristophanes was referring to this play. According to Herodotus (4.67), Scythian soothsayers called the *Enarees* were *androgynoi*. Elsewhere (1.105) he explained that the *Enarees*, who had plundered Aphrodite's temple at Ascalon, were afflicted by the goddess with a hereditary disease, the *thelean nousos*, or female illness. Hippokrates (*peri aer.* 21) described this malady. According to him, aristocratic Scythians, who customarily wore trousers and rode horses, were afflicted by a disorder of the joints that was treated by blood-letting. This cure, Hippokrates says, destroyed sperm and caused impotence. The Scythians attributed their condition to divine punishment. Of a moist, cold nature, the *Enarees* were not only impotent, but also assumed women's roles, tasks, and dress. The Scythian Androgynes, significantly foreigners, thus were effeminate men. On *kinaidia* and effeminate males in classical Athens see E. Cantarella, *Bisexuality in the Ancient World*, trans. C. O Cuilleanain, New Haven, Yale University Press, 1992, pp. 44–50; J. J. Winkler, *The Constraints of Desire: The Anthropology of Sex and Desire in Ancient Greece*, New York, Routledge, 1990, pp. 45–70; K. J. Dover, *Greek Homosexuality*, London, Duckworth and Cambridge, Mass., Harvard University Press, 1978, pp. 68–81; for Athenian perceptions of effeminacy and military cowardice, pp. 144–5.

29 P. C. Sestieri, "Ricerche posidoniasti," *Mélanges de l'École Française de Rome, Antiquité*, 1955, vol. 67, p. 40.

30 C. Williams and H. Williams, "Excavations at Mytilene, 1988," *Echos du Monde Classique*, 1988, vol. 33, pp. 167–81.

31 The Christian writer Arnobius (third to fourth century CE) cites Timotheus, a Eumolpid priest (fourth century BCE) at Eleusis, as an authority on Phrygian

mythology in his account of Cybele and the hermaphrodite Agdistis, providing additional, though tentative, evidence for a fourth-century connection of hermaphrodites and Demeter; also see p. 229 below. For another figurine of Hermaphroditos *anasyromenos*, in marble, found in association with a temple possibly dedicated to Demeter, see A. Schachter, *Cults of Boiotia*, vol. 2, London, University of London, Institute of Classical Studies, 1986, pp. 39, 132–6; G. Korte, "Die antiken Skulpturen aus Boeotien," *Mitteilungen des Deutschen Archäologischen Instituts, Athenische Abteilung*, 1978, vol. 3, p. 396, no. 174.

32 Ajootian 9 *LIMC*, 1990, nos 73–6a. Roman statues of recumbent hermaphrodites have undergone alterations at the hands of modern collectors; male genitals and babies were removed from a copy in the Ince Blundell collection (see S. Howard, "Henry Blundell's Sleeping Venus," in *Antiquity Restored: Essays on the Afterlife of the Antique*, Vienna, IRSA, 1990, pp. 117–29; also T. Hadziteliou Price, *Kourotrophos: Cults and Representations of the Greek Nursing Deities*, Leiden, Brill, 1978, pp. 172–6).

33 On the plague: Thucydides 2.47–54; D. M. Morens and R. J. Littmore, "Epidemiology of the Plague of Athens," *Transactions of the American Philological Association*, 1992, vol. 122, pp. 271–304; R. Sallares, *The Ecology of the Ancient Greek World*, Ithaca, Cornell University Press, 1991, pp. 221–93, with previous bibliography. On the earthquake in Athens: Thucydides 3.89; S. I. Rotroff and J. H. Oakley, *Debris From a Public Dining Room*, Princeton, Princeton University Press, 1992, pp. 51–7. While the population in 415 BCE was apparently adequate to support the Syracusan expedition, only a few years later evidence suggests that there may have been a manpower shortage: Sallares, *Ecology*, pp. 95–9, 258–62; B. S. Strauss, *Fathers and Sons in Athens: Ideology and Society in the Era of the Peloponnesian War*, Princeton, Princeton University Press, 1993, p. 138; *Athens after the Peloponnesian War*, London, Croom Helm, 1986, pp. 70–86; A. W. Gomme, *The Population of Athens in the Fifth and Fourth Century B.C.*, Oxford, Blackwell, 1933, pp. 6–8.

34 For Asklepios in Athens see J. Travlos, *Pictorial Dictionary of Ancient Athens*, New York, Hacker, 1971, pp. 127–8; Amphiaraos, another healing divinity, was established at Oropos by the early fourth century BCE: J. Travlos, *Bildlexikon zur Topographie des antiken Attika*, Tübingen, E. Wasmuth, 1988, pp. 301–18. On foreign cults in Athens see R. Garland, *Introducing New Gods*, Ithaca, Cornell University Press, 1992; R. R. Simms, "Foreign Cults in Athens in the Fifth and Fourth Centuries B.C.," unpublished dissertation, University of Virginia, 1985; H. S. Versnel, *Ter Unus*, Leiden, Brill, 1990, pp. 102–31; J. M. Mikalson, "Religion and the Plague in Athens," in A. L. Boegehold *et al.* (eds), *Studies Presented to Sterling Dow*, Durham, Duke University Press, 1984, pp. 217–25; J. McK. Camp, "A Drought in the Late Eighth Century B.C.," *Hesperia*, 1979, vol. 48, pp. 399–411; esp. pp. 403–4. The development of the sanctuary of Artemis at Brauron has also been attributed by Camp to Athenian concern with the plague. On late fifth-century building projects in Attica see: M. M. Miles, "A Reconstruction of the Temple of Nemesis at Rhamnous," *Hesperia*, 1989, vol. 58, pp. 228–35.

35 The gender iconography of other gods, chiefly Dionysos and Apollo, became more ambivalent in the fourth century BCE. Dionysos, in Euripides' *Bacchae*, possesses characteristics of both sexes, but this quality manifests itself as the feminizing of his masculine nature; see F. I. Zeitlin, "Playing the Other: Theater, Theatricality, and the Feminine in Greek Drama," in J. J. Winkler and F. I. Zeitlin (eds), *Nothing to Do With Dionysos*, Princeton, Princeton University Press, 1990, p. 63.

36 G. Pugliesi Carratelli, "Nuovi documenti del culto privato ellenistico," in *Miscellanea di studi Alessandrini in memoria di Augusto Rostagni*, Turin, Bottaga d'Erasmo, 1963, pp. 162–5. Carratelli (p. 165) sees a possible Orphic connection in the appearance of Pan as Zan or Zeus here, and it is possible that the Orphic character of the inscription might be taken further: Hermaphroditos associated with Protogonos or Phanes, and some of the other *daimonai*, like Hemera and the Horai representing an aspect of Orphic Time or Chronos. This altar provides the earliest epigraphical evidence for the Dioskouri on Kos; Carratelli suggests they may share the general character of *soteres*.

37 One of these works is a small-scale variant of Sleeping Hermaphrodite type, and there are two other frontal types, one draped and another nude.

38 Garland, *The Eye of the Beholder*, pp. 67–72; R. MacBain, *Prodigy and Expiation: A Study in Religion and Politics in Republican Rome*, Brussels, Latomus, 1982, pp. 126–35; and see now T. S. Barton, *Power and Knowledge: Astrology, Physiognomics, and Medicine Under the Roman Empire*, Ann Arbor, University of Michigan Press, 1994, p. 118; also G. Dumézil, *Archaic Roman Religion*, Chicago, University of Chicago Press, 1970, pp. 606–10; A. A. Boyce, "The Expiatory Rites of 207 B.C.," *Transactions of the American Philological Association*, 1937, vol. 68, pp. 157–71.

39 R. Parker, *Miasma*, Oxford, Clarendon Press, 1983, p. 221, n. 75; but see Garland, *The Eye of the Beholder*, p. 102.

40 For discussions of hermaphroditism in nature see G. Herdt, *Third Sex, Third Gender: Beyond Sexual Dimorphism in Culture and History*, New York, Zone Books, 1994; D. Berreby, "Sex and the Single Hermaphrodite," *Discovery*, 1992, vol. 13.6, pp. 88–93; U. Mittwoch, "Men, Women, and Hermaphrodites," *Annals of Human Genetics*, 1986, vol. 50, pp. 103–12.

41 Pausanias (7.17.9) records a short version of this Phrygian myth; a fuller account is provided by Arnobius (*Adversus Nationes* 5.7).

42 On Agdistis: G. Knaack, Pauly–Wissowa, *Real-Encyclopädie*, vol. 1, Stuttgart, J. B. Metzler, 1894, pp. 767–8, s.v. "Agdistis" 2. M. Meslin, "Agdistis ou l'androgynie malséante," in M. B. de Boer and T. A. Eldridge (eds), *Hommages à Maarten J. Vermaseren*, Leiden, Brill, 1978, pp. 765–76; also L. Roller, "Attis on Greek Votive Monuments Greek God or Phrygian?," *Hesperia*, 1994, vol. 63, pp. 245–62, with earlier bibliography.

43 A. Richlin, "Reading Ovid's Rapes," in A. Richlin (ed.), *Pornography and Representation in Greece and Rome*, Oxford and New York, Oxford University Press, 1992, pp. 158–79; especially pp. 165–6.

44 K. W. Slane and M. W. Dickie, "A Knidian Phallic Vase from Corinth," *Hesperia*, 1993, vol. 62, pp. 483–505; esp. pp. 486–94; M. W. Dickie, and K. Dunbabin, "*Invidia vipantur pectora*: The Iconography of Pthonos/Invidia in Graeco-Roman Art," *Jahrbuch für Antike und Christentum*, 1983, vol. 26, pp. 7–137.

45 *quaest. conviv.* 5.7.681e; Slane and Dickie, "A Knidian Phallic Vase," p. 488, n. 34.

46 On the apotropaic powers of bared female breasts see: M. DeForest, "Clytemnestra's Breast and the Evil Eye," in M. DeForest (ed.), *Woman's Power, Man's Game*, pp. 129–48.

47 Ibid., pp. 136–42.

48 K. M. D. Dunbabin, "*Baiarum grata voluptas*: Pleasures and Dangers of the Baths," *Papers of the British School at Rome*, 1989, vol. 64, pp. 6–46.

49 Hermaphroditos in baths: fragments of three Hermaphrodite/Satyr groups from the bath at Cherchel (H. Manderscheid, *Die Skulpturenausstattung der kaiserzeitlichen Thermenlagen*, Berlin, Mann, 1981, p. 127, nos 520–1); bronze

hermaphrodite reported by Christodoros of Thebes (*Anth. Pal.* 2.102–7) in Constantinople, Baths of Zeuxippos, burned in 532 CE (R. Stupperich, "Das Statuenprogramm in den Zeuxippos-Thermen," *Istanbuler Mitteilungen*, 1982, vol. 32, pp. 210–35); *Anth. Pal.* 9.783, an epigram spoken by a Hermaphrodite presiding over a bath used by both sexes. An inscription dating to the early second century BCE inventories the sculptural contents of a gymnasium in Athens, possibly the Gymnasium of Ptolemy; among other statues of gods it lists Hermaphroditos (see D. Clay, *Hesperia*, 1977, vol. 46, pp. 259–67); actual sculptures of hermaphrodites from gymnasia include an aggressive Hermaphrodite and Satyr group from the Roman gymnasium at Salamis in Cyprus (V. Karagheorghis, *Sculptures from Salamis*, Nicosia, Department of Antiquities, 1964, pp. 29–30, no. 21); for a Dresden hermaphrodite/satyr group at one end of a manmade pool at Oplontis see *infra*, n. 62.

50 J. Marcadé, "Reliefs Déliens," *Bulletin de Correspondance Hellénique, Supplement*, 1973, vol. 1, pp. 336–9, 342–7; P. Bruneau, "Apotropaia Déliens: La Massue d'Herakles," *Bulletin de Correspondance Hellénique*, 1964, vol. 88, pp. 159–68. At least two marble *trapezophora* in the form of Hermaphrodite herms from Delos are Hellenistic, but there are later examples as well. On Hermaphrodite herms in general see H. Wrede, *Die antike Herme*, Mainz, P. von Zabern, 1986. Hermaphroditos' protective power may have extended to the realm of the dead as well. A few Hermaphrodite figurines have turned up in graves of the third to second century BCE, one from near Thessalonike (Ajootian, *LIMC*, 1990, no. 14 e) and another of around the same date reported at Olympia (the author thanks Dr. Aliki Moustaka for this information). A relief of Hermaphroditos *kallipygos* adorned one side of a Roman funerary monument in Gaul.

51 Ajootian, *LIMC*, 1990, no. 48.

52 Ajootian, *LIMC*, 1990, no. 49.

53 A. Ajootian, "*Ex utroque sexu*: The Sleeping Hermaphrodite and the Myth of Agdistis," *American Journal of Archaeology*, 1988, vol. 92, pp. 275–6; *Natus Biformis: Hermaphrodites in Greek and Roman Art*, unpublished Ph.D. dissertation, Bryn Mawr College, 1990.

54 Ajootian, *Natus Biformis*, 1990.

55 The two examples from Greece are variants: a smaller marble version found on Kos, and a woman in Sleeping Hermaphrodite pose from Makriyannis, south of the Akropolis (Athens, NM 261; Ajootian, *LIMC*, 1990, no. 56i). For the function and meaning of these pieces in the Roman period, we have little firm evidence. A replica of the Sleeping Hermaphrodite type now in the Terme Museum, however, may provide some clues. It was discovered walled up in a niche in the *atrium* of a villa on the Viminal in Rome. The house had belonged to C. Julius Avitus, a Syrian, the husband of Julia Maesa and proconsul of the Province of Asia late in the second century CE (A. R. Birley, *The African Emperor, Septimius Severus*, London, Batsford, 1988, appendix 2, p. 223, no. 45). While it is not possible to determine when the alterations to the *atrium* occurred, if the sculpture had been owned by Avitus, then it could possibly be related to his experiences in Asia, perhaps governing from Pergamon, where a cult of Hermaphroditos appears to have existed from the second century BCE, or might suggest his involvement with the reformed cult of the Mother in Rome.

56 E. M. de Juliis and D. Loiacono, *Taranto: Il Museo Archeologico*, Taranto, Mandese, 1985, p. 386, no. 474.

57 Ajootian, *LIMC*, 1990, nos 63v–w; P. Gercke, "Pergami Symplegma des Kephisodots?," in M. Schmidt (ed.), *Kanon: Festschrift Ernst Berger*, Basel,

Vereinigung der Freunde antike Kunst c/o Archäologisches Seminar de Universität, 1988, pp. 232–4; K. Kell, *Formuntersuchungen zu spät- und nachhellenistischen Gruppe*, Saarbrucken, Saarbrucker Druckerei und Verlag, 1988, pp. 21–8.

58 Ajootian, *LIMC*, 1990, nos 63n–o; front and back views of this composition were reproduced in a pair of mosaic panels (fourth century CE) for a villa south of the theatre; see pp. 231–33.

59 The other wrestling group of Hermaphrodite and Satyr, where the larger Hermaphrodite appears to be winning the contest, is recognized in a group of some ten relief medallions decorating Calenian bowls of the third to second century BCE (R. Pagenstecher, *Die calenische Reliefkeramik. Jahrbuch des Deutschen Archäologischen Instituts, Ergänzungsheft*, 1909, vol. 8, pp. 37–8). A popular Roman sculptural type of wrestling nymph and satyr was reproduced earlier in relief on a Hellenistic silver vessel (A. Oliver, "New Hellenistic Silver: Mirror, Emblem Dish, and Spoons," *Jahrbuch der Berliner Museen*, 1977, vol. 19, pp. 13–22; esp. pp. 16–20, figs 3–5).

60 Philostratus, *Vit.Apoll.* 6.27; Apollodoros, *Bibl.* 2.1.2; G. M. Hedreen, *Silens in Attic Black-figure Vase-painting*, Ann Arbor, University of Michigan Press, 1992, p. 72.

61 A. Hartmann, in Pauly–Wissowa, *Real-Encyclopädie*, vol. 3, Stuttgart, J. B. Metzler, 1927, cols 42–3, s.v. Silenoi.

62 Ajootian, *LIMC*, 1990, no. 63p; S. De Caro, "The Sculptures of the Villa Poppaea at Oplontis," in *Ancient Roman Villa Gardens*, Washington, DC, Dumbarton Oaks Research Library and Collection, 1987, pp. 98–100, no. 12, figs 15a–b, 16a–b, 38.

63 From the House of the Boat of Psyches: R. Stillwell, *Antioch-on-the-Orontes*, vol. 2, Princeton, Princeton University Press, 1938, p. 185, no. 49, pl. 37; Slane and Dickie, "A Knidian Phallic Vase," p. 490, no. 2; Ajootian, *LIMC*, 1990, no. 63c, f.

64 Ajootian, *LIMC*, 1990, no. 18.

65 R. R. R. Smith, *Hellenistic Sculpture*, London, Thames and Hudson, 1991, p. 156.

66 K. D. Morrow, *Greek Footwear and the Dating of Sculpture*, Madison, University of Wisconsin Press, 1985, pp. 137–40.

67 Yet another "womanly" hermaphrodite type is recognized in a group of Roman bronze figurines, primarily from sites in Roman Gaul. These *kallipygos* figures bind a kerchief around their brows with the left hand while looking back over their shoulders at their buttocks reflected in the mirrors held in their right hands, and this motif was repeated in a number of neo-Attic reliefs; Ajootian, *LIMC*, 1990, nos 12–14 e.

68 Ajootian, *LIMC*, 1990, no. 63b; T. Kraus, *Pompeii and Herculaneum*, New York, H. N. Abrams, 1975, fig. 276.

12

VIOLENT STAGES IN TWO POMPEIAN HOUSES

Imperial taste, aristocratic response, and messages of male control

Ann Olga Koloski-Ostrow

INTRODUCTION[1]

Just as the stage in a theater gives power and presence to the actors who perform on it, critics have recently come to see the architecture and decoration of the Roman house working together to create a kind of private "powerhouse"[2] reinforcing the authority of the *dominus*. The relationships between rooms and the paintings (especially mythological) in those rooms define spaces where the owner put himself and his personal tastes on display to a select clientele. In Wallace-Hadrill's own words,[3] "we must treat the house as a coherent structural whole, as a stage deliberately designed for the performance of social rituals, and not as a museum of artifacts." He concludes that the *patronus* used his house as much for public social rituals as for his private life – an idea generally quite foreign to us in contemporary society.

We can only fully understand the Roman house, therefore, including its design, its decoration, its overall taste, as a kind of stage set where ancient public and private life intersected and was acted out among members of the Roman ruling class. This paper closely examines the decoration and design of two wealthy houses from the last years of Pompeii, Casa del Menandro (I.10.4) and Casa degli Amorini dorati (VI.16.7.38). The mythological paintings, theater-related images, and other architectural features merit special consideration as convincing supports that the artistic and literary tastes of the Julio-Claudian emperors, particularly Nero's taste for the theatre, had a direct influence on the decor of aristocratic Roman houses of the period. Suetonius and other literary sources help capture the spirit of this age. At the same time, by considering closely the strongly erotic and sometimes violent nature of certain painted mythological scenes in these houses, it is possible to penetrate to a subtler and more elusive level of inquiry and understanding. Following in the pioneering footsteps of D. Frederick, who has applied modern feminist film theory to other Pompeian walls, I suggest

that more than external theatrical "culture" is being displayed.[4] While echoing the very taste of the emperor himself, certain paintings may be symbolic statements of control and power, as appropriate to the taste of an emperor as they were to the *patronus* of an individual house.

NERO, THE THEATER, AND IMPERIAL TASTE

Since the emperor was not a purely political figure, his influence surely extended to non-political spheres in the social and cultural life of his day. Although this seems an obvious assumption, it is not one at all well documented. The relationship between a given emperor's public record (dealings in political and military matters) and the response of the Roman upper classes has been more easily addressed from the information in the historians. But how, for example, the private entertainments, passions for certain foods and wines, sexual preferences, religious inclinations, or general cultural preoccupations of the Caesars affected the private world of these same upper classes needs more attention. In the case of cultural and literary pursuits, the emperor Nero's well-documented passion for the dramatic arts had a direct influence on the fashions of interior decoration favored by some wealthy private patrons in contemporary Pompeii.

Although the complex relationship between the imagery of the theater and Fourth Style Pompeian wall-painting has inspired a whole body of scholarly literature,[5] little work has been done on the role of Imperial taste in this development. The Casa del Menandro and the Casa degli Amorini dorati are particularly intriguing when examined from this perspective. Not only is there a suggestive (though impossible to prove beyond all doubt) familial connection between their owners and Nero's second wife Poppaea Sabina, but the theatrical themes that dominate their decorative program can be seen as private domestic evocations of Nero's public and at least quasi-official dramatic enthusiasms and performances.

Suetonius[6] serves up a wealth of material on the private lives of Roman emperors. Although we must use him with caution, there is a coherence in his information and a consistency of his report emperor to emperor (perhaps in itself the best guarantee of Suetonius' overall value) that makes it seem reasonable to consider many of his details as reliable indicators for any role played by the Imperial court in the social and cultural life of the Roman aristocracy.

In a series of amusing anecdotes, Suetonius confirms Nero's interest in the theater:[7] Nero's recitation of his own poems at theater; the public nature of Nero's involvement in the theater; his gifts to the populace in the theater; his habit of watching plays from the *proscenium*; his insistence that senators and knights perform in the arena and theater; his inauguration of the Neronia; his frequent performances in Naples[8] and Rome; his rule that no one was allowed to leave the theater. Suetonius revels in details of

the emperor as a grand actor in his own house,[9] describing Nero's general showiness in the Golden House and his lavish banquets celebrating good news from the provinces with songs and an immense variety of entertainments. Nero's personal tastes paralleled his interest in theater. We learn of his involvement with the Troy Games, how he sang the *Fall of Ilium*, his own poem, as Rome burned, that he possessed Homeric drinking cups which were smashed, and that he immersed himself in the trappings and environment of the theater whenever possible.[10] He also enjoyed bawdy tunes about leaders of revolts, songs that were apparently made popular from his drinking parties. Here we can see a clear example of Nero's personal taste actually spreading into the "popular culture" of his day.

While there is still debate about whether the great tragedian Lucius Annaeus Seneca (*c.* 4 BCE to 65 CE) wrote his tragedies for performance in the theater or merely for recitation,[11] there is no question but of his close connection to Nero.[12] Suetonius tells us that Nero himself sang roles from several of these works.[13] The many resemblances between Seneca's tragic plots, which were packed with escalating levels of sexual violence and carnage on the stage, and Tacitus' account of Nero's violent reign cannot be simply coincidental.[14]

Recent research on the important literary renaissance fostered in the reign of Nero has revealed intricate connections between the Imperial propaganda machine, including the political aims of the emperor, and the desire for patronage. This work also gives renewed attention to the literary circle that Nero formed in 59 CE, surveying both its members and their productions.[15] Although literary patronage by the emperors must be viewed with some caution, there was significant literary activity (especially by Petronius and Seneca) from which we may sketch the cultural setting of the first century CE.

In many particulars, as Wallace-Hadrill has noted,[16] the text of the *Satyricon* explicitly supports the notion that Petronius' world is a stage – theatricality plays a role everywhere, and in particular in the *Cena Trimalchionis*.[17] A porter dressed in green and red shells peas into a silver bowl at the entrance to Trimalchio's house. Above the threshold there hangs a golden bird cage. A painted watch-dog threatens visitors by the porter's cell, followed by a frieze representing the lucky life of the master. There is a shrine displaying silver *lares*, a marble Venus, and a golden box, as well as Homeric and gladiatorial scenes too prolific to take in at once. All of this is a prelude to the *triclinium*, where the reader will soon meet Trimalchio himself. Despite the fact that Petronius' description of the domestic architecture cannot be reconciled in every respect with particulars in actual Roman houses of the period, it does make it clear that there was a Roman awareness of the social function of parts of the house and its decoration.

Nero's penchant for the theater struck a responsive chord in Campania, where all forms of Roman entertainment spectacles flourished under a long

history of popular acclaim. Painted scenes from the repertoire of mythological paintings seem to be derived directly from stage-plays once recited or performed on the actual stage.[18] Images of violence, rape, betrayal, control, and oppression in these scenes predominate. Furthermore, it cannot be denied that the Roman theater, unlike its more subdued Greek forerunner, thrived on theatrical representations of murders, suicides, rapes, and mutilations enacted before the audience on stage.[19]

Enjoying a reputation for jest and merriment even in modern times, ancient Campanians had a true passion for theatrical miming, histrionic dialogue, and the expressiveness of costumes and masks.[20] The stage and stage performances, whether of the Greek or Roman type,[21] were the delight not only of the general populace at Pompeii (cf. the theatrical erotica in the Casa dell' Efebo), but also of the well-to-do, whose taste in architecture and art was strongly imbued with Hellenistic fashions.[22]

Enthusiasm for theatrical performances of all descriptions clearly ran high in Pompeii. The great open-air theater and a covered *odeon*, linked together by the long rows of porticoes flanking the little *palaestra*, stand in full view of the mountains and the sea in one of the most fashionable quarters of the city.[23] There were any number of local mimes and actors whose popularity is vouched for by the frequency with which their names were incised on the walls in public and private places.[24] Comic or tragic masks are common motifs on walls everywhere in the private houses of Pompeii, and, indeed, one of the leading characteristics of much Pompeian wall-painting, especially in the last period of the city, is its remarkable resemblance to stage scenery.[25] When analyzed within this theatrically sophisticated cultural context, the interior decoration of the Casa del Menandro and the Casa degli Amorini dorati suggest strong links to the emperor's own theatrical tastes.

CASA DEL MENANDRO AND CASA DEGLI AMORINI DORATI

The Casa del Menandro (I.10.4) and the Casa degli Amorini dorati (VI.16. 7.38),[26] both reputedly associated with the *gens Poppaea* (a point I shall examine more thoroughly below), are unusually rich in the imagery of Hellenistic and Roman drama. Both of these houses are so physically and thematically theatrical that they immediately recall the description in the *Cena Trimalchionis* of Trimalchio's house and household as one long and noisy stage-show. If the modern visitor to these houses feels the full force of the personality of the owner, the experience is one in which the ancient visitor also was meant to participate.[27]

The Casa del Menandro (Fig. 52) offers perhaps the strongest evidence of the high esteem held by the owner for theatrical themes in decoration.[28] Excavated and published between 1930 and 1932, the house was named

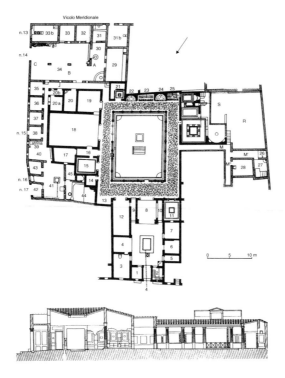

Figure 52 Plan of the Casa del Menandro (I.10.4), Pompeii

Menandro from the portrait of the Greek poet Menander painted on a wall at the south end of the peristyle.[29] The Pompeian red walls of the *atrium* are everywhere painted with theatrical masks clustered in a variety of arrangements. In room 4 on the east side of the *atrium* are three painted panels: the Trojan horse, a scene showing the violent capture of Cassandra on the last night of the Trojan War (Fig. 53), and the death of Laocoon (Fig. 54), to which we shall return.

The design at the south end of the peristyle in the Menandro, a central niche flanked by two semicircular *exedrae*, is unique in Pompeian houses and immediately brings to mind (although not a perfect correspondence) the plan of the stage building of the large theater at Pompeii. Since this feature has been dated by Maiuri to a post-earthquake restoration,[30] it seems reasonable to see this *scaena frons* arrangement in connection with Fourth Style painting, which, in part, was an attempt to represent the three-dimensional stage with all its colourful display.[31] The increasingly obvious use of scene-painting for domestic decoration went hand in hand with new interest in stage mime during the Neronian age. Depicted on this irregular wall are the portrait of Menander, more theatrical masks, a scene of Diana

247

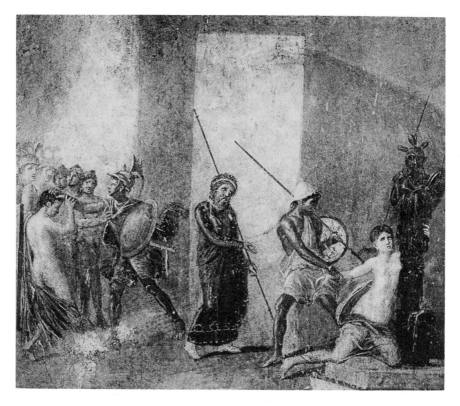

Figure 53 Wall-painting, rape of Cassandra with return of Helen to Menelaus, Casa del Menandro (I.10.4), room 4, Pompeii

and Acteon in apse 22[32] (Fig. 55) and, in apse 24, a pastoral landscape with a structure reminiscent of the stage.

The Amorini dorati (Fig. 56), the second house imbued with the air of the theater, was excavated at the turn of the century and takes its name from the unusual decoration of one of its cubicles off the north side of the peristyle: cupids (Amorini) engraved on gold foil. While the paintings of the *atrium* are mostly destroyed, the central scene from the north wall is preserved in the store rooms of the Superintendency of Pompeii (inv. 20559) and most likely shows a scene of Achilles and Polyxena, an amorous meeting near the gates of Troy.[33] In the *tablinum* we find the partial remains of a painting of Paris persuading Helen to depart for Troy.[34] This scene would clearly have attracted the immediate attention of any visitor's gaze. In *exedra* G we find a third style decoration that was repaired after the earthquake of 62 CE.[35] There are three central panels. Thetis waits in the workshop of Hephaestus on the north wall. Jason stands in front of Pelius while the Peliadi prepare sacrifice on the east wall. Finally, on the south

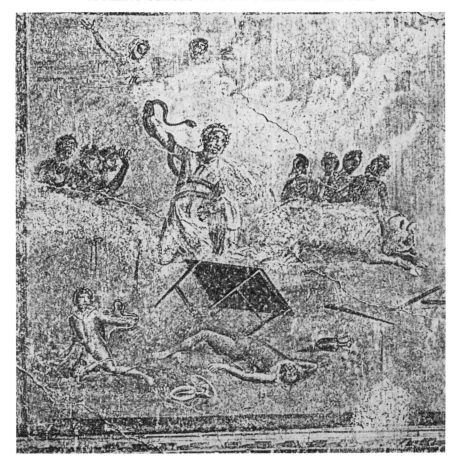

Figure 54 Wall-painting, death of Laocoon, Casa del Menandro (I.10.4), room 4, Pompeii

wall, Agamemnon sits on a throne with Briseis on the left and Achilles on the right with his arms resting on Agamemnon's throne (Fig. 57).[36]

At the west end of the peristyle there is a stage-like design, a raised *pulpitum* (Fig. 58). A magnificent collection of marble masks in relief and in the round was discovered in the garden and inserted in the peristyle's walls. Numerous *oscilla* with images reflecting the stage were suspended between the columns of the peristyle. A painted Isiac shrine sits in the southeast corner of the peristyle.

The tastes represented in Trimalchio's house and the physical remains in the Menandro and in the Amorini dorati document that Homeric scenes were popular painted fare in this period. Since Nero himself composed an epic *Iliupersis*,[37] it is quite reasonable to see these panel paintings with

249

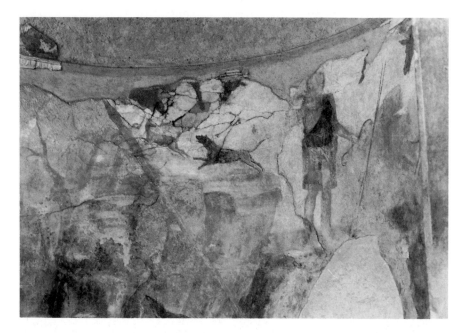

Figure 55 Wall-painting, Actaeon, Casa del Menandro (I.10.4), apse 22 in back wall of peristyle, Pompeii

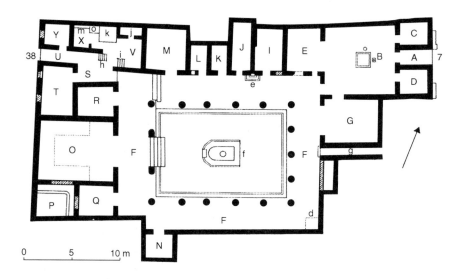

Figure 56 Plan, Casa degli Amorini dorati (VI.16.7.38), Pompeii

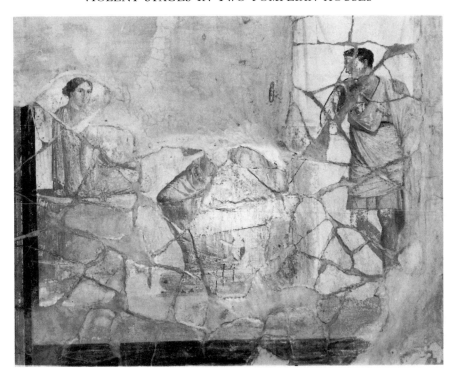

Figure 57 Wall-painting, Agamemnon with Achilles and Briseis, Casa degli Amorini
dorati (VI.16.7.38), *exedra* G, Pompeii

Homeric themes as a reflection of imperial taste, perhaps even a pictor-
ialization of the emperor's own verses. Since there is no evidence to
connect these particular panels with Hellenistic copies, they may possibly
be Roman creations commissioned explicitly to illustrate Nero's poem. The
painting of Laocoon and his sons in the Menandro may have a possible
artistic connection with the sculptural group of Laocoon and his sons from
Rome.[38] Despite the obvious differences (Laocoon is dressed in priestly
robes in the painting; his expression is far less agonized; one son is quite
dead; a sacrificial bull already bloodied by the axe of the *victimarius* lies
behind the main scene; a bronze table for the sacred instruments is tumbled
over in the center of the painting; various figures watch and gesticulate in
the background in the manner of an audience), the triangular arrangement
of the three main figures in the two representations and the almost identical
poses of Laocoon and of the son to the viewer's left (Fig. 54) suggest that
the artist of this painting may at least have been aware of the group in
Rome. A specific piece of imperial art may be echoed here in private house
decoration.

Some features of the decoration from these two houses (Trojan themes

251

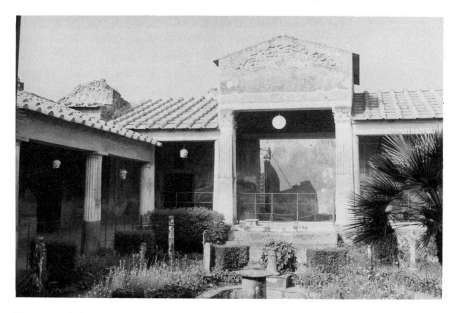

Figure 58 Pulpitum arrangement, Casa degli Amorini dorati (VI.16.7.38), west side of peristyle, Pompeii

related to Aeneas, Venus and Amor or Cupid, in particular) may be more than echoes of Imperial taste. They may reflect a type of state-sponsored Julio-Claudian symbolism. The Caesars traced their ancestry, after all, back to Aeneas and his mother Venus.[39]

The decorative details in the Menandro and in the Amorini dorati, then, were meant to be seen by visitors and clients. In addition, these decorations were meant to send subtle and not-so-subtle messages about the *patronus*. The *pulpitum* in the Amorini dorati was probably used for lavish entertainments at dinner – readings, songs, small stage shows. The delicate and rich decoration in the peristyle garden – reliefs with the theatrical mask as the dominating motif set in the walls of the peristyle, herms, statuettes, low rectangular pilasters carrying double-sided theatrical masks,[40] and masks and carved *oscilla*,[41] which were suspended between the columns of the peristyle – was intended to impress. The painted Isiac shrine[42] adorning the peristyle's south-east corner must have suggested the eclectic spirit of the owner and his sympathies with oriental religions.

POPPAEA, THE *GENS POPPAEA* OF POMPEII, AND HOUSE OWNERSHIP

As noted above, there is a reputed connection between the imperial family (Nero and his second wife Poppaea Sabina)[43] and the *gens Poppaea*[44] of

252

Pompeii. While the connection cannot be established beyond all doubt, both Poppaei Sabini and Ollii, the family name of Poppaea's father, are attested at Pompeii.[45] Ever since A. W. Van Buren's article on "Pompeii–Nero–Poppaea" in 1953, the tie has gone practically undisputed.[46] It has even been suggested (though only on the strength of Van Buren's argument) that Poppaea herself, given the supposed family tie in Pompeii, influenced Nero to rescind the Imperial decree of 59 CE, which closed the amphitheater for ten years.[47]

There was a *gens Poppaea* at Pompeii, and there is evidence that associates it with ownership of various Pompeian properties, however tenuously. Della Corte and Maiuri[48] recognized four houses as belonging to some member of this *gens*: the Amorini dorati, associated with Cn. Poppaeus Habitus on the basis of a seal ring (*anello*);[49] the Menandro, associated with Quintus Poppaeus on the basis of an inscription on a silver ring (*anello d'argento*) and a bronze seal (*sigillo in bronzo*);[50] VI.16.36, a small dwelling or shop associated with Potitus Poppaeus Sabinus on the basis of a seal (*sugello*);[51] and finally VI.16.38, a small commercial establishment associated with C. Poppaeus Firmus on the basis of an inscription on an amphora found in the house.[52]

Quite likely the family of the Empress Poppaea Sabina originally came from Pompeii.[53] Possibly the Menandro and Amorini dorati belonged to members of her own *gens*. Certainly the Poppaei of Pompeii were prominent citizens, well established both in the political[54] and in the economic[55] life of the town. Also, it would not be inconsistent for such aristocrats to own properties such as the Menandro and Amorini dorati. Nero and Poppaea were apparently very popular at Pompeii[56] (though there is no need to explain this by way of Poppaea's "local ties"). Furthermore, since many radical transformations in the architectural design and in the interior decorations of the Menandro and Amorini dorati can be dated to the Neronian age,[57] study of the possible influence of Julio-Claudian taste at Pompeii finds a good beginning in these two houses and is well supported by them.

Even if the owners of the Casa del Menandro and the Casa degli Amorini dorati were not directly related to the Empress Poppaea, the Neronian interior redecoration of their houses might have been expressly designed to foster that fictive impression in the eyes of visitors. Perhaps the graffiti written on the front walls of the Amorini dorati, which proclaim, "Hail Nero!" and "Welcome, Poppaea!," were intended to impress clients and visitors with the prospect of the Imperial couple coming to pay a call, even if they never actually did.

So far, the evidence of these two Pompeian houses suggests a clear aristocratic response to the general cultural agenda of the first century CE with its emphasis on the artistic and literary interests of the imperial court, the popularity of the theater, and the use of private residences as

"stages" for the performance of the identity of their owners. Although no clear-cut cause and effect relationship can be established, an apparent "trickle-down" effect from the world of the imperial court to that of some inhabitants of Pompeii can be detected. The Pompeian *dominus* "stages" himself in his house in emulation of the emperor's own masterful staging strategies, and his aesthetic choices are often patterned after those of the emperor. The archaeological record authenticates numerous details of this process of transmission and reception from the Imperial and public sphere to the aristocratic private sphere.

A NEW WAY OF SEEING HOUSE DECOR AT POMPEII

The mythological wall decorations in the "public" rooms in these two houses of the *gens Poppaea* not only reflect the interest in contemporary theater and Nero's taste, but they transcend the temporal situation to become "theaters of identity" where power is enacted and reinforced both by the visual program and by the gendered spatial layout. As I have shown, an iconography combining eroticism (cf. the rape of Cassandra in the Menandro – Fig. 53), violence (again, Cassandra, but also Laocoon and Acteon in the Menandro – Figs 54, 55), domination, vulnerability, power, and control frequently confronts the viewer (Helen persuaded by Paris in *tablinum* E, Achilles before Agamemnon in Fig. 57, Thetis working on behalf of her son Achilles on the north wall of *exedra* G, etc., in the Amorini dorati). What messages, if any, did these paintings convey to the ancient audience? Were the messages the same for males and females?

As D. Fredrick shows, given the strongly erotic and violent content of this mythological repertoire, feminist film theory offers a fresh approach, a new way to view the paintings in these houses, especially those featuring the nude female body or the bodies of young men who are oppressed or about to be oppressed. Laura Mulvey argues that male viewers obtain pleasure from many films because the narrative presentation actually protects them from any possible feelings of inferiority in their power and status. She labels a man's fear of such inferiority as "castration," because power and status can be read on to the anatomical difference between the sexes.[58] Cinema, Mulvey asserts, allows the (male) viewer two ways of enjoying his power, of avoiding his "castration," of carefully protecting his own power and status while viewing the film. In the first way, the viewer can become fetishistic and fix his eyes on beautifully exaggerated female body parts displayed in the film (for example, breasts, buttocks, long hair), parts that "split up" the woman in the narrative, break her up into idealized pieces, destroy her wholeness.[59] Thus, the viewer becomes ever more powerful than the "parts" he admires on the screen. Mulvey observes that in cinema, women are often "cut up," as it were, into pretty body parts, and this display constantly disavows gender equality, since the parts

appear only as idealized fragments of a whole. The (male) viewer thereby escapes from the "danger" of confronting the full complexity of woman, for she would certainly threaten his own power and status if she were a whole person.

The second way the male viewer protects his own power and status is by becoming a voyeur as he watches the film. As a voyeur he treats the sexual differences displayed in the film, by women in particular, as a guilty offence. In this way the viewer watches the film to see if the woman will be punished or forgiven, and the plot moves towards one or the other end.

Both of these avenues of (male) escape can be illustrated in the painted scenes of the Menandro and the Amorini dorati. Focusing on the scene of rape of Cassandra in the Menandro (Fig. 53) makes this clear. The viewer's attention is immediately drawn to Cassandra – her nude upper torso is very eye-catching. She is also positioned in the extreme foreground of the scene, despite the fact that she is on the far right of the scene.

While this particular scene is an awkward melodrama, it shows a passive woman, semi-nude, in isolation from other figures, her vulnerability and imminent violation openly displayed. She extends an arm in self-defence, but she is essentially immobile and powerless. Ajax (or Odysseus?)[60] gazes longingly at her body and begins to pull her from the supposedly protective *Palladium*. Members of the external audience also focus on her naked torso and "enjoy" her female youth and beauty, or can "move the plot forward" and ponder, with sadistic pleasure, what the outcome of the violence will be. As the male viewer looks at her, then, he actually becomes involved in her rape in this way.

King Priam, Cassandra's father, who punctuates the center of the scene, shows his age by his stooped demeanor and indicates his worry as his downcast eyes glance frantically in the direction of his daughter. The powerless old man extends his right arm as a futile gesture towards Cassandra. At this point the viewer might realize that there is more to the scene. Behind Priam (to the viewer's left) Menelaus is manhandling Helen, grabbing her hair to pull her into submission at last. The Trojan War is over. The city has fallen. Menelaus first arrives on the scene with murder on his mind, and then is overcome by Helen's beauty once again and decides to reclaim her. Helen's mostly nude body is turned away from the viewer, but her shapely buttocks and smooth back capture the viewer's gaze as much as did Cassandra's front side. Cassandra will soon be violated by Ajax. Helen will survive the angry outburst of Menelaus depicted here only to be returned home to serve him in his bed. Mulvey's formula for fetishism and for voyeurism is well served by this scene. A crowd of defeated Trojan men watch all of this from the extreme background of the scene (behind Helen and Menelaus to the viewer's left). If they wish, they too can "enjoy" the front side of Helen's beauty denied to the outside viewer.

In the remaining two scenes in room 4 (death of Laocoon, Fig. 54, and

Cassandra before the Trojan Horse)[61] Mulvey's formula continues to hold. Both paintings have internal audiences which view the tragic scenes from behind the action. The nudity of Laocoon's sons (one already dead and sprawled in the foreground of the scene and the other attempting a fruitless escape) underscores their utter helplessness. Laocoon gazes off to the viewer's right – as if the spectators in the background might bring aid. The story would be well known to the spectators visiting the house. The innocent priest will die for his insubordination, and so too his sons.

If a viewer were "reading" these three interconnected narrative scenes in order, the scene of Cassandra before the Trojan Horse would come first. Her futile attempt to warn the hapless Trojans crowding around her (especially to the viewer's left) about the death and destruction hidden in the Trojan Horse, which stands before her, foreshadows her future power-lessness at the hands of Ajax (Fig. 53). In other words, she is already defeated in this "scene one." Even here the viewer can "fast forward" in his imagination to Cassandra's bitter and violent undoing in the next scene shown on the wall.

Another selection from the Casa del Menandro that demonstrates Mulvey's formula is the scene in apsed niche 22 (Fig. 55). Acteon, who stands in the center of the wall, will soon lose his life to the controlling powers of Artemis on account of his accidental gaze on the goddess's nude beauty. His closest companions, his hunting dogs, run wild behind him in the scene. Soon they will attack and destroy his innocence and youthful curiosity once and for all. Acteon will not escape. He will lose his power, his status, and his life in a very few moments. The male viewer can see in the fate of Acteon the very "castration" which Mulvey argues that all men fear.

As E. Leach has shown,[62] the myth of Acteon became especially popular in Roman painting after Ovid, and its literary history shows how remark-ably flexible it could be for individual interpretations. So too on the Roman wall. A wide variety of "moments" from the myth were popular. Quite likely, each one served the particular taste and desires of individual house owners.

Two scenes from the Amorini dorati return to the somewhat sadistic message of female dependence on the male inherent in many of the scenes discussed here. Returning to the panel on the south wall of *exedra* G, we see that Achilles has had to concede to the power of Agamemnon and give up his beloved concubine, Briseis (Fig. 57). Agamemnon's presence with its implicit power dominate the composition. Briseis, to the viewer's left, while clothed, is represented as the passive, suffering woman. While there is no doubt that her violation is imminent, the spectator has ample time to fantasize her tragedy while taking in this scene.

The painting in the *tablinum*, which shows Paris persuading Helen to depart for Troy,[63] while damaged, also conveys the sense of the female

passivity, beauty to be controlled and manipulated for the larger purposes of males. The viewer is immediately drawn to the voluptuous form of Helen (on the right in the scene). She is clothed in garments colored by soft pastels and looks to the left of the scene where Paris is seated in brilliant oriental splendor. Behind him is probably the figure of Aphrodite, gently encouraging him to move along with the seduction, to invite Helen to join him on his ship, to persuade her to sail with him to Troy. A nude figure of Eros stands in the center of the scene. He gazes in the direction of Helen, encouraging the viewer to gaze along with him. He seems eager to get beyond this moment of her hesitation – for beyond it lies a truly erotic tale. Paris will have his Helen. The viewer participates in desiring Helen's capitulation.

In these two houses alone many other subjects suited for voyeurism and fetishism could be discussed (cf. e.g. Dirce in the Menandro, among others). Fredrick's use of the film theory of Mulvey for "seeing" the Ariadne paintings from the Casa dei Vettii and the Casa della Ara Maxima is the "original seed" for the "new growth" of this application here.[64] As Fredrick notes, the erotic object in Roman wall-painting is not always female. Narcissus (cf. Casa degli Amorini dorati, room T), Hylas (in particular in the Sarno Bath complex),[65] and even the special case of Hermaphroditos[66] are all also popular. In the case of Acteon discussed above, a male is clearly the victim of sexual violence. His symbolic "castration," if not displayed, can be imagined in the scenes which are yet to be painted (in the viewer's mind or by an artist) in order to continue the narrative.

As a spectator of these scenes, the viewer sees not just anatomical differences between men and women, but social difference as well. The men (or gods) who control the women or men of suffering possess more than the penis. They wield the phallus, the ultimate symbol of the male Roman social order. The house owners who commissioned such scenes for their own domestic stages thereby created a painted script with subtle, and not so subtle, messages of control easily legible to visitors and members of their own households. Such mythological images strongly suggest that an inherent "language of power" is painted symbolically in these houses, mainly for the pleasure of male viewers presumably, which emphasizes anew the authority of the *dominus*. Distinctive gender differences are depicted in a visual "language of power" for the pleasure and use of the *dominus* in these houses.[67]

Interestingly, Poppaea met a terrifyingly violent death at the hands of Nero (kicked in the stomach when she was seven months pregnant) "at home" in the imperial palace. Nero's imperial marriage to the beautiful Poppaea had its own "theatrical climax," played out against the backdrop of his own domestic stage. Clearly, violent and erotic stages in these houses were an aristocratic response to an entire cultural milieu.

NOTES

1 Some of the ideas here were first presented at the annual meetings of the AIA–APA in San Francisco in 1990 under the title "Theatrical Tastes in Two Pompeian Houses: the Staging of Owners and Emperors." For an abstract see: *American Journal of Archaeology*, April 1991, vol. 95, p. 305.

My husband, S. E. Ostrow, deserves special thanks for tirelessly travelling with me, both physically and mentally, to first-century Pompeii during the course of my work. S. Brown, C. L. Lyons, and A. E. Haeckl generously read and critiqued the manuscript, and offered much invaluable advice. While space does not permit me to name all of the other friends, colleagues, and teachers who have influenced my thinking about Pompeii over the years, the following offered especially helpful comments, suggestions, and corrections: Bettina Bergmann, G. Cerulli Irelli, B. Conticello, S. De Caro, J. D'Arms, J. Franklin, E. Gazda, N. Horsfall, N. Kampen, E. Leach, R. Ling, M. Marvin, C. Walker. I am, of course, solely responsible for errors of fact or judgement that remain. I use the following abbreviations:

Bieber: M. Bieber, *The History of the Greek and Roman Theater*, Princeton, Princeton University Press, 1961.

Boëthius and W-P: A. Boëthius and J. B. Ward-Perkins, *Etruscan and Roman Architecture*, Harmondsworth, Penguin Books Ltd, 1970.

Castrén, *Ordo*: P. Castrén, *Ordo Populusque Pompeianus: Polity and Society in Roman Pompeii*, Rome, Acta Instituti Romani Finlandiae, vol. viii, 1975.

D'Arms, *RBN*: J. H. D'Arms, *Romans on the Bay of Naples*, Cambridge, Mass., Harvard University Press, 1970.

De Franciscis, *NeueF*: A. De Franciscis, "La Villa Romana di Oplontis," *Neue Forschungen in Pompeji und den anderen vom Vesuvausbruch 79 n. Chr. verschütteten Städten*, Recklinghausen, Bongers, 1975.

Della Corte, *CeA* 3: M. Della Corte, *Case ed abitanti di Pompei* 3, Naples, Faustino Fiorentino, 1965.

A. and M. de Vos, *Laterza Pompei*: A. and M. de Vos, *Guide archeologiche Laterza: Pompei, Ercolano, Stabia*, Rome, Gius. Laterza and Figli, 1982.

Étienne, *La Vie*: R. Étienne, *La vie quotidienne à Pompéi*, Paris, Hachette, 1966.

Grant, *Nero*: M. Grant, *Nero: Emperor in Revolt*, London, Weidenfeld and Nicolson, 1970.

Hanson, *RTT*: J. A. Hanson, *Roman Theater-Temples*, Princeton, Princeton University Press, 1959.

La Rocca *Guida*: E. La Rocca and A. and M. de Vos *Guida archeologica di Pompei*, Verona, Arnoldo Mondadori, 1976.

Maiuri, *Menandro*: A. Maiuri, *La Casa del Menandro e il suo tesoro di argenteria*, Rome, Libreria dello Stato, 1943.

Maiuri, *L'UF*: A. Maiuri, *L'ultima fase edilizia di Pompei*, Rome, Istituto di studi romani, 1942.

Maiuri, *MPI*: A. Maiuri, *Pompei*, Itinerari dei musei e monumenti d'Italia, no. 3, Rome, Libreria dello Stato, 1965.

Mau and Kelsey, 1907: A. Mau and F. Kelsey, *Pompeii: Life and Art*, New York, Macmillan Co., 1907.

Pompei Pitture e Mosaici II & V: I. Bragantini *et al.*, *Pompei pitture e mosaici*, Rome, Istituto della Enciclopedia Italiana, 1993.

Richardson, *Pompeii*: L. Richardson, *Pompeii: An Architectural History*, Baltimore, Johns Hopkins University Press, 1988.

Robertson, *Handbook*: D. S. Robertson, *A Handbook of Greek and Roman Architecture*, Cambridge, Cambridge University Press, 1959.

Sogliano, *NSc*, 1907: A. Sogliano, "Casa degli Amorini dorati, VI. 16. 7," *Notizie degli Scavi di Antichità*, 1907, pp. 549–93.

Wallace-Hadrill, *Houses and Society*: A. Wallace-Hadrill, *Houses and Society in Pompeii and Herculaneum*, Princeton, Princeton University Press, 1994.

Wallace-Hadrill, *PBSR*, 1988: A. Wallace-Hadrill, "The Social Structure of the Roman House," *Papers of the British School at Rome*, 1988, vol. 56, pp. 43–97.

Webster, *GTP*: T. B. L. Webster, *Greek Theater Production* 2, London, Methuen, 1970.

2 Wallace-Hadrill, *Houses and Society*, especially ch. 1, "Reading the Roman House," pp. 3–16 and ch. 2, "The Language of Public and Private," pp. 17–37, originally published as "The Social Structure of the Roman House," *Papers of the British School at Rome*, 1988, vol. 56, pp. 43–97.

3 Wallace-Hadrill, *PBSR*, 1988, pp. 43–97.

4 D. Fredrick was one of the original presenters in our 1993 APA panel, "Feminist Approaches to Classical Art and Archaeology." I am very grateful to him for showing me his paper before it was expanded and published: D. Fredrick, "Beyond the *Atrium* to Ariadne: Erotic Painting and Visual Pleasure in the Roman House," *Classical Antiquity*, 1995, vol. 14(2), pp. 266–89. His work provided much inspiration for the concluding section of this chapter. While I shall focus here on the work of L. Mulvey, "Visual Pleasure and Narrative Cinema," *Screen*, 1975, vol. 16 (3), pp. 6–18 (reprinted in L. Mulvey, *Visual and Other Pleasures*, Bloomington, Indiana University Press, 1989, pp. 14–26) and L. Mulvey, "Afterthoughts on 'Visual Pleasure and Narrative Cinema' Inspired by *Duel in the Sun*," in T. Bennett (ed.), *Popular Fiction, Technology, Ideology, Production, Reading*, London, Routledge, 1990, pp. 139–51, several other important studies should be mentioned from the realm of feminist film theory: M. Doane, *The Desire to Desire: The Woman's Film of the 1940s*, Bloomington, Indiana University Press, 1987; M. Doane, "The Voice in the Cinema: The Articulation of Body and Space," *Yale French Studies*, 1980, vol. 60, pp. 33–50; and K. Silverman, *The Acoustic Mirror: The Female Voice in Psychoanalysis and Cinema*, Bloomington, Indiana University Press, 1988.

5 A. Maiuri, *Roman Painting*, New York, Skira, 1953, especially pp. 91ff.; M. Borda, *La pittura romana*, Milano, Società Editrice Libraria, 1958, pp. 76–90; G. Cerulli Irelli, A. Masanori, S. De Caro *et al.*, *Pompejanische Wandmalerei*, Stuttgart, Belser, 1990, *passim*; B. Conticello, *Riscoprire Pompei. Rediscovering Pompeii Exhibition*, New York, IBM-Italia and Rome, "L'Erma" di Bretschneider, 1990; and R. Ling, *Roman Painting and Mosaic*, New York, Cambridge University Press, 1991, *passim* and notes provide the best overviews. E. Leach, "Some Recent Work in Roman Wall-Painting," *Journal of Roman Archaeology*, 1990, vol. 3, pp. 255–61, summarizes much recent work. W. Archer, "The Paintings in the *Alae* of the Casa dei Vettii in Pompeii," *American Journal of Archaeology*, 1990, vol. 94, pp. 95–123; B. Bergmann, "The Roman House as Memory Theater: The House of the Tragic Poet in Pompeii," *Art Bulletin*, 1994, vol. 76, pp. 225–56; and S. Cerutti and L. Richardson, "Vitruvius on Stage Architecture and Some Recently Discovered *Scaenae Frons* Decorations," *Journal of the Society of Architectural Historians*, 1989, vol. 48, pp. 172–9, are useful for particular questions concerning Fourth Style. Cf. *infra*, n. 25 for the work of A. M. G. Little.

6 Suetonius, *de vita Caesarum* (*Nero*, bk VI). Of course, Suetonius has been attacked as a purveyor of fantasy and scandal for a long time – and there usually is no method of ascertaining any particular item he records. His report is nevertheless

ANN OLGA KOLOSKI-OSTROW

compelling. See A. Wallace-Hadrill, *Suetonius: The Scholar and his Caesars*, New Haven, Yale University Press, 1983, for a thorough account of Suetonius' treatment of Nero. Grant, *Nero*, *passim*, is a useful general study.

7 Suetonius, *Nero* 7, 10–13, 20–5, 30, 51.

8 Nero was in Naples in the following years: 64 CE, Tacitus, *Ann.* 15.33.2; 65 CE, Tacitus, *Ann.* 16.10, 4-5; 66 CE, Cass. Dio 62. 2.3–3.2; 68 CE, Suetonius, *Nero* 40. 4, for an extended visit. During Nero's Neapolitan performance of 64 CE enthusiasm ran so high that despite the interruption caused by an earthquake, which destroyed the theater, the engagement was not cancelled. Cf. Suetonius, *Nero* 20.

9 Suetonius, *Nero* 30–1, 42, 51.

10 Suetonius, *Nero* 7, 22, 38, 39, 42, 47.

11 Cf. D. Robin, "Film Theory and the Gendered Voice in Seneca", in N. S. Rabinowitz and A. Richlin (eds), *Feminist Theory and the Classics*, London, Routledge, 1993, p. 107 and n. 12, for the arguments in the debate about performance versus recitation.

12 Tacitus, *Ann.* 14.7, where he is clearly implicated in Nero's matricide, for example.

13 Suetonius, *Nero* 21. At least Orestes and Oedipus, for example.

14 Robin, *supra*, n. 11, pp. 106ff., details many examples of Nero's life which are paralleled in the events reported in the *Annals*.

15 J. P. Sullivan, *Literature and Politics in the Age of Nero*, Cornell, Cornell University Press, 1985, pp. 19ff. The age of Nero is a particularly fruitful period for the study of the interrelation of these cultural forces because of the mass of literature it produced and the close documentation of the pressures exerted on individual writers.

16 Wallace-Hadrill, *Houses and Society*, 3, and earlier, Wallace-Hadrill, *Papers of the British School at Rome*, 1988, pp. 43ff.

17 See N. Horsfall, "'The Uses of Literacy' and the *Cena Trimalchionis*: I," *Greece and Rome*, April 1989, vol. 36.1, pp. 74–89, and "II," ibid., Oct. 1989, vol. 36.2, pp. 194–209. This study (supported by the Pompeian evidence, other literary texts, and epigraphic material) has made much progress towards recreating the cultural concerns and mental preoccupations of traditonal Roman aristocratic society in the first century CE.

18 Cf., e.g., O. Elia, "Rappresentazione di un pantomino nella pittura pompeiana," *Gli archeologi italiani in onore di A. Maiuri*, Pompei, 1962, pp. 167–80; Borda, *La pittura romana*, pp. 76–90, on the Fourth Style at Pompeii; L. Curtius, "Orest und Iphigenie in Tauris," *Mitteilungen des Deutschen Archäologischen Instituts, Römische Abteilung*, 1934, vol. 49, p. 245; E. Löwy, "Iphigenie in Taurien," *Jahrbuch des Deutschen Archäologischen Instituts*, 1929, vol. 44, pp. 86–103; Maiuri, *Roman Painting*, pp. 91ff., on the theatre in painting; P. H. von Blanckenhagen, "Daedalus and Icarus on Pompeian Walls," *Mitteilungen des Deutschen Archäologischen Instituts, Römische Abteilung*, 1968, vol. 75, pp. 106–43.

19 Robin, *supra*, n. 11, p. 107.

20 For the evidence on drama in Italy in its earliest phases, which comes largely from depictions on vases, see A. D. Trendall, "Phlyax Vases", *Bulletin*, 1957, suppl. 8, London, *passim* for a complete discussion. Other works by Trendall which are extremely helpful for the study of drama from vase-painting include *Paestan Pottery*, London, British School at Rome, 1936; *South Italian Vase-Painting*, London, British Museum, 1966; and *The Red-Figured Vases of Lucania, Campania and Sicily*, Oxford, Clarendon Press, 1967. Cf. Bieber, pp. 129–46 and figs 489–539 for the *phlyax* play. Also see T. B. L. Webster, "Monuments Illustrating

Tragedy and Satyr Plays," 2nd ed., *Bulletin*, 1967, suppl. 20, London; "Monuments Illustrating Old and Middle Comedy," ibid., 1969, suppl. 23; and "Monuments Illustrating New Comedy," ibid., 1969, suppl. 24, with their fine plates. Also, A. D. Trendall and T. B. L. Webster, *Illustrations of Greek Drama*, London, Phaidon, 1971. Cf. Horace, *Sat.*1.5. 51–70, for an account of how two Campanian buffoons indulged in a highly spirited sparring-match.

21 Webster, *GTP*, chs 1–6, offers a very good series of essays on Greek versus Roman drama, including discussion of the theater, scenery, stage machinery, and costumes in Athens, Sicily, mainland Italy, Asia, and Africa. See also W. Beare, *The Roman Stage: A Short History of Latin Drama in the Time of the Republic*, New York, Barnes and Noble, 1963, and more recently, S. Bartsch, *Actors in the Audience: Theatricality and Doublespeak from Nero to Hadrian*, Cambridge, Mass., Harvard University Press, 1994.

22 See M. Lyttelton, *Baroque Architecture in Classical Antiquity*, London, Thames and Hudson, 1974, ch. 2, "Hellenistic Baroque Architecture Illustrated in Pompeian Frescoes;" E. Pernice, *Die hellenistische Kunst in Pompeji – Pavimente und figürliche Mosaiken*, Berlin, Walter de Gruyter and Co., 1938, pl. 70 (mosaic with three women in play); pl. 71 (mosaic of street dancers); pls 72, 73, and 74 (mosaics of masks and actors of Hellenistic origin); and Boëthius and W-P, pp. 115–80, for hellenized Rome.

23 The architectural history of the Pompeian theater and the *odeon* have yet to be fully studied. On this subject see Mau and Kelsey, 1907, pp. 141–52, for the large theater, and pp. 153–6 for the *odeon*; R. C. Carrington, "Notes on the Building Materials of Pompeii," *Journal of Roman Studies*, 1933, vol. 23, pp. 125–38; R. C. Carrington, *Pompeii*, Oxford, Oxford University Press, 1936, pp. 62ff.; E. Fiechter, *Die baugeschichtliche Entwicklung des antiken Theaters*, Munich, Beck, 1914, p. 78 and p. 83, where he argues that the small theater at Pompeii supplies the key to the character of Roman theatrical architecture. He supposes that the tradition of rectangular wooden theaters with straight seats parallel to the stage lies behind the *odeon* at Pompeii. Cf. Vitruvius V.5.7; Maiuri, *MPI*, pp. 27–30; Bieber, pp. 170–7; Hanson, *RTT*, pp. 43–55; A. G. McKay, *Naples and Coastal Campania, Ancient Campania*, Hamilton, Ontario, Vergilian Society of America, 1972, vol. II, pp. 115–18; Boëthius and W-P, pp. 165–75; La Rocca, *Guida*, pp. 146–58. For peculiarities of the Roman theatre in general, see Robertson, *Handbook*, pp. 271–83. For the organization of the Roman theater, the stage and actor's house in general, see Beare, *supra*, n. 21, pp. 164–83. More recently, Richardson, *Pompeii*, pp.75–87, surveys the architectural history of Pompeii's theater area.

24 Mau and Kelsey, 1907, p. 176, describe the herm of Gaius Norbanus Sorex, "a marble pillar with a bronze head, . . . an actor who played second parts." See also L. Richardson, "The Casa dei Dioscuri and its Painters," *Memoirs of the American Academy in Rome*, 1955, vol. 23, p. 93, for an important graffito alluding to the theater: CALOS PARIS ISSE SEPTENTRIO (*CIL* IV.1294). Cf. A. Sogliano, "L'attore Paride in Pompei," *Atti dell'Accademia Pontaniana*, 1908, vol. 38, n. 9. For other Paris graffiti, see *CIL* IV.148 from the exterior wall of the Casa di Pansa, VI.6.1; *CIL* IV.1085 from the east wall of the little colonnade of the scene building of the great theater; *CIL* IV.3866 from one of the tombs outside the Nucerian Gate. This actor, who could style himself Paris Augusti and who was so evidently an immense favorite with the people, could only be Lucius Domitius Paris, the great tragedian and favorite of the Emperor Nero. For evidence about pantomimists at Pompeii in the city's last years, see

J. Franklin, "Pantomimists at Pompeii: Actius Anicetus and His Troupe," *American Journal of Philology*, 1987, vol. 108, pp. 95–107.

25 For one of the best discussions of the backgound history to scene painting in the Greek world, its transmission to the Roman stage and finally to Roman house decoration, see A. M. G. Little, *Roman Perspective Painting and the Ancient Stage*, Kennebunk, Maine, Star Press, 1971, pp. 1–50, which summarizes earlier articles: Little, *American Journal of Archaeology*, 1945, vol. 49, pp. 134–42; and Little, *American Journal of Archaeology*, 1956, vol. 60, pp. 27–33. Cf. Archer, *supra*, n. 5.

26 For the Casa del Menandro (I.10.4), cf. *Pompei Pitture e Mosaici* II, pp. 240–397, and for the Casa degli Amorini dorati (VI.16.7), ibid. V, pp. 714–846, and F. Seiler, *Casa degli Amorini dorati* (VI.16.7.38), *Hauser in Pompeji*, Ed. 5, Munich, Hirmer, 1992.

27 Wallace-Hadrill, *Houses and Society*, p. 3. See also E. Leach, *The Rhetoric of Space*, Princeton, Princeton University Press, 1988, pp. 75–9.

28 Cf. Casa del Centenario, IX.8.6; Casa del Poeta tragico, VI.8.3; I.6.11; I. 2.6; Casa di P. Paquio Proculo, I.7.1.

29 Maiuri, *Menandro*, pp. 106–21, discusses the *exedra* with the portrait of Menander and other poets. He is shown unrolling the *volumen* of his comedies. The house is also known as the Casa del Tesoro delle Argenterie from the precious collections of silver found there in 1930.

30 Maiuri, *L'UF*, pp. 150ff. For a full report on the phases of various parts of the Casa del Menandro, see R. Ling, "The Insula of the Menander at Pompeii: Interim Report," *Antiquaries Journal*, 1983, vol. 63, pt 1, pp. 34–57.

31 This *scaena frons* backdrop could not actually have been used as a stage setting because of two obstructions: the columns of the peristyle itself and the partition, roughly three feet tall, filling the intercolumniations. See H. G. Beyen, "Das stilistische und chronologische Verhältnis der letzen drei pompejanischen Stile", *Antiquity and Survival*, 1948, vol. 11, pp. 349–64; H. G. Beyen, "The Workshops of the Fourth Style at Pompeii and Its Neighborhood," *Studia archaeologica*, Leiden, 1951, pp. 43–65; A. W. Byvanck, "La dernière periode de l'histoire de Pompeji," *Bulletin Antieke Bechaving*, 1953, vol. 28, pp. 24–7; A. M. G. Little, "Formation of a Roman Style in Wall Painting," *American Journal of Archaeology*, 1945, vol. 49, pp. 134–42; A. M. G. Little, "Roman Sourcebook for the Stage," *American Journal of Archaeology*, 1956, vol. 60, pp. 27–33; K. Schefold, "Der Vespasianische Stil in Pompeji," *Bulletin Antieke Bechaving*, 1949–51, pp. 24–6 and pp. 70–5. We cannot here trace the steps that lead from scene-painting to a domestic wall style, but this development was a major Roman achievement in pictorial representation, and the creative process from Second to Third to Fourth Style clearly borrowed more and more from the theatrical set.

32 Cf. E. Leach, "Metamorphoses of the Acteon Myth in Campanian Painting," *Mitteilungen des Deutschen Archäologischen Instituts, Römisches Abteilung*, 1981, vol. 88, pp. 307–27.

33 *Pompei Pitture e Mosaici* V, p. 725.

34 Ibid., p. 738.

35 Ibid., p. 781.

36 Ibid., pp. 784–5. This scene has been variously interpreted as Achilles, Briseis, and Patrocles; and the restoration of Briseis to Achilles by Agamemnon. I follow Bragantini *et al.*

37 *Supra*, n.10.

38 A. F. Stewart, "To Entertain an Emperor: Sperlonga, Laokoon and Tiberius at the Dinner-Table," *Journal of Roman Studies*, 1977, pp. 76–90, reminds us that

"the only direct link between the emperor Nero and the sculpture, the supposed find-spot of the latter in room 80 of the Domus Aurea, has long been known to be false." Nevertheless, despite the fact that the piece is still at the center of scholarly debate over its date, the purpose for which it was designed, and whether it is a Greek original, a Roman copy, or some mixture of the two, no one denies that it gained prominence within the realm of Julio-Claudian ownership.

39　La Rocca, *Guida*, p. 179: "If Troy had not fallen, there would be no Roman empire." Venus and Cupid, or Amor, were symbols of the Julio-Claudian line.

40　For full descriptions see Sogliano, *Notizie degli Scavi di Antichità*, 1907, pp. 558ff. and figs 8–13 and 18–22.

41　See Sogliano, *Notizie degli Scavi di Antichità*, 1907, pp. 584ff. and figs 14–15.

42　Sogliano, *Notizie degli Scavi di Antichità*, 1907, pp. 554ff., for discussion of this shrine with statues of Anubis, Harpocrates, Isis, Sarapis, and other anthropomorphic Egyptian deities.

43　R. Hanslik, "Poppaea Sabina," Pauly-Wissowa, *Real-Encyclopädie*, 1953, vol. 22, pp. 89–90, n. 4. See Tacitus, *Ann.* 13.45.1, where he states that Poppaea Sabina, who became Nero's second wife in 62 CE, *nomen avi materni sumpserat*. For Poppaea Sabina's Pompeian property see L. Arangio-Ruiz and G. Pugliese Carratelli, "Tabulae Herculanenses IV," *La Parola del Passato*, 1954, vol. 9, pp. 56–7 (cited by D'Arms, *RBN*, p. 97, n. 122). Castrén, *Ordo*, p. 209 (also citing L. Arangio-Ruiz and G. Pugliese Carratelli, pp. 55–6), notes that by 63 CE there were *figlinae Arrianae Poppaeae Augustae* in *ager Pompeianus*. Cf. *CIL* X, 1906: C. Poppaei Aug. l. Hermetis, apparently a freedman of Poppaea Sabina. His name appears on pieces of lead pipe discovered in the territory of Baiae near the Lucrine Lake.

44　D'Arms, *RBN*, p. 97, n. 122, and Della Corte, *CeA* 3, pp. 72–3, suggest that the particular Pompeian relative of the empress may have been C. Poppaeus Sabinus, consul 9 CE. This association, however, is fraught with uncertainties.

45　See Castrén, *Ordo*, p. 199, for *Ol(l)ii*. Castrén suggests that they too (as *Poppaei*) may have been colonists from Picenum.

46　A. W. Van Buren, "Pompeii–Nero–Poppaea," *Studies Presented to D. M. Robinson*, St Louis, Washington University Press, 1953, pp. 970–4. See especially p. 972: "The evidence for the *prominence* of *Poppaea's* family in the life of the city has been *ably assembled* and *interpreted* by Della Corte in connection with the four residences which are epigraphically attested as belonging to *Poppaei*; and the *cumulative force* of that evidence amounts to a *strong presumption* that the Empress herself was a well-known figure at Pompeii." The emphases are mine to highlight the unevenness of Van Buren's language. Van Buren does describe a distich, *graphio scriptum*, discovered in 1908 upon the stucco surface of a sepulchral monument outside the Vesuvian Gate at Pompeii which addresses one Sabina. For him there is no doubt in this too that the distich "celebrated the charms and the good fortune of the most beautiful . . . the most fortunate woman of the age, Poppaea Sabina, consort of the Emperor Nero." He says, "inclusion of her *nomen*, Poppaea, therefore was not essential." While the former may well be true, we must also appreciate the speculative nature of some of his argument. Van Buren notes that the graffito, *Sabina fel(l)as no(n) belle fac(i)s* (*CIL* IV.4185) from the peristyle of the Casa delle Nozze d'Argento, can be explained, if it is understood to have been executed "in the period when the marital relations of P. Sabina were in an equivocal state, and when any reference to questionable conduct on the part of a Sabina would have been liable to interpretation as referring to her."

47　Tacitus, *Ann.*14.17.4. See W. O. Moeller, "The Riot of A.D. 59 at Pompeii,"

Historia, 1970, vol. 19, pp. 84–95. Pompeii did attain colonial status during Nero's reign. Cf. *CIL* IV.3525 on which see D'Arms, *RBN*, p. 98, n. 126.

48 Della Corte, *CeA* 3, pp. 72–84, 293–9; Maiuri, *Menandro*, pp. 20–1; also Maiuri, *MPI*, p. 52, briefly on the Casa degli Amorini dorati, and ibid., p. 72, for Casa del Menandro. Cf. La Rocca, *Guida*, p. 175 and p. 282.

49 Della Corte, *CeA* 3, p. 77.

50 Maiuri, *Menandro*, p. 20 and Della Corte, *CeA* 3, p. 294.

51 Della Corte, *CeA* 3, p. 83.

52 *CIL* IV.5880, on which see Della Corte, *CeA* 3, p. 83.

53 De Franciscis, *NeueF*, pp. 15–16, suggested that the magnificent villa of Oplontis at modern Torre Annunziata, in the course of excavation since 1964, was also the property of the *gens Poppaea*, which he equated with the family of Poppaea Sabina. (His argument is based on the inscription, "SECVNDO POPPAEAE," painted on the neck of an amphora discovered at the villa.) By freely using the inscriptional evidence in the Casa degli Amorini dorati, Casa del Menandro, documentation of Poppaea's possible family connections with Pompeii, and the inscription on a wax tablet from Herculaneum ("IN POMPEIANO IN FIGLINIS ARRIANIS POPPAEAE AUG."), De Franciscis concluded that "la villa fosse in proprietà della *gens Poppaea*, almeno nel suo ultimo periodo, e che *Secundus* ne fosse un liberto o addirittura di *procurator*," Cf. La Rocca, *Guida*, pp. 346–7, who follows suit without question. See also A. De Franciscis, "La Villa Romana di Oplontis," *La Parola del Passato*, 1973, vol. 153, pp. 453–66, figs 1–8. It is beyond the scope of this paper to include the theatrical painting from the villa in this discussion.

54 Cf., e.g., *CIL* X.827 re *Q. Poppaeus, aed.* 39–40 CE.

55 See Castrén, *Ordo*, p. 209, for full references to *Poppaei* occurring in wax tablets (important evidence for commercial activity in Pompeii):

C. Poppaeus Ephebus	
Q. Poppaeus Felix	55 CE?
C. Poppaeus Fortis	57 CE
P. Poppaeus Narcissus	
Poppaea Prisci	61 CE
Q. Poppaeus Sorex	57 CE
Poppaea Triquinia ? (according to Castrén, wrongly read)	

56 A brief survey of the number of inscriptions naming *imperatores* and imperial family members painted in private houses (see *CIL* IV, pt 2, 767, Index IV) seems to confirm this:

Name	*Times occurring*
Augustus	15
Livia	1
Agrippa	1
Germanicus	2
Caligula	1
Claudius	4
Nero	37
Poppaea	11
Otho	1
Vespasian	1

It should be noted in passing that we are dealing with the last years of the city, and evidence is best preserved from these last years. Nevertheless, the results are interesting. Most of the inscriptions naming Nero and Poppaea are greet-

ings and notices of well-wishing. Cf. *CIL* IV.1190, "OMINIBUS NERO[N(IS) MUN]ERIBUS FELICITER;" *CIL* IV.3822, "PRO SALUTE NER[ONIS];" *CIL* IV.4814, "NERONI FEL.," etc. See also the following discussions of this evidence: D'Arms, *RBN*, p. 97; Van Buren, *supra*, n. 46, pp. 970–4; and Étienne, *La Vie*, pp. 120–1.

57 See Maiuri, *L'UF*, pp. 113–14, on VI.16.7: "Tutto il quartiere ad ovest del peristilio presenta negli stipiti e nei pilastri in vista, la tipica struttura dell'opera mixta in conci di tufo giallo e duplice filare di laterizi, con rivestimento a stucco di 4 stile tanto dal lato del portico, quanto dal lato dei due *oeci*" Ibid., pp. 150–2 on I.10.4: "La casa di Quinto Poppeo, o altrimenti detta del Menandro, deve la sua attuale mirabile conservazione agli ultimi lavori di restauro che vi si erano in gran parte compiuti e vi si venivano ancora eseguendo, fra l'anno del terremoto e l'anno dell'eruzione" See also Maiuri, *Menandro*, p. 24, concerning "radicali opere di restauro," and Sogliano, *Notizie degli Scavi di Antichità*, 1907, pp. 549ff.

58 Cf. S. Brown, *infra*, pp. 16–17, for a lucid summary of Mulvey's approach.

59 Cf. Fredrick, *supra* n. 4, pp. 269–70 where he makes an excellent argument for this. Cf. also J. Berger, *Ways of Seeing*, Harmondsworth, London, and New York, British Broadcasting Corporation and Penguin, 1972, pp. 46ff. I am grateful to S. Brown for suggesting this source.

60 *Pompei Pitture e Mosaici* II, p. 277.

61 Ibid., p. 281.

62 Leach, *supra*, n. 32.

63 *Pompei Pitture e Mosaici* V, p. 738.

64 Cf. Fredrick, *supra*, n. 4, p. 279. Recent investigations of spectatorship and voyeurism in Roman painting include J. R. Clarke, "Viewer and Voyeur in Neronian Painting," *American Journal of Archaeology*, 1995, vol. 99, p. 332; and M. J. Behen, "Who Watches the Watchmen? The Spectator's Role in Roman Painting", *American Journal of Archaeology*, 1995, vol. 99, p. 346.

65 A. O. Koloski-Ostrow, *The Sarno Bath Complex*, "L'Erma" di Bretschneider, Rome, 1990, p. 78. For full treatment of Hylas in Roman wall-painting, cf. R. Ling, "Hylas in Pompeian Art," *Mélanges de l'École Française de Rome*, 1979, vol. 91, pp. 773–816 and illustrations.

66 Cf. A. Ajootian, *supra*, pp. 220–42.

67 Several works have provided me with important background to questions of gender in Roman antiquity: J. Balsdon, *Roman Women: Their History and Habits*, New York, John Day Co., 1962; L. Bonfante, "Nudity as a Costume in Classical Art", *American Journal of Archaeology*, 1989, vol. 93, pp. 543–70; O. Brendel, "The Scope and Temperament in Erotic Art in the Greco-Roman World," in T. Bowie *et al.* (eds), *Studies in Erotic Art*, New York, Basic Books, 1970, pp. 3–107; A. Cameron and A. Kuhrt (eds), *Images of Women in Antiquity*, Detroit, Wayne State University Press, 1993; E. D'Ambra, *Private Lives, Imperial Virtues*, Princeton, Princeton University Press, 1993; E. D'Ambra, *Roman Art in Context: An Anthology*, Englewood Cliffs, Prentice Hall, 1993; S. Dixon, *The Roman Mother*, Norman, University of Oklahoma Press, 1988; H. Foley (ed.), *Reflections of Women in Antiquity*, New York, Gordon and Breach Science Publishers, 1981; M. Grant, *Eros in Pompeii*, New York, William Morrow and Co., Inc., 1975; C. Johns, *Sex or Symbol: Erotic Images of Greece and Rome*, London, British Museum Publications, 1982; N. Kampen, "Between Public and Private: Women as Historical Subjects in Roman Art," in S. B. Pomeroy (ed.), *Women's History and Ancient History*, Chapel Hill, University of North Carolina Press, 1991, pp. 218–48; N. Kampen, *Image and Status: Roman Working Women in Ostia*, Berlin,

Mann, 1981; N. Kampen, "Social Status and Gender in Roman Art: The Case of the Saleswoman," in N. Broude and M. D. Garrard (eds), *Feminism and Art History: Questioning the Litany*, New York, Harper and Row, 1982, pp. 63–77; E. Keuls, *The Reign of the Phallus: Sexual Politics in Ancient Athens*, New York, Harper and Row, 1985; D. Konstan and M. Nussbaum (eds), "Sexuality in Greek and Roman Society," Special issue of *Differences: A Journal of Feminist Cultural Studies*, 1990, vol. 2 (1); E. Leach, "Reading Signs of Status: Recent Books on Roman Art in the Domestic Sphere," *American Jornal of Archaeology*, 1992, vol. 96, pp. 551–7; S. B. Pomeroy (ed.), *Goddesses, Whores, Wives, and Slaves: Women in Classical Antiquity*, New York, Schocken Books, 1975; A. Richlin, *The Garden of Priapus: Sexuality and Aggression in Roman Humor*, New Haven, Yale University Press, 1983; A. Richlin (ed.), *Pornography and Representation in Greece and Rome*, New York, Oxford University Press, 1992; and R. Sennett, *Flesh and Stone: The Body and City in Western Civilization*, New York and London, W. W. Norton, 1994.

On the application of feminist theory to ancient art, works that have most influenced my thinking are: Berger, *supra*, n. 58; R. Betterton (ed.), *Looking On: Images of Femininity in the Visual Arts and Media*, New York, Pandora, 1987; N. Broude and M. D. Garrard (eds), *Feminism and Art History: Questioning the Litany*, New York, Harper and Row, 1982; K. Clark, *The Nude: A Study in Ideal Form*, New York, Pantheon Books, Mellon Lectures, National Gallery, 1956; B. Colomina (ed.), *Sexuality and Space*, Princeton, Princeton University Press, 1992; P. duBois, *Sowing the Body: Psychoanalysis and Ancient Representations of Women*, Chicago, University of Chicago Press, 1988; E. Englestad, "Images of Power and Contradiction: Feminist Theory and Post-Processual Archaeology," *Antiquity*, 1991, vol. 65, pp. 502–14; M. Haskell, *From Reverence to Rape: The Treatment of Women in the Movies*, New York, Holt, Rinehart, and Winston, 1974; T. Hess and L. Nochlin, *Woman as Sex Object: Studies in Erotic Art, 1730–1970*, *Art New Annual*, New York, vol. 38, 1982; S. Kappeler, *The Pornography of Representation*, Minneapolis, University of Minnesota Press, 1986; R. Kendall and G. Pollock (eds), *Dealing with Degas: Representations of Women and the Politics of Vision*, London, Pandora, 1992; L. Nochlin, *Women, Art, and Power and Other Essays*, New York, Harper and Row, 1988; N. Salomon, "The Art Historical Canon: Sins of Omission," in J. E. Hartman and E. Messer-Davidow (eds), *(En)gendering Knowledge: Feminists in Academe*, Knoxville, University of Tennessee Press, 1991, pp. 222–36; L. Talalay, "Body Imagery of the Ancient Aegean," *Archaeology*, 1991, vol. 44 (4), pp. 46–9; and S. Thurer, *The Myths of Motherhood: How Culture Reinvents the Good Mother*, Boston, Houghton Mifflin, 1994.

13

EPILOGUE
Gender and desire
Natalie Boymel Kampen

If any common point emerges from all of the papers in this volume, it is the *complexity* of the process by which women and men are or were inserted into a social order. Representation reveals this complexity on two levels: firstly, as it shows us the many ways of marking gender on or as body and thus visually constructing or reproducing social identities, and, secondly, as it forces us once more into humility before the problematic relationship of images and social practices. Granted that making images is one social practice among many; nevertheless, what the images tell us is how rarely they directly reflect institutions and behaviors. The enduring puzzle of the Parthenon's iconography (here discussed by John Younger, pp. 120–53), like the struggle to understand the meanings and functions of the Hermaphrodite statue (see here Aileen Ajootian's essay, pp. 220–42), points up the need for gender-conscious interpretation while, at the same time, making evident the resistance of the monument to any simple equation of image and social practice. The job of representation, if we can call it that, is to reconfigure the world; in the process it may help to challenge or to reproduce social arrangements in such way as to make institutions and practices seem completely natural, so inevitable and universal that they couldn't possibly need any help at all.

The anthology's papers demonstrate the participation of visual representation in social reproduction. They show us the many ways people found to give form to gender systems through the representation of individual men and women (and hermaphrodites) in distinctive bodies and clothing, with specific attributes and activities; further, they demonstrate the interconnection of gendered bodies with systems of rank and status as well as age and ethnicity; and, finally, they help us to see the way this very bodiliness could become a part of unconscious and conscious strategies for the maintenance or disruption of social order and power.

In thinking further about how images function in relation to social reproduction, I believe two concepts, *desire* and *desirability*, open some interesting paths. I do not mean to establish these two concepts as in any way necessarily embedded in ancient societies in the same ways that

267

they are in modern, to suggest that they are transhistorical in some untroubled way, or to propose that they are somehow pre-existent categories that I can happily use like Tupperware containers to collect all sorts of stuff without worrying about spoilage. Rather, what I have in mind is to take *desire* and *desirability* as modern terms and experiment with them in relation to ancient representations in order to find out where they may suggest a place for ever deeper and more carefully historicized work for the future.[1]

The two terms interest me because they allow for a reading of gendered bodies (and ethnically or racially specific and classed bodies and those coded by age) relationally. In other words, from the beginning of our use of these categories, bodies are always already understood as in relation because gender, for example, is as much "what one isn't" as "what one is." So, when we look at a tomb in which the men have weapons and the women have jewelry, we are seeing the manifestation of a gender system that thinks about categories in relation to one another and that enacts those categories through material relations, through material objects as participants and signs of relationships (here see especially the chapter by John Robb pp. 43–65). This means that the bodies under consideration are always in relation to other bodies, in the sense both of individual and of collective bodies (such as the body politic), always existing in fluid states of desirability as they are perceived by different viewers.[2]

I will *not* be giving attention here to two crucial issues that require work in the development of a discussion about desire, gender, and body: spatial context and historical change. Both issues are dealt with in deeply satisfying ways in the essay by the late John Winkler, "Phallos Politikos;" this can stand as a model for the kind of work I think classical archaeologists and art historians might want to pursue further.[3] Spatial context, where things are seen, placed, experienced, matters enormously, as Ann Olga Koloski-Ostrow's essay on Pompeian houses (pp. 243–66) reveals, and the role of archaeology in helping to clarify physical context is critically important (as the essays of Shelby Brown, John Robb, Joan Reilly, Aileen Ajootian, Larissa Bonfante, and others here indicate).[4] The discussion of changes over time, such as those offered by John Robb (pp. 43–65) or Aileen Ajootian (pp. 220–42), for example, requires a further inquiry into the ways we might theorize problems that arise from inadequate, lacunose, and unprovenienced evidence.[5]

A second motivation for putting gendered bodies ever more firmly in relation to others is that the process insists on the ability of those bodies to desire, to try to connect with or avoid a particular object (in the psychoanalytic sense of a human object as well as in the wider sense). The consequence is that we can begin to imagine the gender so often thought of by elite male writers of antiquity as passive, or at least as rarely capable of full self-determination, as desiring beings . . . women as agents. They

become more than objects of desire, and at the same time men themselves, the desirers of these men's narratives, can be seen in more complex ways as themselves objects of desire.

A place to start working through some of these ideas would, of course, be with Aphrodite/Venus.[6] Nanette Salomon, in her discussion of the Knidia (pp. 197–219), places useful emphasis on the status of the figure as work of art and as woman and on the way so many Roman texts support that reading. Clearly, to many male writers in Greek and Latin from the first and second centuries CE, Aphrodite had become a kind of prurient tourist joke, but one wonders still whether this was how Greek men and women of the fourth century BCE, and later, usually saw her as they came to her shrines and sanctuaries to worship, to make offerings, to plead for help, and to find in the goddess's power the hope of love and sexual desire.

One reading, through the lens of later appropriations of the figure, places in the foreground the socialization of women through an empathetic relation to the cult statue's body and pose. The statue rendered them time and again *as* body in a process comparable to the way that Christian art came often to use Eve. And the gesture of covering the genitals, the pose of the curving body, came to be read "inevitably" as about shame, about the weakness and flawed nature of *woman*. Revealing the way images can help to make women complicitous in their own diminution, this historical reading is extremely helpful because it allows us to see the very process of inserting women into gender systems at the psychic or somatic level as well as at the symbolic level.

This reading finds important confirmation in the essays of Beth Cohen on the female breast revealed as signifier of the relationship between the erotic and the violent (pp. 66–92), of Francine Viret Bernal on the representation of Clytemnestra as part of a construction of the impossibility of the woman in charge (pp. 93–107), and of Jane Snyder on the muting of Sappho in Attic vase-painting (pp. 108–19). One could also read Joan Reilly's essay on Attic "dolls" in a similar way; the votive figurines with and without arms and legs teach girls to desire a particular gendered body for their own and thus form a particular subjectivity for them (pp. 154–73). At the same time, her essay insists on the participation of women, mothers and grandmothers, aunts and priestesses, in the creation of that state of mind, that feminine embodied Subject. She paints a picture of agency within complicity that makes both terms seem far more complicated than they might otherwise, and she brings them into the larger frame of such later discussions as those about foot-binding or high fashion.[7]

Another reading, and one that must go along with the first, sees Aphrodite's power, her grandeur, her untamed sexual aggression as exhilarating, if not liberatory or exemplary.[8] Could we ever imagine women and men looking at the cult statue and reading something besides humiliation in the goddess's body? The goddess is, at that point, still a deity with all the power

and energy, all the radiance and uncontrollability, the status implies; does the pose of the Knidia tell us of social as well as artistic attempts to constrain that power precisely at the moment when power is being invoked, at the shrine and by the worshipper? Perhaps a reading of Beth Cohen's discussions of the exposed female breast (pp. 66–92) in conjunction with the essay by Larissa Bonfante (pp. 174–96) helps us see this question in a cross-cultural way. The power of the maternal breast, of the memory of plenitude and comfort, may well demand both erasure of that nursing breast and reconfiguration of it into a symptom of vulnerability in Greek culture if not in Italian. The figure of Venus may, likewise, keep some of its numinous force beneath the surface of the matron's portrait, may continue to signify the power of the goddess and notions of sensuality and plenitude even as the goddess Aphrodite is being trivialized in texts such as Lucian's.

Despite the lack of written testimony about women's beliefs or worship of Aphrodite in the Hellenistic period, can an imaginative leap take us to the point of recognizing that this goddess, full of power and glorious in her beauty, held enormous meaning for women? Their very lives depended on being cared for by men, men whom they had to hold by means sensual and procreative as well as legal and economic, and Aphrodite had the power to help them do so. Even though our evidence for Hellenistic beliefs is poor, there is Roman evidence to show that Roman matrons had families prepared to commission portraits using the divine body for its procreative and virtuous imagery. Perhaps, then, the possibility of sexual pleasure, the power to make someone fall in love, the sheer joy of the body emerging from water, could also be evoked for both Greek and Roman viewers along with the promise of health and children (see especially the discussion of the *kourotrophos* in Italy by Larissa Bonfante (pp. 174–96), in which she considers the impact of the nursing mother in relation to religious and social belief systems). Men might not be the only viewers of such images to have a range of responses in which desire and pleasure could play a part.[9]

But there are other directions these imaginings can take us, and they involve both images of men and women *and* male and female viewers. For example, a chain of questions could begin, thinking of Aileen Ajootian's discussion of the hermaphrodite (pp. 220–42) or Jane Snyder's of Sappho (pp. 108–19), by asking whose body is desirable and whose isn't, could wonder in what social, geographical, or temporal circumstances bodies might have such power, and what kinds of meanings the power might have and over or for whom.[10] The answers lead in many directions, but I offer just two examples: the desire of the ruled for the desirable ruler and the desire of women for the female body, the latter a corollary of the discussion about Aphrodite.

To begin with the ruler, I cite the work of Irene Winter on the meanings of the body of Naram-Sîn, radiant ruler of Agade, whose sexual potency and allure evoke his power and legitimacy in the military and political

realm.[11] Like the Egyptian god who speaks of conquering his enemies literally with his phallus,[12] Naram-Sîn is specifically described as potent and his manliness as a crucial component in rulership. He is desirable, in the sense that men and women allow him to rule them and believe in his power, and in the sense that he has the power of literal and metaphoric sexual domination, the power to penetrate. The nakedness of his enemies, and those represented on the victory imagery of other rulers in other cultures, not a nakedness as invulnerability or radiance but as their opposite, stands as confirmation of this power whose corollary is, I think, a sense of his erotic power.[13]

Here it's worth trying out a distinction between sexual and erotic power; if the first resides in the physical potency to penetrate and to sire children, the second might be said to occupy the space of a polymorphous desire for visual, sensual, and emotional pleasure along with the competing desires for protection and domination. This is a long way from a Freudian libido, but it includes the thrill we all experience (regardless of intellectual cynicism) in seeing a *very important person*. The thrill, if the VIP is imagined to be "beautiful," is partly visual and sensual as one imagines oneself either *in/occupying* the body of the VIP or engaged with it (and not merely sexually, since the embrace of the parent can carry a similar charge), and it can, of course, be both. It is, as well, the pleasure of contact with that which confers importance on oneself (the Brush-with-Greatness Syndrome?), the pleasure of association with power. And finally, it takes the form of that paradoxical emotional response in which one gladly accepts domination and control.[14] The process, thus, involves more than sex (but sex is always there somewhere as are other sensual responses), and so the term *erotic* is what I propose in trying to get at the complex emotional responses people may have to their rulers.

This imagery raises the question of who is looking; are not male and female desire and erotic response necessary participants in the game of domination? I am reminded of a passage in the Panegyric of Pliny the Younger, written about 100 CE, in which he has the women of Rome view the triumphant entry of the emperor Trajan and say that seeing him makes them wish to have children, for the world is now a good and safe place (22.3). Multiple displacements are going on here, as we see from the author's comments a few lines earlier about the handsome figure of the ruler.[15] Something about even Trajan can trigger thoughts of attractiveness, allure, and of procreation itself, and not just for women in a purely heterosexual direction but for men as well, since it is the author who describes the physical attractions of the ruler and who then maps his "desire" for the emperor onto the procreative women (Fig. 59: showing the now headless emperor at the left with female personifications, men, and children attending the distribution of largesse or institution of a program of benefaction for rural children).

271

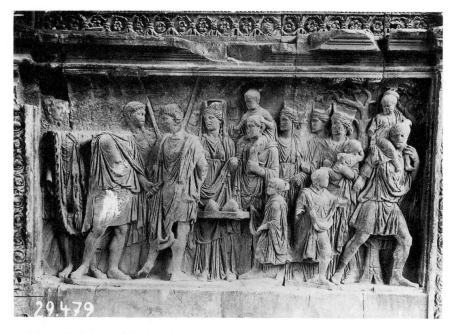

Figure 59 Panel relief, Arch of Trajan, Benevento. Early second century CE

This is not to say that these Roman men and women are feeling the same kind of desire for the emperor or that such desire is the same as that which the texts about the Akkadian ruler express. For desire itself is both contingent and relational in the sense that it takes shape only in relation to another and the shape it takes depends on the context in which it is occurring. So it might be that Pliny has the Roman women speak of their desire for children in relation to the sight of the emperor as a way of displacing both his own desire for the ruler, a desire having perhaps more to do with phallus as power than phallus as penis, and his desire for women to want to have children and thus strengthen the empire. A man views the male ruler; he desires to be like him and to be him; he articulates his desire by constructing the ruler as desirable in terms acceptable to his culture – here explicitly heterosexual and procreative, ruler as father (Fig. 60: with Trajan in the upper left surrounded by his troops before battle).

Homoerotic attraction between men is something we understand for a certain Greek moment, but we need to inquire into the possibility that it was a crucial factor in helping to make people willing to accept a ruler and that it functioned at the level of representation for political purposes in a far wider range of cultural moments in antiquity than fifth-century Athens. This is no easy task for the modern scholar distracted by the possibilities of imagining Calvin Coolidge in his long-johns or thinking of Bill Clinton's

272

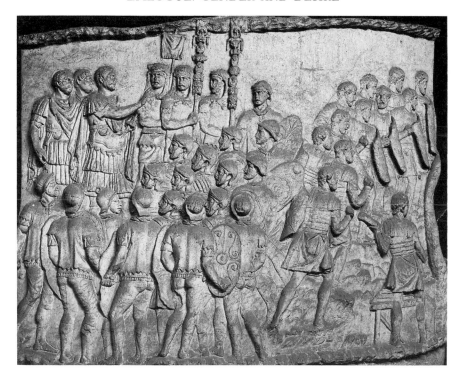

Figure 60 Detail of frieze, Column of Trajan, Rome. Early second century CE

legs, but we must be brave and soldier on, for even the modern male viewer of a US president can find in the rhetoric of democracy a space of bodily association with the maleness of the ruler. And that takes us back into the question of whether the female viewer, like the male viewer, could have a complex relationship of desire to images of men *and* women.

Given that the social institutions of the cultures under discussion here are largely although not exclusively the province of elite men, we can assume the participation of women viewers in dominant ways of seeing, just as we can imagine it for non-elite male viewers. Here we can think about many of the essays in this collection, but especially of those about the Parthenon (pp. 120–53) and about Pompeian house decoration (pp. 243–66). But along with acknowledging this as a fact and therefore being better able to understand the way these institutions and the concomitant ways of seeing help to contain female desire and erotic power, we might want to think further about what it is that is being contained. Would it need so much work, would the work need to be done over and over, generation after generation, if it were not so difficult a project, this containment, if women's desire and the erotic power of women (as imagined at a given

273

moment, of course) that were being contained were not also seen as terribly, fearfully resistant? Gloria Ferrari Pinney has argued that Greek vases with nude girls running, the krateriskoi associated with rituals at Brauron, express through nudity a *not here/impossible now* quality; the imagery on the krateriskoi might even suggest that the nudity of the girls shown there, like the nudity of Aphrodite or of the Roman matrons in her guise, provokes a certain terror-in-desire for men that jokes, distancing, and domestication respond to.[16] But for women, who participate in these acts of containment too, the images may call up emotional and physical responses, forms of empathy that make the body feel desirable. Thus, to wear certain clothing, to tend the body through bathing or cosmetics, to nurse an infant and to mother it, to look at the statue of a beautiful goddess and wish to be in and of her, to participate in ritual enactments of divine power or of adoration, and to feel the possibility of being desired by the god or the hero or the ruler could draw women into the process of desire not only as desirable objects of someone else's gaze but through their own sensual, erotic, and desiring responses. A woman imagines herself the beloved of the god, imagines herself to be in the body of the beloved, imagines herself the wife or mother of the hero or the ruler, and through the body and its empathetic abilities, she desires and thus participates in the construction of power and its social relations. All those stories of women pursued by gods aren't just for men, after all, and our task could be to understand what the range of women's responses might have been.[17]

Let us move from desire as an active response for both men and women, as an erotic answer to the question of why one accepts domination or rule, and return to the question of *desirability* as worth pursuing in our studies of gender. It makes us aware of the constructed nature of desire, since there can be no desire without a something to desire and that something is always embedded in a particular cultural moment rather than being natural and inevitable. Most of us have at one time or another used "beauty" as an unproblematic term, an abstraction that can cross cultural boundaries perhaps too easily, but here again the insistence of *desirability* on the contingent nature of what is desired, of beauty itself, is enormously useful. Indeed, we might see, by using *desirability* heuristically, ways in which social relations determine desirability at the same time that desirability participates in configuring those very relations.

My suggestion would be that we think about desirability as a flexible term, one that might usefully insist on cultural specificity if we keep in mind the variability of its historically constituted meanings. The term, under these conditions, has some advantages. If we deal with it as a contingent term, never a universal given that isn't complicated and annoyingly relative, it might help us to clarify the relationship among social institutions, structures, and individuals. We might be able to see how historically specific institutions such as marriage relate to social and indi-

vidual needs for procreation, or to erotic delectation and sexual exhilaration, or to diverse forms of power. Desirability as a concept allows us to understand more about how the body of the ruler becomes both exemplary and powerful, potent as a man and as a mover of men, and how it does its work on individuals in various times and places.[18] It also reveals the ways in which the body of a marriageable woman, decorated with Aphrodite's youthful nudity or with jewels and flowing garments, comes to seem procreative even in cultures where modern notions of "beauty" might be irrelevant. It can reveal her function as the signifier of the wealth or power of her kin or husband, and we can then begin to see what a historically specific definition of beauty might look like.[19] And it could allow us to talk about a woman's desire to be sexually alluring not simply or only in the service of procreation in cultures that believe she must enjoy sex in order to conceive, but also in the interests of her own pleasure or her religious sentiments.[20] In other words, a concept of desirability would need to be explicit about the way it creates and shapes desire. Just as gender can make sense only within a larger framework of relational thinking, and just as gender is one of the components that helps to create and support the existence of such thinking, so too desire is a product and a maker of relationship. Desire comes into consciousness through socially formed ideas about what is desirable, and the practices and material objects that render these ideas visible at the same time help to reconfigure them, give them new meanings, change them. Desire, configured differently in different cultures and periods, is dazzlingly various in its manifestations: beauty to one is *gravitas* or worldly wealth or fecundity or even ascetic desiccation to another.[21] The contribution of this anthology is its demonstration of the extent to which the represented and viewed body, nude or clothed but always gendered, can become infinitely desirable.

NOTES

1 Credit for developing my thinking about "desire" as a locus for theorizing the relationship of object and viewer in antiquity goes first of all to Page DuBois whose paper on this subject, "Archaic Bodies-in-Pieces," appears in N. B. Kampen (ed.), *Sexuality in Ancient Art*, New York and Cambridge, Cambridge University Press, 1996, pp. 55–64. Irene Winter, Robin Osborne, Françoise Frontisi-Ducroux, Eva Stehle, and Amy Day, Andrew Stewart, John Elsner, and Whitney Davis also deal with issues of desire in that anthology in ways that have shaped my thinking; I cannot imagine writing this piece without having read theirs too. Stewart (1997) appeared after this essay went to press. I am grateful to Ann Olga Koloski-Ostrow and Claire Lyons as well as to Shelby Brown for allowing me to be part of this project, and to the authors who have allowed me to comment on their work for it.

2 On the issue of social system as crucial to any conceptualization of gender, see most recently, M. Beard, "Re-reading (Vestal) Virginity," in R. Hawley and B. Levick (eds), *Women in Antiquity: New Assessments*, London and New York,

Routledge, 1995, pp. 166–77. For a useful overview of feminist theories in the field of classics, an overview with no parallel as yet for art history, see A. Richlin, "The Ethnographer's Dilemma and the Dream of a Lost Golden Age," in N. S. Rabinowitz and A. Richlin (eds), *Feminist Theory and the Classics*, New York and London, Routledge, 1993, pp. 272–303. The essay by Shelby Brown in the present collection, read along with her chapter, "Feminist Research in Archaeology: What Does It Mean? Why Is It Taking So Long?," *Feminist Theory and the Classics*, pp. 238–71, provides an equally helpful survey of the issues and theories in use and under debate in classical archaeology.

3 J. J. Winkler, "Phallos Politikos: Representing the Body Politic in Athens," *differences*, spring 1990, vol. 2 (1), pp. 29–45.

4 C. Kramer, "The Quick and the Dead: Ethnography In and For Archaeology," Distinguished Lecture to the Archaeology Division, American Anthropological Association (unpublished, 1994). See also the work of B. Bergmann on Pompeian painting programs, especially "The Pregnant Moment: Tragic Wives in the Roman Interior," in *Sexuality in Ancient Art*, pp. 199–218.

5 B. S. Ridgway, "The Study of Classical Sculpture at the End of the 20th Century," *American Journal of Archaeology*, 1994, vol. 98, pp. 759–72, especially pp. 732–3.

6 Most recently, C. M. Havelock, *The Aphrodite of Knidos and Her Successors*, Ann Arbor, University of Michigan Press, 1995.

7 See, for example, A. Zito, "Fetishizing Footbinding: Bound to be Represented," paper presented to the American Anthropological Association annual meetings (unpublished, 1993).

8 E. D'Ambra, "The Calculus of Venus: Nude Portraits of Roman Matrons," in *Sexuality in Ancient Art*, pp. 219–32.

9 Cf. A. McClintock, "The Return of Female Fetishism and the Fiction of the Phallus," *New Formations*, spring 1993, vol. 19, pp. 1–21.

10 Cf. C. W. Bynum, *Fragmentation and Redemption: Essays on Gender and the Human Body in Medieval Religion*, New York, Zone Books, 1991, pp. 79–117.

11 I. J. Winter, "Sex, Rhetoric and the Public Monument: The Alluring Body of Naram-Sîn of Agade," in *Sexuality in Ancient Art*, pp. 11–26.

12 G. Robins, "Dress, Undress and the Representation of Fertility and Potency in New Kingdom Egyptian Art," in *Sexuality in Ancient Art*, pp. 35–6.

13 On the erotic power of the ruler in a kind of limit-case, see H. Hirata, "Masturbation, the Emperor, and the Language of the Sublime in Ōe Kenzaburō," *Positions*, spring 1994, vol. 2 (1), pp. 91–112, esp. pp. 103–6, and, on the issue of homosociality, E. K. Sedgwick, *Between Men: English Literature and Male Homosocial Desire*, New York, Columbia University Press, 1985. For an example of naked "barbarians," see H. Walter, *Les barbares de l'occident romain: Corpus des Gaules et des provinces de Germanie*, Besançon and Paris, Annales littéraires de l'Université de Besançon and Les Belles Lettres, 1993, pls II, XXXII, and LIII.

14 See esp. J. Benjamin, *The Bonds of Love: Psychoanalysis, Feminism, and the Problem of Domination*, New York, Pantheon, 1988.

15 The passage, referring to Trajan's triumphant entrance into Rome in 99 CE, begins with comments on the emperor's splendid tall body and with his subjects feasting their eyes (literally filling, but also impregnating) on him. Then Pliny tells of the small children, young people, old men, and the infirm who come out to see the emperor, and he says: "feminas etiam tunc fecunditatis suae maxima voluptas subiit, cum cernerent cui principi cives, cui imperatori milites peperissent" (22.3). "Women looked upon Trajan and rejoiced" (literally "they experienced the greatest pleasure," *voluptas*, with its implication

of sensuality and the erotic, "in their fertility") "because they saw clearly for" (or "to") "which ruler they bore" (or "begot") "citizens, for" (or "to") "which military leader they bore soldiers." Trajan's presence ensures the conditions under which childbearing and rearing will be safe and happy, but, at the same time, the construction of the passage eliminates husbands, and, making Trajan the erotic object by using the word *voluptas*, substitutes him for husbands as father. Here he becomes father to Roman children through the reconfiguration of relations between husbands and wives, adults and children. And, in the process, he takes on the erotic character for the women of Rome that he seems not to have in relation to his own childless wife; he works like an aphrodisiac. In Pliny's construction of an imperial sexuality, Trajan is granted the power to transform all human relationships, to name them as he will.

16 G. Ferrari Pinney, "Fugitive Nudes: The Woman Athlete," *American Journal of Archaeology*, 1995, vol. 99, p. 303; D'Ambra, *Sexuality in Ancient Art*.
17 See A. Stewart, "Rape?", in E. D. Reeder (ed.), *Pandora: Women in Classical Greece*, Baltimore and Princeton, Walters Art Gallery and Princeton University Press, 1995, pp. 74–90.
18 M. E. Combs-Schilling, *Sacred Performances: Islam, Sexuality and Sacrifice*, New York, Columbia University Press, 1989, pp. 162–77.
19 P. Simons, "Women in Frames: The Gaze, the Eye, the Profile in Renaissance Portraiture," *History Workshop Journal*, spring 1988, vol. 25, pp. 4–30. Reprinted in N. Broude and M. D. Garrard (eds), *The Expanding Discourse: Feminism and Art History*, New York, HarperCollins, 1992, pp. 39–57.
20 L. Dean-Jones, "The Politics of Pleasure: Female Sexual Appetite in the Hippocratics and Aristotle," *Helios*, 1992, vol. 19, pp. 72–91.
21 Cf. D. Boyarin on the beauty of the Talmudic scholar in *Unheroic Conduct: The Rise of Heterosexuality and the Invention of the Jewish Man*, Berkeley, University of California Press, 1997.

GLOSSARY

acroterion (-a)
Ornamental finial(s) or sculpture at the apex and/or outer angles of the pediment of a temple.

aegis
The short "goat-skin" cloak worn by Athena, fringed with snakes and bearing the head of Gorgo on the front.

aidos
A sense of shame, modesty, or self-respect.

ala (-ae)
In the Roman house, the wings extending to right and left at the far end of the traditional *atrium*, in front of the *tablinum*.

amazonomachy
Legendary battle in which the Greeks, under either Herakles or Theseus, defeated the Amazons.

anacreontic
On Attic vases, a term referring to the representations of the lyric poet Anacreon or his companions, shown as men dressed in feminine attire and carrying a parasol, lyre, or walking stick.

andreia
Greek for manliness, manhood, manly spirit. Equivalent of Latin *virtus*.

apotropaic
Refers to objects or images that avert evil.

architrave
The horizontal architectural element, of stone or timber, spanning the interval between two columns or piers.

arrhephoroi
Two Athenian maidens of noble birth, chosen in their seventh year, who carried the *peplos* and other holy objects of Athena Polias.

atrium (-a)
The central hall of a traditional Italic private house.

aulos
A double-reed wind instrument similar to an oboe.

barbitos
A musical stringed instrument, the Asiatic lyre.

Brauronia
Annual festival of the cult of Artemis celebrated by women, and girls who perform the bear-dance, at Brauron on the east coast of Attica, beginning in the Archaic period.

bucranium (-a)
Decorative motif in the form of an ox-skull or bull's head, shown frontally.

calyx-krater
A type of krater with a wide mouth, flaring walls, and two up-turned handles on the lower body.

centauromachy
Legendary battle between the centaurs (half human and half horse mythological creatures) and the Lapiths at the wedding feast of Perithous.

chiton
A light, sleeved, one-piece dress worn belted close to the body and fastened with buttons or pins.

chlamys
A short cloak, worn especially by riders.

contrapposto
A pose in which the body's weight is supported on one leg, so that the tension of one side is contrasted with the relaxation of the other.

GLOSSARY

cubiculum (-a)
The bed chamber in a Roman house.

daedalic
A Greek sculptural style of the seventh century BCE named for the legendary Cretan artist, Daedalus, in which the figure is conceived frontally with a flat rendering of the body.

deme
Political subdivision (as village, ward, or precinct) of ancient Attica in Greece.

dominus (-i)
Owner, proprietor, master, or chief host of a Roman household.

Eros
God of love (violent, physical desire) in Greek mythology.

exedra (-ae)
Semicircular or rectangular recess in a Roman house.

fibula (-ae)
A clasp, pin, or brooch.

gens
Clan, stock, tribe, nation, or people. Sometimes also descendant or off-spring.

gravitas
Moral earnestness, authority, seriousness.

gynaikeion
Women's quarters located at the interior of the ancient house.

herm
Stylized representation of the god Hermes, consisting of a bust on a rectangular stone block with a phallus on the front; particularly in Athens, such images were familiar objects of private piety.

himation
A heavy outer mantle or cloak.

hoplite
Infantryman in the Greek city-state, heavily armed with helmet, breastplate, greaves (shin-guards), shield, and spear.

281

hydria
A three-handled vessel used for carrying water.

ithyphallic
Having an erect phallus; a term frequently used to describe satyrs and herms.

***kalos*-name**
"Love-names" appearing on Attic vases of the sixth to fifth century naming certain aristocratic youths as beautiful.

klismos
A form of Greek chair having a curved back and no arms.

komast
A reveler or drinker who participates in a *komos*.

komos
Properly a village festival, but comes to mean a revel, carousal, or procession of drinkers who sing and dance.

kore (-ai)
An Archaic statue of a standing draped female, representing a goddess or dedicant.

kouros (-oi)
An Archaic statue of a standing nude male, representing a young god (Apollo) or dedicant.

kourotrophos (-oi)
Children's nurse or tutor, either human or animal.

krater
A large, wide-mouthed vessel used for mixing wine and water.

Lapiths
Inhabitants of Thessaly who fought with the centaurs at the wedding feast of Perithous.

lares
Household gods whose images were located near the hearth, venerated by the Romans.

lekythos (-oi)
An elongated, one-handled container for oil and unguents often placed at or in graves.

lesche
Club-house or assembly hall where the public gathered to talk and hear news.

loutrophoros (-oi)
A tall vessel usually decorated with nuptial or funeral scenes, used to hold water in a marriage ritual or as a marker at the tomb of unmarried persons.

maenad
A female member of the orgiastic cult of Dionysos, depicted as a woman wearing a crown of ivy, a deer-skin, and carrying a branch or staff (*thyrsos*).

metis
Counsel, plan, undertaking, wisdom or skill.

metope
An architectural element in the form of a panel, usually blank but sometimes decorated, between the triglyphs of the frieze on a Doric building.

mischwesen
"Mixed being," or mythological creature formed of several different animals.

mitra
A miter, turban, or head-dress worn to hold the hair.

Nike
Goddess of victory, represented as a winged female.

Niobid
The sons and daughters of Niobe, slaughtered by Apollo and Artemis.

Nolan amphora
A type of amphora having a slender profile and decorated with one or two figures on each side, named for the site of Nola in Italy where many examples were found.

nutrix
Nurse or caregiver.

odeon
A small roofed theater for musical performances and lectures.

oikos
A house or dwelling, a part of a house such as a room or chamber, or the house of a god such as a temple.

oscilla
Decorative disk in low relief, usually made of marble, which hung between the columns of the peristyle of the Roman house.

palaestra
A porticoed enclosure for sport or an exercise yard in a Roman bath-building.

Palladion
The ancient sacred image of Pallas (Athena) given by Zeus to Dardanus, the founder of Troy, to protect the city.

Panathenaia
An Athenian festival considered to be the birthday of Athena, celebrated annually (and every fourth year with much greater pomp) with a procession, sacrifices, and games, on the 28th of Hecatombaeon (July/August).

parthenos
Maiden. The Parthenon on the Acropolis at Athens was dedicated to Athena Parthenos (Maiden goddess).

patronus
Legal protector of one or more clients or freedmen, patron.

pediment
The triangular space formed by the pitched roof at the ends of a temple.

pelekus
A broad-brimmed felt hat, often associated with travelers and with the god Hermes.

pelike
A variant shape of amphora, broadest at a point below the middle, used for storage.

peplos
A heavy, woolen garment worn by women, fastened at the shoulders with pins and often worn over a *chiton*.

peristyle
The row of columns that surrounds a temple or other building; an open courtyard or garden surrounded by columned porticoes.

petasos
A two-edged or double ax used for felling trees, for battle and for sacrifices.

petroglyph
A carving or line drawing on rock.

pinakes
Tablets or plates with relief or painted decoration, often hung as votives.

plektron
A pluck used to play stringed instruments.

polis
Greek city-state.

pudica (-us, -um)
Adjective meaning chaste, modest, virtuous, pure; from *pudor*, shame or modesty.

pulpitum
The raised platform of the stage of a Roman theater.

pyxis
A small lidded box or container, used to hold cosmetics and personal ornaments.

scaena frons
The façade of the stage-building of a Roman theater, which formed the backdrop of the stage.

silen (-enoi)
Mythological creatures, bestial in their desires and behavior, in the form of men with the ears, feet, and tail of a horse or goat.

spindle whorl
A weight attached to the end of a spindle to facilitate the manipulation of the thread in spinning.

stele (-ae)
Upright stone slab used as a grave-marker, for sculptured reliefs, and for inscriptions.

symposion (adj. sympotic)
Following a banquet, the convivial meeting for drinking, music, and intellectual discussion; of or pertaining to the symposion.

tablinum
The central room at the far end of the *atrium* in a Roman house, originally the main bedroom, later the record room.

theogony
A recitation of the origin and genealogy of the gods.

tondo
In Greek vase painting, the term used for the circular area, often decorated, on the interior of cups.

triclinium
Originally a dining-room, so called from the conventional arrangement of three banqueting couches (*klinai*) located along the walls of the room.

tyrannicides
Assassins of "tyrants" (monarchs in oligarchic city-states).

victimarius (-ii)
An assistant at sacrifices.

volute-krater
A type of krater with a wide mouth, characterized by vertical handles that terminate in a volute.

votive
Small object or figurine dedicated at a sanctuary in fulfillment of a vow or to request divine intervention.

SELECTED BIBLIOGRAPHY

Adam, B. D., *The Rise of a Gay and Lesbian Movement*, New York, Twayne, 1995.

Adams, J. N., *The Latin Sexual Vocabulary*, London, Duckworth and Baltimore, Johns Hopkins University Press, 1990.

Adler, K. and M. Pointon, *The Body Imaged: The Human Form and Visual Culture Since the Renaissance*, Cambridge, Cambridge University Press, 1993.

Ajootian, A., *Lexicon Iconographicum Mythologiae Classicae*, vol. 5, Zurich, Artemis Verlag, 1990, pp. 268–85, s.v. Hermaphroditos.

Alpers, S., "Art History and its Exclusions", in N. Broude and M. D. Garrard (eds), *Feminism and Art History: Questioning the Litany*, New York, Harper and Row, 1982, pp. 183–200.

Archer, L. J., S. Fischler, and M. Wyke (eds), *Women in Ancient Societies: "An Illusion of the Night,"* New York, Routledge, 1994.

Bacus, E., A. W. Barker *et al.*, *A Gendered Past: A Critical Bibliography of Gender in Archaeology*, University of Michigan Museum of Anthropology Technical Report 25, Ann Arbor, Museum of Anthropology Publications, 1993.

Balsdon, J., *Roman Women: Their History and Habits*, New York, John Day Co., 1962.

Bapty, I. and T. Yates (eds), *Archaeology After Structuralism: Post-structuralism and the Practice of Archaeology*, New York, Routledge, 1990.

Barber, E. J. W., *Women's Work: The First 20,000 Years: Women, Cloth and Society in Early Times*, New York, Norton, 1994.

Bartky, S. L., "Foucault, Femininity, and the Modernization of Patriarchal Power", in S. L. Bartky, *Femininity and Domination: Studies in the Phenomenology of Oppression*, New York, Routledge, 1990, pp. 63–82. Reprinted from L. Quinby and I. Diamond (eds), *Feminism and Foucault: Paths to Resistance*, Boston, Northeastern University Press, 1988.

Bartman, E., "Eros' Flame: Sexy Boys in Roman Ideal Sculpture", in E. Gazda (ed.), *The Art of Emulation: Studies in Artistic Originality, Tradition, and Practice from the Present to Antiquity*, Ann Arbor, University of Michigan Press, forthcoming.

Bartoloni, G., "A Few Comments on the Social Position of Women in the Proto-historic Coastal Area of Western Italy Made on the Basis of a Study of Funerary Goods", *Rivista di Antropologia*, 1988, vol. 66, pp. 317–36.

Bassi, K., "Male Nudity and Disguise in the Discourse of Greek Histrionics", *Helios*, 1995, vol. 22, pp. 3–21.

Bauer, D., "Alice Neel's Female Nudes", *Women's Art Journal*, 1994–5, vol. 15 (2), pp. 21–6.

Beard, M., "Re-reading (Vestal) Virginity", in R. Hawley and B. Levick (eds), *Women in Antiquity: New Assessments*, London and New York, Routledge, 1995, pp. 166–77.

Benjamin, J., *The Bonds of Love: Psychoanalysis, Feminism, and the Problem of Domination*, New York, Pantheon, 1988.

Berger, J., *Ways of Seeing*, Harmondsworth, London and New York, British Broadcasting Corporation and Penguin, 1972.

Berger, P., *The Goddess Obscured: Transformation of the Grain Protectress from Goddess to Saint*, Boston, Beacon Press, 1985.

Bergmann, B., "The Pregnant Moment: Tragic Wives in the Roman Interior", in N. B. Kampen (ed.), *Sexuality in Ancient Art*, New York and Cambridge, Cambridge University Press, 1996, pp. 199–218.

Bestor, J., "Ideas about Procreation and their Influence on Ancient and Medieval Views of Kinship", in D. Kertzer and R. Saller (eds), *The Family in Italy from Antiquity to the Present*, New Haven, Yale University Press, 1991, pp. 150–68.

Betterton, R. (ed.), *Looking On: Images of Femininity in the Visual Arts and Media*, New York, Pandora Press, 1987.

Betterton, R., "Introduction: Feminism, Femininity and Representation", in R. Betterton (ed.), *Looking On: Images of Femininity in the Visual Arts and Media*, New York, Pandora Press, 1987, pp. 1–17.

Betterton, R., "How Do Women Look? The Female Nude in the Work of Suzanne Valadon", in H. Robinson (ed.), *Visibly Female, Feminism and Art: An Anthology*, New York, Universe Books, 1988, pp. 250–71. Reprinted from *Feminist Review*, 1985, vol. 19; a shortened version also appears in R. Betterton, *Looking On*, 1987.

Binford, S. R., "Are Goddesses and Matriarchies Merely Figments of Feminist Imagination?", in C. Spretnak (ed.), *The Politics of Women's Spirituality: Essays on the Rise of Spiritual Power Within the Feminist Movement*, Garden City, Anchor Books, 1982, pp. 541–9.

Blundell, S., *Women in Ancient Greece*, London, British Museum Press, 1995.

Board, M. L., "Constructing Myths and Ideologies in Matisse's Odalisques", in N. Broude and M. D. Garrard (eds), *The Expanding Discourse: Feminism and Art History*, New York, IconEditions, HarperCollins, 1992, pp. 359–79.

Boardman, J., "Classical Archaeology: Whence and Whither?", *Antiquity*, 1988, vol. 62, pp. 795–7.

Böhm, S., *Die "nackte Göttin": Zur Ikonographie und Deutung unbekleideter weiblicher Figuren in der frühgriechischen Kunst*, Mainz, P. von Zabern, 1990.

Bonfante, L., "Dedicated Mothers", in *Visible Religion*, Institute of Religious Iconography, Leiden, Brill, 1984, pp. 1–17.

Bonfante, L., "Votive Terracotta Figures of Mothers and Children", in J. Swaddling (ed.), *Italian Iron Age Artefacts in the British Museum*, London, British Museum Publications, 1985, pp. 195–203.

Bonfante, L., "L'iconografia della madre nell'arte dell'Italia antica", in A. Rallo (ed.), *Le donne in Etruria*, Rome, "L'Erma" di Bretschneider, 1989, pp. 85–106.

Bonfante, L., "Nudity as a Costume in Classical Art", *American Journal of Archaeology*, 1989, vol. 93, pp. 543–70.

Bonfante, L., "The Naked Greek: The Fashion of Nudity in Ancient Greece", *Archaeology*, Sept.–Oct. 1990, vol. 43, pp. 28–35.

Bonfante, L., *Nudity as a Costume in Ancient Art*, forthcoming.

Boswell, J., "Revolutions, Universals and Sexual Categories", *Salmagundi*, fall 1982/winter 1983, vols 58–9, pp. 106–9.

Boswell, J., "Revolutions, Universals, and Sexual Categories", in M. Duberman, M. Vicinus, and G. Chauncey, Jr (eds), *Hidden from History: Reclaiming the Gay and Lesbian Past*, New York, Penguin Group, 1990, pp. 17–36.

Boyarin, D., *Unheroic Conduct: The Rise of Heterosexuality and the Invention of the Jewish Man*, Berkeley, University of California Press, 1997.

288

Brandes, S., *Metaphors of Masculinity: Sex and Status in Andalusian Folklore*, Philadelphia, University of Pennsylvania Press, 1980.

Bremmer, J., "An Enigmatic Indo-European Rite: Paederasty," *Arethusa*, 1980, vol. 13, pp. 279–98.

Brendel, O., "The Scope and Temperament in Erotic Art in the Greco-Roman World," in T. Bowie *et al.* (eds), *Studies in Erotic Art*, New York, Basic Books, 1970, pp. 3–107.

Brisson, L., "Hermaphrodite chez Ovide," in F. Monneyron (ed.), *L'Androgyne dans la Littérature*, Paris, A. Michel, 1990, pp. 24–37.

Broude, N. and M. D. Garrard (eds), *Feminism and Art History: Questioning the Litany*, New York, Harper and Row, 1982.

Broude, N. and M. D. Garrard (eds), *The Expanding Discourse: Feminism and Art History*, New York, IconEditions, HarperCollins, 1992.

Broude, N. and M. D. Garrard (eds), *The Power of Feminist Art: The American Movement of the 1970s, History and Impact*, New York, Harry Abrams, 1994.

Brown, S., "Death as Decoration: Scenes from the Arena in Roman Domestic Mosaics," in A. Richlin (ed.), *Pornography and Representation in Greece and Rome*, New York, Oxford University Press, 1992, pp. 180–211.

Brown, S., "Feminist Research in Archaeology: What Does It Mean? Why Is It Taking So Long?," in N. S. Rabinowitz and A. Richlin (eds), *Feminist Theory and the Classics*, New York and London, Routledge, 1993, pp. 238–71.

Bryson, N., *Vision and Painting: The Logic of the Gaze*, New Haven, Yale University Press, 1983.

Buchli, V. A., "Interpreting Material Culture: The Trouble With Text," in I. Hodder, M. Shanks, A. Alexandri *et al.* (eds), *Interpreting Archaeology: Finding Meaning in the Past*, London, Routledge, 1995, pp. 181–93.

Bynum, C. W., *Fragmentation and Redemption: Essays on Gender and the Human Body in Medieval Religion*, New York, Zone Books, 1991, pp. 79–117.

Calame, C., *I Greci e l'Eros*, Roma and Bari, Laterza, 1992.

Cameron, A. and Kuhrt, A. (eds), *Images of Women in Antiquity*, Detroit, Wayne State University Press, 1983.

Cantarella, E., *Pandora's Daughters: The Role and Status of Women in Greek and Roman Antiquity*, Baltimore, Johns Hopkins University Press, 1987.

Cantarella, E., *Bisexuality in the Ancient World*, trans. C. O. Cuilleanain, New Haven, Yale University Press, 1992.

Carrol, M. D., "The Erotics of Absolutism: Rubens and the Mystification of Sexual Violence," in N. Broude and M. D. Garrard (eds), *The Expanding Discourse: Feminism and Art History*, New York, IconEditions, HarperCollins, 1992, pp. 139–59.

Carson, A., "Putting Her in Her Place: Woman, Dirt, and Desire," in D. M. Halperin, J. J. Winkler, and F. I. Zeitlin (eds), *Before Sexuality: The Construction of Erotic Experience in the Ancient Greek World*, Princeton, Princeton University Press, 1990.

Cartledge, P., "The Politics of Spartan Pederasty," *Cambridge Philological Society, Proceedings*, 1981, vol. 27, pp. 17–36.

Caws, M. A., "Ladies Shot and Painted: Female Embodiment in Surrealist Art," in N. Broude and M. D. Garrard (eds), *The Expanding Discourse: Feminism and Art History*, New York, IconEditions, HarperCollins, 1992, pp. 381–95.

Chadwick, W., *Women, Art and Society*, London, Thames and Hudson, 1990.

Chard, C., "Nakedness and Tourism: Classical Sculpture and the Imaginative Geography of the Grand Tour," *Oxford Art Journal*, 1995, vol. 18, pp. 14–28.

Chicago, J., *Embroidering Our Heritage: The Dinner Party Needlework*, Garden City, Anchor, 1980.

Chippindale, C., "Grammars of Archaeological Design: A Generative and Geometrical Approach to the Form of Artifacts", in Jean-Claude Gardin and C. S. Peebles (eds), *Representations in Archaeology*, Bloomington, Indiana University Press, 1992, pp. 251–76.

Claassen, C. (ed.), *Exploring Gender Through Archaeology: Selected Papers from the 1991 Boone Conference*, Monographs in World Archaeology 11, Madison, Prehistory Press, 1992.

Clarke, J., *Looking at Lovemaking: Constructions of Sexuality in Roman Art 100 BC–AD 250*, Berkeley, University of California Press, 1998.

Clarke, J. R., "The Decor of the House of Jupiter and Ganymede at Ostia Antica: Private Residence Turned Gay Hotel?", in E. K. Gazda and A. E. Haeckl (eds), *Roman Art in the Private Sphere: New Perspectives on the Architecture and Decor of the Domus, Villa, and Insula*, Ann Arbor, University of Michigan Press, 1991, pp. 89–104.

Clarke, J. R., *The Houses of Roman Italy, 100 B.C.–A.D. 250: Ritual, Space, and Decoration*, Berkeley, University of California Press, 1991.

Clarke, J. R., "The Warren Cup and the Contexts for Representations of Male-to-Male Lovemaking in Augustan and Early Julio-Claudian Art", *The Art Bulletin*, June 1993, vol. 75 (2), pp. 275–94.

Cohen, B., "The Anatomy of Kassandra's Rape: Female Nudity Comes of Age in Greek Art", *Source: Notes in the History of Art*, 1993, vol. 12 (2), pp. 37–46.

Cohen, D., "Seclusion, Separation and the Status of Women in Classical Athens", *Greece and Rome*, 1989, vol. 36, pp. 3–15.

Cohen, D., "The Augustan Law on Adultery: The Social and Cultural Context", in D. Kertzer and R. Saller (eds), *The Family in Italy from Antiquity to the Present*, New Haven, Yale University Press, 1991, pp. 109–26.

Cohen, M. N. and S. Bennett, "Skeletal Evidence for Sex Roles and Gender Hierarchies in Prehistory", in B. D. Miller (ed.), *Sex and Gender Hierarchies*, New York, Cambridge University Press, 1993, pp. 273–96.

Cole, S. G., "The Social Function of Rituals of Maturation: the Koureion and the Arkteia", *Zeitschrift für Papyrologie und Epigraphik*, 1984, vol. 55, pp. 233–44.

Colomina, B. (ed.), *Sexuality and Space*, Princeton, Princeton Architectural Press, 1992.

Combs-Schilling, M. E., *Sacred Performances: Islam, Sexuality and Sacrifice*, New York, Columbia University Press, 1989, pp. 162–77.

Conkey, M. W., "Making the Connection: Feminist Theory and the Archaeologies of Gender", in H. du Cros and L. Smith (eds), *Women in Archaeology: A Feminist Critique*, Canberra, Department of Prehistory, Research School of Pacific Studies, Australian National University, 1993, pp. 3–15.

Conkey, M. and J. Gero, "Tensions, Pluralities and Engendering Archaeology: An Introduction to Women and Prehistory", in J. Gero and M. Conkey (eds), *Engendering Archaeology: Women in Prehistory*, Oxford, Basil Blackwell, 1991, pp. 3–30.

Conkey, M. W. and Janet D. Spector, "Archaeology and the Study of Gender", *Advances in Archaeological Method and Theory*, 1984, vol. 7, pp. 1–38.

Conkey, M. W. and R. E. Tringham, "Archaeology and the Goddess: Exploring the Contours of Feminist Archaeology", in D. C. Stanton and A. J. Stewart (eds), *Feminisms in the Academy*, Ann Arbor, University of Michigan Press, 1995, pp. 199–247.

Conkey, M. W., with S. W. Williams, "Original Narratives: The Political Economy of Gender in Archaeology", in M. di Leonardo (ed.), *Gender at the Crossroads of Knowledge: Feminist Anthropology in the Postmodern Era*, Berkeley, University of California Press, 1991, pp. 102–39.

290

Cornwall, A. and N. Lindisfarne, "Introduction," in A. Cornwall and N. Lindisfarne (eds), *Dislocating Masculinity: Comparative Ethnographies*, New York, Routledge, 1994, pp. 1–10.

Cucchiari, S., "Sexual Meanings: The Cultural Construction of Gender and Sexuality," in S. Ortner and H. Whitehead (eds), *Sexual Meanings*, New York, Cambridge University Press, 1981, pp. 31–79.

Culham, P.,"Ten Years After Pomeroy: Studies of the Image and Reality of Women in Antiquity," in *Rescuing Creusa: New Methodological Approaches to Women in Antiquity, Helios*, 1987, N.S. vol. 13 (2), pp. 1 and 9–30.

Cullen, T., "Contributions to Feminism in Archaeology," *American Journal of Archaeology*, 1996, vol. 100, pp. 409–14.

D'Ambra, E., "The Calculus of Venus. Nude Portraits of Roman Matrons," in N. Kampen (ed.), *Sexuality in Ancient Art: Near East, Egypt, Greece, and Italy*, New York and Cambridge, Cambridge University Press, 1996, pp. 219–32.

Dean-Jones, L., "The Cultural Construct of the Female Body in Classical Greek Science," in S. B. Pomeroy (ed.), *Women's History and Ancient History*, Chapel Hill, University of North Carolina Press, 1991, pp. 111–37.

Dean-Jones, L., "The Politics of Pleasure: Female Sexual Appetite in the Hippocratics and Aristotle," *Helios*, 1992, vol. 19, pp. 72–91.

Dean-Jones, L. A., *Women's Bodies in Classical Greek Science*, Oxford, Clarendon Press, 1994.

DeForest, M., "Clytemnestra's Breast and the Evil Eye," in M. DeForest (ed.), *Woman's Power, Man's Game: Essays on Classical Antiquity in Honor of Joy K. King*, Wauconda, Bolchazy-Carducci, 1993, pp. 129–48.

Demand, N., *Birth, Death and Motherhood in Classical Greece*, Baltimore, Johns Hopkins University Press, 1994.

Denzin, N. K., "Sexuality and Gender: An Interactionist/Poststructural Reading," in P. England (ed.), *Theory on Gender/Feminism on Theory*, New York, Aldine de Gruyter, 1993, pp. 199–221.

di Leonardo, M., "Introduction: Gender, Culture, and Political Economy: Feminist Anthropology in Historical Perspective," in M. di Leonardo (ed.), *Gender at the Crossroads of Knowledge: Feminist Anthropology in the Postmodern Era*, Berkeley, University of California Press, 1991, pp. 1–48.

Dickison, S., "Women in Rome," in M. Grant and R. Kitzinger (eds), *Civilization of the Ancient Mediterranean*, New York, Scribner's, 1988, pp. 1319–32.

Dimen, M., "Gender/Body/Knowledge: Feminist Reconstructions of Being and Knowing," in A. M. Jaggar and S. R. Bordo (eds), *Gender/Body/Knowledge*, New Brunswick and London, Rutgers University Press, 1989, pp. 34–51.

Dixon, S., *The Roman Mother*, Norman, Univeristy of Oklahoma Press, 1988.

Doane, M., "The Voice in the Cinema: The Articulation of Body and Space," *Yale French Studies*, 1980, vol. 60, pp. 33–50.

Doane, M., *The Desire to Desire: The Woman's Film of the 1940s*, Bloomington, Indiana University Press, 1987.

Dobres, M.-A., "Re-considering Venus Figurines: A Feminist Inspired Re-analysis," in A. Sean Goldsmith *et al.* (eds), *Ancient Images, Ancient Thought: The Archaeology of Ideology. Proceedings of the 1990 Chacmool Conference*, Alberta, Archaeological Association of the University of Calgary, 1992, pp. 245–62.

Dobres, M.-A., "Gender and Prehistoric Technology: On the Social Agency of Technical Strategies," *World Archaeology*, 1995, vol. 27, pp. 25–49.

Dover, K. J., *Greek Homosexuality*, London, Duckworth and Cambridge, Mass., Harvard University Press, 1978.

Dover, K. J., "Greek Homosexuality and Initiation," in K. J. Dover (ed.), *Greek and*

the Greeks: Collected Papers, Oxford, Blackwell, 1988, vol. II: *The Greeks and Their Legacy*, pp. 115–34.

DuBois, P., *Sowing the Body: Psychoanalysis and Ancient Representations of Women*, Chicago, University of Chicago Press, 1988.

DuBois, P., *Centaurs and Amazons: Women and the Pre-history of the Great Chain of Being*, Ann Arbor, University of Michigan Press, 1991.

DuBois, P., "Archaic Bodies-in-Pieces," in N. B. Kampen (ed.), *Sexuality in Ancient Art*, New York and Cambridge, Cambridge University Press, 1996, pp. 55–64.

du Cros, H. and L. Smith, *Women in Archaeology: A Feminist Critique*, Occasional Papers in Prehistory 23, Canberra, Department of Prehistory, Research School of Pacific Studies, Australian National University, 1993.

Dunbabin, K. M. D., "*Baiarum grata voluptas*: Pleasures and Dangers of the Baths," *Papers of the British School at Rome*, 1989, vol. 57, pp. 6–46.

Duncan, C., "Virility and Domination in Early Twentieth-Century Vanguard Painting," in N. Broude and M. D. Garrard (eds), *Feminism and Art History: Questioning the Litany*, 1982, pp. 293–313. Reprinted (revised) from *Artforum*, Dec. 1973.

Duncan, C., "The Aesthetics of Power in Modern Erotic Art," in A. Raven, C. L. Langer, and J. Frueh (eds), *Feminist Art Criticism: An Anthology*, Ann Arbor, UMI Research Press, 1988, pp. 59–69. Also published by HarperCollins, 1991. Reprinted from *Heresies: A Feminist Publication on Art and Politics*, Jan. 1977, vol. 1.

Duncan, C., "The MoMA's Hot Mamas," in N. Broude and M. D. Garrard (eds), *The Expanding Discourse: Feminism and Art History*, New York, IconEditions, HarperCollins, 1992, pp. 347–57.

Duran, J., *Toward a Feminist Epistemology*, Savage, Rowman and Littlefield, 1991.

Dyson, S. L., "A Classical Archaeologist's Response to the 'New Archaeology'," *Bulletin of the American Schools of Oriental Research*, 1981, vol. 242, pp. 7–13.

Dyson, S. L., "From New to New Age Archaeology: Archaeological Theory and Classical Archaeology – A 1990s Perspective," *American Journal of Archaeology*, 1993, vol. 97 (2), pp. 195–206.

Eisner, W., "The Consequences of Gender Bias in Mortuary Analysis: A Case Study," in D. Walde and N. Willows (eds), *The Archaeology of Gender: Proceedings of the 22nd Annual Conference of the Archaeological Association of the University of Calgary*, Calgary, University of Calgary, 1991, pp. 352–7.

Embree, L., "The Structure of American Theoretical Archaeology: A Preliminary Report," in V. Pinsky and A. Wylie (eds), *Critical Traditions in Contemporary Archaeology: Essays in the Philosophy, History, and Socio-politics of Archaeology*, New York, Cambridge University Press, 1989, pp. 28–37.

Engelstad, E., "Images of Power and Contradiction: Feminist Theory and Post-processual Archaeology," *Antiquity*, 1991, vol. 65, pp. 502–14.

Eyben, E., "Family Planning in Antiquity," *Ancient Society*, 1980-1, vols 11–12, pp. 5–82.

Faderman, L., *Surpassing the Love of Men: Romantic Friendship and Love between Women from the Renaissance to the Present*, New York, Morrow, 1981.

Fantham, E., H. P. Foley, N. B. Kampen, S. B. Pomeroy, and H. A. Shapiro (eds), *Women in the Classical World: Image and Text*, New York and Oxford, Oxford University Press, 1994.

Ferrari, G., "Figures of Speech: The Picture of Aidos," *Métis: Revue d'Anthropologie du Monde Grec Ancien. Philologie – Histoire – Archéologie*, 1990, vol. 5, pp. 185–204.

Foley, H. P. (ed.), *Reflections of Women in Antiquity*, New York, Gordon and Breach Science Publishers, 1981.

Foley, H. P., "Background: The Eleusinian Mysteries and Women's Rites for

Demeter," in H. P. Foley (ed.), *The Homeric Hymn to Demeter: Translation, Commentary and Interpretative Essays*, Princeton, Princeton University Press, 1994.

Formentini, R., "L'immagine femminile nelle statue-menhirs," in W. Waldren, J. Ensenyat, and R. Kennard (eds), *Second Deya International Conference of Prehistory: Recent Developments in Western Mediterranean Prehistory: Archaeological Techniques, Technology and Theory, vol. 2*, Oxford, Tempus Reparatum BAR International Series 574, 1991, pp. 365–85.

Fotiadis, M., "What is Archaeology's 'Mitigated Objectivism' Mitigated By? Comments on Wylie," *American Antiquity*, 1994, vol. 59, pp. 545–55.

Foucault, M., *The History of Sexuality: The Use of Pleasure*, trans. R. Hurley, vol. 2, New York, Pantheon, 1985.

Foxhall, L., "Pandora Unbound: A Feminist Critique of Foucault's *History of Sexuality*," in A. Cornwall and N. Lindisfarne (eds), *Dislocating Masculinity: Comparative Ethnographies*, New York, Routledge, 1994, pp. 133–46.

Foxhall, L., *Studying Gender in Classical Antiquity*, Cambridge, Cambridge University Press, forthcoming.

Fredrick, D., "Beyond the *Atrium* to Ariadne: Erotic Painting and Visual Pleasure in the Roman House," *Classical Antiquity*, 1995, vol. 14 (2), pp. 266–89.

Frontisi-Ducroux, F. and F. Lissarrague, "From Ambiguity to Ambivalence: A Dionysiac Excursion through the 'Anakreontic' Vases," in D. M. Halperin, J. J. Winkler, and F. I. Zeitlin (eds), *Before Sexuality: The Construction of Erotic Experience in the Ancient Greek World*, Princeton, Princeton University Press, 1990, pp. 211–56.

Frueh, J., "Towards a Feminist Theory of Art Criticism," in A. Raven, C. L. Langer, and J. Frueh (eds), *Feminist Art Criticism: An Anthology*, Ann Arbor, University of Michigan Press, 1988, pp. 153–65. Also published by HarperCollins, 1991. Reprinted from *New Art Examiner*, Jan. and June 1985.

Frueh, J., "The Body Through Women's Eyes," in N. Broude and M. D. Garrard (eds), *The Power of Feminist Art: The American Movement of the 1970s, History and Impact*, New York, Harry Abrams, 1994, pp. 190–207.

Fuller, P., *Seeing Berger: A Reevaluation of Ways of Seeing*, London, Writers and Readers Publishing Cooperative, 1981.

Garb, T., "Renoir and the Natural Woman," in N. Broude and M. D. Garrard (eds), *The Expanding Discourse: Feminism and Art History*, New York, IconEditions, HarperCollins, 1992, pp. 295–311.

Garb, T., "The Forbidden Gaze: Women Artists and the Male Nude in Late Nineteenth-Century France," in K. Adler and M. Pointon (eds), *The Body Imaged: The Human Form and Visual Culture Since the Renaissance*, Cambridge, Cambridge University Press, 1993, pp. 33–42.

Gardin, J.-C., "Semiotic Trends in Archaeology," in J.-C. Gardin and C. S. Peebles (eds), *Representations in Archaeology*, Bloomington, Indiana University Press, 1992, pp. 87–104.

Garrard, M. D., "Artemisia and Susanna," in N. Broude and M. D. Garrard (eds), *Feminism and Art History: Questioning the Litany*, New York, Harper and Row, 1982, pp. 147–71.

Garrard, M. D., "Leonardo da Vinci: Female Portraits, Female Nature," in N. Broude and M. D. Garrard (eds), *The Expanding Discourse: Feminism and Art History*, New York, IconEditions, HarperCollins, 1992, pp. 59–85.

Gerber, D. E., "The Female Breast in Greek Erotic Literature," *Arethusa*, 1978, vol. 11, pp. 203-12.

Gero, J. M. and M. W. Conkey (eds), *Engendering Archaeology: Women and Prehistory*, Cambridge, Mass. Basil Blackwell, 1991.

Gibbs, L., "Identifying Gender Representation in the Archaeological Record: A Contextual Study", in I. Hodder (ed.), *The Archaeology of Contextual Meanings*, Cambridge, Cambridge University Press, 1987, pp. 79–101.

Gilchrist, R., "Women's Archaeology? Political Feminism, Gender Theory and Historical Revision", *Antiquity*, 1991, vol. 65, pp. 495–501.

Gilchrist, R., *Gender and Material Culture: The Archaeology of Religious Women*, New York, Routledge, 1994.

Gimbutas, M., *The Goddesses and Gods of Old Europe 6500–3500 BC: Myths and Cult Images*, Berkeley, University of California Press, 1982.

Gimbutas, M., *The Language of the Goddess: Unearthing the Hidden Symbols of Western Civilization*, San Francisco, Harper and Row, 1989.

Gimbutas, M., *The Civilization of the Goddess: The World of Old Europe*, New York, HarperCollins, 1991.

Goldberg, M. Y., "Deceptive Dichotomy: Two Case Studies", in M. Casey, D. Donlon, J. Hope and S. Wellfare (eds), *Redefining Archaeology: Feminist Perspectives. Proceedings of the Third Australian Women in Archaeology Conference*, ANH (Australian National University) Publications, Canberra, 1998, pp. 107–12.

Golden, M., "Slavery and Homosexuality at Athens", *Phoenix*, 1984, vol. 38, pp. 308–24.

Goldhill, S. and R. Osborne, *Art and Text in Ancient Greek Culture*, Cambridge, Cambridge University Press, 1994.

Gouma-Peterson, T. and P. Matthews, "The Feminist Critique of Art History", *The Art Bulletin*, 1987, vol. 69 (3), pp. 326–57.

Grant, M., *Eros in Pompeii: The Secret Rooms of the National Museum in Naples*, New York, William Morrow and Co., 1975.

Gregory, A. P., "'Powerful Images': Responses to Portraits and the Political Uses of Images in Rome", *Journal of Roman Archaeology*, 1994, vol. 7, pp. 80–99.

Griffin, J., "Love and Sex in Greece", *The New York Review*, 29 March 1990, pp. 6–12.

Habinek, T. (ed.), *The Roman Cultural Revolution*, New York, Cambridge University Press, 1997.

Hallett, J., "Roman Attitudes towards Sex", in D. Kertzer and R. Saller (eds), *The Family in Italy from Antiquity to the Present*, New Haven, Yale University Press, 1991, pp. 1265–78.

Hallett, J. P., "Feminist Theory, Historical Periods, Literary Canons, and the Study of Greco-Roman Antiquity", in N. S. Rabinowitz and A. Richlin (eds), *Feminist Theory and the Classics*, New York, Routledge, 1993, pp. 44–72.

Halperin, D. M., "Sex Before Sexuality: Pederasty, Politics, and Power in Classical Athens", in M. Duberman, M. Vicinus, and G. Chauncey, Jr (eds), *Hidden from History: Reclaiming the Gay and Lesbian Past*, New York, Penguin Group, 1990, pp. 37–53.

Halperin, D. M., *One Hundred Years of Homosexuality and other Essays on Greek Love*, New York, Routledge, 1990.

Halperin, D. M., J. J. Winkler, and F. I. Zeitlin (eds), *Before Sexuality: The Construction of Erotic Experience in the Ancient Greek World*, Princeton, Princeton University Press, 1990.

Hanson, A. E., "The Medical Writers' Woman", in D. M. Halperin, J. J. Winkler, and F. I. Zeitlin (eds), *Before Sexuality: The Construction of Erotic Experience in the Ancient Greek World*, Princeton, Princeton University Press, 1990, pp. 208–337.

Hanson, A. E., "Conception, Gestation, and the Origin of Female Nature in the *Corpus Hippocraticum*", *Helios*, 1992, vol. 19, pp. 31–71.

Harding, S., *The Science Question in Feminism*, Ithaca, Cornell University Press, 1986.

Hartman, J. E. and E. Messer-Davidow (eds), *(En)gendering Knowledge: Feminists in Academe*, Knoxville, University of Tennessee Press, 1991.

Haskell, M., *From Reverence to Rape: The Treatment of Women in the Movies*, New York, Holt, Rinehart, and Winston, 1974.

Havelock, C. M., "Mourners on Greek Vases," in N. Broude and M. D. Garrard (eds), *Feminism and Art History: Questioning the Litany*, New York, Harper and Row, 1982.

Hawley, R. and B. Levick (eds), *Women in Antiquity: New Assessments*, London and New York, Routledge, 1995.

Hayden, B., "Observing Prehistoric Women," in C. Claassen (ed.), *Exploring Gender Through Archaeology: Selected Papers from the 1991 Boone Conference*, Monographs in World Archaeology 11, Madison, Prehistory Press, 1992, pp. 33–47.

Hays, K. A., "When Is a Symbol Archaeologically Meaningful?: Meaning, Function, and Prehistoric Visual Arts," in N. Yoffee and A. Sherratt (eds), *Archaeological Theory: Who Sets the Agenda?* Cambridge, Cambridge University Press, 1993, pp. 81–92.

Hekma, G., "A History of Sexology," in J. Bremmer (ed.), *From Sappho to De Sade: Moments in the History of Sexuality*, New York, Routledge, 1989, pp. 173–93.

Herbert, T. Walter, Jr, "The Erotics of Purity: The Marble Faun and the Victorian Construction of Sexuality," *Representations*, 1991, vol. 36, pp. 114–32.

Herdt, G., *Third Sex, Third Gender: Beyond Sexual Dimorphism in Culture and History*, New York, Zone Books, 1994.

Hess, T. and L. Nochlin, *Woman as Sex Object: Studies in Erotic Art, 1730–1970, Art New Annual*, New York, Newsweek, vol. 38, 1972.

Himmelmann, N., *Ideale Nacktheit in der griechischen Kunst*, Berlin, W. de Gruyter, 1990.

Hitchcock, L. A., "Engendering Domination: A Structural and Contextual Analysis of Minoan Neopalatial Bronze Figurines," in E. Scott and J. Moore (eds), *Invisible People and Processes: Writing Gender and Childhood into European Archaeology*, London, Leicester University Press, 1997.

Hodder, I. (ed.), *Symbols in Action*, Cambridge, Cambridge University Press, 1982.

Hodder, I., "Postprocessual Archaeology," *Advances in Archaeological Method and Theory*, 1985, vol. 8, pp. 1–26.

Hodder, I., *Reading the Past. Current Approaches to Interpretation in Archaeology*, Cambridge, Cambridge University Press, 1991.

Hodder, I., *Theory and Practice in Archaeology*, New York, Routledge, 1992.

Hodder, I., M. Shanks, A. Alexandri *et al.* (eds), *Interpreting Archaeology: Finding Meaning in the Past*, New York, Routledge, 1995.

Hoffmann, G., *La jeune fille, le pouvoir et la mort dans l'Athènes classique*, Paris, De Boccard, 1992.

Holland, P., "The Page Three Girl Speaks to Women, Too," in R. Betterton (ed.), *Looking On: Images of Femininity in the Visual Arts and Media*, New York, Pandora Press, 1987, pp. 105–19. Reprinted from *Screen*, 1983, vol. 24 (3).

Hooper-Greenhill, E., *Museums and the Shaping of Knowledge*, New York, Routledge, 1992.

Hurcombe, L., "Our Own Engendered Species," *Antiquity*, 1995, vol. 69, pp. 87–100.

Irby-Massie, G. L., "Women in Ancient Science," in M. DeForest (ed.), *Woman's Power, Man's Game: Essays in Classical Antiquity in Honor of Joy K. King*, Wauconda, Bolchazy-Carducci, 1993, pp. 354–72.

Johns, C., *Sex or Symbol?: Erotic Images of Greece and Rome*, London, British Museum Publications and Austin, University of Texas Press, 1982.

Joshel, S., *Work, Identity and Legal Status at Rome: A Study of the Occupational Inscriptions*, Norman, University of Oklahoma Press, 1992.

Just, R., *Women in Athenian Law and Life*, London, Routledge, 1989.

Kampen, N. B., *Image and Status: Roman Working Women in Ostia*, Berlin, Gebr. Mann Verlag, 1981.

Kampen, N. B., "Social Status and Gender in Roman Art: The Case of the Saleswoman," in N. Broude and M. D. Garrard (eds), *Feminism and Art History: Questioning the Litany*, New York, Harper and Row, 1982, pp. 63–77.

Kampen, N. B., "Between Public and Private: Women as Historical Subjects in Roman Art," in S. B. Pomeroy (ed.), *Women's History and Ancient History*, Chapel Hill, University of North Carolina Press, 1991, pp. 218–48.

Kampen, N. B., "The Muted Other: Gender and Morality in Augustan Rome and Eighteenth-Century Europe," in N. Broude and M. D. Garrard (eds), *The Expanding Discourse: Feminism and Art History*, New York, IconEditions, Harper-Collins, 1992, pp. 161–9.

Kampen, N. B., "Material Girl: Feminist Confrontations With Roman Art," *Arethusa*, 1994, vol. 27 (1), pp. 111–37.

Kampen, N. B., "Looking at Gender: The Column of Trajan and Roman Historical Relief," in D. C. Stanton and A. J. Stewart (eds), *Feminisms in the Academy*, Ann Arbor, University of Michigan Press, 1995, pp. 43–73.

Kampen, N. B. (ed.), with B. Bergman, A. Cohen, P. duBois, B. Kellum, and E. Stehle, *Sexuality in Ancient Art: Near East, Egypt, Greece, and Italy*, New York, Cambridge University Press, 1996.

Kappeler, S., *The Pornography of Representation*, Minneapolis, University of Minnesota Press, 1986.

Karp, I. and S. D. Lavine (eds), *Exhibiting Cultures: The Poetics and Politics of Museum Display*, Washington, DC, Smithsonian Institution Press, 1991.

Kasson, J. S., *Marble Queens and Captives: Women in Nineteenth-Century American Sculpture*, New Haven, Yale University Press, 1990.

Katz, M. A., "Sexuality and the Body in Ancient Greece," *Métis, Revue d'Anthropologie du Monde Grec Ancien*, 1989, vol. 4, pp. 155–79.

Katz, M. A., "Ideology and 'the Status of Women' in Ancient Greece," in R. Hawley and B. Levick (eds), *Women in Antiquity: New Assessments*, New York, Routledge, 1995, pp. 21–43.

Kehoe, A. B., "Contextualizing Archaeology," in A. L. Christenson (ed.), *Tracing Archaeology's Past: The Historiography of Archaeology*, Carbondale, Southern Illinois University Press, 1989, pp. 97–106.

Keller, E. F., *Reflections on Gender and Science*, New Haven, Yale University Press, 1985.

Kelley, J. H. and M. P. Hanen, *Archaeology and the Methodology of Science*, Albuquerque, University of New Mexico Press, 1988.

Kendall, R. and G. Pollock (eds), *Dealing with Degas: Representations of Women and the Politics of Vision*, London, Pandora Press, 1992.

Kent, S., "Looking Back," in S. Kent and J. Morreau (eds), *Women's Images of Men*, London, Writers and Readers Publishing, 1985, pp. 55–74.

Keuls, E. C., *The Reign of the Phallus: Sexual Politics in Ancient Athens*, Berkeley, University of California Press, 1993 (first ed. 1985).

Kilmer, M. F., *Greek Erotica on Attic Red-Figure Vases*, London, Duckworth, 1993.

King, H., "Bound to Bleed: Artemis and Greek Women," in A. Cameron and A. Kuhrt (eds), *Images of Women in Antiquity*, Detroit, Wayne State University Press, 1983, pp. 109–27.

King, H., "Medical Texts as a Source for Women's History," in Anton Powell (ed.), *The Greek World,* London, Routledge, 1995.

King, K., "Producing Sex, Theory, and Culture: Gay/Straight Remappings in Contemporary Feminism," in M. Hirsch and E. F. Keller, *Conflicts in Feminism,* New York, Routledge, 1990, pp. 82–101.

Kleiner, D. E. E. and S. Matheson, *I Claudia: Women in Ancient Rome,* Austin, University of Texas Press, 1996.

Kohl, P. L., "Limits to a Post-processual Archaeology (Or, The Dangers of a New Scholasticism)," in N. Yoffee and A. Sherratt (eds), *Archaeological Theory: Who Sets the Agenda?* Cambridge, Cambridge University Press, 1993, pp. 13–19.

Kokkinidou, D. and M. Nikolaidou, *Archaeology and Gender: Approaches to Aegean Prehistory,* Thessaloniki, Ekdoseis Banias, 1993 (in Greek).

Koloski-Ostrow, A. O., *The Sarno Bath Complex,* "L'Erma" di Bretschneider, Rome, 1990.

Konstan, D. and M. Nussbaum (eds), "Sexuality in Greek and Roman Society," *Differences,* 1990, vol. 2 (1) (special issue on sexuality in the classical world).

Kriz, K. Dian, "Dido versus the Pirates: Turner's Carthaginian Paintings and the Sublimation of Colonial Desire," *Oxford Art Journal,* 1995, vol. 18, pp. 116–32.

Langer, C. L., "Emerging Feminism and Art History," *Art Criticism,* 1979, vol. 1 (2), pp. 66–83.

Langer, C. L., "Against the Grain: A Working Gynergenic Art Criticism," in A. Raven, C. L. Langer, and J. Frueh, (eds), *Feminist Art Criticism: An Anthology,* Ann Arbor, UMI Research Press, 1988, pp. 111–31. Also published by HarperCollins, 1991. Reprinted from *International Journal of Women's Studies,* 1982, vol. 5 (3).

Langer, C. L., "Turning Points and Sticking Places in Feminist Art Criticism," *College Art Journal,* 1991, vol. 50 (2), pp. 21–8.

Langer, C. L., *Feminist Art Criticism: An Annotated Bibliography,* New York, G. K. Hall, 1993.

Lardinoi, A., "Lesbian Sappho and Sappho of Lesbos," in J. Bremmer (ed.), *From Sappho to De Sade: Moments in the History of Sexuality,* New York, Routledge, 1989, pp. 15–35.

Lefkowitz, M. and M. Fant, *Women's Life in Greece and Rome: A Source Book in Translation,* Baltimore, Johns Hopkins University Press, 1982, 2nd ed. 1992.

Licht, H., *Sexual Life in Ancient Greece,* New York, Barnes and Noble, 1963.

Lissarrague, F., in P. Schmitt Pantel (ed.), *A History of Women: From Ancient Goddesses to Christian Saints,* Cambridge, Mass., Harvard University Press, 1994.

Lissarrague, F., "Women, Boxes, Containers: Some Signs and Metaphors," in E. Reeder (ed.), *Pandora: Women in Classical Greece,* Baltimore and Princeton, Princeton University Press (and Walters Art Gallery), 1995, pp. 99–101.

Little, B. J., "Consider the Hermaphroditic Mind: Comment on 'The Interplay of Evidential Constraints and Political Interests: Recent Archaeological Research on Gender'," *American Antiquity,* 1994, vol. 59, pp. 539–44.

Loraux, N., *Tragic Ways of Killing a Woman,* trans. A. Forster, Cambridge, Mass., Harvard University Press, 1987.

Loraux, N., "Herakles: The Super-male and the Feminine," in D. M. Halperin, J. J. Winkler, and F. I. Zeitlin (eds), *Before Sexuality: The Construction of Erotic Experience in the Ancient Greek World,* Princeton, Princeton University Press, 1990, pp. 21–52.

Loraux, N., *The Children of Athena: Athenian Ideas about Citizenship and the Division between the Sexes,* trans. by C. Levine, Princeton, Princeton University Press, 1993.

Loraux, N., "What is a Goddess?," in P. Schmitt Pantel (ed.), *A History of Women:*

From Ancient Goddesses to Christian Saints, Cambridge, Mass., Harvard University Press, 1994, pp. 11–44.

Loraux, N., *The Experiences of Tiresias: The Feminine and the Greek Man*, Princeton, Princeton University Press, 1995.

Lyons, C., "Gender and Burial in Early Colonial Sicily: The Case of Morgantina," in L. Hurcombe and M. Donald (eds), *Representations of Gender from Prehistory to the Present*, London, Macmillan, in press.

MacAlister, S., "Gender as Sign and Symbolism in Artemidoros' *Oneirokritika*: Social Aspirations and Anxieties," *Helios*, 1992, vol. 19, pp. 140–60.

McClintock, A., "The Return of Female Fetishism and the Fiction of the Phallus," *New Formations*, spring 1993, vol. 19, pp. 1–21.

McDonnell, M.,"The Introduction of Athletic Nudity: Thucydides, Plato, and the Vases," *Journal of Hellenic Studies*, 1991, vol. 111, pp. 182–93.

McGuire, R. H. and R. Paynter (eds), *The Archaeology of Inequality*, Oxford, Basil Blackwell, 1991.

Mack, R., "Ambiguity and the Image of the King," in W. Davis (ed.), *Gay and Lesbian Studies in Art History*, New York, Haworth Press, 1994, pp. 11–34.

Mack, R., *Ordering the Body and Embodying Order*, Ph.D. dissertation, University of California, Berkeley, 1996.

McNiven, T., "The Unheroic Penis," *Source*, fall 1995, vol. 15 (1), pp. 10–16.

Malhotra Bentz, V. and P. E. F. Mayes (eds), *Women's Power and Roles as Portrayed in Visual Images of Women in the Arts and Mass Media*, Lewiston, NY, Edwin Mellen Press, 1993.

Marter, J., "Joan Semmel's Nudes: The Erotic Self and the Masquerade," *Women's Art Journal*, 1996, vol. 16 (2), pp. 24–8.

Meskell, L., "Goddesses, Gimbutas, and 'New Age' Archaeology," *Antiquity*, 1995, vol. 69, pp. 74–86.

Meslin, M., "Agdistis ou l'androgénie malséante," in M. B. de Boer and T. A. Eldridge (eds), *Hommages à Maarten J. Vermaseren*, Leiden, Brill, 1978, pp. 765–76.

Miller, B. D., "The Anthropology of Sex and Gender Hierarchies," in B. D. Miller (ed.), *Sex and Gender Hierarchies*, New York, Cambridge University Press, 1993, pp. 3–31.

Miller, D., M. Rowlands, and C. Tilley (eds), *Domination and Resistance*, London, Unwin Hyman, 1989.

Moi, T. (ed.), *French Feminist Thought: A Reader*, Oxford, Basil Blackwell, 1987.

Molino, J., "Archaeology and Symbol Systems," in J.-C. Gardin and C. S. Peebles (eds), *Representation in Archaeology*, Bloomington, Indiana University Press, 1992, pp. 15–29.

Morris, I. (ed.), *Classical Greece: Ancient Histories and Modern Archaeologies*, Cambridge, Cambridge University Press, 1994.

Mulvey, L., "Introduction," in L. Mulvey (ed.), *Visual and Other Pleasures*, Bloomington, Indiana University Press, 1989, pp. vii–xvi.

Mulvey, L., "Visual Pleasure and Narrative Cinema," in L. Mulvey (ed.), *Visual and Other Pleasures*, Bloomington, Indiana University Press, 1989, pp. 14–38. Reprinted from *Screen*, Autumn 1975, vol. 16 (3).

Mulvey, L., "Afterthoughts on 'Visual Pleasure and Narrative Cinema' Inspired by *Duel in the Sun*," in T. Bennett (ed.), *Popular Fiction, Technology, Ideology, Production, Reading*, London, Routledge, 1990, pp. 139–51.

Myerowitz, M., "The Domestication of Desire: Ovid's *Parva Tabella* and the Theater of Love," in A. Richlin (ed.), *Pornography and Representation in Greece and Rome*, New York, Oxford University Press, 1992, pp. 131–57.

Myers, K., "Fashion 'n' Passion," in R. Betterton (ed.), *Looking On: Images of*

Femininity in the Visual Arts and Media, New York, Pandora Press, 1987, pp. 58–65. Reprinted from *Screen*, 1982, vol. 23 (3–4).

Nead, L., *The Female Nude: Art, Obscenity and Sexuality*, New York, Routledge, 1992.

Nead, L., "Seductive Canvases: Visual Mythologies of the Artist and Artistic Creativity," *Oxford Art Journal*, 1995, vol. 18 (2), pp. 59–69.

Nochlin, L., "Eroticism and Female Imagery in Nineteenth-Century Art," in L. Nochlin (ed.), *Women, Art, and Power and Other Essays*, New York, Harper and Row, 1988, pp. 136–44. Reprinted from T. B. Hess and L. Nochlin (eds), *Woman as Sex-object: Studies in Erotic Art, 1730–1970*, New York, Newsweek Books, 1972, *Art News Annual*, vol. 38.

Nochlin, L., "Why Have There Been No Great Women Artists?," in L. Nochlin (ed.), *Women, Art, and Power and Other Essays*, New York, Harper and Row, 1988, pp. 144–78. Reprinted from *Art News*, 1971, vol. 69. (First appeared as "Why Are There No Great Women Artists?," in Vivian Gornick and B. Moran (eds), *Women in Sexist Society*, New York, Basic Books, 1971.)

Nochlin, L., "Women, Art, and Power," in L. Nochlin (ed.), *Women, Art, and Power and Other Essays*, New York, Harper and Row, 1988, pp. 1–36.

Nochlin, L., "Starting from Scratch: The Beginnings of Feminist Art History," in N. Broude and M. D. Garrard (eds), *The Power of Feminist Art: The American Movement of the 1970s, History and Impact*, New York, Harry Abrams, 1994, pp. 130–7.

Nordbladh, J. and T. Yates, "This Perfect Body, This Virgin Text: Between Sex and Gender in Archaeology," in I. Bapty and T. Yates (eds), *Archaeology After Structuralism: Post-structuralism and the Practice of Archaeology*, New York, Routledge, 1990, pp. 222–37.

Oakley, J. H., "Nuptial Nuances: Wedding Images in Non-Wedding Scenes of Myth," in E. D. Reeder (ed.), *Pandora: Women in Classical Greece*, Baltimore and Princeton, Princeton University Press, 1995.

Oakley, J. H. and R. H. Sinos, *The Wedding in Ancient Athens*, Madison, University of Wisconsin Press, 1993.

Olender, M., "Aspects of Baubo: Ancient Texts and Contexts," in D. M. Halperin, J. J. Winkler, and F. I. Zeitlin (eds), *Before Sexuality: The Construction of Erotic Experience in the Ancient Greek World*, Princeton, Princeton University Press, 1990, pp. 83–113.

Orenstein, G. F., *The Reflowering of the Goddess*, Elmsford, New York, Pergamon Press, 1990.

Orenstein, G. F., "Recovering Her Story: Feminist Artists Reclaim the Great Goddess," in N. Broude and M. D. Garrard (eds), *The Power of Feminist Art: The American Movement of the 1970s, History and Impact*, New York, Harry Abrams, 1994, pp. 174–89.

Ortner, S., "On Key Symbols," *American Anthropologist*, 1972, vol. 75, pp. 1338–46.

Ortner, S. and H. Whitehead, "Introduction: Accounting for Sexual Meanings," in S. Ortner and H. Whitehead (eds), *Sexual Meanings, the Cultural Construction of Gender and Sexuality*, Cambridge, Cambridge University Press, 1981, pp. 1–28.

Osborne, R., "Looking On – Greek Style: Does the Sculpted Girl Speak to Women, Too?," in I. Morris (ed.), *Classical Greece: Ancient Histories and Modern Archaeologies*, Cambridge and New York, Cambridge University Press, 1994, pp. 81–96.

Owens, C., "The Discourse of Others: Feminists and Postmodernism," in N. Broude and M. D. Garrard (eds), *The Expanding Discourse: Feminism and Art History*, New York, IconEditions, HarperCollins, 1992, pp. 487–502. Reprinted

from H. Foster (ed.), *The Anti-Aesthetic: Essays on Postmodern Culture*, Port Townsend, Bay Press, 1983.

Padel, R., "Women: Model for Possession by Greek Daemons," in A. Cameron and A. Kuhrt (eds), *Images of Women in Antiquity*, Detroit, Wayne State University Press, 1983, pp. 3–19.

Parker, H. N., "Love's Body Anatomized: The Ancient Erotic Handbooks and the Rhetoric of Sexuality," in A. Richlin (ed.), *Pornography and Representation in Greece and Rome*, New York and Oxford, Oxford University Press, 1992, pp. 90–111.

Parker, R., *Miasma*, Oxford, Clarendon, 1983.

Passman, T., "Out of the Closet and Into the Field: Matriculture, the Lesbian Perspective, and Feminist Classics," in N. S. Rabinowitz and A. Richlin (eds), *Feminist Theory and the Classics*, New York, Routledge, 1993, pp. 181–208.

Patrik, L. E., "Is there an Archaeological Record?," *Advances in Archaeological Method and Theory*, 1985, vol. 8, pp. 27–62.

Peradotto, J. and J. P. Sullivan (eds), *Women in the Ancient World: The Arethusa Papers*, Albany, State University of New York Press, 1984.

Percy III, W. A., *Pederasty and Pedagogy in Archaic Greece*, Urbana and Chicago, University of Illinois Press, 1996.

Peristiany, J. (ed.), *Honour and Shame: The Values of Mediterranean Society*, Chicago, University of Chicago Press, 1967.

Pinney, G. F., "Fugitive Nudes: The Woman Athlete," *American Journal of Archaeology*, 1995, vol. 99, p. 303.

Pinney, G. F., *Figures of Speech*, Chicago, University of Chicago Press, forthcoming.

Pointon, M., *Naked Authority: The Body in Western Painting, 1830–1908*, Cambridge, Cambridge University Press, 1990.

Pollock, G., "What's Wrong with Images of Women?," in R. Betterton (ed.), *Looking On: Images of Femininity in the Visual Arts and Media*, New York, Pandora Press, 1987, pp. 40–8. Reprinted from *Screen Education*, 1977, vol. 24.

Pollock, G., "The Politics of Theory: Generations and Geographies, Feminist Theory and the Histories of Art Histories," *Genders*, 1993, vol. 17, pp. 97–120.

Pomeroy, S. B., "Selected Bibliography on Women in Classical Antiquity," in J. Peradotto and J. P. Sullivan (eds), *Women in the Ancient World: The Arethusa Papers*, Albany, State University of New York Press, 1984, pp. 315–72.

Pomeroy, S. B. (ed.), *Women's History and Ancient History*, Chapel Hill and London, University of North Carolina Press, 1991.

Pomeroy, S. B., *Goddesses, Whores, Wives, and Slaves: Women in Classical Antiquity*, New York, Schocken Books, 1995 (new edition of 1975 version with new preface and supplemental bibliography).

Preziosi, D., *Rethinking Art History: Meditations on a Coy Science*, New Haven, Yale University Press, 1989.

Price, T. Hadzisteliou, *Kourotrophos: Cults and Representations of the Greek Nursing Deities*, Leiden, Brill, 1978.

Rabinowitz, N. S., "Introduction," in N. S. Rabinowitz and A. Richlin (eds), *Feminist Theory and the Classics*, New York, Routledge, 1993, pp. 1–20.

Raehs, A., *Zur Ikonographie des Hermaphroditen: Begriff und Problem von Hermaphroditismus und Androgynie in der Kunst*, Frankfurt, P. Lang, 1990.

Raven, A., C. L. Langer, and J. Frueh (eds), *Feminist Art Criticism: An Anthology*, Ann Arbor, UMI Research Press, 1988. Also published by HarperCollins, 1991.

Rawson, B., "From 'Daily Life' to 'Demography'," in R. Hawley and B. Levick (eds), *Women in Antiquity: New Assessments*, New York, Routledge, 1995, pp. 1–20.

Reeder, E. (ed.), *Pandora: Women in Classical Greece*, Baltimore and Princeton, Princeton University Press (and Walters Art Gallery), 1995.

Reilly, J., "Many Brides: 'Mistress and Maid' on Athenian Lekythoi", *Hesperia*, 1989, vol. 58, pp. 411–44.

Reinsberg, C., *Ehe, Hetärentum und Knabenliebe im antiken Griechenland*, Munich, C. H. Beck, 1989.

Renfrew, C., *Approaches to Social Archaeology*, Edinburgh, Edinburgh University Press, 1984.

Richlin, A., "Zeus and Metis: Foucault, Feminism, Classics", *Helios*, 1991, vol. 18 (2), pp. 160–80.

Richlin, A., *The Garden of Priapus.: Sexuality and Aggression in Roman Humor*, New York, Oxford University Press, 1992 (rev. ed. of 1983).

Richlin, A., "Reading Ovid's Rapes", in A. Richlin (ed.), *Pornography and Representation in Greece and Rome*, Oxford and New York, Oxford University Press, 1992, pp. 158–79.

Richlin, A. (ed.), *Pornography and Representation in Greece and Rome*, New York, Oxford University Press, 1992.

Richlin, A., "The Ethnographer's Dilemma and the Dream of a Lost Golden Age", in N. S. Rabinowitz and A. Richlin (eds), *Feminist Theory and the Classics*, New York, Routledge, 1993, pp. 272–303.

Richlin, A., "Not Before Homosexuality: The Materiality of the Cinaedus and the Roman Law Against Love Between Men", *Journal of the History of Sexuality*, 1993, vol. 3 (4), pp. 523–73.

Ridgway, B. S., "Ancient Greek Women and Art: The Material Evidence", *American Journal of Archaeology*, 1987, vol. 91, pp. 399–409.

Robb, J., "Burial and Social Reproduction in the Peninsular Italian Neolithic", *Journal of Mediterranean Archaeology*, 1994, vol. 7, pp. 27–71.

Robb, J., "Gender Contradictions: Moral Coalitions and Inequality in Prehistoric Italy", *Journal of European Archaeology*, 1994, vol. 2, pp. 20–49.

Robb, J., *From Gender to Class: Inequality in Prehistoric Italy*, Ph.D. dissertation, Department of Anthropology, University of Michigan, 1995.

Robb, J., "Violence and Gender in Early Italy", in D. Frayer and D. Martin (eds), *Troubled Times: Violence and Warfare in the Past*, New York, Gordon and Breach, 1997, pp. 108–41.

Robertson, M. and M. Beard, "Adopting an Approach", in T. Rasmussen and N. Spivey (eds), *Looking at Greek Vases*, Cambridge, Cambridge University Press, 1991, pp. 1–36.

Robin, D., "Film Theory and the Gendered Voice in Seneca", in N. S. Rabinowitz and A. Richlin (eds), *Feminist Theory and the Classics*, New York, Routledge, 1993, pp. 102–21.

Robins, G., "Dress, Undress and the Representation of Fertility and Potency in New Kingdom Egyptian Art", in N. B. Kampen (ed.), *Sexuality in Ancient Art: Near East, Egypt, Greece and Italy*, New York and Cambridge, Cambridge University Press, 1996, pp. 27–40.

Robinson, D. M., *Sappho and Her Influence*, Boston, Marshall Jones, 1924.

Rousselle, A., *Porneia: On Desire and the Body in Antiquity*, Oxford and New York, Basil Blackwell, 1988.

Sahlins, M., *Historical Metaphors and Mythical Realities in the Early History of the Sandwich Islands*, Ann Arbor, University of Michigan Press, 1981.

Said, E. W., *Orientalism*, New York, Pantheon, 1978.

Salomon, N., "The Art Historical Canon: Sins of Omission", in J. E. Hartman and E. Messer-Davidow (eds), *(En)gendering Knowledge: Feminists in Academe*, Knoxville, University of Tennessee Press, 1991, pp. 222–36.

Salomon, N., "The Venus Pudica: Uncovering Art History's 'Hidden Agendas' and

Pernicious Pedigrees," in G. Pollock (ed.), *Generations and Geographies in the Visual Arts: Feminist Readings*, London, Routledge, 1996, pp. 69–87.

Schneider, L. Adams, "Ms. Medusa: Transformation of a Bisexual Image," *The Psychoanalytic Study of Society*, vol. 9, New York, 1981, pp. 105–53.

Scott, E. M. (ed.), *Those of Little Note: Gender, Race, and Class in Historical Archaeology*, Tucson, University of Arizona Press, 1994.

Scott, J. W., *Gender and the Politics of History*, New York, Columbia University Press, 1988.

Scott, J. W., "Deconstructing Equality-versus-Difference: Or, the Uses of Post-structuralist Theory for Feminism," in M. Hirsch and E. F. Keller (eds), *Conflicts in Feminism*, New York, Routledge, 1990, pp. 134–48.

Scully, V., "The Great Goddess and the Palace Architecture of Crete," in N. Broude and M. D. Garrard (eds), *Feminism and Art History: Questioning the Litany*, New York, Harper and Row, 1982, pp. 33–43.

Sedgwick, E. K., *Between Men: English Literature and Male Homosocial Desire*, New York, Columbia University Press, 1985.

Sennett, R., *Flesh and Stone: The Body and the City in Western Civilization*, New York and London, W. W. Norton, 1994.

Serwint, N., "The Female Athletic Costume at the Heraia and Prenuptial Initiation Rites," *American Journal of Archaeology*, 1993, vol. 97, pp. 403–22.

Shanks, M. and I. Hodder, "Processual, Postprocessual and Interpretive Archaeologies," in I. Hodder, M. Shanks, A. Alexandri *et al.* (eds), *Interpreting Archaeology: Finding Meaning in the Past*, New York, Routledge, 1995, pp. 3–29.

Shanks, M. and C. Tilley, *Re-constructing Archaeology: Theory and Practice*, Cambridge, Cambridge University Press, 1987.

Shanks, M. and C. Tilley, *Social Theory and Archaeology*, Albuquerque, University of New Mexico Press, 1987. Also published by Polity Press, Cambridge, 1987.

Shapiro, H. A., "Courtship Scenes in Attic Vase-Painting," *American Journal of Archaeology*, 1981, vol. 85, pp. 133–43.

Shapiro, H. A., "Eros in Love: Pederasty and Pornography in Greece," in A. Richlin (ed.), *Pornography and Representation in Greece and Rome*, Oxford and New York, Oxford University Press, 1992, pp. 53–72.

Silberberg-Pierce, S., "The Muse Restored: Images of Women in Roman Painting," *Woman's Art Journal*, 1993–4, vol. 14 (2), pp. 28–36.

Silverman, K., *The Acoustic Mirror: The Female Voice in Psychoanalysis and Cinema*, Bloomington, Indiana University Press, 1988.

Simons, P., "Women in Frames: The Gaze, the Eye, the Profile in Renaissance Portraiture," in N. Broude and M. D. Garrard (eds), *The Expanding Discourse: Feminism and Art History*, New York, IconEditions, HarperCollins, 1992, pp. 39–57. Reprinted from *History Workshop: A Journal of Socialist and Feminist Historians*, spring 1988, vol. 25.

Sissa, G., "Maidenhood without Maidenhead. The Female Body in Ancient Greece," in D. M. Halperin, J. J. Winkler, and F. I. Zeitlin (eds), *Before Sexuality: The Construction of Erotic Experience in the Ancient Greek World*, Princeton, Princeton University Press, 1990, pp. 339–64.

Sissa, G., *Greek Virginity*, Cambridge, Mass., Harvard University Press, 1990.

Skeates, R., "Ritual, Context and Gender in Neolithic South-eastern Italy," *Journal of European Archaeology*, 1994, vol. 2, pp. 199–214.

Skinner, M. B., "Nossis Thēly Glōssos: The Private Text and the Public Book," in S. B. Pomeroy (ed.), *Women's History and Ancient History*, Chapel Hill and London, University of North Carolina Press, 1991, pp. 20–47.

Slane, K. W. and M. W. Dickie, "A Knidian Phallic Vase from Corinth," *Hesperia*, 1993, vol. 62, pp. 483–505.

Slater, P. E., *The Glory of Hera: Greek Mythology and the Greek Family*, Boston, Beacon Press, 1968.

Snodgrass, A., "Structural History and Classical Archaeology," in J. Bintliff (ed.), *The Annales School and Archaeology*, Leicester, Leicester University Press, 1991, pp. 57–72.

Snyder, J. McI., "Sappho and Other Women Musicians in Attic Vase Painting," forthcoming in A. Buckley (ed.), *Sound Sense: Essays in Historical Ethnomusicology*, Liège, Études et Recherches Archéologiques de l'Université de Liège.

Songe-Møller, V., "The Definition of 'Male' and 'Female' – An Unsolved Problem," *Studia Theologica*, 1989, vol. 43, pp. 91–8.

Sourvinou-Inwood, C., *Studies in Girls' Transitions: Aspects of the Arkteia and Age Representation in Attic Iconography*, Athens, Kardamitsa, 1988.

Spector, J. D., "What This Awl Means: Toward a Feminist Archaeology," in J. M. Gero and M. W. Conkey (eds), *Engendering Archaeology: Women and Prehistory*, Cambridge, Mass., Basil Blackwell, 1991, pp. 388–406.

Spector, J. D., with C. C. Cavender *et al.*, *What This Awl Means: Feminist Archaeology at a Wahpeton Dakota Village*, St Paul, Minnesota Historical Society Press, 1993.

Stanton, D. C. (ed.), *Discourses of Sexuality: From Aristotle to AIDS*, Ann Arbor, Univeristy of Michigan Press, 1992.

Stanton, D. C. and A. J. Stewart (eds), "Introduction. Remodeling Relations: Women's Studies and the Discipline," in D. C. Stanton and A. J. Stewart (eds), *Feminisms in the Academy*, Ann Arbor, University of Michigan Press, 1995, pp. 1–16.

Stanton, D. C. and A. J. Stewart (eds), *Feminisms in the Academy*, Ann Arbor, University of Michigan Press, 1995.

Steinberg, L., "The Signal at the Breast," in *The Sexuality of Christ in Renaissance Art and in Modern Oblivion*, New York, Pantheon Books, 1983, pp. 127–30.

Stewart, A., "Rape?," in E. D. Reeder (ed.), *Pandora: Women in Classical Greece*, Baltimore and Princeton, Walters Art Gallery and Princeton University Press, 1995, pp. 74–90.

Stewart, A., *Art, Desire, and the Body in Ancient Greece*, Cambridge, Cambridge University Press, 1997.

Stocking, G. W., *Objects and Others: Essays on Museums and Material Culture*, Madison, University of Wisconsin Press, 1985.

Stone, P. and R. MacKenzie (eds), *The Excluded Past: Archaeology in Education*, Boston, Unwin Hyman, 1990.

Strauss, B. S., *Fathers and Sons in Athens: Ideology and Society in the Era of the Peloponnesian War*, Princeton, Princeton University Press, 1993.

Strömberg, A., *Male or Female? A Methodological Study of Grave Gifts as Sex-indicators in Iron Age Burials from Athens*, Studies in Mediterranean Archaeology and Literature, Jonsered, P. Åstroms Förlag, 1993.

Sutton, R. F., Jr, "Pornography and Persuasion on Attic Pottery," in A. Richlin (ed.), *Pornography and Representation in Greece and Rome*, Oxford and New York, Oxford University Press, 1992, pp. 3–52.

Talalay, L. E., "Body Imagery of the Ancient Aegean," *Archaeology*, 1991, vol. 44 (4), pp. 46–9.

Talalay, L. E., "A Feminist Boomerang: The Great Goddess of Greek Prehistory," *Gender and History*, 1994, vol. 6 (2), pp. 165–83.

Thomas, J., "After Essentialism: Archaeology, Geography, and Post-Modernity," *Archaeological Review from Cambridge*, 1993, vol. 12 (1), pp. 3–27.

Thorpe, J., "The Social Construction of Homosexuality," *Phoenix*, 1992, vol. 46, pp. 54–61.

Thurer, S., *The Myths of Motherhood: How Culture Reinvents the Good Mother*, Boston, Houghton Mifflin, 1994.

Tickner, L., "The Body Politic: Female Sexuality and Women Artists since 1970," in R. Betterton (ed.), *Looking On: Images of Femininity in the Visual Arts and Media*, New York, Pandora Press, 1987, pp. 235–53. Reprinted from *Art History*, 1978, vol. 1 (2).

Tickner, L., "Feminism, Art History, and Sexual Difference," *Genders*, 1988, vol. 3, pp. 92–128.

Tilley, C., "On Modernity and Archaeological Discourse," in I. Bapty and T. Yates (eds), *Archaeology after Structuralism: Post-structuralism and the Practice of Archaeology*, New York, Routledge, 1990, pp. 128–52.

Trigger, B. G., "History and Contemporary American Archaeology: A Critical Analysis," in C. C. Lamberg-Karlovsky (ed.), *Archaeological Thought in America*, Cambridge, Cambridge University Press, 1989, pp. 19–34.

Trigger, B. G., *A History of Archaeological Thought*, Cambridge, Cambridge University Press, 1989.

Tringham, R., "Households with Faces: The Challenge of Gender in Prehistoric Architectural Remains," in J. M. Gero and M. W. Conkey (eds), *Engendering Archaeology: Women in Prehistory*, Cambridge, Mass., Basil Blackwell, 1991, pp. 93–131.

Tringham, R., "Engendered Places in Prehistory," *Gender, Place, and Culture*, 1994, vol. 1, pp. 169–203.

Tyrrell, W. B., *Amazons: A Study in Athenian Mythmaking*, Baltimore, Johns Hopkins University Press, 1984.

Vernant, J.-P., "Between Shame and Glory: The Identity of the Young Spartan Warrior," in F. I. Zeitlin (ed.), *Mortals and Immortals: Collected Essays*, Princeton, Princeton University Press, 1991, pp. 220–43.

Versnel, H. S., *Ter Unus. Isis, Dionysos, Hermes. Three Studies in Henotheism*, Leiden, E. J. Brill, 1990.

Vida Navarro, M. L., "Warriors and Weavers: Sex and Gender in Early Iron Age Graves from Pontecagnano," *Journal of the Accordia Research Center*, 1992, vol. 3, pp. 67–100.

Vogel, L., "Fine Arts and Feminism, The Awakening Consciousness," in A. Raven, C. L. Langer, and J. Frueh (eds), *Feminist Art Criticism: An Anthology*, Ann Arbor, UMI Research Press, 1988, pp. 21–57. Also published by HarperCollins, 1991. Reprinted from *Feminist Studies*, 1974, vol. 2.

Walde, D. and N. Willows (eds), *The Archaeology of Gender: Proceedings of the 22nd Annual Chacmool Conference*, Alberta, Calgary University Press, Archaeological Association of the University of Calgary, 1991.

Wallace-Hadrill, A., "The Social Structure of the Roman House," *Papers of the British School at Rome*, 1988, vol. 56, pp. 43–97.

Wallace-Hadrill, A., *Houses and Society in Pompeii and Herculaneum*, Princeton, Princeton University Press, 1994.

Whelan, M., "Gender and Archaeology: Mortuary Studies and the Search for Gender Differentiation," in D. Walde and N. Willows (eds), *The Archaeology of Gender: Proceedings of the 22nd Annual Chacmool Conference*, Alberta, Calgary University Press, Archaeological Association of the University of Calgary, 1991, pp. 358–65.

Whitehouse, R. "Tools the Manmaker: The Cultural Construction of Gender in Italian Prehistory," *Journal of the Accordia Research Center*, 1992, vol. 3, pp. 41–54.

Whitehouse, R., *Underground Religion: Cult and Culture in Prehistoric Italy*, London, Accordia Research Center, 1992.

Wickert-Micknat, G., *Die Frau, Archaeologica Homerica*, Göttingen, Vandenhoeck and Ruprecht, 1982.

Williams, R., "Selections from Marxism and Literature," in N. Dirks, G. Eley, and S. Ortner (eds), *Culture/Power/History: A Reader in Contemporary Social Theory*, Princeton, Princeton University Press, 1994, p. 598.

Williamson, J., "Decoding Advertisements," in R. Betterton (ed.), *Looking On: Images of Femininity in the Visual Arts and Media*, New York, Pandora Press, 1987, pp. 49–52. Reprinted from J. Williamson, *Decoding Advertisements: Ideology and Meaning in Advertising*, London, Marion Boyars, 1978.

Winkler, J. J., "Phallos Politikos: Representing the Body Politic in Athens," *differences*, spring 1990, vol. 2 (1) = D. Konstan and M. Nussbaum (eds), *Sexuality in Greek and Roman Society*, pp. 29–45.

Winkler, J. J., *The Constraints of Desire: The Anthropology of Sex and Gender in Ancient Greece*, New York, Routledge, 1990.

Winter, I. J., "Sex, Rhetoric and the Public Monument: The Alluring Body of Naram-Sin of Agade," in N. B. Kampen (ed.), *Sexuality in Ancient Art: Near East, Egypt, Greece and Italy*, New York and Cambridge, Cambridge University Press, 1996, pp. 11–26.

Wright, R. P., (ed), *Gender and Archaeology*, Philadelphia, University of Pensylvania Press, 1996.

Wylie, A., "Gender Theory and the Archaeological Record: Why is there no Archaeology of Gender?" in J. Gero and M. Conkey (eds), *Engendering Archaeology: Women in Prehistory*, Oxford, Basil Blackwell, 1991, pp. 31–54.

Wylie, A., "Beyond Objectivism and Relativism: Feminist Critiques and Archaeological Challenges," in D. Walde and N. Willows (eds), *The Archaeology of Gender: Proceedings of the 22nd Annual Chacmool Conference*, Calgary, The Archaeological Association of the University of Calgary, 1991, pp. 17–23.

Wylie, A., "The Interplay of Evidential Constraints and Political Interests: Recent Archaeological Research on Gender," *American Antiquity*, 1992, vol. 57, pp. 15–35.

Wylie, A., "Foreword: Gender Archaeology/Feminist Archaeology," in E. Bacus, A. W. Barker, *et al.*, *A Gendered Past: A Critical Bibliography of Gender in Archaeology*, University of Michigan Museum of Anthropology Technical Report 25, Ann Arbor, Museum of Anthropology Publications, 1993, pp. vii–xiii.

Wylie, A., "A Proliferation of New Archaeologies: Beyond Objectivism and Relativism," in N. Yoffee and A. Sherratt (eds), *Archaeological Theory: Who Sets the Agenda?* Cambridge, Cambridge University Press, 1993, pp. 20–6.

Wylie, A., "On 'Capturing Facts Alive in the Past' (Or Present): Response to Fotiadis and to Little," *American Antiquity*, 1994, vol. 59, pp. 556–60.

Wylie, A., "The Constitution of Archaeological Evidence: Gender Politics and Science," in P. Galison and D. J. Stump (eds), *The Disunity of Science: Boundaries, Contexts, and Power*, Stanford, Stanford University Press, 1996.

Yoffee, N. and A. Sherratt, "Introduction: The Sources of Archaeological Theory," in N. Yoffee and A. Sherratt (eds), *Archaeological Theory: Who Sets the Agenda?* Cambridge, Cambridge University Press, 1993, pp. 1–9.

Zeitlin, F., "The Dynamics of Misogyny: Myth and Mythmaking in the *Oresteia*," *Arethusa*, 1978, vol. 11 (1–2), pp. 149–84.

Zeitlin, F., "Configurations of Rape in Greek Myth," in Sylvana Tomaselli and Roy Porter (eds), *Rape*, Oxford, Basil Blackwell, 1986, pp. 122–51.

Zeitlin, F., "Playing the Other: Theater, Theatricality, and the Feminine in Greek Drama," in J. J. Winkler and F. I. Zeitlin (eds) *Nothing to Do With Dionysos?*, Princeton, Princeton University Press, 1990.

INDEX

social stratification: in prehistoric Italy
52, 58; *see also* aristocracy, class
soma gunaikos 163
Sophocles 97
sophrosyne 210
Sparta 130
spear, as gender symbol in prehistoric
Italy 49, 58
spindle whorl, as gender symbol in
prehistoric Italy 50–1
spinning, as gender symbol in
prehistoric Italy 51–2; *see also*
weaving
stage, theatrical: architecture of 261 n.
23; as decoration 243, 247, 260 n. 18;
as design set 243, 247; metaphorical
staging 254; in private house
(*pulpitum*) 249, 252; taste for 243; *see
also* theater
stelae: Attic grave stelae 122–3, 154–60,
163–5, 175; Bologna 51, 179;
Castelluccio dei Sauri 48–9; Daunian
46–7, 51–2, 58; Etruscan 51, 179; Le
Faraglioni 48; Lagundo 48; Lunigiana
46–52; Sardinian 51; Sounion 211;
Thessalian 176; Venetic 51;
Villanovan 46
stool: in the Parthenon frieze 9, 120; *see
also diphrophoroi*
strigil, as gender symbol in prehistoric
Italy 50
structuralism 14, 16–17, 37 n. 61, 53
Suetonius 243, 259 n. 6, 260 nn. 7, 9,
10, 13
sword, as gender symbol in prehistoric
Italy 51, 58
symbols, and gender 45–6
symposion 135, 188, 225, 285

taboo: and Athenian sexuality 136–7;
and female nudity 141 n. 21; sight of
naked breast 188
Tacitus 260 n. 8; *Germania* 187
taste, imperial: *see* Emperors, Nero
Terence, *Eunuchus* 184
Thamyris 7, 8, 115
theater, Roman 243, 254; architecture
of 258 n. 1, 261 n. 2; *scaena frons* 247;
see also masks, theatrical;
performance, theatrical; scene-
painting
Thetis 248, 254

titthe 175, 186
tombs, princely burials in Campania,
Etruria, Latium 58
tools, as gendered grave goods in
prehistoric Italy 49, 51
Toppo Daguzzo 52
tragedy, Roman: *see* Seneca, Lucius
Annaeus
transgendering 4
Trimalchio 249; *see also* Petronius,
Satyricon
Troilus 135, 151 n. 78
Trojan War 69; in Pompeian painting
247, 251, 255–6; Trojan Horse 247,
255, 256
Troy Games 245
Turan 186

Uni 186
uterus 5, 163

Valcamonica 46–7, 51
Valtellina 49
Veii, terracotta statues of Leto and
Apollo 177–8
veil: in iconography of Agamemnon's
murder 95–7; worn by Aphrodite
and Hera in the Parthenon frieze
133–4
Venus 245, 252, 269–70; *see also*
Aphrodite
Venus Genetrix: *see* Aphrodite, Louvre
(Venus Genetrix) type
Venus rings 122–3
Verres 109
violence: against women 72, 77, 79–81,
266 n. 67; in the formulation male-
violence-power 4–5; in legendary
history of Rome 43; in Roman
domestic decor 10, 243, 247, 251,
254; on Roman stage 245–6; *see also*
rape
virginity 135, 148 n. 61
votives 161–3, 230
voyeurism 208, 231, 255, 265 n. 64; *see
also* feminist theory

wall painting 244, 247; *see also* houses,
Roman
warfare 132; and gender ideology in
Iron Age Italy 46, 50; warriors 102,
146 n. 48

weaponry: as class symbol in prehistoric
Italy 58–60; as gender symbol in
prehistoric Italy 5, 45, 48–55, 57, 59
weaving: as class symbol in prehistoric
Italy 58, as gender symbol in
prehistoric Italy 5, 46, 50–1; in
iconography of Agamemnon's
murder 97; *see also* spinning

wives 5: Clytemnestra as 93, 103; on the
Parthenon frieze 134, 136, 138, 140
n. 7; *see also* marriage, matron
wrestling, as gendered activity 54,
232–3

Zeus 69, 71, 80, 133, 138, 185–7, 226
Zeuxis 185